Van Gogh and Gauguin

Van Gogh
and
Gauguin

*Electric Arguments and
Utopian Dreams*

Bradley Collins

A Member of the Perseus Books Group

Copyright © 2004 by Westview Press

Published in the United States of America by Westview Press, A Member of the Perseus Books Group, 5500 Central Avenue, Boulder, Colorado 80301–2877, and in the United Kingdom by Westview Press, 12 Hid's Copse Road, Cumnor Hill, Oxford OX2 9JJ.

Find us on the world wide web at www.westviewpress.com

Westview Press books are available at special discounts for bulk purchases in the United States by corporations, institutions, and other organizations. For more information, please contact the Special Markets Department at the Perseus Books Group, 11 Cambridge Center, Cambridge, MA 02142, or call (617) 252-5298, (800) 255-1514 or email j.mccrary@perseusbooks.com.

A Cataloging-in-Publication data record for this book is available from the Library of Congress.
ISBN 0-8133-4157-4

The paper used in this publication meets the requirements of the American National Standard for Permanence of Paper for Printed Library Materials Z39.48–1984.

Text design by Heather Hutchison
Set in 11 pt Bulmer by the Perseus Books Group

10 9 8 7 6 5 4 3 2 1

Contents

Illustrations

Color Plates

Preface

Why another volume on two of the most celebrated and extensively scrutinized figures in the history of art? Despite the mountainous literature on each of the legendary *artistes maudits,* very few writers have concentrated exclusively on van Gogh and Gauguin's relationship. Many questions about their collaboration remain unresolved—from the precise nature of their influence on each other to the degree of Gauguin's responsibility for van Gogh's ear cutting. And the inevitable emphasis on the Arles period with its bloody climax has obscured the very important dealings the artists had with each other both before and after their occupation of the Yellow House. Art historians, moreover, have made many discoveries since the midcentury outpouring of psychoanalytic writings on van Gogh and his fateful encounter with Gauguin. I have taken advantage of this more recent scholarly material to deepen and refine the psychoanalytic interpretations of the artists, their relationship, and their paintings. It has been very tempting for art historians and psychoanalysts alike to see van Gogh and Gauguin in terms of polarities—father versus son, rogue versus saint, champion of the imagination versus advocate for reality. These dualities have a tight grip on the imagination not only because they contain kernels of truth but also because the artists themselves helped construct them in their writings and in their art. I have tried to introduce nuance and complexity into this polarized conception of van Gogh and Gauguin—without entirely dismantling the mythical oppositions.

This book is both a narrative history intended for the general reader and an unabashedly psychobiographical study of van Gogh's and Gauguin's intersecting careers. I have examined the many ways in which the artists revealed themselves—in their art, letters, and behavior—in order to illuminate the unconscious as well as the conscious dimensions of their relationship. I have also attempted to show in my account of both artists' development how important aspects of their collaboration were foreshadowed by earlier experiences. This does not mean, however, that artworks are reduced to items of evidence in support of psychoanalytical interpretations. Nor have I succumbed to jargon or theoretical hairsplitting. By focusing on van Gogh's and Gauguin's inner worlds I run counter to a strong current in contemporary art-historical thinking that regards psychobiography as the enemy of a properly historicized view of artists in general and of these two in particular. But I do not see why a psychobiographical approach cannot happily coexist with the grounding of an artist's life and work in all of the dense particulars of his era.

David Sweetman, who has written entertaining and well-researched biographies of each artist, declared that he had "tried as hard as [he] could to avoid the words 'maybe' and 'perhaps' with which the thesis writer cloaks any uncertainties in his subject's doings." I cannot make the same claim and have instead acknowledged the speculative nature of not only my psychoanalytic ideas but also my reconstruction of historical events where documentation is ambiguous or insufficient. I have also been unable to prevent a certain one-sidedness in favor of van Gogh. This was inevitable as the number of van Gogh's surviving letters greatly exceeds those by Gauguin. For long periods, van Gogh wrote to his brother Theo on a nearly daily basis, and we almost always have more information about his thoughts on any given matter. This book cannot, of course, give a full account of each artist's life or of the paintings discussed. My emphasis has been on van Gogh and Gauguin's relationship, and I will have succeeded to the extent that I have shown that this relationship powerfully informed some of their most important works.

My interest in this subject springs from my dual passions for art history and psychoanalysis, and I have benefited from the advice and expertise of figures in both disciplines and especially from those who have combined careers as art historians and practicing analysts. I am particularly indebted to Laurie Wilson

for allowing me to explore my ideas about van Gogh and Gauguin in various seminars and symposia at New York University and to Mary Gedo, who encouraged me to examine the psychoanalytic literature on Gauguin in its entirety. My greatest thanks, however, must go to Laurie Adams for reading each chapter with exemplary attentiveness and to my editor Cass Canfield for his encouragement and forbearance.

1

Van Gogh

Zundert to Paris

I

Although art historians have spent decades demystifying van Gogh's legend, they have done little to diminish his vast popularity. Auction prices still soar, visitors still overpopulate van Gogh exhibitions, and *The Starry Night* remains ubiquitous on dormitory and kitchen walls. So complete is van Gogh's global apotheosis that Japanese tourists now make pilgrimages to Auvers to sprinkle their relatives' ashes on his grave. What accounts for the endless appeal of the van Gogh myth? It has at least two deep and powerful sources. At the most primitive level, it provides a satisfying and nearly universal revenge fantasy disguised as the story of heroic sacrifice to art. Anyone who has ever felt isolated and unappreciated can identify with van Gogh and hope not only for a spectacular redemption but also to put critics and doubting relatives to shame. At the same time, the myth offers an alluringly simplistic conception of great art as the product, not of particular historical circumstances and the artist's painstaking calculations, but of the naive and spontaneous outpourings of a mad, holy fool. The gaping discrepancy between van Gogh's long-suffering life and his remarkable posthumous fame remains a great and undeniable historical irony. But the notion that he was an artistic idiot savant is quickly dispelled by even the most glancing examination of the artist's letters. It also must be dropped

after acquainting oneself with the rudimentary facts of van Gogh's family back-
ground, upbringing, and early adulthood.

The image of van Gogh as a disturbed and forsaken artist is so strong that
one easily reads it back into his childhood and adolescence. But if van Gogh
had died at age twenty, no one would have connected him with failure or men-
tal illness. Instead he would have been remembered by those close to him as a
competent and dutiful son with a promising career in the family art-dealing
business. He was, in fact, poised to surpass his father and to come closer to liv-
ing up to the much-esteemed van Gogh name.

The van Goghs were an old and distinguished Dutch family who could trace
their lineage in Holland back to the sixteenth century. Among Vincent's five
uncles, one reached the highest rank of vice-admiral in the Navy and three oth-
ers prospered as successful art dealers. Van Gogh's grandfather, also named
Vincent, had attained an equally illustrious status as an intellectually accom-
plished Protestant minister. The comparatively modest achievements of the
artist's father, Theodorus, proved the exception, not the rule. Although
Theodorus was the only one of grandfather Vincent's six sons to follow him
into the ministry, he faltered as a preacher and could obtain only modest posi-
tions in provincial churches. It was for this reason that Theodorus and his new
wife, Anna, found themselves in Groot Zundert, a small town near the Belgian
border. Vincent was born a few years after their arrival.

Van Gogh enjoyed a relatively uneventful childhood save for the birth of five
siblings (three by the time he was six and two more by his fourteenth year) and
his attendance at two different boarding schools. In rural Zundert he took long
walks in the Brabant countryside and developed a naturalist's love of animals
and plants. At his two boarding schools, he excelled at his studies and laid down
the foundation for his lifelong facility in French and English. The family's deci-
sion to apprentice him at sixteen to Uncle Vincent's art gallery in The Hague
was far from a nepotistic last resort. Uncle Vincent, called "Cent," had trans-
formed an art supply store into a prestigious art gallery and had become a senior
partner in Goupil et Cie., one of the largest art-dealing firms in Europe. Vincent
had no better opportunity for advancement than working at The Hague branch
of Goupil's. And it was a testament to Vincent's abilities that the childless "Un-

cle Cent" took a paternal interest in him and arranged for his position as Goupil's youngest employee.

Vincent's duties progressed from record keeping and correspondence chores in the back office to dealing, if only in a subordinate way, with clients. This confronts us with the nearly unthinkable image of the "socially competent" Vincent. But such was the case at this stage in his life. The same man whose eccentricity would one day make young girls scream in fright dressed appropriately and charmed customers with his enthusiasm for art. Vincent also ingratiated himself with the local artists of The Hague School and earned his colleagues' respect. Although his status as Uncle Cent's nephew and protégé must have smoothed his way, Vincent appears to have been genuinely dedicated and effective at Goupil's. His boss, Tersteeg, sent home glowing reports and after four years at The Hague he was promoted to the London branch.

By the time the twenty-year-old van Gogh settled in London, he possessed an exceptional knowledge of European art. Not only had he seen the contemporary paintings in Goupil's stock, but he had also exhaustively versed himself in the Golden Age of northern art by visiting museums in The Hague, Amsterdam, and Brussels. Added to this was his sojourn in Paris on his way to London. In Paris he thoroughly explored Goupil's three branches and other collections as well as the Louvre. The museums and exhibitions in London only deepened his exposure to pictures. Of course, his immersion in images extended beyond original paintings and drawings. He would have seen thousands of reproductions in the course of his work. Goupil's specialized in selling both engravings and photographic reproductions (Vincent, in fact, had been in charge of the photographic sales at The Hague). Although Vincent had not toured Italy, this constituted one of the few lacunae in his visual education. Nor were van Gogh's cultural interests limited to art. He voraciously read novels, poetry, and historical works in three languages (Dutch, French and English). After only a few months in London, he could already quote Keats in his letters. So much for van Gogh as a "primitive." The rawness that he later permitted in his appearance and cultivated in his art disguised a sensibility of extreme sophistication.

Vincent's first year in London took him to a great height of euphoria from which he plunged precipitously. He was exhilarated by the city, his work continued to engage him, and, most important, he fell in love. He became smitten with his landlady's daughter, Eugénie Loyer. For months van Gogh quietly nursed his affections and assumed, on no basis whatsoever, that Eugénie reciprocated his passion. This irrational belief grew so firm that when he finally spoke to her of his romantic feelings he skipped all preliminaries and simply proposed marriage. The shocked Eugénie not only emphatically rejected the offer but disclosed that she was already secretly engaged to a previous boarder. Eugénie's response entirely derailed Vincent. He became distracted at Goupil's and sought consolation for his deep depression in religious fervor and manic Bible study. In the next year and a half Uncle Cent and the other partners shuttled Vincent back and forth between Goupil's Paris and London branches in an attempt to jolt him out of his despair. Nothing worked and Goupil's finally dismissed him in January of 1876. From this point onward Vincent would never again succeed at a conventional occupation and would always remain a source of embarrassment to his family.

Why was this romantic disappointment so catastrophic for van Gogh? Why couldn't he shake it off as so many young men do? A psychoanalytic explanation finds the answer, not surprisingly, in van Gogh's childhood. A startling fact of the artist's infancy is that he was preceded by a first, stillborn Vincent, who died exactly a year to the day before his own birth. The death of a first child deals a severe blow to any mother, but this loss would have been particularly harsh for the thirty-three-year-old Anna, who married late and eagerly wished for a family. The official mourning period extended beyond Vincent's birth and may have been more than a formality in this case. Vincent would have found himself with a mother consumed by her grief and unable to lavish undivided attention on him. Making matters worse, Vincent would continue to suffer displacement in his mother's affections first by his sister, Anna, born when he was two, and then by Theo's birth when he was four. These successive disappointments during the crucial first years of infancy may have formed a deep, unconscious reservoir of depression. Eugénie's rejection would have tapped into this reservoir and opened the floodgates.

That an unavailable mother lived on powerfully in van Gogh's unconscious is dramatically underscored by the type of woman to whom he invariably attached himself. Indeed, one would be hard put to find a more insistent case of repetition compulsion (that is, the compulsion to return to traumatic or painful situations). Eugénie was only the first in a line of preoccupied women on whom van Gogh became fixated. Eugénie had lost her father in her childhood and now had her secret engagement to the boarder to fill her thoughts. A surviving photograph reveals her as a forbiddingly severe latter-day replacement for the once-distant Anna. Kee Vos-Stricker, who had lost both an infant son *and* her husband, would eventually succeed Eugénie in this role of unattainable love object. Yet even at the early stages of Vincent's infatuation with Eugénie he had already come across an image of a mourning woman that held him in thrall. One of his favorite authors, Jules Michelet, had written evocatively of a portrait in the Louvre, then attributed to Philippe de Champaigne, that depicted a woman dressed in black mourning clothes. Vincent hung an engraving of the painting on his wall and quoted Michelet's words in a letter to friends in The Hague:

. . . who took my heart, so candid, so honest, sufficiently intelligent, yet simple, without the cunning to extricate herself from the ruses of the world. This woman has remained in my mind for thirty years, persistently coming back to me, making me say: "But what was she called? What has happened to her? Has she known some happiness? And how has she overcome the difficulties of the world?"[1]

When one views the actual portrait, the sitter appears as an extremely unlikely source of devotion for a twenty-year-old man. She is markedly dour, middle-aged, and plain. It is resounding evidence—almost too good to be true—that Vincent's mother stood behind his obsession with mourning women. And Michelet's account of a female figure who "has remained in my mind . . . persistently coming back to me," strikingly mirrors the stubborn presence of the grieving Anna in Vincent's unconscious.

If we can trace the roots of van Gogh's attraction to Eugénie and his subsequent devastation to his childhood, we can also see his means of recuperation

as a legacy of his early years. Vincent embraced Theodorus's world of religious piety just as he may have turned as a child from rageful ambivalence toward his indifferent mother to yearning for his father. Vincent's letters to his brother Theo disclose the growing momentum of his religious mania. It starts with occasional quotations from the New Testament a few months after his failed proposal and moves on to three separate exhortations to Theo to destroy his books and read nothing but the Bible—a remarkable proscription from the bibliophilic Vincent. The intense spiritual preoccupations reach a crescendo with a multipage letter, written almost a year after his dismissal from Goupil's, that consists of a relentless and unorganized flow of citations from Scripture, sermonizing admonitions, and outpourings of faith. The letter contrasts so greatly with Vincent's usual cheeriness, descriptions of paintings and scenery, and warm solicitousness toward his brother and other family members that it must have disturbed Theo.

Vincent's second job after leaving Goupil's gave him an outlet for his feverish religiosity. A Methodist minister, Reverend Thomas Slade-Jones, hired him as an assistant and as a teacher in his day school in Isleworth. Jones encouraged van Gogh's ambition to preach the gospel and even arranged for him to give his first sermon in a Wesleyan chapel in Richmond. The text, which Vincent transcribed for Theo, unifies many of his concerns and offers both intentional and unintentional glimpses into his psyche. He begins with a quote from Psalm 119—"I am a stranger on the earth."[2] This passage enunciates the sermon's theme of man as a wayfarer passing through his mortal existence but must also have been an expression of Vincent's own sense of isolation from his former colleagues and friends. He ends with an elaborately described recollection, which appears more like a fantasy than an actual memory, of a "very beautiful picture." It is an allegorical painting in which a pilgrim seeks knowledge about the journey of life from "a woman, or figure in black, that makes one think of St. Paul's word: As being sorrowful yet always rejoicing." Here, Vincent not only brings together his twin loves of religion and art but also presents two of the strongest currents in his inner world—the image of the mourning woman and the attitude of being "sorrowful yet always rejoicing" (a phrase that recurs dozens of times in his letters of this period). The image and the phrase are, of course, intertwined. The "lady in black"—his grieving mother—creates

sorrow that must always be met with rejoicing, just as Vincent must always answer his depression with manic activity.

Vincent's religious utterances also reveal both a symbolic and explicit love of his father. In the letter to Theo mentioned above, in which Vincent becomes so frenzied that he seems to write in tongues, he recalls Theodorus's visit to his boarding school:

> . . . I was standing in the corner of the playground when someone came and told me that a man was there, asking for me; I knew who it was, and a moment later I fell on Father's neck. What I felt then, could not it have been "because ye are sons, God hath sent forth the Spirit of his Son into your hearts, crying, Abba, Father"? It was a moment in which we both felt we had a Father in heaven; for Father too looked upward, and in his heart there was a greater voice than mine, crying, "Abba, Father."[3]

This passage provides one of the best examples of the nearly indistinguishable nature for Vincent of his own "father" and his "Father" in heaven. Such outpourings of filial piety are accompanied in the letters by an impassioned idealization of Theodorus as well as an identification with his calling. Van Gogh's father is "more beautiful than the sea" and "enrich[es] our lives with moments and periods of higher life and higher feeling."[4] His sermons are "beautiful," and a day spent with him is "glorious."[5] Theodorus even takes his place in Vincent's pantheon alongside exalted figures such as Jules Breton, Millet, and Rembrandt. These artists, Vincent wrote, resemble Theodorus, but Vincent "value[s] Father higher still."[6] Van Gogh's worshipful stance appears especially striking as Theodorus, who belonged to a moderate wing of the Dutch Reformed Church, reacted more with concern than encouragement to his son's religious enthusiasms. It is as if Vincent's vision of his father remained completely immune to Theodorus's actual accomplishments, religious views, and treatment of Vincent himself. This same capacity for extreme idealization would recur in van Gogh's later relationships with father figures such as Anton Mauve and Paul Gauguin (as would the attitude's flip side: angry rebellion and denunciation).

Van Gogh's religious fanaticism was coupled with, and provided a rationalization for, self-denying behavior of an often drastic and bizarre nature. He

shocked family members with his shabby clothes, unkempt hair, and a frailty that resulted from weight loss and sleep deprivation. A fellow boarder in his Dordecht rooming house recalls that at dinner Vincent "said lengthy prayers and ate like a penitent friar: for instance, he would not take meat, gravy, etc."[7] His tutor in Latin and Greek, Mendes da Costa, reported traits that went well beyond adolescent otherworldliness and clearly entered the realm of masochism:

> . . . Whenever Vincent felt that his thoughts had strayed further than they should have, he took a cudgel to bed with him and belabored his back with it; and whenever he was convinced he had forfeited the privilege of passing the night in his bed, he slunk out of the house unobserved at night, and then, when he came back and found the door double-locked, was forced to go and lie on the floor of a little wooden shed, without bed or blanket. He preferred to do this in winter, so that the punishment . . . might be more severe (no. L122a).[8]

Vincent took these self-flagellating measures to even more spectacular lengths in the Borinage, where he gave away his money, clothes, and bed; allowed himself to become black with coal dust; and abandoned his boarding-house for a miner's hut.

One of the stranger paradoxes of this period is that van Gogh's extreme piety and self-sacrifice coexisted with irresponsibility and defiance of authority. Despite letters to Theo in which he declared that "duty sanctifies and unifies everything,"[9] he ran through four jobs in little more than a year. After leaving Goupil's, he abandoned a short-lived teaching position in Ramsgate, did not return to Reverend Jones in Isleworth after visiting his family for Christmas, and then took only a few months to lose his new job as a bookstore clerk. His religious obsessions seem to have transcended every other concern and justified a stubborn refusal to surrender himself to his work. Perhaps the best example of van Gogh's religiosity as a covert means of insubordination occurred after his family found him employment in a Dordecht bookstore, Blussé & Van Braam. While supposedly taking orders at his desk, he would secretly translate the Bible into three languages, using a ruled page with columns for French, English, German, and the original Dutch. Yet this was only one in-

stance of many subtle and some explicit acts of aggression. He precipitated his dismissal from Goupil's by leaving for home during the busy holiday weeks. Although he possessed great skill with languages, he resisted learning the Greek and Latin required for admission to the seminary. And at the school for evangelists in Belgium he not only mocked his teachers but struck a fellow student who teased him.

Fired from the Dordecht bookstore, van Gogh piled failure upon failure. In what should have been a glorious opportunity, Theodorus arranged for Vincent to study for the entrance exams to the seminary. Now he could finally pursue a career of his own choosing, emulate his saintly father, and serve God. He might also redeem the disappointments of the preceding years, which seemed to have resulted from his preoccupation with his true calling. While Vincent prepared for the exams, his uncle the vice-admiral put him up in his comfortable lodgings in Amsterdam, and another relative, the respected and well-connected Reverend Johannes Stricker, secured two of the best instructors. Yet Vincent could not, or would not, make sufficient progress in his Greek and Latin. He famously asked of Mendes da Costa, his classics tutor: "Mendes, do you seriously believe that such horrors [Greek verbs] are indispensable to a man who wants to do what I want to do: give peace to poor creatures and reconcile them to their existence here on earth?"[10] Halfway through the course of preparations, Mendes, Vincent, and Theodorus all agreed that he should give up. Although his father had attained only relatively humble clerical positions, van Gogh had eliminated any possibility of reaching even that level. What is more, he had squandered not only a year in a fruitless endeavor but also his family's generosity and extensive string pulling.

Although Vincent threw up his hands in the face of the entrance exams, he remained undaunted in his desire to become a pastor of some sort. One solution was to enter an Evangelical school in Brussels. The program consisted of only three years of study as opposed to six at the university seminary, and the ultimate vocation—doing missionary work among the miners—appealed to Vincent's already aroused social conscience. But Vincent spoiled this chance as well. He acted eccentrically, spoke defiantly to his teachers, and did not even survive the three-month trial period. Only after Theodorus's intervention did the Evangelical committee allow him to go to the Borinage on a provisional ba-

sis as an unpaid assistant. This led to his solitary triumph—a temporary nomi-
nation for six months. Vincent, however, sabotaged this victory by appearing
so odd and ragged at the end of the probationary term that the committee's in-
spector, a man with the upright name of Rochedieu ("rock of God"), promptly
wrote a negative report. Still persistent, van Gogh trekked on foot to Brussels
and pleaded with the most sympathetic member of the committee, a Reverend
Pietersen, who suggested he return to the Borinage once again as an unpaid
and unassigned assistant. Van Gogh did so, but the situation remained hope-
less, and despite his staying more than a year in a miner's household, the com-
mittee made no other offer. By now he had spent a total of three years in useless
study for the seminary and in a vain attempt to achieve the lowest possible cler-
ical vocation. Van Gogh had become a success at failure.

In the Borinage, Belgium's southern industrial region, Vincent witnessed
firsthand the luridly oppressive working-class conditions he had read about in
Dickens and had glimpsed in London. In addition to the usual miseries such as
endless hours, child labor, and untreated diseases, the miners suffered from vi-
olent, large-scale "fire-damp" explosions. These were triggered by the build-
up of underground gases and could collapse shafts as well as send flames sear-
ing through the tunnels. An explosion could leave hundreds dead and many
more wounded with injuries that included horrible burns. In the past Vin-
cent's religious convictions had served as a persuasive rationalization for his
masochistic behavior. Now he had both piety and the desire to share the min-
ers' plight as an impetus to self-mortification. Although his official duties con-
sisted of assisting the ministers, preaching sermons in the Protestant meeting
hall, and conducting Bible study in the miners' homes, Vincent went much fur-
ther. He gave away his food and clothing and spent most of his time nursing
miners' families. Vincent even tore up his own linens for the bandages, dipped
in olive oil and wax, that were used to treat burns. But his immersion in the
world of the miners involved more than a wish to ameliorate their suffering. He
also wanted to collapse any hypocritical distance between himself and those he
served. To this end, he made a trip down a mine shaft (dramatically evoked in a
letter to Theo), tried to move into a miner's hovel—a mere wooden shed—and
refused to wash off the coal dust that covered him from head to toe. All of this
so alarmed Vincent's first landlady that she convinced Theodorus to make an

emergency trip to the Borinage. Theodorus managed to temporarily restrain Vincent's more flamboyant slumming. But once Theodorus returned to Holland, Vincent could not resist indulging in the kind of extreme self-denial that incurred Rochedieu's wrath. From the Evangelical committee's point of view, Vincent was supposed to lead the miners to God, not become one of them.

II

In retrospect, van Gogh had reason to be grateful for Rochedieu's disapproval. It hastened his turn toward drawing and ultimately his career as a painter. The Borinage period saw the waning of Vincent's religious fanaticism and the first stirrings of his ambitions as a creator, not merely an admirer, of art. Van Gogh had always made sketches and drawings. As a child, he was a skillful, if not particularly precocious, draftsman, and in later life he would routinely include in his letters illustrations of his current dwelling place or the view from his window. But in the Borinage Vincent started to make sketches of his surroundings that were more than adjuncts to his correspondence. He also began applying himself to the serious apprentice work of copying engravings after Millet and the plates in Bargue's *Cours de Dessin* and *Exercices au Fusain* (two popular nineteenth-century instruction books). By the end of his stay, his commitment to his newly discovered vocation ran so deep that he wistfully declared to Theo that "someday or other I shall earn a few pennies with some drawings of miners" and "you will see that I too am an artist."[11]

Why did such a momentous transformation take place at this point? The causes, of course, are complex and overdetermined. Vincent appears to have exhausted his prospects for employment as a pastor and to have experienced a diminishment of his religious mania. He came, moreover, to regard organized religion in a much more skeptical light. He informs Theo that certain church leaders, whom he compares to academic painters, are "often detestable, tyrannical, the accumulation of horrors, men who wear a cuirass, a steel armor, of prejudices and conventions."[12] He also arrives at a view of art and religion as equally worthy. In a letter full of searching ruminations about painting, religion, and literature, he tells Theo that he finds "something of Rembrandt in the Gospel, or something of the Gospel in Rembrandt."[13] And he adds, "I

think that everything which is really good and beautiful—of inner moral, spiritual and sublime beauty in men and their works—comes from God."[14] In this way, art becomes an extension, not a betrayal, of his past religious zeal.

He had always viewed the Borinage through the filter of art. No matter how horrible the suffering and no matter how impassioned his outrage, he would still think of the miners and their pitiful milieu in terms of pictures. No contradiction existed between the moral and aestheticizing faculties. In the same letter in which he praises *Uncle Tom's Cabin* and alludes to the miners' oppression by stating, "there is still so much slavery in the world," he remarks on the "chiaroscuro effect" of the Borinage's industrial haze and compares it to a "Rembrandt or Michel or Ruysdael."[15] The Borinage, moreover, presents a new spectacle not yet depicted in art. We can see this rapid and seamless switch from moral to artistic concerns in his description of one of the oldest pits, Marcasse:

> Most of the miners are thin and pale from fever; they look tired and emaciated, weather-beaten and aged before their time. On the whole the women are faded and worn. Around the mines are poor miners' huts, a few dead trees black from smoke, thorn hedges, dung hills, ash dumps, heaps of useless coal, etc. Maris could make a wonderful picture of it.
>
> I will try to make a little sketch of it presently to give you an idea of how it looks.[16]

He moves without pause from hellish squalor to "a wonderful picture." In the same letter Vincent writes that a painting of a mine shaft interior would be "something new and unheard of—or rather, never before seen."[17] To represent the miners would constitute both a moral and an artistic victory.

Yet Vincent decided to become an artist in a far from sudden and conclusive way. In two letters to Theo, defending against the latter's charges of "idleness," Vincent explains that he is not so much idle as undergoing a transformation—a "molting time."[18] He does not want to end this period by too hastily choosing a profession and taking another wrong turn. Although he had already started sketching, he remains uncertain about how he can be "of use in the world."[19] What reveals the mounting pressure of his imminent choice are the metaphors that he uses to describe his situation. When he tells Theo that he does not want to work in an occupation ill fitted to him, he compares this to a "picture cata-

logued as a Memling but having nothing to do with Memling."[20] And when he describes his gradual metamorphosis toward a suitable identity he puts it this way: "That aim becomes more definite, will stand out slowly and surely, as the rough draft becomes a sketch, and the sketch becomes a picture."[21]

On a more practical level, drawing functions as a sort of therapy for him. He tells Theo not to "fear for me" as drawing "will set me right again."[22] Through drawing he has "recovered [his] mental balance."[23] And in his pilgrimage on foot to Jules Breton's house in Courrières, art becomes his salvation:

> Well, even in that deep misery [sleeping without shelter in the frost and rain] I felt my energy revive, and I said to myself, In spite of everything I shall rise again: I will take up my pencil, which I have forsaken in my great discouragement, and I will go on with my drawing. From that moment everything has seemed transformed for me. . . . [24]

Vincent also seizes on drawing as a means of reestablishing his relationship with his brother. It is a way of proving to him that he is not "idle" and of restoring a vehicle—the shared love of art—for expressions of affection. And, on a deeper level, Vincent's turn to art involves an identification with his mother. She had always made a hobby of pencil drawings and water colors and had encouraged Vincent's artistic leanings in his childhood. He had already followed in her footsteps by becoming an inveterate and prolific letter writer.

So art reconciled much in Vincent's inner and outer life. As he yearned to make pictures of peasant and working people, he could translate his religious preoccupations into a moralizing art. The spirit of Theodorus as well as Anna would inform his drawings. Solitary work in his studio and in the fields would also make his eccentric dress and manner much less of a handicap. The great difficulty, of course, was money. Vincent was entering into a long training period that should have started when he was in his late teens. Even if his art took a commercially promising direction, it would take years before he could support himself as an artist. Thus began the financial dependency on Theo, now a successful director of one of Goupil's Parisian galleries, that would last until Vincent's death.

For someone who would later serve as a prototype for the avant-garde artist, van Gogh's initial approach could not have been more conventional. Like any fledgling academician, he methodically copied the plates in Charles Bargue's exercise books. These handsome engravings allowed students to gradually master the figure by copying isolated parts of the body before moving on to the full torso. The course, which emphasized firm outlines, culminated in figural groups created by Jean-Léon Gérôme, the great defender of the academy in the face of Impressionism. Once he had finished with Bargue the typical pupil in an École des Beaux-Arts would then tackle plaster casts until finally permitted to draw after a live model. The unsupervised Vincent clung to his Bargue plates as if they were a substitute for a proper instructor and assiduously copied the exercises, sometimes doing over a lengthy series as many as three times.

More reflective of Vincent's own sensibility was his copying of engravings after Millet. Vincent worshipped Millet as an artistic god. For Vincent, no other artist, not even Rembrandt, imbued the humble, everyday world with such sanctity. A spiritual aura surrounded his weavers, spinners, and sowers as they went about their seemingly timeless and ritualistic tasks. Millet brought together all of Vincent's great passions—the beauty of even the most ordinary rural setting, the nobility of the peasant, and the virtue of an unpretentious piety. In fact, Millet was so important for Vincent that it is hard to say whether he found in him an echo of his own moral and artistic inclinations or whether his early exposure to Millet and other Barbizon artists had given birth to those very inclinations in the first place. Yet Millet's paintings, though they gave the peasant classes a sometimes provocative monumentality, had by the 1880s become very much an established taste. Millet's works hung in the finest museums and in the most opulent collections. Although Vincent identified with the "outsiders" celebrated by Millet, he was emulating a painting style that was now forty years old and could not have been less threatening.

The other major influence on van Gogh's early years were the engravings in illustrated newspapers, such as the *Graphic* and the *Illustrated London News*, that he had first seen during his stay in England. These showed the urban poor in various settings—soup kitchens, veteran's hospitals, the slums of London— with a stark vividness that took full advantage of the medium's incisive lines and black-and-white contrasts. Vincent not only cut out and collected these

woodblock engravings—at one point, buying all 212 of the *Graphic* volumes from 1870 to 1880—but aspired to become an illustrator himself. He inscribed English titles on the most successful early drawings and held out the possibility to Theo that work as an illustrator would constitute his first source of income. At first, however, he could only attempt single figures. So his output during the first year consisted mostly of Milletesque peasant workers—sowers, diggers, women sewing—and literally "illustrational" depictions of human suffering such as the sunken old man in *Worn Out.*

After leaving the Borinage, Vincent lived in a cheap hotel in Brussels and continued copying his Bargue exercises. Mitigating these dreary circumstances was his new friendship with a fellow Dutchman and aspiring artist, Anton van Rappard. Van Rappard, whom Theo had met in Paris in 1879, had come to Brussels to attend painting classes at the Academy. Vincent and Van Rappard formed something of a mismatched couple. Van Rappard came from a family of minor nobility, enjoyed his father's full moral and financial support, and had already achieved a significant degree of technical mastery under teachers such as Gérôme. In fact, Van Rappard's concern for technique elicited from Vincent one of his first articulations of an aesthetic that placed expressive power above technical prowess. Although they would ultimately fall out over Van Rappard's withering criticism of *The Potato Eaters,* Vincent's relationship with Van Rappard amounted to one of his longest lasting and least tumultuous friendships with a fellow artist. Despite their differences they shared a preference for rural and peasant imagery and often went out together on sketching excursions. The relative serenity of their relationship may also have been due to their ages. Van Rappard, who was five years younger than Vincent, could not so easily become a highly charged father figure.

After Van Rappard embarked on a sketching campaign in the Netherlands, Vincent had little to keep him in Brussels and much to save in expenses by moving home to Etten. This set the stage for some of the most dramatic, not to say melodramatic, months of Vincent's life. In August 1881 his cousin Kee Vos-Stricker came to stay in the parsonage with her seven-year-old son, Johannes. Kee had become the consummate "woman in black." Indeed, Vincent had seldom seen her in anything but mourning clothes. He first met her in Amsterdam while studying for the seminary with the tutor that her father, the

Reverend Johannes Stricker, had helpfully secured. At that time, Kee had not only suffered the recent loss of an infant son but also faced the imminent death from an incurable lung disease of her minister husband. When she arrived in Etten she had been a widow for two years. Vincent played with Johannes, sketched Kee's portrait, and harbored a mounting affection. As in the case with Eugénie, he could not take a gradual and insinuating approach and instead proposed out of the blue. Once again, his sudden and apocalyptic overtures received a blunt rejection. Kee delivered the seemingly ultimate and unanswerable reply, "No, never never."[25] And her actions were as unequivocal as her words. Soon after the exchange she collected her son and returned to Amsterdam. Letters from Vincent trailed after her, but she left them all unread.

This time, however, Vincent did not take no for an answer and did not keep quiet about his passion. In his letters to Theo his avowals of love vied with his insistence on pursuing Kee despite the outraged reactions of her family and his own. Kee's rejection did nothing to lessen her allure and, for Vincent, "she, and no other," would satisfy him.[26] After two months of pleading his case, he finally extracted from Theo the train fare to Amsterdam. Upon arriving, he went directly to the Stricker's house only to be told by Kee's parents that she was out. Not believing this, Vincent placed his hand over a lamp and uttered the famous words, "Let me see her for as long as I can keep my hand in the flame."[27] Not surprisingly, the Reverend and Mrs. Stricker declined this request and Vincent had no choice but to leave.

Vincent's account to Theo of this mortifying incident contains more than a few unexpectedly humorous notes. While waiting vainly for Kee, he allowed "Uncle Stricker" to read a letter that the Reverend must have hoped would put an end to all of Vincent's hopes. But when Vincent did not immediately acquiesce, "Uncle S." became "full of consternation at my not being absolutely convinced that the utter limit of human capacity for feeling and thinking had been reached."[28] Their words became heated and Uncle S. "lost his temper too—as much as a clergyman can."[29] And although "he did not exactly say 'God damn you,' any other but a clergyman in Uncle S.'s mood would have."[30] Despite all of this, the evening ended with the good Strickers asking Vincent to stay for the night and then finding him lodgings when he refused their invitation. "And, dear me," he tells Theo, "those two old people went

with me through the cold, foggy, muddy streets, and they did indeed show me a very good, cheap inn"[31] The most outrageous provocations prove in the end no match for bourgeois complacency and politeness. Vincent returned the next day and spoke again with his long-suffering uncle, but Kee still sequestered herself. This finally crushed Vincent's seemingly indomitable resolve, and he left for The Hague.

Even more than his unrequited love for Eugénie, Vincent's attachment to Kee provides dramatic proof of the enduring influence of his childhood disappointments. It would be difficult to find a closer substitute for his mourning and distracted mother than Kee. Not only was she a minister's wife who had lost an infant son, but she was almost exactly the same age in Etten that Anna had been when she gave birth to Vincent. And, like Eugénie and *The Woman in Black,* she appears forbiddingly solemn in a photograph taken at this time. Moreover, her monumental indifference and constant preoccupation with the past—Vincent writes that she "buried herself in it"—only seems to heighten her desirability.[32] At one point, he even tells Theo, "But, I am so glad with my 'no, never never,' I should like to shout with glee."[33] That Vincent reenacted his desperate attempts to hold onto an unresponsive mother reveals itself in his richly metaphorical language. He casts his romantic battle with Kee in the following terms:

> To determine which will win, the coldness of that block of ice or the warmth of my heart, that is the delicate question about which I can give no information as yet. . . . If I had an iceberg from Greenland or Nova Zembla before me, I do not know how many meters high, thick and wide, then it would be a difficult case, to clasp that colossus and press it to my heart to thaw it.[34]

Like an infant overwhelmed by a gigantic-seeming mother, Kee becomes a huge, ice-cold figure that Vincent struggles to embrace.

We can also detect traces of Vincent's original rage. This sometimes takes a sadistic form such as his characterization of his "brusque and rough" proposal as a "knife thrust."[35] He also speaks of his firm persistence as a "steel blade."[36] But, typically, his aggression is more often turned on himself as in his linking the loss of love with "tak[ing] his own life."[37] And of course nothing could be

more flamboyantly masochistic than his thrusting his hand into the flame. The gesture implicitly equates his beloved with physical pain at the same time that it redirects onto himself his wish to punish Kee and her family. In fact, so masochistic was Vincent's futile ardor that even Theo recognized it and told him that he was "too fond of that 'no, never never.'"[38]

Vincent quickly followed up the crisis in Amsterdam with another in Etten. On Christmas, of all days, he refused to attend church services. This inevitably provoked his father whose reputation in the small town depended on at least his own family listening to his sermons. It was also the last straw after many arguments with Vincent over his embarrassing and wrongheaded pursuit of Kee. At the end of an extremely angry exchange, Theodorus ordered Vincent to leave the house. Although Theodorus had made such an exhortation before, Vincent obeyed him this time and left the same day. He wrote Theo that he "did not remember ever having been in such a rage in [his] life."[39] After this "violent scene with Father," he went immediately to The Hague where he contacted his artist cousin, Anton Mauve, and set himself up in a rented studio.[40]

This Christmas explosion served as an important rehearsal for the more disastrous Christmastime eruption in Arles and forces an examination of several issues. First, Christmas itself possessed a crucial psychic significance for Vincent. It involved feelings of piety, generosity, and fellow feeling that overlay extreme envy and aggressiveness. On the conscious level, Vincent associated Christmas not only with the nativity story but also with the intimacy of family gatherings. While working in The Hague, in London, and in Paris he would write Theo telling him that he was "longing so much for Christmas" because, among other things, this would allow him to return home for vacation.[41] Later, after rejecting conventional religion, he would still speak to Theo of "the eternal poetry of the Christmas night" and confess that he "highly respect[ed] the Christmas and New Year's sentiment."[42]

On the unconscious level, Vincent, who was so much affected in childhood by the singular birth and death of the first Vincent, must have identified with the miraculously born Christ Child. Christmas allowed him to glory in this identification with the divine, universally adored infant. At the same time, the image of the newborn Christ Child would have evoked his

rage at displacement by the first Vincent as well as by his siblings Anna and Theo. The "perfect" first Vincent, who never lived long enough to reveal his flawed humanity, would have become an especially enviable and Christlike figure in van Gogh's unconscious. So Christmas also stirred up Vincent's hostility and his wish to punish actual or symbolic parental figures for favoring the special child. And given Vincent's masochistic character, he expressed his fury in a manner that damaged himself more than his target. This explains the timing of his provocative and self-destructive behavior on at least three occasions. In Paris, he prompted the partners at Goupil's to dismiss him after he returned home without permission during the busy Christmas holidays. In Etten, he enraged his father and lost his lodgings by missing Christmas services. And in Arles, of course, he acted in an increasingly bellicose manner toward Gauguin only to injure himself with his ear-cutting two days before Christmas.

One of Vincent's favorite illustrations discloses some of these contradictory attitudes. In a letter to Theo he singles out a drawing by Boyd Houghton that depicts "a few invalids, one with crutches, a blind man, a street urchin, etc. come to visit the painter on Christmas Day."[43] The engraving celebrates a cheery familylike gathering in which even the wretched overcome their suffering. Led by a cripple, blind men hold onto coattails as if playing blindman's bluff while the "urchin" rides on one of their backs. It could be a scene from Dickens's *Christmas Carol*—Tiny Tim multiplied sixfold. Yet beneath its sentimental surface, the illustration emphasizes injury and loss and in this way fulfills the unconscious fantasy of damaging family members or oneself. Vincent, in fact, came to resemble one of Houghton's bandaged "invalids" after slashing his ear.

The other major element in Vincent's departure from Etten was his de-idealization of his father. The man who once rivaled Millet and Rembrandt in nobility had now fallen precipitously in Vincent's eyes. "Father," he tells Theo, "cannot understand or sympathize with me, and I cannot be reconciled to Father's system—it oppresses me, it would choke me."[44] Clergymen, whom he once heroized, now reveal themselves as "unbelieving," "hard-hearted," and "worldly."[45] They produce "odious" and "awfully indigestible" sermons.[46] In fact, the animosity between father and son had become so severe that Vincent

had to defend himself at length against Theodorus's charge that he was killing him. Vincent tried to laugh off this accusation by informing Theo that their father delivered it while still reading the newspaper. But Vincent's underlying guilt remained strong enough for him to seriously worry that others will regard him as "little less than . . . a parricide."[47] And he even sardonically referred to himself as the safely departed "murderer."[48]

This extreme devaluation of Theodorus exactly coincided with an equally strong worship of Anton Mauve and demonstrates the ease with which Vincent could transfer his idealizations onto a substitute. Mauve, a well-established but notoriously moody member of The Hague school, had treated Vincent in a surprisingly helpful manner. He carefully reviewed Vincent's sketches, pushed him to move from drawing to painting, and told him, to his great joy, that he might soon sell his work. Vincent waxed rhapsodic to Theo:

> My trip to The Hague is something I cannot remember without emotion. When I came to Mauve my heart palpitated a little, for I said to myself, Will he also try to put me off with fair promises, or shall I be treated differently here? And I found that he helped me in every way, practically and kindly and encouraged me.[49]

In another letter, he declares, "each day I find Mauve cleverer and more trustworthy, and what more can I want?"[50] Theo easily perceived that Mauve had taken the unrealistic place once occupied by Theodorus in his brother's affections. And, in a letter excoriating Vincent for his treatment of their father, Theo said:

> At present it is Mauve who attracts you, and as you are always exaggerating, everyone who is not like him is not to your taste. Is it not bitterly hard for Father when he sees himself counted for nothing by somebody who calls himself more liberal. . . . [51]

Vincent would not again worship an artistic mentor with the same intensity until his relationship with Gauguin. Mauve, like Gauguin years later, could move easily into a paternal role as he was not only a more experienced and successful artist than Vincent, but also older, married, and an actual father.

III

In the four months from August to December 1881, Vincent fell in love, made a shocking, unwanted marriage proposal to a widow, loudly pursued the proposal against nearly everyone's wishes, threatened his father's reputation as a pastor in Etten, and was ejected from his family home. This would seem to have been enough turbulence for half a year, but Vincent had not finished rocking the boat. After the failed attempt to approach Kee in Amsterdam, Vincent immediately went to The Hague, stopped in at Mauve's studio, and then spent the night with a prostitute. It was probably this same prostitute, Christine Clasina Maria Hoornik (called "Sien"), with whom Vincent began to associate early in the next year. Vincent thought of Sien as essentially the opposite of Kee, and his relationship with her amounted to a vengeful rejection not only of Kee herself but also the genteel world to which she belonged. Sien, as he described her to Theo, "did not have a lady's hands like Kee, but the hands of one who works too much."[52] She was "not distinguished, nothing extraordinary, nothing unusual."[53] Yet Vincent's conversation with her was "more interesting . . . than, for instance, with my very learned, professorial cousin."[54] Sien was one of the women "condemned and damned by the clergymen" and therefore a kindred spirit for Vincent, who had faced his own condemnation from clergymen.[55] He would eventually tell Theo that Kee had been his "illusion" and that "reality" was Sien—"the woman of the people."[56]

On the unconscious level, however, Sien was yet another variation on the "lady in black" and in that respect very much like Kee. Once again, Vincent had attached himself to a female distracted by various losses and preoccupied with the other figures in her life. The husbandless Sien had lost two children, was pregnant when she encountered Vincent, and had a daughter to look after. Her identity as a prostitute, moreover, defined her as someone incapable of faithfulness. She also had the same careworn countenance that had characterized Eugénie and Kee. According to Vincent, "life had been hard for her . . . her youth was gone, gone."[57] And his many drawings of her, not least the famous *Sorrow*, testify dramatically to her haggard and downcast character. Finally, the connections between Sien and Vincent's infancy emerged in his man-

ner of defending the relationship to Theo. Vincent's attitude reflected a desire to reverse roles with Anna and undo his childhood deprivations. He becomes the good mother who rescues the neglected Sien/Vincent:

> Nobody cared for her or wanted her, she was alone and forsaken like a worthless rag, and I have taken her up and have given her all the love, all the tenderness, all the care that was in me; she has felt this and she has revived, or rather, she is reviving.[58]

That "forsaken" and "worthless rag" resembles Vincent's later description of himself as a "big rough dog, . . . a foul beast" dreaded by his own family.[59] Instead of suffering helplessly as the ignored and devalued child, he can now save another and give her the comfort and warmth that he lacked. And this rescue fantasy came to involve not only Sien but an actual infant son after she gave birth. In Vincent's mind, their very existence depended on him. As he repeatedly claimed to Theo, he could not abandon Sien even if he were willing to conform to middle-class conventions. His departure would mean her return to the streets and the ruin of her own life as well as those of her children.

Vincent paid a heavy price for his affair with Sien. At this point in his career he needed to establish ties with fellow artist and potential patrons. Surprisingly, he had made significant progress on both fronts by successfully cultivating Mauve and by receiving a very welcome commission from his uncle Cornelius for drawings of city scenes. Yet his public relationship with a former prostitute destroyed whatever goodwill he had generated among his contacts in The Hague. Although the termination of Vincent's friendship with Mauve had complicated causes, it fell apart largely because of Sien. Mauve refused to visit Vincent's studio, and when they met accidentally in the dunes of Scheveningen, a popular painting site, Mauve ended everything by bluntly uttering, "You have a vicious character."[60] Tersteeg, Vincent's old boss at The Hague branch of Goupil's, became so outraged that he not only helped sour Mauve but also threatened to make Theo cut off his support. This frightened and infuriated Vincent. But no less horrifying to him was Theodorus's reaction. His son's behavior so dismayed him that he seriously pursued the possibility of having him certified as insane and institutionalized in a mental hospi-

tal. Theo remained sympathetic and continued to send money, but he too frowned on the relationship and opposed Vincent's wish to marry.

Nor were Vincent's difficulties limited to the shocked reactions of his family and colleagues. In addition to giving him a case of gonorrhea, painfully treated at a local hospital, Sien placed an unendurable financial burden on Vincent. By the time her son had been born and her mother had moved into the new studio, Theo's modest monthly allowance had to support no fewer than six people—Vincent, Sien, her infant son, her daughter, her young sister, and her mother—as well as pay for art supplies. All of this exacerbated the inherent tensions between Vincent and Sien. Her character did not make her a tractable Galatea to Vincent's Pygmalion. At best she was passive and moody and at worst tempestuous and suicidal, threatening to kill herself by drowning. Goaded by her suspicious mother and her criminal-minded brother, who encouraged her to return to prostitution, Sien ultimately made life impossible for Vincent. After nearly two years, in which he came as close as he ever would to marriage and fatherhood, Vincent resolved to leave in September 1883 for Drenthe. This barren region of northern Holland with its picturesque heaths and cheap living conditions had attracted various artists, including Max Liebermann as well as Mauve and Van Rappard. Although full of sadness and regret, Vincent made his farewells to Sien and her son at the train station and prepared for a long campaign.

Despite Vincent's travails in The Hague, his art made great strides. For one thing, he could use Sien and her family as models. This opportunity allowed him not only to produce many portraits of the brooding Sien but also to put the whole family to work posing in more ambitious, multifigure compositions such as a "soup kitchen" in Vincent's studio. Of all the images of Sien, perhaps the drawing entitled *Sorrow* has proved most enduring. Vincent recognized its value himself and wrote to Theo that it was "the best figure I have drawn yet."[61] Vincent demonstrated in *Sorrow* [1.1] that he could combine merciless realism with a new mastery of proportion and sinuous contours. A naked and pregnant Sien crouches on the ground, her arms folded on her bent knees and her head buried in her arms. Although Vincent does not hesitate to detail Sien's scrawny limbs and withered dugs, he defines her figure with continuous and softly arcing contours that conform to an oval composition. Against these

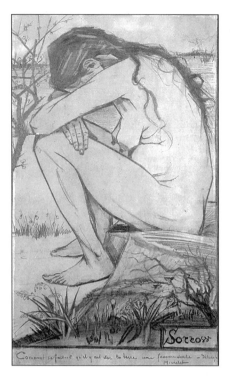

Figure 1.1 Vincent van Gogh, *Sorrow*
(1885)

curvilinear outlines, he sets spiky branches and roots that Vincent considered
expressive of Sien's "grim tenacity."[62] *Sorrow*, as Vincent observed, rivaled the
graphic impact of his beloved British illustrations. His line had finally attained
enough sureness to take full advantage of a stark subject depicted in brutally
contrasting black and white.

Vincent made an equally impressive advance with his new use of perspec-
tive. In the winter of 1882, he arranged for a carpenter and blacksmith to fabri-
cate a perspective frame. This simple construction with its asterisk-like net-
work of wires allowed him to organize his landscapes and cityscapes along
sharply tilted orthogonals. Although his drawings attained a greater and more
convincing expansiveness, perspective from the beginning played more an ex-

pressive than a descriptive role. Instead of endowing his drawings with a sense of rationalized order, the plunging orthogonals, speeding off to a distant horizon, implied restlessness and yearning. The rushing valences could evoke either anxious flight or a transcendental urge to soar beyond the mundane world. Vincent never formulated a precise emotional analogy, but he wrote Theo about the "dizzy feeling" that one gets when trying to "follow the fugitive lines in a landscape and to account for them."[63] And, describing a view from his studio, he said, "the lines of the roofs and gutters shoot away into the distance like arrows from a bow, they are drawn without hesitation."[64] Often these views establish a powerful tension between the rocketing orthogonals and the carefully constructed details of the foreground scene. In the well-known *Carpenter's Yard*, for example, Vincent renders every plank, clapboard, and slat with such meticulousness that it replicates the slow, measured work of carpentry itself. Yet the orthogonals of highway and rooftop fly away leaving all of these hard, closely observed facts far behind.

It was not only Holland's endlessly flat topography that encouraged Vincent's explorations of perspective. His studio looked out on the undeveloped outskirts of The Hague, neither suburb nor countryside, that anticipated the lonely industrial landscapes of the twentieth century. Vincent, with his typical disdain for the idealized, took full advantage of his surroundings and drew such lowly but modern subjects as train station sheds, iron mills, and gas tanks. Vincent often created a sense of desolate anonymity in these scenes by depopulating them altogether or placing only a few figures in the distance. The expanse of a highway or the looming presence of an industrial structure invariably overwhelm these human specks. A similar pathos informs the depictions of "orphan-men," residents of the Dutch Reformed Old People's Home who posed for Vincent in shabby greatcoats and dilapidated top hats. The bearded and bald-headed Adrianus Jacobus appears most often in these works and has been identified by the somewhat degrading numbers he and the other "orphan-men" had stitched into their clothes. Jacobus sat for the forlorn man cradling his bald pate with his fists in *At Eternity's Gate*—the male counterpart to *Sorrow*—and for the figure slumped in prayer before a modest meal in *Bénédicité*.

Although Drenthe liberated Vincent from Sien and her conniving relatives, the trip fell into a lifelong pattern of peripatetic frustration. His restless pere-

grinations would typically take the following course: Vincent would first generate great hope about the subject matter, practicality, and economic advantages of a new locale. He would then write Theo with manic enthusiasm about the money he will save and the wonderful pictures he will paint. The new site will allow him to finally put down roots and to establish a permanent studio. Upon arrival, Vincent would rent rooms, buy furniture, and make expansive arrangements with local artists and tradesmen. But soon enough he would encounter difficulties with finances, models, or his health, and his most recent "last stand" would be abandoned for the next. In Drenthe, a combination of bitterly cold weather, trouble obtaining painting supplies, and insuperable loneliness drove him back to his parents' house in Neunen after only two months. Nevertheless—and this proved a lifelong pattern as well—personal turmoil did not stand in the way of creating striking images. Earth and sky dominate the drawings and paintings from this period. Working of the soil, whether by plowmen, diggers, or sowers, always preoccupied Vincent—a legacy perhaps of his infantile concern with the first Vincent's grave. And in Drenthe he found an autochthonous world, where toiling peasants seem half-buried in the peat bogs and cottage gables, which barely emerge above ground level and dot the landscape with inverted "V"s. The vast flat, empty spaces also forced Vincent to observe Drenthe's unobstructed sky and to make some of his first studies of sunsets and turbulent clouds.

Once in Neunen, Vincent moved into the parsonage and established an uneasy peace with his father. His studio's location in the small shed used as a laundry room indicated his precarious status. And his reimmersion into irksome family politics upset the equilibrium of his relationship with Theo. Vincent's attitude toward his brother, who often argued for more sensitivity toward their parents, traveled the full spectrum from a wish to fuse their identities to a near rupture of their relationship. Isolated in Drenthe, Vincent tried desperately to convince Theo that, even if he did not know it himself, his true talent lay not in dealing but in making paintings. He should resign from Goupil's and join Vincent as an artist. The absurdity of this fantasy testifies to its emotional urgency. If Theo had given up his job as a dealer he would have doomed both brothers to a penniless existence. Yet Vincent insisted that Theo enter all the way into his quixotic world:

... I do *not* admit a difference or divergence, much less a contrast between you and me.

In my opinion, it would be an error of judgement if you continue doing business in Paris.

So the conclusion is: both brothers painters.[65]

No longer would Vincent play child to Theo's parent or envy his brother's established position at Goupil's. Both would abandon conventional society with all of its material rewards for the marginal but more spiritually rewarding life of an artist. They would dissolve all physical and psychological boundaries and become doubles working side by side:

So, boy, do come and paint with me on the heath, in the potato field, come and walk with me behind the plow and the shepherd—come and sit with me, looking into the fire—let the storm that blows across the heath blow across you.[66]

Theo, of course, declined this offer, and his refusal, however gently worded, amounted to a provocation. It combined in Vincent's mind with stored-up anger from the dissolution of his relationship with Sien. He began to feel that Theo, acting on his father's wishes, had coerced him into leaving Sien and the child. What is more, Theo, in Vincent's view, had not sufficiently exerted himself as his dealer. In one letter he went so far as to declare, "you have *never sold a single* [drawing] *for me* neither for much nor for little—and in fact *you have not even tried*" (Vincent's italics).[67] The supremely forbearing Theo continued to send Vincent's monthly allowance during this period and even offered to increase the amount. Yet Theo's unfailing generosity only made matters worse. Vincent experienced his total financial dependency on his younger brother as a nearly unbearable humiliation. To bite the hand that fed him restored his pride. He also mitigated his abject position by commanding Theo to regard the monthly allowance not as "charity," but as payment for the purchase of Vincent's work.[68] "Let me send you my work," he wrote, "and keep what you like for yourself, but I insist on considering the money I receive from you after March as money I have earned."[69]

Unfortunately, this redefinition of their financial relationship did not diminish Vincent's mounting rage. He threatened to cut off all ties with Theo and

accused him of being "self-righteous," "sterile," and "useless."[70] He even
called him "vicious"—the same unforgivable epithet hurled at Vincent by
Mauve.[71] The venom culminated in a long discussion of the barricade de-
picted in Delacroix's *Liberty Leading the People* (which Vincent mistakenly
dated to 1848):

> But my opinion is, if you and I lived then . . . we might have confronted each other as
> direct enemies for instance on such a barricade, you before it as a soldier of the gov-
> ernment, I behind it, as a revolutionary or rebel. . . . Now in 1884, the ciphers happen
> to be the same only just reversed, we are again confronting each other.[72]

Vincent tempered his animosity by treating his differences with Theo as
symptomatic of a larger social upheaval. "We are living," he argued, "in a time
of renovation and reform, and many things have totally changed."[73] But hints
of outright aggression were never very far from his complaints. In some in-
stances this took the form of protesting too much that he was "contemplating
no harm" or that, as brothers, they should "avoid killing each other."[74] At other
times the possibility of coming to blows surfaced directly and Vincent warned
that, if they did not separate, they would have a "violent quarrel."[75]

The clash with Theo illustrates once again the extreme ambivalence and
emotional lability that characterized Vincent's relationships with important
male figures. Idealization and identification could turn to hatred and contempt
within a matter of months. Even Vincent himself recognized his ability to turn
Theo into a father figure. "I do not want," he wrote Theo, "to be mixed up in a
second series of quarrels (such as I had with *Father No. I*) with *Father No. II.
And Father No. II would be you*" (Vincent's italics).[76] Equally striking and typi-
cal is the masochistic way in which he expressed his hostility. Vincent continu-
ally threatened to end his friendship with Theo and break off their financial
arrangement. Of course, if Vincent had carried out these threats the chief vic-
tim, both psychologically and monetarily, would have been himself. It is a small
step to the ultimate masochistic threat of suicide, and this too entered Vin-
cent's passive-aggressive armamentarium. In one of many prophetic state-
ments, he gave notice to Theo that, "If I should drop dead—*which I should not
try to evade if it happened, but which I should not seek expressly*—you would be

standing on a skeleton, and this would be a damned insecure standpoint" (Vincent's italics).[77]

Tensions eventually eased as Vincent moved into a more spacious studio in the house of the Catholic sexton and as other events such as Margot Begemann's attempted suicide and Theodorus's death took precedence. Theo, moreover, never failed in his financial support, no matter how recriminating and bilious Vincent became. Vincent put Theo to an extreme test and must have been reassured by his brother's nearly unconditional sympathy. As always, nothing—not even fratricidal combat—got in the way of his work. And among the drawings and paintings that Theo now "purchased," two new themes became prominent—weavers and an old church tower. The former subject, which had been treated by artistic heroes such as Max Liebermann and Josef Israëls, held various attractions. On a practical level, Vincent could work indoors for long hours with a relatively immobile model. He told Theo that he spent "from morning till night" with the weavers.[78] And, from the artistic point of view, the loom's rectilinear workings automatically generated a compositional structure. Vincent, who must have identified with these solitary, overworked, and economically insecure manual laborers, also discovered great expressionistic possibilities in their "contraption of sticks."[79] Seen through Vincent's gloomy monochrome, the weaver's apparatus becomes a cage, prison, or a mechanical spider enclosing its prey. Indeed, in one of Vincent's paintings, a weaver seems not just trapped but, as one art historian put it, "guillotined" by the beams of his loom.[80] Vincent himself referred to his rendering of the looms as "spectral" and the man inside as a "black ape or goblin or spook."[81]

The old tower of the abandoned Catholic church presides over the flat fields of many of Vincent's Neunen landscapes. A squat rectangle with a pinnacle top, it even appears through the windows of some of the weavers' hovels. To Vincent, who had rejected his earlier religiosity, the crumbling structure, torn down entirely in 1885, became an obvious symbol of the decline of Christian belief—Matthew Arnold's "Sea of Faith" at its low ebb in European culture. As Vincent wrote to Theo, "those ruins tell me how faith and a religion moldered away—strongly founded though they were."[82] Yet the tower would have had other, more subtle meanings. It could have represented the aging Theodorus,

who would die unexpectedly during the Neunen period and end the line of ministers in his immediate family. Vincent also associated the tower, which was surrounded by a graveyard, with specific ideas about death. Vincent articulated these notions in a letter describing *Peasant Cemetery,* his culminating painting of the tower:

> . . . I wanted to express how those ruins show that *for ages* the peasants have been laid to rest in the very fields which they dug up when alive—I wanted to express what a simple thing death and burial is, just as simple as the falling of an autumn leaf—just a bit of earth dug up—a wooden cross . . . the life and the death of the peasants remain forever the same budding and withering regularly, like the grass and the flowers growing there in that churchyard.[83]

This conception of an easy and continuous passage from life to death may reflect Vincent's unconscious wish to become the special, first Vincent. Instead of the infinite gulf between the dead and idealized first Vincent and the live and fallible second Vincent, this gap would be narrowed to the difference between a budding and withering flower. The second Vincent could become the first as swiftly and effortlessly as "the falling of an autumn leaf." Later, in Arles, he would speak in a similar vein of taking "death to reach a star" just as easily as one takes a train to reach a "black dot" on a map.[84]

The Potato Eaters [1.2] stands, of course, as the high point of the Neunen period. Although Vincent completed the painting in a few weeks and mostly from memory, it was the product of months spent in peasant cottages working on an exhaustive series of portrait heads. No canvas up to this time had been so thoroughly rehearsed and thought out. It embodied on a more monumental scale long-held artistic convictions regarding the worthiness of peasants as subjects, the expressionistic value of distortion, and the superiority of authentic roughness over a dry prettiness. "I have tried," Vincent wrote, "to emphasize that these people eating their potatoes in the lamplight, have dug the earth with those very hands they put in the dish, and so it speaks of *manual labor,* and how they have honestly earned their food" (Vincent's italics).[85] Such an image cannot possess a "conventional charm" or be "perfumed."[86] Instead it must smell of "bacon, smoke, potato, steam."[87] *The Potato Eaters* fulfilled Vin-

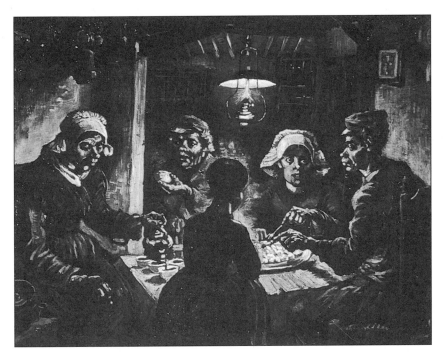

Figure 1.2 Vincent van Gogh, *The Potato Eaters* (1885)

cent's desire to make a picture that would merit the sort of comment once made about Millet's work: "His peasant seems to be painted with the earth he is sowing."[88] In Vincent's case, it was not the earth that his peasants resembled but a "very dusty potato, unpeeled of course."[89]

Vincent's celebration of the coarse and the ugly and his disdain for academic technique dates from the beginning of his artistic career. As early as Etten, Vincent, in a letter to Van Rappard, described the academy as a mistress "who freezes you, who petrifies you, who sucks your blood."[90] These sentiments only grew stronger over the years and shortly after completing *The Potato Eaters* he provided Theo with an eloquent defense of his aesthetic:

Tell Serret [a painter in Paris who had shown interest in Vincent's work] that *I should be desperate if my figures were correct,* tell him that I do not want them to be academi-

cally correct. . . . Tell him that I adore the figures by Michelangelo though the legs are
undoubtedly too long, the hips and the backsides too large. Tell him that, for me, Mil-
let and Lhermitte are the real artists for the very reason that they do not paint things as
they are, traced in a dry analytical way, but as *they*—Millet, Lhermitte, Michelangelo—
feel them. Tell him that my great longing is to learn to make those very incorrect-
nesses, those deviations, remodelings, changes in reality, so that they may become,
yes, lies if you like—but truer than literal truth (Vincent's italics).[91]

Vincent articulates here what would become one of the chief tenets of Mod-
ernism and, though unaware of it, echoes Degas's contemporary mot that "art
is a lie to which we give an accent of truth." Vincent would also have heartily
applauded the remark made by Picasso upon seeing an exhibition of children's
art: "When I was their age I could draw like Raphael, but it took me a lifetime
to draw like them."[92] Yet Vincent, unlike Picasso, never possessed a precocious
technical virtuosity to struggle against. And a skeptic might regard Vincent's
exaltations of the "rough" and "incorrect" as merely rationalizations of his se-
vere shortcomings. Indeed, it would be difficult to find in the early work of any
other great artist so many examples of ham-fisted draftsmanship and all-
thumbs paint handling.

It comes as a surprise, then, to see how self-consciously Vincent planned
the "deviations" in *The Potato Eaters*. Although the preparatory studies re-
veal how profoundly Vincent transformed each of the figures, the young man
seated at the left underwent a particularly drastic mutation. He first appears
with regular features in several studies only to transmogrify in the final ver-
sion into a creature with his ears enlarged almost to a satyr's length, the right
eye popped out under a cantilevered brow, and the cheekbone angled into a
gleaming blade. Vincent willfully turned the picture into a hymn to the
gnarled and knobby. Everything—chair finials, gas lamp, noses, and espe-
cially the much-studied hands—possesses an exaggerated, bulbous crudity.
Vincent's painstaking orchestration of all of these effects is clearly evident
from his remark to Theo that the "threads" of the picture have been "chosen
carefully and according to certain rules"[93] Earlier he had recommended to
van Rappard that their work should be so canny ("savant") that it only
"seems naive."[94]

Living more than a hundred years after the artistic revolution that van Gogh and others initiated, it is hard to appreciate the boldness and independence of the ideas that informed *The Potato Eaters*. We must strain to imagine an art world dominated by academic standards and regulations. Vincent, moreover, needed special resolve as he was largely ignorant of the very school, Impressionism, that might have legitimated many of his assumptions. Unaware of recent developments in Paris, Vincent was forced to search for validation in the past. And a heavy irony hangs over his desperate attempts, often at the expense of strict historical accuracy, to construct an avant-garde tradition that might support his unconventional and seemingly infelicitous art. He repeatedly insists to Theo that Daumier, Millet, and Corot all suffered long periods of neglect and critical abuse. They are those "damned brave fellows . . . those pioneers" [95] Even the much celebrated Delacroix enters the rolls of the unjustly ignored as Vincent recalls that the master once had seventeen paintings refused by the Salon. Such are the difficulties in trying to find solace in a "van Gogh myth" without knowing that the creation of this myth awaits one's own later career and posthumous fame. Vincent, nonetheless, displayed an eerily prescient ability to anticipate his own legend with comments such as this to Theo: "the history of great men is tragic . . . for usually they are no longer alive when their work is publicly acknowledged, and for a long time they are under a kind of depression because of the opposition and the difficulties of struggling through life." [96]

If *The Potato Eaters*'s "ugliness" was calculated, so too were its religious overtones. It is, in fact, an homage to one of Vincent's most admired Rembrandt paintings—*The Supper at Emmaus* in the Louvre. And Vincent employs various devices to transform the mysterious child in the foreground into a Christ revealing Himself to the apostles. Not only does steam from the potatoes create a nimbus around this central figure, but she also stands almost directly below the gas lamp—the only source of light. This lamp in turn becomes a Holy Spirit as the insistent orthogonals of the roof beams—another example of the expressive use of perspective—flatten out and become divine rays emanating from this miraculous beacon. The solemnity of the figures and the ponderousness of their gestures also make the scene readable as a *Last Supper*. The older man, in particular, holds his coffee cup so reverentially that he

seems to offer it up as the body and blood of Christ. Vincent himself cues the
viewer to his religious allusions by placing a small print of the Crucifixion be-
hind the young man. Of course, by imbuing the peasants' daily routine with a
ritualistic sanctity, Vincent invokes Millet as well as Rembrandt. Indeed, Vin-
cent's little picture of the Passion serves much the same purpose as Millet's dis-
tant church steeple in *The Angelus*.

Digging deeper into the religious imagery of *The Potato Eaters*, the psycho-
analyst Albert Lubin has found in the spectral, haloed child an unconscious
representation of the first Vincent.[97] Just as the first Vincent would have be-
come an angelic figure in the minds of the family so the child stands silhouetted
by a holy light. And just as the stillborn first Vincent never came to possess ei-
ther a concrete identity or particular features so the little girl faces away from
the viewer. Lubin, moreover, considers her position within the picture as a vi-
sual metaphor of Vincent's displacement by his namesake. He sees the young
man, who sits on a chair bearing Vincent's signature, as the artist's symbolic
counterpart. The older woman on the right represents Anna preoccupied by
her grief. A strangely protruding partition blocks her off from the rest of the
group, and she fails to meet the young man's imploring glance. She also stares
downward and inexplicably points toward the earth as if fixing on the first Vin-
cent's grave. Between the "Vincent" and "Anna" figures looms the special,
transfigured child. She literally and figuratively comes between the mother and
her ability to respond to her son's yearnings for affection. Such an evocative
theory cannot ultimately be proved or disproved. Yet the emotional signifi-
cance of *The Potato Eaters* for Vincent seems incontestable. It not only was his
most ambitious composition to date in spiritual as well as artistic terms but also
contained imagery that reappeared in such psychologically potent later works
as *The Night Café*.

Although the Neunen period, unlike the years in Etten and The Hague, did
not brim over with incident, Vincent still exhibited his talent for scandal. He
did this most sensationally by making an alliance with Margot Begemann, one
of the daughters of a local mill owner. The unmarried, forty-one-year-old Mar-
got became attached to Vincent while she and her sisters helped him nurse his
mother, who had injured herself in a fall. Vincent, though he felt no great pas-
sion for Margot, did not discourage their friendship and even indulged her talk

of marriage during their long strolls in the fields. Her father, however, strenuously objected to his daughter's liaison with a notoriously eccentric and permanently unemployed artist. She came under attack as well from her older sisters, who were also spinsters and apparently jealous. The harshness of her family's censure drove her to take strychnine before one of her walks with Vincent. To his horror she suddenly collapsed, lost her ability to speak, and began convulsing. Fortunately, a surprisingly clearheaded Vincent guessed that she may have swallowed poison, extracted the truth from her, and got her to start vomiting. He then carried her to her brother, who administered a strong emetic. Having survived the initial effects, she left for a six-month convalescence in Utrecht under a doctor's supervision. Vincent had acquitted himself relatively well in this mostly sad affair. He had prudently refrained from becoming sexually involved with Margot despite her own eagerness and in the moment of crisis had effectively saved her life. But none of this prevented the town from gossiping or his own family from holding him responsible.

Margot Begemann largely broke the mold of the "lady in black" type with whom Vincent had habitually become involved. Although she was older, marked by her age, and clearly troubled, she had not suffered a recent loss, was not preoccupied with someone else, and, most important, was the pursuer, not the pursued. Vincent, who never became fixated on Margot, observed to Theo that he should have met her ten years before. Now, she was like a "Cremona violin which had been spoiled by bad, bungling repairers."[98] More revealing psychologically than Margot's problematic status as another "lady in black" is Vincent's identification with her. He twice wrote that Margot's sisters, who had made her suicidally desperate, had criticized her in the same way that Theo had assailed him. He added that, unlike Margot, he could "stand it" and did "not take such things lying down."[99] But the very comparison with Margot contains the veiled threat that if treated unfairly he too might kill himself.

IV

Theodorus's sudden death set off the most significant emotional repercussions of the Neunen period. On March 26, 1885, he fell unconscious on the steps of his church and died shortly thereafter. As Theo immediately joined

the family in Neunen for the funeral, we do not have letters that might reveal Vincent's thoughts. But if no extensive written expression of his sentiments has survived, we do have an artistic one. A few months after Theodorus's death, Vincent painted a still life [1.3] which unsentimentally memorialized their contentious past. He depicted his father's massive Bible next to a snuffed-out candle, a conventional symbol of mortality. Less conventionally, he juxtaposed the Bible with a paperback of Zola's *Joie de Vivre*. This book, of course, represented just the sort of godless French novel that had once enraged Theodorus. And Vincent may have subtly acknowledged his own history of provocations by showing the Bible opened to the Book of Isaiah, the second verse of which reads, "Here, O heavens, and give ear, O earth: for the Lord hath spoken, I have nourished and brought up children, and they have rebelled against me." The title of the paperback and its bright yellow color, set against the worn grey of the Bible, also seem to daringly oppose the dull habits of conventional religion to the vibrant sensuality of advanced French culture.

But, as we have seen so often, Vincent could not make an aggressive or defiant gesture without at the same time punishing himself. So he renders the Bible as vastly larger than his own paperback and reinforces its weighty, patriarchal power by joining it with a phallic candle. Furthermore, his paperback is not only smaller and tattered, but set precariously on the edge of the table. Finally, Zola's title is ironic. Instead of a bohemian idyll the novel describes a tale of woe. Vincent made only one other artistic record of his father's death. He painted another still life depicting Theodorus's pipe and tobacco pouch in front of a vase of flowers. And here too Vincent displayed both ambivalence and masochism. Although the work represented one of only two commemorations of his father's death and merited a description and a sketch in a letter to Theo, he painted it over several months later. He thereby effaced both a symbol of his father and one of his own creations.

In the wake of Theodorus's death everything pointed to Vincent leaving Neunen. He would soon have no family ties to keep him. His mother, obliged to give up the parsonage, planned to move to Breda. But even if Vincent had wished to linger, the local Catholic priest had ruined his prospects. Someone had impregnated Sien de Groot, the peasant who had posed for the wide-eyed young girl in *The Potato Eaters,* and the priest unjustly identified Vincent as

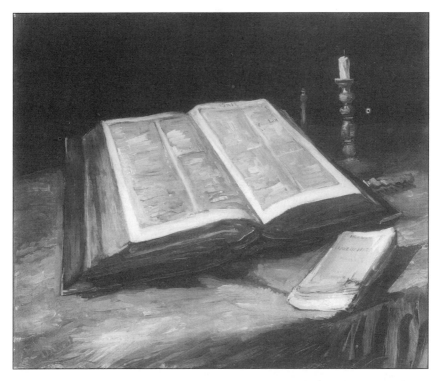

Figure 1.3 Vincent van Gogh, *Still Life with Open Bible, Candlestick and Novel* (1885)

the culprit. He forbade his congregation from posing for Vincent and even promised to match whatever Vincent might pay. As Vincent's studio, and now his living quarters, were under the roof of the Catholic sexton, they too had been put in jeopardy. Although Vincent made the best of things by painting still lifes and landscapes for a few months, he finally moved to Antwerp. There he could visit the churches and museums and find models at the Academy.

In Antwerp Vincent discovered Japanese prints and lightened his palette under the influence of the Rubens paintings he found in various collections. But this three-month sojourn mostly amounted to treading water before the inevitable trip to Paris. Although Vincent had been champing at the bit for at least a year, Theo had discouraged him from taking this leap for obvious rea-

sons. Sharing Theo's tiny Montmartre apartment with even the most accommodating personality would have been a burden, but with Vincent it spelled disaster. Despairing of convincing Theo in his correspondence, Vincent simply showed up without warning in Paris and sent Theo a note to meet him in the Louvre's Salon Carrée. The first line adopted a famously disarming tone: "Do not be cross with me for having come all at once like this; I have thought about it so much, and I believe that in this way we shall save time."[100] He yearned for Paris not only because he wanted to learn from it but also because no other city equaled his ambitions. Despite his self-criticisms and his insistence that his paintings were merely "studies," his growing sense of mastery had solidified after *The Potato Eaters*. Although virtually alone in his high valuation of his work and with his greatest accomplishments still before him, he nonetheless possessed an uncannily prophetic sense of his powers. Even before leaving Neunen, he could reply in this manner to a friend who wanted his signature on a landscape:

> . . . it isn't necessary; they will surely recognize my work later on, and write about me when I'm dead and gone. I shall take care of that, if I can keep alive for some little time.[101]

So nothing less than Paris, the center of the artistic universe, would suffice as his next arena and testing ground.

— 2 —
Gauguin
Lima to Pont-Aven

I

Although van Gogh and Gauguin are often cast as opposites—the innocent versus the rogue, the masochist versus the willful manipulator—their art comes cloaked in a remarkably similar set of myths. At the most primitive level of this mythology, their paintings are seen as raw, untutored, and spontaneous—volcanic eruptions of the soul. Both artists contributed to this mystique. Van Gogh repeatedly insisted that the viewer recognize "deep feelings" in his paintings.[1] And, in an unusual lapse in artistic self-awareness, he made this claim without ever acknowledging the endlessly complicated gap between daubs on a canvas and one's inner world. Gauguin, for his part, talked of his "savage" nature and of the "savagery" of his art as if he too could directly communicate his primal emotions. These statements and the fantasy of unmediated expression that they evoke disguise not only the artists' cultivated sensibilities but also the weight of their respective pasts and family traditions. Just as Vincent's career amounted to a continuation, in however rebellious a form, of the van Goghs' dual allegiances to art and religion, so Gauguin's eventful life displayed a surprising continuity with his own distinguished, though more exotic, ancestors. Instead of a bourgeois stockbroker suddenly transforming himself into a bohemian, Gauguin, by becoming a revolutionary artist, reverted to family type.

Among a colorful gallery of forebears that included Borgias, Spanish Colonialists, radical journalists, and criminals, the relative whose fame bore down most inescapably on Gauguin was his grandmother, Flora Tristan. She combined a sensational life with a career as a renowned writer and social activist. A feminist and Saint-Simonian champion of the industrial laborer, she gave public lectures throughout France and published widely read tracts such as *The Workers' Union* and *The Emancipation of Women*. In her own way, she cut a figure nearly as singular and flamboyant as her grandson. And as one reviews her peripatetic strivings many surprising parallels emerge with Gauguin's own life. Both Flora and Gauguin abandoned their spouses and their children to make their way in the world. Flora left her engraver husband, André Chazal, and three children in an unsuccessful attempt to secure an inheritance from her relatives in Lima. Both struggled with poverty and adversity. Raised by a widowed mother of no means, Flora never again enjoyed financial security after leaving Chazal. Both made bold trips to the tropics to attain success. Although Flora failed to extract a legacy from Don Pio Tristan Moscoso, her uncle and the last viceroy of Peru, she turned the memoirs of her voyage into her first publishing triumph, *Peregrinations of a Pariah*. Both Flora and Gauguin challenged authority and agitated for social change until the ends of their lives. Flora died after a lecture tour made more exhausting by police harassment and agents provocateurs, while Gauguin continued to attack the colonial powers in the South Pacific until his last fevered days. And finally, both pursued esoteric religious studies. Flora adhered to Prosper Enfantin's mysticism, and Gauguin immersed himself in Maori mythology. Above all, they shared a monumental willfulness as well as a complete disdain for convention.

Flora's life would have grabbed headlines even without her celebrated political activities. Her husband embroiled her in a lurid domestic scandal that involved not only sexual molestation but also attempted murder. Before embarking on her Peruvian sojourn, Flora left Aline, her daughter and Gauguin's future mother, with Aline's grandmother. A grotesque caricature of a modern custody battle ensued as the eight-year-old Aline shuttled back and forth like a tennis ball from one Parisian domicile to another. First, the increasingly debt-ridden and mentally unhinged Chazal abducted Aline. She was taken back by the police only to be kidnapped once again by Chazal. Although Aline then es-

caped and was placed in a boarding school, Chazal obtained a court order and reclaimed her once more. As if the young girl had not suffered enough from these ceaseless disruptions, Chazal further traumatized her by making sexual advances. Flora brought incest charges against Chazal and succeeded in recovering Aline, though not in keeping Chazal in jail. The crazed Chazal, free to wander the streets, lurked about Flora's lodgings and one day shot her as she returned home. Flora survived, and this time Chazal received a twenty-year prison sentence.

Despite such a nightmarish childhood, Aline remained a gentle and attractive girl. George Sand, who had known Flora, took the nineteen-year-old Aline under her wing after Tristan's death. Sand entered Aline into a respectable boarding school, and it was at this institutions' weekly salon that she met the artist's father, Clovis Gauguin. Clovis had come to Paris from Orléans, the Gauguin family's ancestral city, to work as an editor at the republican journal *Le National.* Aline married Clovis in 1846, gave birth to their first child, Marie, in 1847, and had their first son, Paul, a year later. In a birth that was prophetic of his tempestuous life, the artist entered the world in the middle of the violent uprisings of 1848.

Clovis's association with *Le National* and his republican and anti-Bonapartist sympathies led to the family's decision to leave France for Peru. With Louis-Napoleon setting the stage for a new Empire, Clovis feared retribution. Yet their departure involved more than a flight to political asylum. Aline had kept alive her mother's hopes that a substantial inheritance lay waiting in Lima. And Clovis believed that he might find work as a journalist or start his own newspaper. So Aline, Clovis, their two-year-old daughter, and their one-year-old son embarked from Le Havre in August 1489. As it turned out, Clovis was no safer eight thousand miles away from Paris. During a stopover in the Port of Famine, near the Straits of Magellan, he collapsed in a rowboat from a ruptured aneurysm. After a hasty funeral, Aline, Marie, and Paul resumed the long sail up the west coast of Latin America.

Aline's luck began to change once she arrived in Lima. Her charms continued to sustain her, and she was warmly received by Don Pio. He allowed Aline and her two children to stay with him in the sizable mansion of his son-in-law, José Rufino Echenique. Here she and the children would enjoy their own

rooms and servants in a house large enough to encompass three interior court-yards. When Echenique became president of Peru in 1852 and moved with his wife to the presidential palace, the setting became even more ample and sump-tuous. The boom in guano (bird droppings sold as fertilizer) had made Peru flush with new wealth and foreign goods. Neither Aline nor her son would ever again enjoy such luxurious surroundings for such an extended period. Unfor-tunately, political events once again threatened Aline's happiness. In 1854 the corruption of Echenique's regime provoked the former president, Ramon Castilla, to gather forces for an overthrow of the government. These storm clouds combined with an easing of tensions in France, and the promise of an inheritance from Clovis's father prompted Aline to return to her homeland with her children. By 1855 she had installed herself in the Gauguin family's house in Orléans.

How did Peru shape Gauguin's character? So little attention has been paid to this period that it is easy to underestimate its importance. Yet Gauguin spent no less than five impressionable years—from one and a half to six and a half—in Echenique's capacious household. Part of the difficulty of evaluating these Peruvian years derives from Gauguin himself. In his memoir, *Avant et après*, Gauguin emphasizes Lima's considerable impact on him: "I have a re-markable visual memory, and I remember that period, our house, and a lot of things that happened."[2] But *Avant et après*, written near the end of Gauguin's life, provides tantalizingly few details of his infancy. And one suspects that what he does mention has been passed through the filter of self-mythification. Gauguin admits as much when he states in *Avant et après*, "you wish to know who I am. . . . Even at this moment, as I write, I am revealing only what I want to reveal."[3]

Yet one fact of Gauguin's infancy is certain. It was marked not just by the opulent Peruvian setting but by Clovis's death. Although Gauguin remains typically terse about this loss in *Avant et après*, he does make one suggestive remark. He characterizes the ship's captain as a "dreadful man," who did Clovis "terrible harm."[4] But he does not explain what constituted this "harm." By referring to an unspecified crime and by assigning it to a marginal figure such as the ship's captain, Gauguin seems to defend against the uncon-scious fantasy that Clovis's death involved definite wrongdoing committed by

a figure closer to home. What might have been the content of such an unconscious fantasy for the infant Gauguin? Among other things, he may have felt that Clovis had abandoned him by dying. Such a response, which is not uncommon in young children, would provide one explanation for the frequent departures in Gauguin's life. Gauguin may have attempted to undo the trauma of Clovis's perceived abandonment by becoming the one who leaves, not the one left behind. Gauguin, in fact, symbolically turned the tables in 1886 when he left a "Clovis," his son, in a boarding school near Paris while he took off for Brittany. And the artist himself hints at the unconscious importance of leave-taking in *Avant et après*. He recounts two stories about becoming separated from Aline and states that, as a child, he "always had a fondness for running away."[5]

Clovis's death had the equally important result of leaving Gauguin with no male rival for his mother's affections. Aline neither remarried nor had any other children. Unlike Vincent, Gauguin did not suffer displacement by a series of siblings. How did these circumstances affect him? It is tempting to trace several adult traits back to Gauguin's fatherless childhood. His willfulness, pride, and nonconformity may have flourished in the absence of a patriarchal figure who would have suppressed such attitudes. He may also have developed a strong feminine identification against which he struggled for the rest of his life. This would account for his need to present himself as a hypermasculine figure who womanized, dominated others, and always stood poised for a fight. In general, Aline's and Gauguin's special relationship may have heightened the ambivalence and oedipal dynamics that invariably exist between a mother and her son. Gauguin's later fondness for femmes fatales in his art certainly testifies to this. Gauguin, in fact, was so devoted to the image of the destructive woman that he wanted his ceramic sculpture *Oviri* (also called *The Murderess*) placed on his grave. The work depicts a wild-eyed female nude trampling a bloodied wolf while pressing a wolf cub to her thigh. Although Gauguin, in *Avant et après*, rarely becomes expansive about Aline, one can still tease out a few meanings. Gauguin projects his own privileged position and his own ambivalence onto his mother. She, not Gauguin, is "petted and spoiled as a child," and she possess a "soft" and "caressing" nature that coexists with an "imperious" and "violent" one.[6]

Another significant theme lurking behind the artist's fragmentary childhood memories is voyeurism. Gauguin makes much in *Avant et après* of his mother's habit of draping a mantilla over her face in such a way that it left only one eye visible. It was this eye that was so "soft and imperious . . . so pure and caressing."[7] Gauguin also recalls a strange incident involving the madman who lived on the terraces of Echenique's mansion (property owners received a tax exemption for supporting such unfortunates and allowing them to sleep on the rooftops in the nearly rainless Lima). One night this mysterious character climbed down and entered Paul's and Marie's room. According to Gauguin, "Not one of us dared say a word. I saw, and I can still see, the madman come into our room, look at us, then quietly climb back up to his terrace." Immediately afterward, Gauguin recounts another nocturnal trauma:

> . . . I was awakened in the middle of the night and saw the superb portrait of the uncle hanging in the room. He was staring at us and he was moving. It was an earthquake.[8]

These memories with their nighttime upheavals, staring figures, and uncanny happenings appear to contain a latent sexual content. Are they thinly disguised recollections of the "primal scene" (the infant's witnessing of coitus)? Whatever their source, they seem continuous with the mood of sexual menace in paintings such as the frankly voyeuristic *Spirit of the Dead Watching*. Here an adolescent girl lies naked and vulnerable on a bed while a sinister cronelike apparition presides over her. An ominously voyeuristic mood also pervades the earlier *The Little Dreamer, Study*. In this work, the viewer peers down intrusively at a sleeping child—Gauguin's four-year-old daughter, Aline—whose nightgown has been hiked up above her thigh. A doll dressed as a jester leers out at the spectator and enhances the picture's disquieting effect. These similarities between text and paintings may be no accident. Gauguin, with his proto-Freudian canniness, could well have consciously planted in *Avant et après* such parallels between his childhood memories and his later art.

Peru defined Gauguin both as an actual experience and as a symbol. He used the fact of his Peruvian ancestors and his Peruvian infancy to authenticate his "savage" nature and his embrace of non-Western cultures. He may actually have seen native artworks as a child. Aline collected ceramic pieces as well as silver

figurines while in Lima. But this was less important than the impetus his Peruvian past gave him to seek out "primitive" art later in life. He encountered one of the most influential Peruvian sources for his painting—a mummy in a fetal position—not in Peru, but at the Musée d'Ethnographie in Paris. Yet he would not have paid such close attention to this artifact without his Peruvian identity.

After the rarified world of Lima, the return to France brought about a sharp decline in Aline's fortunes. She was unlucky in her inheritance both from her father-in-law and from Don Pio. As Clovis's father died several months after Aline and her children moved into his house, she quickly came into the inheritance intended for Marie and Paul. But this legacy consisted of rental properties and farmland that did not provide much income and could not be easily liquidated. Back in Peru, the long struggle begun by Aline's grandmother to recover a share of the Moscoso estate took a few ironic twists. Although Don Pio, nearing death, finally consented to Aline's inclusion in his will, her relatives in Peru did not honor his wishes, and she ultimately received nothing. Aline, in fact, ended up with so little that she was forced to move to Paris and work near the bottom of the social ladder as a seamstress.

As an adolescent, Gauguin did little to mitigate Aline's distress in the face of inexorable downward mobility. If Vincent's good grades and efficiency as a clerk stand out as anomalies in his life, Gauguin's student years seem all too consistent with his later rebelliousness. Initially the seven-year-old Gauguin, who had spoken Spanish in Lima, had difficulty with the new language. But even after mastering French he hardly distinguished himself as a scholar. When placed in the Loriol Institute in Paris to prepare for the Naval Academy exams, he dropped out and had to return to a local lycée in Orléans. There, he performed so poorly that the teachers refused to let him take the test. Nor did Gauguin compensate for his poor academic skills with politeness and charm. In her will Aline stated that Paul should "get on with his career, since he has made himself so unliked by all my friends that he will one day find himself alone."[9] The only bright spot seems to have been the boarding school, attached to a seminary outside of Orléans, which Gauguin attended from his eleventh to his fourteenth year. The priests gave Gauguin a thorough and rigorous secondary education in a variety of subjects including two—drawing and religion—that would later become Gauguin's obsessions.

Although Gauguin missed the cutoff year of seventeen for the Naval Academy exam, he could reapply after experience at sea. With this loophole in mind, he entered the merchant marine as an ordinary seaman. Ultimately, he would never take the qualifying exam and would simply enlist in the Navy as a seaman third class. All of the original maneuvering to get Gauguin into the Naval Academy appears to have been Aline's attempt to ensure that, if he had to go to sea, at least he would do so as an officer. However, the decision itself to make a career as a sailor was entirely Gauguin's. Such a profession carried no great stigma for a member of the middle class, especially at this stage in his life. Baudelaire, Manet, and Monet—just to mention the artistically accomplished— had all gone to sea as young men. But Aline must have had higher ambitions for her son, and one wonders about Gauguin's conscious and unconscious motivations. A long sea journey would have been associated with two traumas—Clovis's death and the departure from Lima. Was Gauguin's desire to become a sailor the equivalent of Vincent's need to attach himself to a rejecting "lady in black"? In both cases the repetition compulsion would have involved revisiting a trauma in order to master it. At the same time, a tour at sea held the prospect of a return to the tropical setting of his childhood. And Gauguin did, in fact, return both to the Straits of Magellan and to Peru on his third voyage. Later when Gauguin traveled to Tahiti he acknowledged the regressive nature of such far-flung treks. In an article based on interviews with the artist, Octave Mirbeau described Gauguin's "obsessive nostalgia for these suns, these people, these lush islands . . . where to his great surprise he would rediscover the familiar songs of his mother."[10]

Gauguin spent as much time at sea as he had in Lima—six years, from the age of seventeen to twenty-three. Yet the influence of this period is difficult to assess. Although he pulled in at many memorable and visually stunning locales—Rio, Constantinople, the Greek Islands, Naples, Venice—one looks in vain for any descriptions of these sights in *Avant et après*. Instead Gauguin documents his precocious sexual conquests—an opera singer in Rio on his first tour and a plump Prussian woman on his return. Nor does one find any record of Gauguin's reaction to Aline's death, which occurred while he was on his third tour with the merchant marine. Gauguin never advanced very far in either the merchant marine or the Navy and must eventually have tired of his

ordinary seaman's status. His growing weariness with his lot may have short-ened his already combustible temper. While serving in the Navy, he came to blows with a quartermaster and dunked his head in a bucket of water. This cost him two years with no promotion and anticipated later self-destructive scrapes such as the one in the Breton town of Concarneau that left him with a shattered leg. Given a ten-month leave at the end of the Franco-Prussian War, Gauguin never returned to the Navy. If nothing else, his years at sea must have instilled in him a sense of self-sufficiency and the confidence to undertake the many distant and arduous journeys that punctuate so much of his adult life.

II

Although Gauguin had insisted on a career as a sailor, the next stage—employ-ment on the stock exchange—was arranged for him by his guardian, Gustave Arosa. Arosa had already played an important role. After moving to Paris Aline had fallen in with Arosa as a result of mutual Spanish and Peruvian connec-tions. A successful businessman, Arosa extended his considerable largesse to Aline's entire family. In fact, so generous was Arosa that one biographer has speculated that Aline served as his mistress and that Gauguin's discomfort with this arrangement became one factor in his desire to go to sea. Whatever the actual basis of Arosa's relationship with Aline and her children, he treated Marie as if she were his own daughter and secured for Gauguin a position as *liquidateur* at the firm of Paul Bertin. A *liquidateur* acted as the nineteenth-century equivalent of a futures broker (that is, someone who arranges the buy-ing and selling of shares at a certain price at a certain future date) and received commissions for trades as well as a yearly bonus. Gauguin proved surprisingly competent at this job, which required more in the way of accounting skills than entrepreneurial swashbuckling, and soon earned a handsome income.

Arosa, however, did much more than find his ward a well-paying job. He al-lowed Gauguin to glimpse a world of advanced taste that could not have been better suited for a budding artist with progressive ideas. Both Gustave and his brother, Achille-Antoine, owned impressive collections. Gauguin could see in their homes in Paris and Saint-Cloud paintings by Delacroix, Courbet, and the Barbizon school. Yet Gustave did more than simply avoid the Gérômes and

Bouguereaus preferred by more conventional Parisian businessmen. He also bought adventurous contemporary works and was one of the few who actually purchased paintings from the first Impressionist exhibition. He and his brother favored Pissarro, and probably on one of Pisarro's visits to Gustave's Parisian household the older painter and Gauguin first met. Gustave also collected porcelain and other ceramic pieces including pre-Columbian works from Peru that must have caught Gauguin's eye. Achille-Antoine, moreover, shared his brother's taste for the exotic and had actually traveled as far as Tahiti and the Marquesas Islands, thereby anticipating Gauguin's later interests. Finally, Arosa, who knew Nadar, owned a company that made photolithographic copies of art monuments. The company's first publication, a set of reproductions of casts of sculpture from the Parthenon, fascinated Gauguin. He kept offprints from this volume for the rest of his life, and some of them, such as the plates of the horsemen from the Panathenaic Procession, would end up as figural sources for his art. Indeed, Arosa and his circle appear to have served as the matrix for many of Gauguin's crucial interests—avant-garde painting, ceramics, non-Western art, and even the usefulness of photographic reproductions (Gauguin traveled everywhere with a little museum of reproductions that included, among many other items, Botticelli's *Birth of Venus,* Manet's *Olympia,* and sculpture from Borobudur). All of this makes one wonder at Gauguin's complete silence about his guardian in his memoirs. He may have wished to bury the name of the man who kept his mother as a mistress. But Gauguin may also have wanted to conceal the fact that someone such as Arosa could have significantly determined his own, seemingly self-created artistic identity. And, on a deeper level, he may have preserved the fantasy of not needing a father by denying the existence of this father substitute.

As if securing employment and shaping his artistic sensibility were not enough, Arosa also provided Gauguin with the opportunity to meet and court his future wife. Gauguin first encountered Mette-Sophie Gad at one of Gustave's many parties and continued to pursue her at subsequent gatherings. Although tall, fair-skinned, Danish, and in many respects Gauguin's opposite, Mette had also lost a father and had seen her family's status fluctuate dramatically. Theodor Gad, who had been a prominent provincial magistrate, died when Mette was ten and left her with few financial and social resources. At sev-

enteen she obtained work as a live-in tutor for the children of one of Denmark's largest landowners. This arrangement, however, only underscored her insecurity about her social position, as she was attached to a wealthy family, yet merely a servant. In Gauguin, she saw a young man who seemed well on his way toward the haute-bourgeois status of his guardian. What Gauguin saw in Mette is another question. One of her more outstanding traits was a mannishness in dress and character. Large, strong-willed, and independent, she smoked cigars, showed up at one of Arosa's costume balls dressed as a man, and appears, in Gauguin's bust of her, with a forbiddingly sharp profile and severely close-cropped hair. It is perhaps too easy to regard Gauguin's attraction to the masculine Mette as an unconscious compensation for the missing Clovis or as his need to defend against oedipal yearnings for the "soft and caressing" Aline. But Mette must have satisfied some compelling desire in him, for they were married in less than a year despite the resistance of Gauguin's sister and Mette's mother. They quickly began to have children—three in five years—and eventually would have five in all.

The marriage came to grief, of course, over Gauguin's increasing commitment to painting. This was not at all a dramatically sudden decision on Gauguin's part, but rather a gradual and complex process. Why art attracted him in the first place is essentially a mystery. He had started carving wood and sketching as an adolescent, and as a young adult was surrounded by art galleries, art collectors, and artists. Not only was his employer located on rue Laffitte, in the heart of the gallery district, but his friend and fellow *liquidateur* at Bertin's, Emile Schuffenecker, was already an accomplished amateur who had won a drawing contest held by the city of Paris. Schuffenecker, moreover, regarded his work at the Bourse as merely a transition to a full-time career as an artist. He in fact presented Gauguin with Gauguin's future self at a time when his own artistic ambitions were only nascent. All of this reinforced the impact of Arosa's collection and his circle, which included critics such as Philippe Burty and Adrien Marx as well as artists. Even Gustave's daughter, Marguerite, contributed to Gauguin's development, as she too had artistic interests, eventually became a painter herself, and sketched with Gauguin at the Arosas' villa in Saint-Cloud. But outside influences cannot account for the inclinations of someone as independent minded as Gauguin. The solitariness of painting

would have appealed to him as it suited his antiauthoritarian nature and freed him from irritating social interactions. Yet deeper reasons must have existed for his desire to paint. Could art have sublimated the scopophilia (sexualized looking) that seems to have played such an important role in his Peruvian childhood? This interpretation, which resembles the one that Freud applied to Leonardo da Vinci, remains so speculative as to be nearly useless. And it begs the question of why seeing became eroticized in his infancy. However, something about the process of drawing and painting must have deeply satisfied Gauguin, as he possessed no striking precociousness or immediately marketable talent.

Whatever its unconscious roots, Gauguin's newfound passion only became more consuming after he began drawing and visiting museums with Schuffenecker. He progressed to oils under Schuffenecker's supervision, eventually painted *en plein air* with Pissarro, and explored sculpture and ceramics. Yet Gauguin saw nothing irreconcilable between painting and earning money from various business ventures. This attitude derived partly from necessity—he could hardly devote himself exclusively to advanced art with a wife and large brood to support—and partly from success at juggling both aspects of his life. Even after his work was accepted at the official Salon, included in several Impressionist exhibitions, and bought for good prices by Durand-Ruel, Gauguin continued to pursue business opportunities. In fact, he had one of his best years financially in 1879 at the same time that he successfully maneuvered his way into his first Impressionist exhibition, the fourth, with a bust of his son Emil.

III

Art historians have tried to identify decisive turning points, such as Gauguin's listing of his profession for the first time as "Artist-painter" when he registered his son Pola's birth in 1883. But by the next year this "Artist-painter" had become a sales representative in Copenhagen for the French textile manufacturer Dillies et Frères. Instead of boldly resolving to surrender himself to painting, Gauguin became a full-time artist more by default than anything else. In the wake of the financial crisis brought about by the failure of the Union Générale

in 1882, he could no longer obtain employment on the stock exchange. These desperate circumstances led to the famous incident in which he was reduced to working as a bill poster when Clovis came down with smallpox. Yet the overwhelming power of his new obsession showed itself in his refusal to accept a better job from the same advertising company that had hired him for the poster hanging. Even with an empty bank account and a sick son on his hands he wanted to spend every minute preparing work for the eighth Impressionist exhibition.

Gauguin's preoccupation with painting only exacerbated the already existing strains in his marriage. In addition to having many children in quick succession, Paul and Mette changed their address six times in ten years. Gauguin made these moves largely to save money and to gain access to fellow artists and their studios. But from Mette's point of view, it was all downhill after their second apartment in the fashionable sixteenth arrondissement. Each subsequent dwelling became more modest and farther from the center of Paris until finally they were out of Paris altogether in Rouen and then Copenhagen. Mette might have more easily endured these hardships if she had shared her husband's enthusiasm for art or respected his ambitions. But painting held no interest for her, and she preferred her Scandinavian friends to Gauguin's bohemian associates. She also possessed an extravagant streak that only made the family finances more precarious. Six years into the marriage the tensions became so great that Mette, accompanied by Emil, went home to her mother in Copenhagen. Although Mette eventually returned to Paris, Emil stayed on and received his education in Denmark. That Gauguin allowed himself to become separated from his firstborn child and eldest son—named in honor of his friend Emile Schuffenecker—indicates that even at this point he must have harbored doubts about his ability and willingness to support his large family.

Everything came to a head four years later in Copenhagen. After months of exile in Rouen, Mette leapt at her seaman uncle's offer to arrange passage to Denmark. While she originally planned no more than a temporary visit and took only Aline and Pola, once in Copenhagen she intended to relocate the whole family. Gauguin, though no admirer of his in-laws, went along with this plan because a friend at Dillies et Frères had found him a position as the company's sales agent in Scandinavia. Gauguin hoped, among other things, to land

a large contract for tarpaulin from the Zeeland Railway Company. But the venture presented enormous difficulties for a Frenchman who spoke no Danish and proved a miserable disappointment. Gauguin's failure was made all the more humiliating as Mette's family witnessed every step of the disaster. Gauguin's *Self-Portrait (Gauguin at his Easel)* from this period captures his desperation. Seated in a cramped and gloomy attic room, he wedges his head into a vicelike triangle formed by the chair back, the tilted beam of the mansard roof, and the edge of the canvas on his easel. Gauguin reinforces the sense of unendurable pressure by prominently echoing the enclosing wedge shape in the large notch of his lapel. His sidelong glance, which must depict his checking his likeness in a mirror, also reads as the look of a shamed man peering over his shoulder in anticipation of yet another slight. (Gauguin no doubt set the painting in the same room about which he wrote, "Every day I ask myself if I mustn't go to the attic and put a rope around my neck.")[11] Making matters even worse, an exhibition of Gauguin's work in Copenhagen failed to make a stir. He had convinced himself that he could spread the faith of Impressionism to the Danes and found that his paintings neither won praise nor provoked a succès de scandale. Defeated on both the artistic and the financial fronts, Gauguin decided to give up his position with Dillies et Frères and return to Paris with Clovis. Although he did not at all envision it this way, the trip to Paris constituted his crossing the Rubicon. Despite his wishes to the contrary, he and his family would only reunite once again for an impossibly brief week in Copenhagen in 1891. And, save for a short stint in Panama, he would never again work at a conventional job.

So the scenario that Somerset Maugham devised in his Gauguin-inspired *Moon and Sixpence* rests, not surprisingly, more on fiction than fact. Unlike Maugham's Strickland, Gauguin did not abandon his wife, children, and the stock exchange with explosive suddenness. Nor, after leaving his family penniless, did he profess complete indifference to their fate. For at least the next decade, Gauguin assumed that he would eventually enjoy enough success to reassemble his family. Yet Strickland does accurately resemble his model in his mysterious and overriding compulsion to paint. Maugham's narrator can find no better explanation for this compulsion than to make the admittedly "romantic" comparison between Strickland's "deep rooted instinct of creation" and a

religious conversion.[12] We have seen that the seeds of Gauguin's creative desires fell on far more fertile ground than one might have guessed. But why the creative urge overtook him in the first place and why he became so attracted to painting as opposed to poetry, or journalism, or music remain largely an enigma.

IV

Gauguin and Vincent shared several traits when they first turned to art. They were both in their midtwenties, had spent their late adolescence in peripatetic and mostly unconventional activities, and had not received any academic training. Yet the differences in those years must have far outweighed the similarities. Vincent had taken yet another leap into the abyss after his sensationally failed attempt to become an Evangelist in the Borinage. He had to justify his unpromising and unremunerative choice to himself, to his family, and to a brother who knew only too well the difficulties of starting an artistic career at twenty-five. Vincent, moreover, felt the pressure of academic tradition more keenly. He simulated a traditional course of training by relying on Bargue's exercise books and worked side by side with friends, such as Van Rappard, who valued correct technique. Finally, Vincent could find support for his rebellion against an arid and inexpressive academic style not among actual colleagues but only in an imaginary avant-garde formed by Millet and Delacroix. None of these problems afflicted Gauguin. He bypassed the struggle with academic art altogether and simply began in a Barbizon-derived style and moved toward Impressionism under Pissarro's tutelage. Gauguin also avoided the existential angst that beset Vincent. Neither his identity nor his income depended, at this point, on his success as an artist.

It is not difficult to spot the influences on Gauguin's early works, especially the landscapes. One finds towering poplars silhouetted against the sky à la Troyon, rustic houses behind a placid stream out of Daubigny country, and, above all, the Pissarroesque suburbs with their whitewashed walls, triangular eves, and red roofs forming a series of variously angled pentagonal planes. As well as Pissarro's subject matter, Gauguin adopted his thin, strawlike brushstroke, which he sometimes varied so that it resembled Cézanne's "construc-

tive" stacking of parallel touches. But Gauguin did not excel in paint handling
and his works display few of the virtuoso Impressionist passages that one finds
in a Manet or Monet. No rose petals exquisitely rendered with one or two deft
brushstrokes and no glossy stretches of the Seine reflecting coruscating sum-
mer light. Gauguin himself, in a letter to Pissarro, admitted that his sometimes
fussy touch was "dull" and "lusterless."[13] This vice, however, may ultimately
have proved a virtue. Just as Vincent's lack of facility propelled him toward a
more original style, so Gauguin's inability to achieve a sumptuous Impression-
ist touch may have pushed him further in his own direction.

The paintings from Gauguin's Impressionist period that stand out most
prominently are inevitably those figural works that seem to anticipate the mys-
terious aura and latent symbolism of his mature oeuvre. In *Intiérieur du Pein-
tre rue Carcel,* for example, one sees both his debt to Degas and hints of later
ambiguities. Mixing genres as Degas had in *Woman with Chrysanthemums,*
Gauguin places a large bouquet of zinnias on a table in the foreground, which
seems to make the painting a still life. But in the back of the room, partially hid-
den by a screen, a woman plays an upright piano while a man (her husband?)
peers over the piano top. The work abounds in Degas-like croppings and vi-
sual puns, such as the tiny cylinder of a candle vying with the large cylinder of a
stovepipe and the squat Oriental figurine that subtly mocks the seated piano
player. Unfortunately, Gauguin, who organizes his picture around a monoto-
nous series of vertical accents, hardly equals Degas's compositional pyrotech-
nics. What reveals his own artistic character are such details as the unexpected
pair of clogs hanging from the wall, a round sewing basket opened in such a
way that it becomes an eyeball staring back at the viewer, and the implicit equa-
tion of the profuse bouquet with the music emanating from the piano. Equally
forward-looking are the *Little Dreamer,* mentioned above, and another depic-
tion of Gauguin's slumbering offspring, *Sleeping Child.* Although they resem-
ble Mary Cassatt's contemporaneous depictions of middle-class children in
unexpected poses, both works shift the focus from social observation to the
realm of fantasy. The decorative wallpaper that takes up the upper half of the
paintings contains fanciful plants and birds that seem to visualize the dreams of
the child below. And, by drawing musical notes on the wallpaper in *Little*

Dreamer, Gauguin once again establishes a Symbolist equivalence between art and music.

It took a young J. K. Huysmans, on the verge of writing *À Rebours*, to give Gauguin his first significant critical attention. What caught Huysmans's eye was a large figural work, *Nude Study, Suzanne Sewing*, which had been included in the sixth Impressionist exhibition in 1881. Huysmans praised Gauguin's plump and ungainly nude model for a realism that surpassed Courbet and approached Rembrandt. "Here is a girl of our days," argued Huysmans, "a girl who doesn't pose for an audience, who is neither lascivious nor affected, who is simply occupied with mending her clothes."[14] Gauguin's unidealized rendering of the model's flesh especially impressed Huysmans. No doubt thinking of pumiced and depilated Venuses of the Salon painters, Huysmans declared, "this is not the smooth, even skin, the skin dipped in a vat of pink and then gone over with a warm iron, that the other artists produce, here is skin beneath which the blood flows. . . . "[15] But for all its prescience about the artist's talent, the review says as much about Huysmans the fledgling critic as it does about Gauguin's painting. Huysmans, who was then emerging from Zola's Naturalist circle, mistook Gauguin's labored paint handling for vigorous innovation, gave Gauguin credit for a modern rendering of the nude that rightly belonged to Degas, and saw "a vehement note of realism" in a painting that contained quite a few fantastic and proto-Symbolist elements.[16] "Real" women do not sew while sitting naked on an unmade bed. Nor do they turn away from the light to thread their needle. What is more, Gauguin places his nude figure (either a servant named Suzanne or a hired model) in a distinctly unrealistic milieu. She sits in front of a violet-colored wall on which hang two Orientalist props—a woven rug and a mandolin. These objects allow Gauguin to assert yet again a Symbolist correspondence between art and music as the rug's multicolored stripes appear to visualize the different notes that might be plucked from the mandolin. Gauguin, who either chafed at Huysmans' misreadings or refused to admit his vulnerability even to praise, reacted with surprising coolness. Instead of crowing over his first favorable review, he complained to Pissarro that "in spite of the flattering part . . . he is attracted only by the literary dimension of my female nude, and not by how it is painted."[17]

Many forces pushed Gauguin beyond Impressionism in the mid-eighties. He began formulating his own Post-Impressionist aesthetic in a series of notebook jottings during his stay in Copenhagen (later collected as "Notes Synthétiques"), but he lagged behind other advanced painters in putting these concepts into practice. Before he left for his first trip to Brittany in 1886, four works that define Post-Impressionism were already in progress or had been completed—Seurat's *A Bathing Place (Asnières)* and *A Sunday on the Grande-Jatte—1884*, Renoir's *Bathers,* and Cézanne's *Montagne Ste.-Victoire* in the Courtauld. All of these paintings attempted to replace the Impressionist embrace of instantaneousness and the fugitive effects of light with a new respect for structure, form, and monumentality. They strove, in Cézanne's famous words, "to make out of Impressionism something enduring and solid like the art of the museums."[18] And Gauguin's intimate knowledge of Cézanne's paintings, six of which he owned, certainly nudged him toward a more considered art. But the greatest spur, and the most irritating, must have been Seurat's two canvases. Although only in his twenties and twelve years younger than Gauguin, Seurat had established himself as the leader of the Parisian avant-garde. No other painter had broken so decisively with the previous generation. Where Impressionism's ambient light dissolved form and blurred edges, he insisted on crisp contours and clearly contained shapes. In place of Impressionism's celebration of momentary flux and random movement, he restored a definite and calculable order. And instead of subordinating his palette to the optical sensations before him he carefully applied a color system based on complementaries that he executed in the studio. Gauguin dabbled briefly with Seurat's precise, dotlike brushstrokes, but never became, as Pissarro did, a full-fledged pointillist. Seurat's style was too methodical and rational, at least in its theoretical trappings, for someone who valued the "innermost recesses of man's mind."[19] Yet Seurat had raised the stakes, and Gauguin knew he had to produce something bold.

Gauguin found his springboard for the leap out of the Barbizon School and Impressionism at Pont-Aven in Brittany. Here he would begin to find his own way and seriously challenge Seurat. But his motives for visiting the town that he helped make so famous were surprisingly banal. Although writers as well as artists had long been attracted to Brittany's rugged landscape, medieval monu-

ments, and elaborately costumed peasants, Gauguin came to Pont-Aven to save on expenses. And once ensconced at Madame Gloanec's Inn, the cheapest lodgings available, he rarely ventured beyond the town limits. Art historians have recently emphasized the extent to which Gauguin falsified Brittany. By seeing it as "savage" he endorsed a view of the region as supporting a timeless culture that ritually reenacted centuries-old agricultural and religious practices. This flies in the face of the disruptive realities of nineteenth-century capitalism, which profoundly transformed Brittany as well as other rural *départements*. Gauguin's depiction of the most "primitive" costumes and religious structures also belies the extent to which such seemingly ancient traditions had been recently invented and tailored to the tourist trade.[20] But such criticisms miss the point of Gauguin's art. It was not his aim to present a demystifying account of Brittany's current social history. Nor was an accurate understanding of Breton folk culture crucial to his progress as a painter. The myth of Brittany served his own purposes by giving him a vehicle for ideas that he had already been developing. While in Copenhagen he had written to Schuffenecker about primordial "laws" of expression that lay beneath and could bypass the crust of civilization. A "great spider," a "tree trunk in the forest," "lines and color"—all of these things could more powerfully and immediately penetrate the mind than the most correctly rendered and quasi-photographic image produced for the Salon. As he told Schuffenecker, "all our five senses reach the brain *directly*, affected by a multiplicity of things and which no education can destroy."[21] To turn to Brittany's peasant types was to find a preindustrial subject that seemed perfectly suited to the primal force of his own emerging style.

Four Breton Women Gossiping over a Wall [2.1] serves as the best example of this style as it took hold on the first trip to Pont-Aven. Gauguin endows the work with a new structural and figural rigor. In a rustic version of the three graces, a trio of peasant girls stands friezelike in front of a wall while one poses behind it. This dominant three-plus-one formula extends to other elements of the picture, such as the three profile heads combined with one *profil perdu,* and the three geese who turn in profile to the left as another stands apart and looks to the right. Degas's influence persists in the incisive linearity of the contours and in the pose of a girl who adjusts her boot just as a Degas ballerina

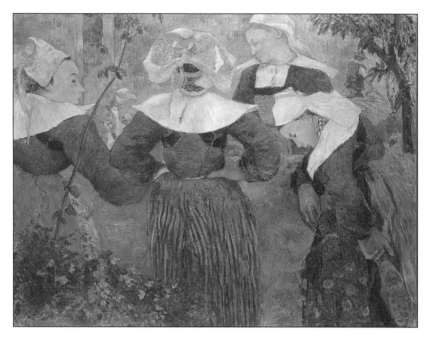

Figure 2.1 Paul Gauguin, *Four Breton Women Gossiping* (1886)

might fiddle with her shoulder strap. But Gauguin simplifies the composition in ways that repudiate his master. He flattens the space by placing the wall parallel to the picture plane and by reducing the background to a screen of grass. And instead of Degas's plunging orthogonals he stretches Hokusai-like branches across, not into, the picture surface. He also narrows and intensifies his palette. Although mediated by umber neutrals, bright red and green complementaries run through the girls' dresses, skin tones, and hair.

The equation of the geese with the girls contains, of course, a misogynistic joke. Not only does Gauguin implicitly compare the gossips to animals, but to creatures especially associated with stupidity. In French slang, "*une oie blanche*" (a white goose) means a "simple and naïve girl." The young women, moreover, mingle idly while a farmer in the upper right virtuously guides a plow. So they emerge as indolent as well as imbecilic. Gauguin's culturally

sanctioned misogyny often manifested itself in his later art and may have been yet another defense against his identification with Aline. But the parallelism of the girls and the geese results as much from Gauguin's concern for structural cohesion as it does from any sly contempt for women. The white feathers of the geese echo the girls' white headdresses, which create such a strong and simple rhythm across the picture surface. And despite the title, the girls, who hardly converse, possess a classical stillness. The middle figure, in particular, embodies the new sense of pictorial order. She stands in the exact center of the picture securely framed by a compositional triangle that reaches its apex just above her bonnet. Unlike Impressionism's cropped and angled urbanites, she looms up as a peasant icon with her akimbo arms winging out in perfect symmetry and her starched collar forming a neat semicircle.

V

Gauguin's first trip to Pont-Aven lasted only four months. In mid-October, when the autumn chill had set in and most of the other artists had left, he returned to Paris. His next artistic leap would take place in Martinique, another "savage" yet much more temperate and lush locale. This Caribbean island, however, had not been his intended destination. He arrived there circuitously and by means of one of those half-baked and over-optimistic schemes that too often guided his life. He had heard from his sister that his brother-in-law, Juan Uribe, was prospering in Panama as a result of the canal project. Convinced that Uribe would arrange well-paying work for him, Gauguin and his artist friend, Charles Laval, left Saint-Nazaire bound for Colón, Panama, on April 10, 1887. Once they arrived, they faced a series of shocking disappointments. Colón, instead of offering the amusements of a boomtown, had been reduced to a dirty, rat-infested shambles by the disasters attendant on digging the canal. Malaria and yellow fever plagued a city that already had to contend with overpopulation, inadequate housing, and violent uprisings. Gauguin and Laval crossed the isthmus to Panama City only to suffer further rude awakenings. Far from running a bank, as Gauguin believed, Uribe only managed a modest and not very profitable general store. Returning to Colón, Gauguin worked briefly as a bookkeeper for a company connected with the canal construction. Al-

though fired after two weeks, he had accumulated enough in wages for a ticket to Martinique. Gauguin and Laval had admired the island when their ship put in at the second largest city, Saint-Pierre, on their way to Panama.

Gauguin lived even more cheaply in Martinique than he had in Pont-Aven. Forsaking the comfort of an inn, Gauguin and Laval stayed in an abandoned shack in the Negro district of a settlement about two miles from Saint-Pierre. They paid no rent and ate fruit picked from the trees. Gauguin also had a ready subject in his neighbors, especially the female ones, whom he repeatedly depicted in his sketches and paintings. In a letter to Schuffenecker, he explained his fascination with these local types:

> We have been in Martinique, home of the Creole gods, for the last three weeks. The shapes and forms of the people are most appealing to me and every day there are constant comings and goings of negresses in cheap finery, whose movements are infinitely graceful and varied. For the time being I have restricted myself to making sketch after sketch of them, so as to penetrate their true character, after which I shall have them pose for me. They chatter constantly, even when they have heavy loads on their heads. Their gestures are very unusual and their hands play an important role in harmony with their swaying hips.[22]

Unfortunately, the Martinique sojourn hardly lasted longer than the summer months in Brittany. This time illness, not autumn, cut off the idyll. Laval had contracted yellow fever on the isthmus, and Gauguin suffered so badly from dysentery and other unspecified diseases that a doctor ordered him to return to France. Yet in the few months available to him his art made significant advances not only in the broadening of his figural repertoire but also in the luminosity of his palette.

There is something inevitably disappointing about the Martinique paintings. One expects the sun-drenched locale to have automatically endowed Gauguin's colors with the Fauve-like intensity that they would acquire in Tahiti. Instead the Martinique works look comparatively dull, and their still short brushstrokes give them an unexpected density. But Gauguin breaks out of his Barbizon-derived muddiness in the saturated blues of his ocean waters

and in the refulgent white clouds of his skies. Furthermore, he uses the setting to remake Puvis de Chavannes and Seurat in the tropics. He tilts up the horizon line and stretches flat strips of sky, sea, and beach across broad canvases. As a counterpart to the languid weight of these horizontal zones he creates vertical axes out of tree trunks and natives walking with their cargoes on their heads. These Negresses, to whom Gauguin was so attached, take on the columnar stateliness of Poussin's water carriers in *Rebecca and Eliezer.* Gauguin also replaces Seurat's poodles and monkeys with wild dogs and goats that echo, sometimes comically, the contours of sitting and bending figures. This anticipates his Tahitian canvases as does the practice of using the flat patterning of the background to heighten the sensual modeling and careful drawing of the native women in the foreground. These women, like their Tahitian counterparts, often possess a mysterious aloofness as they go about their tasks or converse among themselves. Their refusal to meet the spectator's eye becomes the visual equivalent of the impenetrable foreign dialect that they speak.

Seen through the lens of Gauguin's later work, the Martinique paintings appear as very important first steps toward a new visual lexicon for native figures within a tropical landscape. Gauguin, in fact, wrote to Charles Morice, a young poet and eventual collaborator, that "I had a decisive experience in Martinique. It was only there that I felt like my real self, and one must look for me in the works I brought back from there rather than those from Brittany, if one wants to know who I am."[23] But these canvases generated little excitement in Paris. They neither blazed with the radiance that critics expected nor displayed any technical breakthroughs. Gauguin had still not produced work that could equal the impact of Seurat's *Grande Jatte.* There was, however, one extremely important exception to the general indifference. The van Gogh brothers, who would have seen the paintings at Portier's Montmartre gallery, responded enthusiastically. Vincent, with his nearly automatic affection for the marginal and downtrodden saw "high poetry" in Gauguin's pictures of Negresses. "Everything his hands make," Vincent insisted to Emile Bernard, "has a gentle, pitiful, astonishing character."[24] Theo, for his part, was impressed enough to spend nine hundred francs for various works and to exhibit them at Boussod and Valadon.

VI

By the time Gauguin had resettled in Paris, he had not only won over the van Goghs but had also traveled the long distance from fledgling student to respected master. His manner of negotiating this transition, however, raises many questions about his character. Although it is easy to exaggerate Gauguin's roguishness and egotism, he certainly managed to offend more than a few of his colleagues. Factional disputes in general and infighting over group exhibitions in particular brought out the worst in him. As early as 1882, Eugène Manet described him as "play[ing] the dictator" in his dealings with other artists.[25] And his fierce careerism as well as his penchant for switching sides in internecine battles forced Pissarro to call him "deeply commercial" and "cunning" and himself "naïve" for having once defended his protege.[26] He inspired suspicion in both Cézanne and Seurat. Cézanne would accuse him of stealing his "little sensation" and "trail[ing] the poor thing about in ships . . . across America . . . Brittany and Oceania,"[27] while Seurat, unaware of an agreement between the two artists, refused to give Gauguin the key to Signac's studio. Seurat's stance provoked such a rage in Gauguin that it terminated their relationship. Finally, Félix Fénéon, though praising his ceramics in an article in *La Revue Indépendente*, characterized Gauguin as "*grièche*," that is, "soreheaded" or "disagreeable."[28]

On a deeper level, Gauguin's prickliness appears grounded in his strong resistance to a submissive or subordinate role in relation to another man. Despite all that Gustave Arosa did for him as a generous guardian and as a supporter of his budding artistic interests, Gauguin failed to show up at his funeral and entirely eliminated him from his memoirs. And, though he allowed himself to play student to Pissarro's teacher, he also turned the tables by becoming a collector as well as a dealer of Pissarro's works and thereby made the older artist financially dependent on him. His ferocious response to Seurat over the key incident shows how stubbornly he refused to take orders from someone else. He wrote to Signac, "I may be an artist full of hesitancy and with little knowledge, but as a man of the world *I will allow no one to mess me about*"[29] (italics mine).

Yet Gauguin's preference for the dominant role, however much it was rooted in his insecurities, did not prevent him from attracting followers. He had al-

ready assembled a small group of disciples among the younger artists during his first trip to Brittany. And one of these, Laval, became so smitten with his new master that he eagerly agreed to join him on the difficult trek to Panama. Laval, moreover, remained loyal to Gauguin after working with him over an extended period and in the closest and most straitened circumstances. Something more than Gauguin's talent as an artist or his understanding of the latest avant-garde tendencies must have been responsible for the spell that he cast. Whether it was his rough wit, his swagger, or his self-mystification as a dandy and "savage," he could exert a great pull over others. Not the least of these admirers was, of course, Vincent van Gogh, who, as we shall see, placed Gauguin in the forefront of his thoughts in the next decisive months.

─── 3 ───

Van Gogh in Paris and First Encounters with Gauguin

I

It is easy to regard Vincent's years in Paris as merely a prelude to Arles. Everything begun in Paris becomes more dramatic in the South. Bright colors turn blindingly radiant, and subtle contrasts polarize into sonorous clashes. Vincent's life becomes equally heightened as he paints more, carouses more, and behaves more violently. Yet to see the Paris period in this way obscures Vincent's great artistic strides. Even an expert might mistake a painting from 1881 with one from 1885, but no one would confuse a still life or landscape from 1887 with a pre-Paris work. The most obvious reason for this is Vincent's rejection of loamy Milletesque earth tones for a lighter and more vivid palette. But the Paris period also witnessed dramatic changes in his paint handling and his compositions. In two years he not only assimilated the most advanced art in Europe but began pushing it in new directions.

This is all the more remarkable given Vincent's nearly total ignorance up to this point of avant-garde developments. As he wrote to his sister, Wil, he initially reacted to Impressionism with surprise and hostility:

One has heard talk about the impressionists, one expects a whole lot from them and
. . . when one sees them for the first time one is bitterly, bitterly disappointed, and
thinks them slovenly, ugly, badly drawn, bad in color, everything that is miserable.

This was my first impression too when I came to Paris, dominated as I was by the
ideas of Mauve and Israëls. . . . [1]

In addition to unburdening himself of Mauve's and Israëls's biases, Vincent
had to confront the Post-Impressionist revolution at the same time that he was
absorbing the shock of Impressionism. Theo, who displayed Impressionist
paintings on the second floor of Boussod & Valadon's Montmartre gallery,
could show Vincent works by Manet, Renoir, Monet, Sisley, Guillaumin, and
Degas. And Vincent could supplement this education by visits to various exhi-
bitions and to Durand-Ruel's gallery. Yet in May 1886, only two months after
Vincent's arrival in Paris, he also came face to face at the eighth Impressionist
exhibition with Seurat's *Grande Jatte* as well as Divisionist works by Signac
and Pissarro. His engagement with Post-Impressionism only grew more in-
tense as he eventually met and befriended many of those creating the newer art.

Although by 1886 Impressionism had lost its innovative edge, this did not
make matters any simpler for Vincent. He brought a problematic set of skills
and inclinations to his incorporation of the style. On the one hand, he shared
the Impressionist rejection of pompous historical subjects and fussy academic
standards. His own vigorous execution, moreover, had many affinities with Im-
pressionism's thick, loose, and quickly applied brush strokes. Yet, on the other
hand, he had never devoted himself to the naturalistic depiction of light and
atmosphere. Nor had he ever sought the instantaneous glimpse of worlds in
movement. Impressionism's multiple narratives were well beyond the reach of
someone who had struggled in The Hague and Neunen with the most basic il-
lustrational themes. As a result, many typical Impressionist subjects are miss-
ing from Vincent's Parisian works. One searches in vain for jolly boating par-
ties or café concerts with their varied social types or the hectic traffic of a
Haussmannized boulevard. Much of this stemmed from Vincent's difficulties
with the figure. And during his first months in Paris he attempted to improve
his abilities by drawing plaster casts in Fernand Cormon's studio. But he could
not orchestrate groups with anything even approaching the finesse of a Manet

or a Degas. And on the rare occasion that he did paint men and women strolling in the park or sitting in a café he shows them at such a remove that they emerge as distant stick figures.

It was easier and cheaper for Vincent to instruct himself in Impressionist chromaticism by painting still lifes of flowers. He described these works, which make up a large part of his Parisian output, as accustoming him to "a scale of colors other than gray—namely pink, soft and vivid green, light blue, violet, yellow, orange, rich red."[2] He was encouraged in this by his love of Adolphe Monticelli, a flamboyant Provençal painter who whipped up flower studies with such mountainous layers of impasto that they made even Vincent's touch seem restrained. He also turned to the area surrounding the apartment that he and Theo shared on the rue Lepic in Montmartre. This indeterminate and still-developing region—what Parisians called the *banlieu*—contained a mixture of rural and urban views. Boulevards intersected dirt paths, smokestacks outnumbered church steeples, and a farm might share the same street with an apartment building. Victor Hugo in *Les Misérables* characterized such districts as "a kind of bastard countryside, somewhat ugly but bizarre . . . End of trees, beginning of roofs, end of grass, beginning of paving stones, end of ploughed fields, beginning of shops."[3] By the 1880s the *banlieu*'s suggestive incongruities had become a favorite subject for the Impressionists as well as more anecdotal painters such as Jean-Francois Raffaelli. Vincent would have been especially attracted to its lonely and disjunctive topography because he had depicted a similar world in his drawings of city scenes in The Hague. Ironically, he repeatedly chose a Dutch motif—the few surviving windmills of the Butte de Montmartre—that he had mostly avoided in his native Holland.

Not far from these mills, Vincent painted one of his most successful Impressionist works—*A Wheat Field*. Here he comes closer to capturing a specific place and time enveloped in its own atmosphere. Instead of removing the viewer to a safe distance Vincent situates him as if he were standing amidst the stubble and facing a wall of uncut wheat. And he adds to the scene's immediacy by cropping the field on both sides and by suggesting that a gust of wind has just bent the stalks, wafted a solitary lark, and sent wispy clouds scudding across the sky. Vincent also introduced a new lightness to his paint handling

that allows *A Wheat Field* to become, in Meyer Schapiro's words, "a breathing work."[4] This lightness involves not only thinner and softer brushstrokes but also a consistently blond tonality subtly underscored by flecks of black, green, and red. Air, sun, and a spring breeze—everything missing from the claustral hovels of Neunen—permeates this painting. Yet for all of its emulation of Impressionism, *A Wheat Field* contains the seeds of Vincent's later style. The blunt reduction of the composition to three parallel zones of stubble, wheat, and sky anticipates the geometric simplifications of his Arles paintings. And his use of structural brushstrokes to render both the form and texture of objects looks forward to his marriage of drawing and painting in his signature works. In *A Wheat Field* these structural touches create a particularly strong equivalence between each waving stalk and the long, thin, cursive stroke that defines it.

It is typical of Vincent's wide range of experimentation in Paris that the very same spring of 1887 that produced *A Wheat Field* also saw the creation of his most fully Divisionist canvas, *Interior of a Restaurant.* He had become thoroughly acquainted with the style not only from examining Seurat's works at various exhibitions but also from his meetings with Pissarro and from his friendship with Paul Signac. Signac, a young and extremely precocious artist, had worked closely with Seurat during the early formulation of Divisionism. Signac, however, did not share Seurat's frosty aloofness, and he painted alongside Vincent in the Parisian suburbs where the latter found the setting for *Interior of a Restaurant.* As art historians have observed, this work demonstrates a remarkable dampening of Vincent's expressive impulses in his attempt to master the new approach. Vincent, who habitually slathered paint on canvas with a vehement rapidity, forced himself to make small, methodical touches over the entire surface of the painting. And he matches the uncharacteristic primness of the paint handling with a surprisingly quiet and orderly composition. He has chosen the still moment before diners have arrived when chairs, dishes, upside-down glasses, and floral decorations remain tidily in place. This allows him to construct a neat rectilinear structure that is extended and reinforced by frames and moldings of the background walls. He also displays the Divisionist's love of repeated modular forms. So three tables with their white tablecloths, like the bonnets in Gauguin's *Four Breton Women Gossiping over a*

Wall, beat out an even visual rhythm across the picture. One has only to think of *The Potato Eaters'* willful mutations or *The Night Cafe's* jarring discontinuities to recognize the anomalous nature of *Interior of a Restaurant.*

Despite such efforts to conform to Divisionism's strictures, Vincent, like Gauguin, had little affinity for the school's scientific aspirations. He could pursue a pointillist touch to the extent that it emphasized the materiality of paint and liberated him from concerns with academic or even Impressionist illusionism. But he could never become imprisoned by a technique that aimed only to maximize control over optical effects. So his dots grew tails and rebelled. One can see this even in a work such as *People Walking in a Public Garden at Asnières,* where he tries to paint his own measured and harmonious version of the *Grande Jatte.* Although the passages depicting the figures and the park remain relatively restrained, the strokes in the sky lengthen out and create shimmering vibrations. In *Vegetable Gardens in Montmartre* these parallel marks become harnessed to Vincent's obsession with perspective and align themselves with the orthogonals of a road. They turn this worn path into a teeming river of directional lines flowing towards the vanishing point and in doing so break all of the rules of Divisionist pictorial decorum. Nor could Vincent accept Divisionism's coolly rational understanding of color. He could never regard complementaries as merely a matter of "simultaneous contrast." As early as 1885 he declared to Theo that *"color expresses something in itself."*[5] And later, having invested colors with the most intimate meanings, he would argue that "there are colors which cause each other to shine brilliantly, which form a *couple,* which complete each other like man and woman."[6]

Vincent continued to bend the rules of Divisionism in the self-portraits that made up such a large part of his Parisian oeuvre. In one of these works he disciplines his dots so that they complement his unusually soigné appearance, but more often they scatter wildly. He also puts pointillist devices to unexpected uses, such as his adaptation of the dots that radiate from a gaslight to the space around a human head. The sitter thus acquires a "halo," and Vincent employs this technique in a self-portrait that depicts him with a suitably far-off and visionary glance. The artist as seer, however, is just one of the many personae that he presents in paintings that show him trying on all kinds of clothes, attitudes, and artistic styles. In one he is a Parisian dandy decked out in felt hat,

trimmed beard, high collar, and buttoned jacket, while in another his bristling hair, dirty smock, and ferocious expression turn him into a caricature of an irascible bohemian. Still others reveal him as pensive, imploring, downtrodden, and stern at all levels of formality from top hat and wing collar to unbuttoned peasant blouse. They are painted, moreover, in an equal variety of styles, from the conventionally Rembrantesque to attempts at Manetlike suavity to the improvisatory pointillism mentioned above. Only in the last Parisian self-portrait does he move well beyond pastiche into a style fully his own.

The protean quality of the self-portraits also reflects Vincent's multiple and often contradictory identities during the Paris years. He started out as a student at Cormon's and an outsider entirely dependent on Theo for his introduction to advanced art and for his entrée into avant-garde circles. But he ended up as someone who had organized two influential exhibitions—one of his beloved Japanese prints and the second of works by himself, Toulouse-Lautrec, Emile Bernard, Louis Anquetin, and others. What is more, he transformed himself from the isolated eccentric of Neunen into someone who, if not a boulevardier, had an eventful social and amorous life. He frequented cafés (where Toulouse-Lautrec famously portrayed his fierce countenance presiding over an absinthe) and, as he wrote to Wil, carried on "the most impossible" love affairs.[7] One of these entanglements most likely involved Agostina Segatori, the owner of a Montmartre café (Le Tambourin) where Vincent showed his collection of Japanese prints. Although Segatori was yet another older woman who had seen hard times, Vincent remained more self-possessed and less masochistic in his relations with her. Finally, he proved himself surprisingly broadminded in his attitude toward the avant-garde disputes swirling around him. Almost alone in his ability to move easily within Impressionist, Divisionist, and Synthetist circles, he played a mediating rather than an inflammatory role among the warring artistic factions.

II

While Vincent's personal expansiveness benefited his art, it came at the expense of Theo's serenity. As we have seen in Vincent's letters from Drenthe, he possessed a strong fantasy of fusing his life with Theo's. In Paris he had the

chance to put this fantasy into practice and to collapse psychic and physical borders. Although Theo treated his apartment as a tasteful and orderly extension of his gallery, Vincent had no other concern than his painting and allowed his studio to spill over into every room. One imagines Theo, who had enjoyed ten years of an independent existence, coming home from work only to trip over unframed canvases and discover unwanted piles of dirty brushes and paint tubes. But all of this must have seemed tolerable compared to Vincent's endless arguing about every issue from the most abstract question of Impressionist aesthetics to the more immediate dilemma of Theo's future as a dealer. According to Jo van Gogh Bonger, the woman whom Theo would soon marry, Vincent would not even let Theo's essential, human need for sleep get in the way of his harangues. He would simply pull up a chair next to his brother's bed and continue to declaim. In a letter to Wil, Theo gave full vent to his exasperation:

> My home life is almost unbearable. No one wants to come and see me any more because it always ends in quarrels, and besides, he is so untidy that the room looks far from attractive. I wish he would go and live by himself. He sometimes mentions it, but if I were to tell him to go away, it would just give him a reason to stay; and it seems I do him no good. I ask only one thing of him, to do me no harm; yet by his staying he does so, for I can hardly bear it.[8]

Yet even at his wit's end Theo retained enough affection for his brother to follow up his complaints with a deservedly well-known passage that poignantly described his brother's dual nature and self-destructiveness:

> It seems as if he were two persons: one, marvelously gifted, tender and refined, the other, egoistic and hard-hearted. They present themselves in turns, so that one hears him talk first in one way, then in the other, and always with arguments on both sides. It is a pity that he is his own enemy, for he makes life hard not only for others but also for himself.[9]

At some level, Theo must have conspired in this symbiotic relationship, or else he would not have put up with it for two years. Fortunately, tensions eased as Vincent spent more time away from the apartment, first at Cormon's and

then during his painting campaigns in Montmartre and in Asnières. Years later, Vincent himself seemed to have recognized his excessive need to merge with Theo and wrote to his mother, "it is a good thing that I did not stay in Paris, for we, he and I would have become too interested in each other."[10] The first still lifes of worn shoes date from this period, and in their intimate pairing, complete with intermingled laces and shared weathering, they become a metaphor of Vincent's fantasy of his relationship with Theo. That one still life apparently depicts not a pair but two left shoes only underlines the theme of doubleness.

Vincent's behavior as Theo's roommate was remarkable enough, but he surpassed it during the summer of 1886, when Theo visited Holland. Theo's troubled former mistress, the mysterious "S" of the letters, had suddenly reappeared and moved into the apartment that Vincent now shared with Theo's friend Andries Bonger. Distressed and confused, she still clung to the relationship that Theo had ended. This pathetic situation gave Vincent a surprising new opportunity to fuse with his brother. His incredible solution to the problem of "S" was to take her on as his own mistress and even marry her if necessary. He explained this "obvious" plan in a letter to Theo:

> It would be a good thing if you accepted the idea that the affair cannot be settled in the way you propose, by treating her harshly you would immediately drive her to suicide or insanity, and the repercussions on you would be sad indeed and leave you a broken man . . . you should try and pass her on to somebody else, and I told Bonger explicitly what my feelings on the subject are—that an amicable arrangement, which would seem obvious, could be reached by your passing her on to me. So much is certain that, if you could reconcile yourself to it, and S. too, I am ready to take S. off your hands, i.e. preferably *without* having to marry her, but if the worst comes to the worst *even* agreeing to a marriage de raison.[11]

Vincent condenses many conscious and unconscious meanings in this stunning proposal, which of course no one adopted. He not only wants to become his brother's double but also is to compete with him. By offering to take on "S," he drew on the ancient desire to displace the first Vincent and then Theo in his mother's affections. Yet, at the same time, he identifies with "S" as someone dependent on Theo and terrified of losing his support. By saying that "treating her

harshly" will drive "S" to "suicide or insanity" he implicitly warns, as he had done before, that he will go mad or kill himself if Theo abandons him. A year later, after learning of Theo's intention to marry Jo Bonger, Vincent responds to this potential disruption of his relationship with his brother by making the same implicit threat. He ends an overtly congratulatory letter with the ominous statement, "It's better to have a gay life of it than commit suicide."[12]

III

If Gauguin had known about Theo's tribulations he would never have set foot in Vincent's Yellow House in Arles. But the extremes of Vincent's personality were hidden from him in Paris. Although one would like a memorable first encounter between the two artists—Gauguin engaging Vincent in a café debate or singling out one of his paintings for an impassioned critique—it is not certain when they first met. As Vincent had no need of writing Theo while they were both in Paris, we lack a detailed, day-to-day account of his activities. Gauguin does not, in fact, appear in Vincent's correspondence until the latter had established himself in Arles in the spring of 1888. As their lives intersected in several ways, they could have met in 1886 either before or after Gauguin's first trip to Pont-Aven. Theo would have known of Gauguin through his visits to the Impressionist Exhibitions over the years. He dealt, moreover, in works by close associates of Gauguin's, such as Pissarro and Degas. Vincent, for his part, would have seen nineteen of Gauguin's at the eighth Impressionist exhibition in the spring of 1886 and may have heard about him from Emile Bernard. However, so many of the first documented interactions between Gauguin, Vincent, and Theo cluster around the end of 1887 and the beginning of 1888, it seems unlikely that they met before this period.

A likely reconstruction of events would have Gauguin, upon his return from Martinique in mid-November 1887, meeting Theo through one of their mutual art-world acquaintances. Gauguin would have encountered Vincent either at Theo's gallery or at the exhibition that Vincent had organized in a restaurant on the Avenue de Clichy called Le Grand Bouillon. There Gauguin could see one hundred paintings by Vincent as well as works by Anquetin and Bernard that had strong affinities with his own efforts. From this point, the ties

between the van Gogh brothers and Gauguin quickly strengthened. First, Gauguin and Vincent agreed to an exchange of paintings. The terms of this agreement, however, clearly established Gauguin as the recognized master. While Vincent allowed Gauguin to pick two paintings of cut sunflowers, he modestly accepted only one small Martinique scene for himself. An undated letter by Gauguin probably from December 1887 informs Vincent that he can pick up his painting at a framer's in rue Fontaine.[13] Gauguin goes on to state, somewhat aloofly, that as he so seldom ventures into Vincent's *quartier*, he cannot receive his pictures in person and would rather have them deposited at Boussod & Valadon. Gauguin was, in fact, lodging far from Montmartre in Montparnasse, where the reliable Schuffenecker had put him up. When Theo, probably accompanied by Vincent, made a visit to Schuffenecker's studio they had their first glimpse of Gauguin's Martinique works. Theo lost no time in putting together an exhibition of Gauguin's paintings and ceramics in the entresol of his gallery in December and displayed Gauguin's work again in January. While Gauguin must have been pleased with Theo's sympathetic appreciation of his art, he would have been even more satisfied by his ability to find buyers. Theo not only succeeded in selling two works, but also purchased for himself a Martinique picture, *Among the Mangoes*, for four hundred francs. A receipt dated January 4, 1888, exists for this transaction. Gauguin, moreover, wrote to Mette around this time that "someone at Goupil's [Theo] was most enthusiastic about my pictures and eventually brought three of them for 900 francs and intends (he says) to take others from me."[14] The period of Vincent's and Gauguin's initial acquaintance was surprisingly brief. Gauguin, weakened by illness contracted in Martinique, only spent a little over two months in Paris before leaving for Pont-Aven at the end of January. It is a testament to the force of his personality that he made such a deep impact on Vincent in such a short time.

What first impressions did the artists make on each other? For Gauguin, Vincent must have appeared not so different from other younger bohemian men he had encountered in Montmartre and Pont-Aven. Vincent's argumentativeness, temperamental moods, and unconventional dress would hardly have put him off as these were traits he possessed himself. But Gauguin, who had always made his own way no matter how daunting or humiliating the circumstances, would have regarded Vincent's total financial dependence on Theo as

a sign of weakness. This would have placed Vincent more squarely in the category of a disciple such as Laval or a usable friend such as Schuffenecker. Gauguin adopted an intimate tone with Vincent. He would, for example, begin letters to his fellow artist with "Mon Cher Vincent" while addressing Theo, the professional dealer, as "Mon cher Monsieur Van Gogh." However, it was not the intimacy of equals but rather of one figure playing a paternal or avuncular role toward the other. Although Gauguin clearly felt himself superior to Vincent both as a man and an artist, Vincent's status as Theo's brother obscures the exact nature of nearly every other emotion that Gauguin might have harbored. Would Gauguin have had anything to do with Vincent if not for his ties to one of the largest art-dealing firms in Europe? It is too harsh to say that Gauguin had no sympathy for Vincent or respect for his painting. But one cannot ignore the element of calculation that entered into Gauguin's stance toward the van Gogh brothers.

How did Gauguin react to Vincent's art at this stage? To the extent that Vincent was working through Impressionism his paintings would have seemed *retardataire* to Gauguin, and to the extent that he was assimilating Divisionism he would have been working in a style that Gauguin had rejected. The roughness of Vincent's paint handling, though in many ways more forward-looking than Gauguin's, would also have seemed amateurish to him. Vincent, furthermore, lacked the elegant sinuosity of line that informs even Gauguin's most "primitive" figures. An almost condescending observation sums up Gauguin's cagily ambivalent response to Vincent's art. He wrote to Theo in May 1888 that Vincent had a "curious eye and I hope that he does not change it for another."[15] Better a "curious" eye than a "bad" one, but where does it really leave Vincent? Yet, despite his apparent misgivings about Vincent's talent, Gauguin made a surprisingly astute choice of works in their exchange. Obviously, in picking still lifes of sunflowers he displayed a remarkable prescience about what would become Vincent's most famous subject matter. These early versions, however, are in some respects more radical. In one, the tight focus on the two orblike disks gives them an unworldly scale and, in typically Northern Romantic fashion, condenses macrocosm and microcosm. Vincent also depicts pairs of cut flowers that, like the worn shoes, sit in an intertwined proximity and thereby reassert the powerful doubling theme. Finally, his touch exhibits a

rich variety as it moves from the fluid directional strokes that create "halos" around the flowers to the network of incisive radial lines that define the seed heads.

Vincent's admiration for Gauguin booms out from his letters. Gauguin is "superior," "has such great talent," and is "so great an artist."[16] But it was not his art alone that made Gauguin such an impressive figure for Vincent. Although only five years separated them in age—Vincent was thirty-five in 1888 and Gauguin forty—the latter would have appeared older to Vincent for several reasons. While Vincent's life up to this point seemed like a protracted adolescence, Gauguin had married, fathered children, and had successfully pursued a financial career. And in the realm of art, he was not only much more established, but had shown in the Impressionist exhibitions, which were now taking on something of a mythical quality. In light of this, Gauguin's egotism and arrogance, instead of appearing repellent to Vincent, may have made him all the more alluring as a confident master. That Gauguin could inspire extreme devotion is testified to by one of Laval's letters written shortly after the former's return to Paris. Laval, still recovering from his illness, wrote effusively to Gauguin from Martinique:

> Everybody wounds you and you remain good, calm, and loyal. . . . You have broadened my horizons you have given me space; I was in a little black hole when you found me. I wish to succeed to prove that you have only done good. . . . I have faith in you, eyes will open and you will have the best place; you will rule over those who know how to understand. For my part, the longer I go the more I admire your talent and I feel respect and affection for you. . . . I embrace you tenderly like a courageous older brother who has set an example for me.[17]

At the same time, the lamentable fact that so great an artist as Gauguin still had to struggle to sell paintings only made him more of a hero for Vincent and strengthened his belief in the need for an artists' collective.

Vincent would have been especially struck by the Japanese aspects of Gauguin's Martinique works, such as the flat, overlapping zones of bright color and the tree trunks rendered as meandering diagonal strips. But he seems to have responded as much to the content of Gauguin's paintings as to their formal

qualities. He would have seen in Gauguin's figures a tropical version of the laboring peasants that he had depicted in Holland and abandoned in his Parisian works. The remarks that precede Vincent's aforementioned rhapsody to Bernard about the Martinican Negresses show that he saw them as victims of colonial oppression:

> . . . You are quite right to see that those Negresses were heart-rending. You are quite right not to think such a thing innocent.
>
> I have just read a book—not a beautiful one and not well written for that matter—about the Marquesas Islands, but sad enough when it tells of the extermination of a whole native tribe—cannibal in the sense that once a month, let us say, an individual got eaten—what does it matter!
>
> The whites, very Christian and all that . . . in order to put a stop to this barbarity (?), really not very cruel . . . could find no better means than the extermination of the tribe of cannibal natives as well as the tribe against which the latter fought (in order to provide themselves from time to time with the necessary palatable prisoners of war).
>
> After which they annexed the two isles, which then become unutterably lugubrious!!
>
> Those tatooed races, Negroes, Indians, all of them, all, all are disappearing or degenerating. And the horrible white man with his bottle of alcohol, his money and his syphilis—when shall we see the end of him? The horrible white man with his hypocrisy, his greediness and his sterility.
>
> And those savages were so gentle and so loving![18]

So Vincent equates the Negresses with the beleaguered natives of the Marquesas Islands (and does so, interestingly enough, before Gauguin had even considered the South Pacific as his refuge from civilization). He reads, in fact, more stark pathos into the largely anonymous and not visibly suffering Martinicans than Gauguin intended. For Vincent, they become symbols of a variety of themes and not simply of the "noble savage" destroyed by the grasping, soulless West. He identifies with the Negresses and other "primitive" peoples as a class of innocents who suffer, just as he and his fellow artists have, at the hands of an impersonal, industrialized Europe that has no need for them. Yet "those tatooed races" have spiritual resources—"so gentle and so loving"—that make them more potent than the "sterile" white man. And it is this po-

tency that he hopes to acquire by absorbing Japanese art and moving to the South of France. That he could conflate Provence, Japan, the Marquesas Islands, and Martinique reflects not only Vincent's quirky cultural constructions but also the sweeping binary oppositions between Occident and Orient and colonialist and colonized that were endemic to the age.

IV

Gauguin, however, was not the only one of Vincent's contemporaries to make a strong impression on him in Paris. A fourth figure who entered importantly into the orbit of Theo, Vincent, and Gauguin was the young painter Emile Bernard. The son of a textile merchant from Lille, Bernard, like a surprising number of his fellow Post-Impressionists, demonstrated a remarkable precociousness. Despite his father's disapproval of his artistic ambitions, Bernard entered Cormon's studio at the age of sixteen. Once there, he extended his rebellion against authority by rejecting Cormon's academic practices. In a notorious incident, he painted the dull brown curtain behind the model in bright stripes of red and green—the complementaries that figured so conspicuously in Seurat's *Grande Jatte*. This proved too much for Cormon, who told Bernard's father that his son "is very gifted, but he is an independent and I can't keep him."[19] Bernard senior responded by becoming even more hardened against his son's artistic interests. He cut off his support, forbade him to paint, and reputedly burned his son's brushes (a castrating gesture that seems too oedipally fitting to be true). Bernard found a more sympathetic paternal figure in the Montmartre color grinder and dealer Julien Tanguy (called "Père Tanguy" by Vincent), who sustained him through this difficult period. And it was at Tanguy's shop that Bernard met Vincent, whom he had seen during a farewell visit to Cormon's. Vincent admired the works by Bernard hanging at Tanguy's, and the two artists quickly sealed their nascent friendship by exchanging paintings. After a doting grandmother had a wooden studio addition built for Emile at the family house in Asnières, Vincent and his new companion worked often in that suburban area. Hence the tantalizingly elusive photograph of Vincent facing Bernard, but turning his back to the camera, while sitting on the banks of the Seine near the railway bridge at Asnières. But after Vincent

quarreled with Bernard's father over his refusal to sanction his son's artistic career, the Asnières studio was off-limits, and they had to meet in Montmartre.

Gauguin, for his part, had encountered Bernard a year before Vincent did, during his first trip to Pont-Aven. Bernard, in the wake of his flare-up with Cormon, had set off on a walking tour through Brittany. Although Bernard had an introduction from Schuffenecker and stayed at the same inn as Gauguin, they kept their distance at this time. Bernard, fresh from his exposure to the latest Post-Impressionist innovations, may have found Gauguin's transitional style relatively dull. Later, when both were in Paris they reached stages in their artistic development that permitted more common ground. Among other things, they now shared a dislike for Divisionism. Both had dabbled in the pointillist style but abandoned it and developed a personal as well as aesthetic aversion to Signac and Seurat. Bernard, in fact, felt so strongly about this that he vetoed the inclusion of Signac in Vincent's Le Grand Bouillon exhibition. But despite their common dislike for Divisionism Bernard and Gauguin would argue strenuously over other artistic matters, much to Vincent's distress. Bernard's adolescent absolutism only provoked Gauguin's own dogmatic judgements. The squabbles among the Post-Impressionists as well as those between Gauguin and Bernard made Vincent long for an artistic community in which money worries and factional clashes would be replaced by cooperative harmony. In letters to Bernard in particular he laments "disastrous civil wars in which they [artists] are all trying to cut each other's throats" and proposes instead that painters love "each other like comrades-in-arms."[20]

Bernard and his fellow Cormon alumnus Louis Anquetin, another startlingly young member of the avant-garde, were arguably the most advanced artists in Paris in 1887. If one looks, for example, at Anquetin's *La Place Clichy, Evening,* or Bernard's *Bridge at Asnières,* one sees a simplification of forms and a flattening of pictorial space unmatched by anything in the works of the Divisionists. While Seurat, and even Renoir, had restored the clear contours that Impressionism had dissolved, Anquetin not only left outlines intact but fortified them with thick lines. These outlines were, in fact, so marked that they resembled the leading of stained glass or the metal *cloisons* that enclose shapes in medieval enamel work (thus the term Cloisonism for the style). But Anquetin, for all of his originality, still used Impressionist devices such as

cropped figures, tilted perspectives, and the evocation of a specific time and place. Both the subject—a wintry Montmartre street with Parisians bustling along in front of a butcher's shop—and the composition—a plunge into the middle of the rushing crowd—might have appeared in a Degas or a Caillebotte canvas. Bernard, by contrast, eliminates all vestiges of Impressionism and presents shockingly flat, schematic shapes and uninflected zones of nonnaturalistic color. Especially remarkable is the railroad engine screeching in at the upper right, which becomes as rudimentary as a child's drawing of a "choo-choo" train. Its bold thrust across the picture surface is answered by the nearly abstract shape of an upturned pleasure boat jutting in at the lower left. The elongated curve of the hull forcefully enunciates the motif of flattened arches that continues in the steel bridge in the background. Perhaps the most daring element in the painting consists of the two figures walking along the quay with their backs to the viewer. This mysterious couple—a man in a stovepipe hat and a hooded woman—exist only as stark, completely black silhouettes without a hint of modeling. Although very little in Bernard's picture appears pretty or technically accomplished even to twentieth-century eyes, he had clearly made a stunning conceptual leap.

Why were Anquetin, Bernard, and, to varying degrees, Vincent and Gauguin attracted to this style? Art historians often beg the question either by reflexively turning to sources—Japanese prints, Italian primitives, *Images d'Epinal*, and popular engravings—or by seeing Bernard's and Anquetin's innovations as part of an inexorable march toward twentieth-century abstraction. The latter explanation is especially tempting as Maurice Denis's famous defense of art for art's sake appeared only two years after Bernard painted *The Railroad Bridge at Asnières*. In words that might have been written by Roger Fry, Denis stated, "it is well to remember that a picture before being a battle horse, a nude woman, or some anecdote is essentially a plane surface covered with colors in a certain order."[21] But Cloisonism and related Post-Impressionist developments represented much more than diverting formal experiments for Vincent and Gauguin. As we have seen, Vincent found in Japanese prints a vision of an ideal non-Western society. And Gauguin had already worked out a Post-Impressionist aesthetic that saw basic shapes and colors as bypassing "education" and evoking primal emotions. For both artists, form always possessed extra-artistic meaning either as the visual

equivalent of an interior state or as a vehicle of spiritual liberation from a diseased and decadent culture.

V

Despite his encouraging dealings with Theo, Gauguin left Paris around the end of January 1888. As he explained to Mette, "on the eve of being launched I must make a supreme effort for my painting and I am going to Pont-Aven in Brittany for six months to paint."[22] He must have felt that Theo would orchestrate an even greater "launch" for him and that he needed to produce a significant body of new work. He may also have wanted to prepare for the Universal Exhibition of 1889. Staying in Paris would only impede his ambitions. It was too expensive, too distracting, and incapable of providing him with suitable subject matter. Gauguin had never cared much for painting urban life. Now his entire artistic identity depended on capturing rural "primitives," whether they were Martinican Negresses or Breton peasants.

Gauguin's departure served as an impetus for Vincent, who left for Arles shortly after, on February 19. But the former's absence only counts as one of a multitude of causes for Vincent's escape from the city. From the point of view of his physical and psychological well-being, Paris, with its stresses and excessive stimuli, had become intolerable. As he later remarked to Gauguin, "when I left Paris, [I was] seriously sick at heart and in body, and nearly alcoholic."[23] He also needed a more peaceful locale in which to absorb all of the impressions of the past two years. Writing to Theo from Arles, he observed, "It seems to me almost impossible to work in Paris unless one has some place of retreat where one can recuperate and get one's tranquility and poise."[24] Of course, his move to Arles fell into a well-established pattern of seeing paradise over the next horizon. Just as he had believed that The Hague, then Drenthe, then Antwerp, and then Paris would redeem him, so Provence now promised salvation. At the very least, it would spare him the hardships of another northern winter.

Vincent's artistic motives for traveling south were more long standing. As early as the fall of 1886 he wrote to his friend and fellow painter Horace Livens, "in spring—say February or even sooner—I may be going to the South

of France, the land of the *blue* tones and gay colors."[25] Vincent wanted to inhabit a world that corresponded to the bright colors and luminosity of his own palette and of the artists he admired. In Saint-Rémy he summed up his rationale for going to Provence in a letter to Theo:

> My dear brother, you know that I came to the South and threw myself into my work for a thousand reasons. Wishing to see a different light, thinking that looking at nature under a bright sky might give us a better idea of the Japanese way of feeling and drawing. Wishing also to see this stronger sun, because one feels that one could not understand Delacroix's pictures from the point of view of execution and technique without knowing it, and because one feels that the colors of the prism are veiled in the mist of the North.[26]

In addition to seeking a better understanding of Delacroix, he wanted to gain more direct access to the landscape that had inspired Cézanne and, in particular, Monticelli. Practical concerns also made Paris increasingly insupportable. Vincent could not get models to pose for him and he was prevented from painting in the streets. Theo, moreover, would finally regain an uncluttered apartment if his brother left and must have readily agreed to give Vincent a stipend during his sojourn in the Midi. Finally, Vincent hoped to establish a Studio of the South that would not only attract a likeminded community of fellow artists but also ease his financial burdens.

Although Vincent's venture into the South seems inevitable, he made an enigmatic choice in going to Arles. Arles, unlike Pont-Aven, had no history as an artist's colony. Vincent may have heard about the town from artist friends such as Toulouse-Lautrec, who had rhapsodized about his childhood in Provence, and from writers such as Alphonse Daudet, whose tales of the South Vincent greatly admired. But it is also possible that he never intended Arles as his final destination. At first he may have envisioned it only as a starting point before branching out to other cities such as Marseilles, the home of his hero Monticelli. Theo, in fact, wrote in early 1888 that Vincent "has first gone to Arles to look about him, and then will probably go to Marseilles."[27]

During his last night in Paris Vincent and Bernard hung paintings in Theo's apartment in such a way that they would serve as substitutes for the absent Vincent. The large number of self-portraits must have conveyed his spirit with

a nearly overwhelming vividness. This gesture, however, seems to have had more to do with Vincent's own fears than with the need to reassure Theo. Like the idea of the Studio of the South, the image of his continuing presence in Theo's life must have comforted him as he traveled alone into unknown territory. Soon after his arrival in Arles, he could stave off loneliness by entertaining an even more powerful fantasy—sharing his studio with Gauguin.

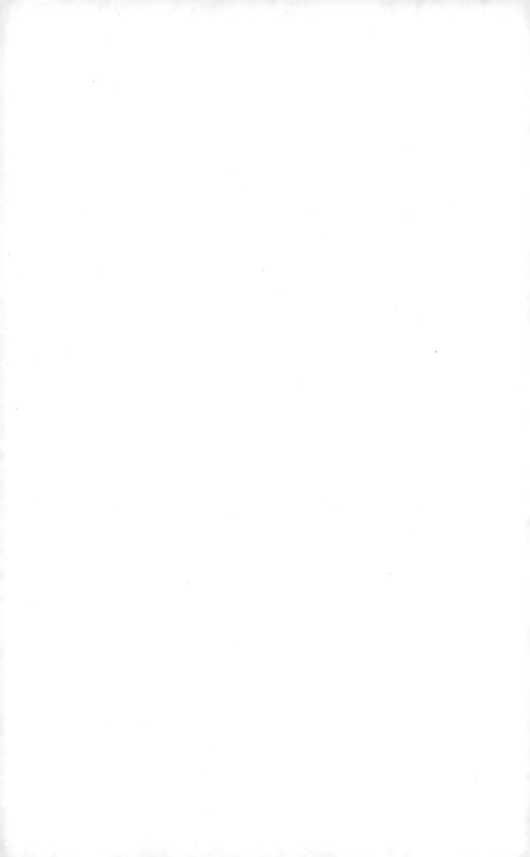

4

Jean Valjean and the Buddhist Monk

Van Gogh in Anticipation of Gauguin

I

From the winter until the fall of 1888, when Gauguin joined Vincent in Arles, both artists made tremendous artistic strides. Vincent famously reached that "high yellow note" that allowed him to produce some of the most accomplished works in his oeuvre. And Gauguin in Pont-Aven finally broke free of all vestiges of Impressionism to create his first fully Symbolist paintings. It would be an exaggeration to say that the two artists' entirely epistolary relationship during this period proved indispensable to their artistic advances. But it certainly affected the content, the quantity, and, in subtle ways, the style of their output. On the emotional level, the impact was greatest on Vincent, who turned the prospect of sharing his "Yellow House" with Gauguin into an overriding obsession. Yet Gauguin, who received many letters from Vincent and could read those sent to Bernard, did not remain unaffected. He became absorbed by a sensibility whose depths he had hardly penetrated in Paris.

The central drama during these months was when and how Gauguin would make his way to Arles. As early as May, Theo and Vincent had offered to pay Gauguin's living expenses in Arles in exchange for paintings. Yet it would take

five months before Gauguin finally arrived, on October 23. Gauguin had many reasons for remaining in Pont-Aven. He suffered from the lingering effects of ailments contracted in the Caribbean, and he needed to settle his considerable debts with his doctor and his inn before he could depart. The fluctuations in his health and in his finances contributed to the fitful nature of his communications with Vincent and the vagueness of his promises to leave for the South. The constant uncertainty about whether Gauguin would ever arrive drove Vincent to extremes of hopefulness, anger, and despair. Gauguin's idealized status, aloof stance, and frequent silences had the effect of turning him into the distant, "neutral" analyst upon whom the analysand, Vincent, could direct all sorts of revealing fears and fantasies.

Although many exchanges of letters between Vincent and Gauguin have been lost, we can trace the evolution of the proposal to Gauguin and Vincent's reactions to its ups and downs through Vincent's voluminous, nearly daily, correspondence with Theo. Vincent kept Theo up-to-date about every twist and turn of his thoughts about Gauguin. We also have in addition to the surviving letters from Gauguin to Vincent those from Gauguin to Schuffenecker, which sometimes disclose sentiments hidden from the van Gogh brothers. Not surprisingly, both artists second-guessed the other's motives. It was, however, Gauguin, the less ardent partner, who sowed the seeds of the offer to come to Arles by writing Vincent in February. He complained of his pressing debts and ill health and asked Vincent to intervene on his behalf with Theo. Gauguin vividly characterized his desolate financial situation by remarking that "zero is a negative force."[1] And he reported his willingness to lower the prices of his pictures. Vincent first reacted by writing a friend, the Australian painter John Russell, to persuade him to purchase one of Gauguin's works. This attempt produced no immediate result, and Vincent heard only bad news a few weeks later when Gauguin wrote about rainy weather in Pont-Aven and his continuing illness. Vincent took Gauguin's difficulties very much to heart and told Theo that he felt "deeply sorry for Gauguin's plight, especially because now his health is shaken."[2] Yet at this point Vincent had no means of helping the older artist.

Inviting Gauguin to Arles did not become a possibility until Vincent started renting the Yellow House [4.1] on May 1. Vincent had been living unsatisfac-

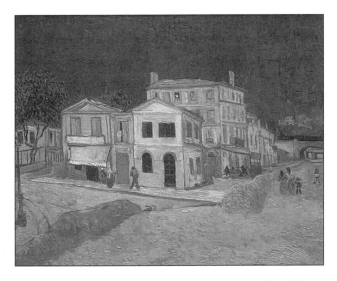

Figure 4.1 Vincent van Gogh, *Vincent's House* (1888)

torily at the Hôtel-Restaurant Carrel, where he disliked the food and thought that he was paying too much for his lodgings. The Yellow House offered the solution to many problems. A two-story structure with two rooms on each floor, it would provide space for a studio, a bedroom, a kitchen, and a guest room. Vincent would liberate himself from the oppressiveness of hotel living and would finally enjoy relatively expansive quarters of his own. The Yellow House also had several advantages that went beyond practical considerations. It looked out on a public garden that contained attractive sites for painting. The house's yellow walls corresponded to the color of the sun and the wheat that so entranced him in Arles. And, more idiosyncratically, the house made up one half of a paired complex of buildings—its twin housed a grocery store—which must have appealed to his love of doubled forms.

Vincent could not move immediately into the Yellow House. It needed renovation and furnishing, and he initially used it as a studio while continuing to live at the Hôtel-Restaurant Carrel and then, after a dispute over his bill, at the Café de la Gare. He would not, in fact, spend his first night at the Yellow House until

September. Yet from the beginning he thought of sharing the house with another artist. In the same letter that announced the rental, Vincent mused to Theo, "Perhaps Gauguin will come south? Perhaps I could come to some arrangement with MacKnight [an American painter friend]. Then the cooking could be done in one's own place."[3] Vincent's desire for a boarder arose in part from his acute loneliness in Arles. He did not speak the Provençal dialect, had few friends, and would go days without speaking to anyone except café waiters. Such remarks to Theo as "you always lose by being isolated" were typical of many laments about his arid social existence.[4] Vincent also felt guilty about spending so much of Theo's money. Living expenses in Arles had turned out to be greater than he expected, and he hoped that he could better justify Theo's generous stipend by taking in a companion. According to Vincent's calculations, he and his comrade could live on the same amount that Theo already paid. Theo would then profit by receiving paintings from two artists instead of one.

A month passed before Vincent made the first proposal to Gauguin. In the intervening weeks, matters had become so desperate that Gauguin overcame his fear of bothering Theo and wrote him directly. He informed him that, to his great embarrassment, he had been living on credit at his inn for the last three months. Vincent, after hearing about this dire state of affairs, wrote to Gauguin suggesting that his brother might send them both 250 francs a month in exchange for paintings. Theo, who had seen a draft of Vincent's letter, followed up with a more formal offer specifying that Gauguin would receive 150 francs a month in return for one picture a month.

Although Vincent mused to Theo that the new arrangement might "even mean a profit," he spoke to Gauguin of their prospective collaboration in terms that suggest more than a simple business deal:

> . . . if I could find another painter inclined to work in the South, and who, like myself, would be sufficiently absorbed in his work to be able to resign himself to living like a monk who goes to the brothel once a fortnight—who for the rest is tied up in his work, and not very willing to waste his time, it might be a good job.[5]

On the conscious level, Vincent's reference to "living like a monk" alludes to his recurrent vision of a community of painters who would dedicate them-

selves to art with monklike selflessness and devotion. But this preoccupation with purity and asceticism, which would culminate in his *Self-Portrait as a Buddhist Monk,* also hints at Vincent's deeper need to reassure himself that he could control his impulses. He was in the midst of a period of manic activity and must have worried that various urges might overwhelm him. Although he makes explicit the connection between a monklike existence and suppressing sexual desires (i.e., going to the brothel only "once a fortnight"), he may have been concerned as well with aggressiveness, self-punitive tendencies, and his habitually disorganized living habits.

Vincent must have thought that Gauguin would fervently embrace this chance to found a utopian Studio of the South. But he was to be disappointed. Although Gauguin's reply to Vincent has been lost, it appears to have been diffident at worst and temporizing at best. Despite saying "in principle I accept your proposition," which Vincent quotes in a letter to Theo, Gauguin appears to have given no indication that he actually intended to leave Pont-Aven.[6] After trying so strenuously to devise a solution to Gauguin's dilemma, Vincent clearly felt aggrieved:

I thought he was on the rocks, and there I was with money, and this boy who does better work than I do with none; so I said, He ought to have half of mine, and let him, if he likes.[7]

Vincent then quickly turns from his wounded pride to strained assertions of equanimity and self-possession:

But if Gauguin isn't on the rocks, then I am in no great hurry. And I withdraw my proposal categorically . . . if he is not keen on it, if it is all the same to him, if he has something else in mind, let him remain independent and me too.[8]

This protesting too much appears frequently in later letters. After lengthy moaning about Gauguin's absence and fevered speculations about his possible arrival, Vincent will make vehement statements such as *"we do not need him,"* "do not think that working alone bothers me," and "if I see that he [Gauguin] isn't coming, I shall not be in the least upset."[9]

One of the reasons for Gauguin's cool reaction to Vincent's invitation was his own interest in a grand scheme for organizing a society of artists. He explained

this plan in a letter to Schuffenecker that has recently surfaced.[10] First Gauguin tells Schuffenecker that Vincent's offer to come to Arles "perplexes" him and that he would like his friend's advice. He says that he has nearly accepted but wants to remain close to Paris in order to orchestrate his "vast project." This consists of acquiring five hundred thousand francs in capital from a Laval family connection so that he can set up a gallery specializing in "pictures at a reasonable price . . . by young people of talent." Each artist in the society will donate ten paintings in exchange for the free exhibition of his work and a "strong voice" speaking for him in the market. The gallery will also enlist silent partners who will benefit from the appreciation in value of the donated works. Gauguin does not spell out exactly what claims—whether shares or percentages—that artists and silent partners will have on the society's holdings. But he specifies that the enterprise will be headed by Theo van Gogh and will accomplish for the new generation what Durand-Ruel's gallery realized for the Impressionists. Moreover, it will take advantage of the increasing number of small buyers of Post-Impressionist works by creating a central market for the avant-garde. So swept up is Gauguin by this grandiose venture that he not only insists on Schuffenecker's "absolute silence" but underlines and capitalizes "absolute."

Nothing better illustrates the differences between Gauguin and Vincent than their contrasting ideas for an artist's collective. While Vincent dreams of a quasi-religious community working collectively and honestly in the countryside, Gauguin envisions a society that is urban, secretive, tied to market speculation, and based on financial self-interest. So clashing are these notions that Vincent displaces his anger at Gauguin's implicit rejection of his Arles offer by loudly attacking his gallery scheme. His rage drives even the saintly Vincent to uncharacteristic outbursts of anti-Semitism:

> But if Gauguin and his Jewish bankers came tomorrow and asked me for no more than 10 pictures for a society of dealers, and not a society of artists, on my word I do not know if I'd have confidence in it, though I would willingly give 50 to a society of artists.[11]

And again as a postscript in the same letter to Theo:

> What I'm inclined to think particularly strange in Gauguin's plan is this: The society *gives its protection in exchange* for ten pictures, which the artists have to *give*; if the

artists did this, this Jew Society would pocket a good 100 pictures "to begin with." Pretty dear, this protection by a society which doesn't even exist![12]

Yet Vincent also displays a surprising psychological astuteness. He realizes that the worldly and hardheaded Gauguin was as capable as anyone of indulging in fantastic solutions to his problems. And he speaks of Gauguin's scheme as "a fata morgana, a mirage of destitution, the more destitute you are—especially if you are ill—the more you think of such possibilities."[13]

In the subsequent months Gauguin continued to send mixed signals. He wrote two more letters reiterating his assent to the Arles plan but did not disclose anything definite about his departure. Finally, toward the end of July he admitted that his deepening debts made it nearly impossible for him to leave. Only at the beginning of October did Vincent receive a letter that allowed him unqualified optimism about Gauguin's intentions. Yet Gauguin's ill health and money problems persisted, and Vincent still harbored doubts. Vincent suspended these doubts only when Gauguin informed him, a week before his arrival, that he had sent off his trunk.

Gauguin's endless delays heightened Vincent's ambivalence toward a figure who both attracted and intimidated him. And during his five months of limbo Vincent's attitudes covered a wide spectrum from fawning idealization to bitter recrimination and dark suspicions. Vincent's concern for Gauguin forms a constant refrain in his letters. Again and again he exclaims, "I am thinking a lot about Gauguin," or, "I am very curious to know what Gauguin will do," or, "my whole mind . . . is set on Gauguin."[14] Despite all of the trouble he has taken to rent and furnish the Yellow House, he repeatedly insists on his willingness to drop everything and go to Pont-Aven if that is the only way he and Gauguin might work together. And he pathetically interprets Gauguin's stony silence on this subject as a sign that he "tacitly accepts my suggestion."[15] He also makes a strikingly revealing slip motivated by his desire to live with Gauguin. After sending dozens of letters to Theo in Paris, he twice misaddressed an envelope by writing "rue Laval" instead of "rue Lepic." Vincent clearly wanted to take Charles Laval's place as someone who had shared close quarters with Gauguin. Later, when Laval arrived in Pont-Aven, Vincent became very fearful that Gauguin would reject his offer in favor of a "combination" with his older friend.

The positive side of Vincent's ambivalence reached its peak with letters written to Theo and Gauguin in early October. He had just received a "very remarkable" letter from Gauguin—"a thing of extraordinary importance"—that allowed him to vent all of his pent-up emotions.[16] What particularly excited him was the possibility that not only Gauguin but also Bernard, Laval, and perhaps others might come to Arles. This filled him with ecstatic thoughts of realizing his dream of an artists' collective. The group, however, would not be a society of equals. Gauguin, whom Vincent characterizes as a "very great master" and a "man absolutely superior in character and intellect," would become the unquestioned head of the studio.[17] "I stipulate at the outset," Vincent tells Theo, "that there must be an abbot to keep order, and that would naturally be Gauguin."[18] Under Gauguin's leadership the community of artist-monks will usher in nothing less than a new age:

> . . . we shall enlarge our enterprise, and try to found a studio for a renaissance and not for a decadence . . . we are at the beginning of a very great thing, which will open a new era for us . . . we shall be giving our lives for a generation of painters that will last a long while.[19]

But it was not enough for Vincent to exalt Gauguin as the spiritual leader of this revolutionary movement. Vincent, in his letter to Gauguin, also had to devalue himself:

> I always think my artistic conceptions extremely ordinary when compared to yours.
> I have always had the coarse lusts of a beast.
> I forget everything in favor of the external beauty of things, which I cannot reproduce, for in my pictures I render it as something ugly and coarse. . . . [20]

Vincent makes the comparison as invidious as possible by using the same adjective—"coarse"—for his "lusts" and his "pictures." He thereby conflates his character with his art (as was his wont) and renders both inferior to the more refined Gauguin. What's more, the phrase "coarse lusts of a beast" recalls the view of himself as a "a rough dog . . . with wet paws . . . a foul beast" that he ascribed to his parents during the Neunen period.[21] So Vincent becomes the naughty child, and Gauguin the parental authority. Finally, Vincent, who had opposed this expenditure for months, makes an additional gesture of

masochistic self-abasement by insisting to Theo that paying Gauguin's train fare *"comes before everything else*, to the detriment of your pocket and mine. *Before everything else."*[22]

Gauguin was fast becoming yet another father figure. The extreme idealization in the letters and the quick elevation of Gauguin to "abbot" point strongly to this. Although Vincent could turn even his younger brother into "Father Number II," it helped that Gauguin was older and an actual father with a large family. Vincent had in fact only recently learned of this and worried, rather irrationality, that by bringing Gauguin to Arles he would take him further from his wife and children. Vincent had a hunger for father figures that year in Arles. He doted on the death of Anton Mauve, his imperious former teacher, and dedicated a picture to his memory. He replaced "Père" Tanguy with the benevolently patriarchal Joseph Roulin. Of this local postman, whom he befriended in July, Vincent said, "though he is not quite old enough to be like a father to me, nevertheless [he] has a silent gravity and a tenderness for me such as an older soldier might have for a young one."[23] He became fixed as well on making a portrait of a peasant, Patience Escalier, who closely resembled his father. And, as if all this weren't enough, he also planned, very near to Gauguin's arrival, to produce an actual portrait of his father to complement one he had just made of his mother.

The oedipal nature of their relationship made Vincent's attitude towards Gauguin as mentor especially charged and ambivalent. On the one hand, he wanted to submit to his teachings:

His coming will alter my manner of painting and I shall gain by it. . . . [24]

. . . (for he will certainly influence me I hope) . . . [25]

On the other hand, he felt compelled to assert his own character:

. . . I have nevertheless pushed what I was working on as far as I could in my great desire to be able to show him something new, and not to be subjected to his influence . . . before I can show him indubitably my own individuality.[26]

The uneasiness of these passages suggests that Vincent felt uncertain about finding an appropriate middle way between excessive submission and

excessive rebellion. He had already miscalculated the correct level of intimacy with Gauguin by addressing him as *"tu"* in several letters only to revert to *"vous"* after Gauguin did not *tutoyer* him in turn. At the same time, he repeatedly acknowledged the danger that quarreling might sink their collaboration.

Yet this "anxiety of influence" did not prevent Vincent from harboring an entirely different set of emotions. Vincent's desire to save Gauguin from his despair in Pont-Aven recalls the rescue fantasy that preoccupied him while living with Sien in the Hague. He had tried to undo his own experience of faulty mothering by becoming the good mother to Sien. Instead of remaining a helpless child at the mercy of parental whims, he would become the figure who determines whether someone else thrives or withers. In this case, he had convinced himself both that Gauguin suffered terribly in Pont-Aven and that he could effect his cure by bringing him to Arles. Gauguin, languishing in Pont-Aven, is in "terrible trouble," "living in a hell with no way out," and a "creature at bay."[27] In Arles, he will "recover more quickly," "have peace and quiet," and "breathe freely as an artist."[28] Vincent clings so tightly to this fantasy that he misreads Gauguin's self-portrait, *Les Misérables,* as an expression of physical, not spiritual, anguish:

> Gauguin looks ill and tormented in his portrait!![29]
>
> . . . you will see what I think of Gauguin's portrait. Too dark, too sad . . . but he will change, and he must come . . . there is nothing so urgent for Gauguin, nothing better for him to do, than to join me.[30]

Vincent himself nearly makes his unconscious fantasy explicit when, in another context, he says that he and Theo must behave toward Gauguin "like the mother of a family."[31]

Vincent's maternal stance did not, in its turn, preclude other, less affectionate attitudes. On the negative side of Vincent's ambivalence one finds suspicions of Gauguin that combine paranoia with shrewd observation. In general, Vincent mistrusts Gauguin as a calculating opportunist—a "speculator" who will remain faithful only "if it is to his advantage."[32] In a letter to Theo that overflows with doubts about Gauguin's intentions, Vincent writes:

I feel instinctively that Gauguin is a schemer who, seeing himself at the bottom of the social ladder, wants to regain a position by means which will certainly be honest, but at the same time, very politic.[33]

More specifically, Vincent suspects Gauguin of cynically exploiting the Arles offer as a sort of insurance policy. Despite his many assurances, Gauguin will come only if he fails to sell enough paintings or find a more generous benefactor:

I myself think that Gauguin would rather try to fight his way through with his friends in the North, and if by good luck he sells one or more pictures, he may have other plans for himself than coming to join me.[34]

As for Gauguin, perhaps he is letting himself drift with the current, not thinking of the future. And perhaps he thinks that I shall always be here and that he has our word.[35]

. . . we can see that Gauguin would already have left us completely in the lurch if Laval had had ever so little money.[36]

Interestingly, Vincent realizes that his earnest persona makes him appear incapable of understanding such cunning. And he tells Theo that Gauguin "little knows that I am able to take all this into account."[37]

What were Gauguin's actual sentiments about Arles? Why *did* he stay so long in Pont-Aven? Gauguin's ailments and debts were real enough. But he was disingenuous in giving the impression that these constituted his only reasons for remaining in Brittany. From the point of view of his art, he had a wealth of subjects—the Breton landscape, peasants in costume, religious monuments, and folk customs—to which he had become extremely attached. And it was during this very sojourn in Pont-Aven that he made the famous remark to Schuffenecker, "I like Brittany, I find a certain wildness and primitiveness here. When my clogs resound on this granite soil, I hear the dull, matt powerful tone that I am looking for in my painting."[38] He also enjoyed proximity to Paris, an indulgent innkeeper at the Pension Gloanec, the company of Bernard's attractive sister, Madeleine, and a growing circle of admiring younger artists. Gauguin, in fact, inspired fear in Vincent that he was establishing an alternative Studio of the North consisting of himself, Laval, Bernard,

and newcomers Henry Moret and Ernest de Chamaillard. So when Gauguin wrote Vincent in July to say that his "trunks would already be packed" if not for "this wretched money," he was largely dissembling.[39] Why leave the friendly hills of Pont-Aven for unfamiliar surroundings in the scorched and mosquito-ridden South?

What tipped the balance was not only the departure of Madeleine Bernard and the gloomy prospect of winter in Brittany, but also an unexpected influx of cash. After Uncle Cent's death left Theo with a small inheritance, he applied some of these funds to the Arles plan. This money, combined with the sale of three hundred francs' worth of ceramics in early October, allowed Gauguin to settle his debts and purchase the train fare for Arles. Gauguin's motivations for going to Arles were not simply mercenary. Apart from his genuine affection for Vincent and his curiosity about Arles, he would have wanted to remain in the good graces of a dealer as important to him as Theo. He also entertained the notion that Arles would amount only to a relatively short interlude during which he would recover his health and save enough to make another trip to Martinique.

Gauguin does not disparage the Arles plan in his letters to his wife and to Schuffenecker. On the contrary, he mentions the offer in order to boast of finding such beneficent and admiring patrons. And he sends one of Vincent's more effusive letters to Schuffenecker so the latter can show it to a collector and thereby demonstrate that "you are not alone in holding me in esteem."[40] Indeed, Gauguin's pride on this subject becomes so overweening that, in a letter to Schuffenecker, he suspects Theo of making the Arles offer only to exploit his growing reputation:

> Mark this well, a wind is blowing at this moment *among artists* which is all in my favor; I know it from one or two indiscretions and rest assured, however much [Theo] may be in love with me, he would not bring himself to feed me in the South for my beautiful eyes. He has surveyed the terrain like a cautious Dutchman and intends to push the matter to the utmost of his powers, and to the exclusion of everything else.[41]

This image of the self-sacrificing, fatally noncommercial Theo greedily cornering the market in Gauguin paintings would be comical if it did not reveal an

ugly side of the artist. Gauguin's fierce sense of autonomy made it nearly impossible for him to acknowledge dependence on another's generosity. His grandiosity dictated that only respect for his talent, not sympathy for his plight, could have compelled the van Gogh brothers. Such an inaccurate, not to mention ungrateful, reading of the circumstances ends up revealing Gauguin's own egotism, which has been projected onto Theo.

Gauguin's responses to Vincent's imploring letters about Arles are by turns apologetic, condescending, sympathetic, and defensive. At one point in September, Vincent chided Gauguin and Bernard for taking so long to paint portraits of each other for a proposed exchange of works. Although Gauguin had been infuriatingly slow in replying to Vincent's letters, and even slower in getting himself to Arles, he feigns surprise at Vincent's annoyance and tells him piously "*friends* do not get angry." In the same letter, he tells Vincent that he "twists the knife in the wound" by arguing that he must come to the Midi. Gauguin reminds him sternly that he has already written a formal letter of acceptance, as if this settled the issue, and then says that he would be committing a "*mauvais action*" if he were to leave without paying his creditors.[42] The tone captures Gauguin at his most manipulative. He denies a truthful implication of foot-dragging and then turns Vincent, not himself, into the guilty party.

Gauguin and Vincent brought fundamentally different expectations to the collaboration in Arles. For Gauguin it offered a temporary solution to his need for financial support and lodging during the winter months. Instead of wishing to become the "abbot" of an artists' colony in the Midi, he had his eyes set on a more far-flung, tropical outpost for painting and on success in Paris. As far as his relationship with Vincent was concerned, he must have hoped for a loyal and tractable companion, like Laval, who would make as few demands as possible. For Vincent, on the other hand, Gauguin's arrival would herald the dawn of a new era. He would help establish a utopian collective that would not only produce great art but also solve the material problems inherent in the artist's life. And far from a stopgap, the Arles community would be a permanent institution. Indeed, there is a great poignancy in Vincent's insistence to Theo that Gauguin will "stay with us always" and that the Arles collective will prove "more lasting than ourselves."[43]

In one corner of his mind Vincent must have recognized the impossibility of this vision. He could not even share an apartment with someone as sympathetic as his own brother without turning the arrangement into a complete disaster. How could he live harmoniously with a man who was in many ways a stranger and who had his own prickly temperament? He persisted in this belief, at least in part, because it drew on his powerful unconscious identification with Christ. And he indicates in several ways that he saw the artists' collective as equivalent to Christ and his twelve apostles. He compares his longed-for society to the twelve members of the Pre-Raphaelite Brotherhood, and shortly before Gauguin's arrival he makes the extravagant purchase of twelve chairs for the Yellow House. Furthermore, he twice attempted and then scraped off a painting of Christ in the Garden of Gethsemane. The ostensible reason for abandoning the two canvases was the impossibility of attempting something so ambitious without models. But, in reality, he must have been troubled by a subject that touched so closely on his greatest hope and fear—the creation of an exalted community and its destruction by the bad faith of one of its members.

II

How did Vincent's preoccupation with Gauguin affect his art during this period? One must first distinguish between Gauguin's actual paintings and views on art, as described in his letters, and his status as a figure in Vincent's imagination who would become a partner, teacher, and cofounder of the Studio of the South. The latter, imaginary Gauguin exerted tremendous influence on Vincent as a catalyst and helped make 1888 such an extraordinarily productive year. Vincent executed dozens of drawings specifically in hope of selling them to raise money for Gauguin's trip and, in general, strained himself to the point of exhaustion to create a body of work that would impress Gauguin. The promise of Gauguin's arrival also contributed to Vincent's use of optimistic images in his paintings, such as the sun, sunflowers, fruit, strolling couples, and sowers, that he associated with his idealized vision of Japan and with a utopian brotherhood. However, Vincent's obsession with Gauguin expressed itself most directly in his decorations for the Yellow House and in particular in the paintings intended for Gauguin's room. Here, Vincent was motivated by the

desire not only to display his artistic talent but also to fashion an environment so pleasing that Gauguin would find it irresistible.

In his typically self-sacrificing way, Vincent had reserved the "prettier" of the two upstairs bedrooms for Gauguin. While he would settle for "simple" furniture "all in white deal," Gauguin would enjoy the "elegant" corner room appointed with a walnut bed, dressing table, and cupboard.[44] Within Gauguin's quarters Vincent planned two impressive decorative programs—a series of still lifes of sunflowers and four special depictions of the public gardens as a "poet's garden." The first series, of course, produced Vincent's most famous image, and it is remarkable that Gauguin's influence extended so far as to inspire even these signature works. But why sunflowers for Gauguin? In his letters, Vincent emphasizes their stunning visual impact. Like the Japanese, who "instinctively seek contrasts," he will hang in the small room large canvases of his "great yellow sunflowers."[45] "Chromatic yellows" will shine out from the "palest Veronese to *royal blue*" to create a coloristic "symphony."[46] And in a nod to Cloisonism, the sunflowers will have the effect of "stained-glass windows in a Gothic church."[47] Beyond these formal considerations, Vincent may have chosen sunflowers because Gauguin had selected two sunflower still lifes for their first exchange in Paris. Sunflowers also served as symbols of faith and love, which would have harmonized with Vincent's conception of Gauguin as the leader of a loving brotherhood of artists. Finally, we can see a hint of Vincent's fixation on the apostolic twelve in his claim to Theo that he would make a "dozen" panels. Yet, more than anything else, Vincent may have simply understood the power of his sunflowers as works of art. He would have wanted Gauguin to respond to the radiant, saturated yellows and oranges unabashedly set against each other and to the strangely evocative disks that loom out from their stalks like huge eyes, faces, or suns themselves.

While Vincent left the precise symbolism of the sunflowers unexplained, he provided explicit iconological information about the "poet's garden" series. In the same letter in which he confesses to his artistic inferiority and his "coarse" lusts, Vincent tells Gauguin:

I have expressly made a decoration for the room you will be staying in, a poet's garden. . . . The ordinary public garden contains plants and shrubs that make one

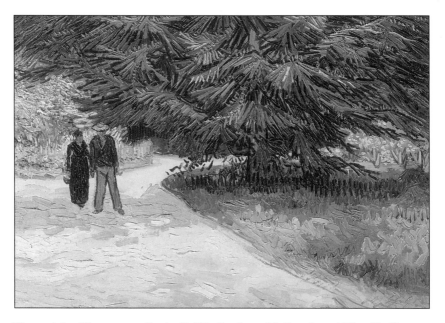

Figure 4.2 Vincent van Gogh, *Public Garden with Couple and Blue Fir Tree* (1888)

dream of landscapes in which one likes to imagine the presence of Botticelli, Giotto, Petrarch, Dante and Boccaccio. In the decoration I have tried to disentangle the essential from what constitutes the immutable character of the country.

And what I wanted was to paint the garden in such a way that one would think of the old poet from here (or rather from Avignon), Petrarch, and at the same time of the new poet living here—Paul Gauguin. . . .

However clumsy this attempt may be, yet it is possible you will see in it that I was thinking of you with a very strong emotion while preparing your studio.[48]

The most immediate source for the allusion to Botticelli, Giotto, Petrarch, Dante, and Boccaccio was an article by Henri Cochin titled "Boccace, d'après ses oeuvres et les témoignages de ses contemporains," which Vincent had recently read in the *Revue des Deux Mondes*.[49] Cochin discussed the other figures as either towering artists of the early trecento, such as Giotto, or as links in a

chain of distinguished friendships that ran from Dante and Virgil through Dante and Petrarch to Petrarch and Boccaccio. Vincent invokes Petrarch not only to compliment Gauguin with his comparison, but also to endow Provence with a noble and artistically accomplished past. Vincent continually feared that Gauguin would find Arles shabby, dull, and much less compelling than tradition-laden Pont-Aven. Privately, Vincent must have entertained several fantasies triggered by the Cochin article. He and Gauguin would take their place both as famous friends and as great artists in the line established by Dante, Petrarch, and Boccaccio. Vincent, who saw Monticelli as a Boccaccio-like figure and in turn identified with Monticelli, would play Boccaccio to Gauguin's Petrarch. And, in the spirit of these poets, Vincent, Gauguin, and the other members of the Studio of the South would effect a renewal of the arts equivalent to the fourteenth-century Renaissance.

Yet one detects little of this grand analogy when looking at the actual paintings of the "poet's garden." The first two depict a corner of the garden that contained a round cedar bush on a field of grass leading to flowering oleanders. What distinguishes these views from Vincent's other pictures of the public gardens is the nearly complete elimination of details identifying the locale as a park. Vincent must have thought that the absence of Impressionist incident—strollers, children, couples on benches etc.—rendered these scenes timeless and meditative and therefore more appropriate as the imaginary retreat of Petrarch and Boccaccio. Vincent also associated oleanders with love, and this too must have suggested poetry to him. In fact, he gets so carried away with these plants that he seems to project his own manic passions onto them in his description of the second *Poet's Garden:* "The row of bushes in the background is all oleanders, raving mad; the blasted things are flowering so riotously they may well catch locomotor ataxia."[50] But apart from the very indirectly implied themes of poetry and love it is difficult to see how the paintings relate to Gauguin as Petrarch or to Gauguin himself.

The second two versions of *The Poet's Garden* reveal less ambiguous connections to the trecento poets. In both Vincent has depicted strolling lovers. One couple walks under the shade of a giant blue fir tree [4.2] while the other saunters in front of a row of cypresses beneath a crescent moon. Here, Vincent draws much more directly on the traditional topos of the Garden of Love. And

this suits his symbolic program as Petrarch wrote *The Triumph of Love* and
Boccaccio not only composed the Decameron but set these tales of love in a
garden. Vincent also alludes to Monticelli, who painted many pictures of lovers
in gardens, including one owned by Theo. But Cochin's emphasis on close
male friendships and Vincent's longing for Gauguin as an ideal companion
make the choice of male and female couples surprising. Equally startling are
the distinctly feminine terms "dainty" and "pretty" that Vincent used to de-
scribe the overall effect of his decorations, which included special furnishings
as well as sunflowers and *Poet's Garden* paintings. Even more unexpected is
one of his remarks to Theo regarding his decorative program. He tells his
brother that he is trying to make Gauguin's room "as much as possible like the
boudoir of a really artistic woman."[51]

Why would Vincent conceive of Gauguin's room as a "boudoir"? Con-
sciously, Vincent worried that Gauguin would find his Yellow House as
"coarse" as his paintings if he did not provide a gracious and "elegant" interior.
He had in mind attempts at the coherent decorations of households that he
had read about in Felix Braquemond's *Du dessin et de la couleur* and Edmund
de Goncourt's *La maison d'un artist* and most recently in an article in *Le
Figaro* on "La maison d'un Moderniste." The *Le Figaro* article especially in-
trigued him as it described an "impressionist house" that allowed sunlight to
filter through walls of violet-colored glass bricks. But at the unconscious level,
he may have imagined Gauguin's room as feminine and Gauguin himself as a
woman in order to defend against his homoerotic desires. In this manner of
thinking, it would be a woman for whom he desperately yearned, not a man.
And, in particular, he may have assuaged his fears that he would assume a
"feminine" stance in relation to the daunting Gauguin by transforming the
older artist, not himself, into the opposite sex. Vincent's letters provide many
similar examples of his blurring of homosexual and heterosexual desires. In
one letter, he immediately shifts from talking about sharing the Yellow House
with a man to observing that the studio is too public to turn a "petticoat crisis"
into a long-term affair.[52] In another letter, he remarks that the only remedy for
his financial situation is either a "woman with money" or "some fellows who
will join me." He concludes, "I don't see the woman, but I do see the fel-
lows."[53] Finally, Vincent quickly follows up thoughts about Gauguin with his

wish to express "the love of two lovers by a wedding of two complementary colors, their mingling and their opposition, the mysterious vibration of kindred tones."[54] Vincent's rhapsodic descriptions of his male subjects also contain homoerotic strains. One sees this especially in his careful inventory of a Zouave soldier's features: "a boy with a small face, a bull neck, and the eye of a tiger . . . bronzed, feline head . . . a savage combination."[55]

That a sexual element, whether conscious or unconscious, coexisted with all of the other emotions that Vincent brought to his relationship with Gauguin helps explain the electric intensity of his letters. They contain all of the psychological extremes of a passionate romance. And only a lover's note could sound as urgent as Vincent's wild pleading to Gauguin two weeks before his arrival:

> And do come as soon as you possibly can!
>
> P.S. to Gauguin. If you are not ill, do please come at once. If you are too ill, a wire and a letter please.[56]

III

While the decorations for the Yellow House serve as a telling expression of Vincent's attitudes toward Gauguin, even more important as an artifact of Vincent's long wait for the older artist was his *Self-Portrait as a Buddhist Monk.* [pl.1] Vincent specifically offered this painting to Gauguin and prominently placed a dedication—"*à mon ami* Paul Gauguin"—at the upper left of the canvas. The painting represented an ideal image of the artist intended to convince Gauguin of his soundness as a partner and to reassure Vincent himself. He finished the work by September 16 but added the dedication and sent the painting to Pont-Aven only after receiving Gauguin's self-portrait, *Les Misérables,* on October 4. He clearly meant to counteract Gauguin's troubling depiction of himself as a "Jean Valjean, oppressed by society," with his own more hopeful and resolute self-portrait.[57]

Perhaps the most striking elements of the work are the almond-shaped "oriental" eyes. Vincent explains this detail in the description he gave to Gauguin:

> I have a portrait of myself, all ash-colored. The ashen-gray color that is the result of mixing Veronese green with an orange hue, on pale Veronese ground, all in harmony with the

reddish-brown clothes. But as I also exaggerate my personality, I have in the first place aimed at the character of a simple bonze [monk] worshipping the Eternal Buddha.[58]

He elaborated further to Theo that he had made his eyes "*slightly* slanting like the Japanese."[59] An obvious reason for this distortion was Vincent's love of the flat planes and bright, unmodulated colors of Japanese prints. But Japan signified much more for him than a country that enjoyed a visual culture consistent with Post-Impressionism. As Tsukasa Kodera has observed, Vincent and other nineteenth-century Westerners used Japan as a screen onto which they could project a variety of utopian ideals.[60] Ignorance of the actualities of Japanese society only encouraged these fantastic notions. For Vincent, Japan constituted a primitivistic "golden land" in which artists labored humbly, exchanged their works, and lived in harmony with nature.

About a week after completing the self-portrait, Vincent summed up the virtues of the Japanese sensibility in a letter to Theo:

> If we study Japanese art, we see a man who is undoubtedly wise, philosophic and intelligent, who spends his time doing what? In studying the distance between the earth and the moon? No. In studying Bismarck's policy? No. He studies a single blade of grass.
>
> But this blade of grass leads him to draw every plant and then the seasons, the wide aspects of the countryside, then animals, then the human figure. . . .
>
> Come now, isn't it almost a true religion which these simple Japanese teach us, who live in nature as though they themselves were flowers?
>
> And you cannot study Japanese art, it seems to me, without becoming much gayer and happier, and we must return to nature in spite of our education and our work in a world of convention.[61]

Instead of seeing the universe in a grain of sand, the Japanese "man of nature" finds it in a blade of grass, just as Vincent himself discovers infinity in a sunflower. "Japan," as this passage reveals, served as a remarkably flexible concept in Vincent's hands. It involved a set of oppositions that he could apply to diverse people, places, and art. In addition to the antinomies we see above concerning Western rationalism versus "true religion" and convention versus nature, Vincent's quirky Orientalism generated many others such as North ver-

sus South, shadow versus sun, city versus country, decadence versus renaissance, and technique versus spontaneity. The expansiveness of these dualities allowed him to see his Japan nearly anywhere and he could say to Wil, "I don't need Japanese pictures here [Arles], for I am always telling myself *that here I am in Japan.*"[62]

During the summer of 1888 Vincent read one of the recent products of the popular craze for Japonism, Pierre Loti's fanciful novel *Madame Chrysanthème.* Vincent's edition of the book contained illustrations depicting Buddhist monks, and he may have used these drawings as sources for his self-portrait. But the text that played a more central role in shaping Vincent's approach was an article in the July 15 issue of the *Revue des Deux Mondes* by Emile Burnouf on "Le Bouddhisme en Occident."[63] What would have particularly impressed Vincent in Burnouf's account of Buddha's life were the many points of comparison between Christ and the Eastern holy man. Buddha's birth was not only miraculous, but took place on December 25. When Buddha retired to the desert to purify himself he too was tempted by an evil spirit. Buddha's teachings, moreover, had a Christian aspect with their emphasis on good works, charity toward one's enemies, and renunciation of the self. Yet Burnouf also pointed out the ways in which Buddhism differed from Christianity. As no personal God existed, Buddhist monks were not, strictly speaking, priests. Nor did they perform holy sacrifices as intermediaries between humanity and a Supreme Being. Instead of praying to an Almighty Buddha they meditated on the life of a mortal man who had attained a supreme degree of wisdom and virtue.

All of these aspects of Buddhism would have appealed to Vincent in his current spiritual state. He had rejected the zealotry and fanaticism of his earlier religious mania but retained his profound admiration for Jesus. In June he had written to Bernard that Christ "lived serenely, *as a greater artist than all other artists*, despising marble and clay as well as color, working in living flesh."[64] Buddhists dedicated themselves to a Christlike figure but, at the same time, dispensed with the authoritarian structure of conventional Christianity that Vincent found so distasteful. Instead of placing a God above humanity and creation, Buddhism came closer to Vincent's own "naturalized religion," that is, his transfer of divinity from God to nature.[65] We can see such a shift in his

praise of the "true religion" of the nature-loving Japanese and in the enveloping suns of his Arles paintings that have taken the place of the severe church towers that once presided over his landscapes. Vincent would also have discovered in Burnouf's article specific parallels between himself and Buddha. Siddhartha, whose head was shaved like Vincent's, became Buddha at the age of thirty-five after seven years of meditation and abstinence. Vincent had turned thirty-five in 1888 and had spent the last seven years devoting himself with religious fervor and self-sacrifice to his art.

So Vincent, by transforming himself into a Buddhist monk, could affirm both his own idiosyncratic Japonism and his post-Christian religiosity. He could also present himself to Gauguin as someone who not only shared his Japan-inspired pictorial convictions but was sober, disciplined, and ready to subordinate himself to the new "abbot" of the studio of the South. Vincent even endowed the portrait with a feminine quality in the refinement of the features, the neatness of his clothes, and the brooch pinned to his white collar. At the unconscious level, the "oriental" eyes themselves may have involved a feminine identification if they were borrowed from Gauguin. Although no evidence of this survives, Gauguin may have made a sketch in one of his letters to Vincent of his *Still-Life with Fruit,* painted in the summer of 1888. In this work a young girl with distinctly slanted eyes peers at a table of fruit. This girl serves as a prototype for a very important Eve-like figure that will recur in Gauguin's oeuvre. Gauguin dedicated the painting to Laval, who had just returned from Martinique, and this may have aroused Vincent's envy. Bernard had also painted women with slit eyes in his *Breton Women in a Meadow.* Japan, moreover, was associated with feminine delicacy, aristocratic refinement, and rococo charm among the French Japonist writers whom Vincent had read. Vincent would have consciously counterposed this image of Japanese craft culture with his own vision of a masculine and collectivist society of artists. But the linking of Japan with femininity would have persisted in his unconscious.[66]

While Vincent intended to assuage Gauguin's fears and to demonstrate the salubrious effect of the Midi, the actual impact of the self-portrait must have been shocking. Both the execution of the painting and its sitter possess a disturbingly extreme and absolute character. Vincent creates a particularly strident juxtaposition out of the bright Veronese green in the background and the reddish-orange tones of the head and jacket. These complementaries dominate

the entire painting and establish a blunt "all-over" power that anticipates minimal art. The insistent color scheme even extends to Vincent's eyes, which have orange irises and green whites. Vincent also reinforces the orientalizing distortions of his eyes and eye sockets by echoing their angularity in the prominent notches of his jacket lapels. All of this only increases the unsettling quality of his intense gaze. His head, moreover, appears to emerge out of a vortex of circular strokes. This green whirlpool was Vincent's attempt at giving himself a modern halo. But the result is a spinning nimbus that picks up on the already rhyming oval shapes of the brooch, eyes, and head and accentuates them vertiginously. Despite Vincent's intentions, his self-portrait, with its pale, "ashengray" skin and clipped scalp, becomes as much a warning as an invitation. It suggests that the sitter has taken his physical and psychic resources to the limit and may push them even further.

Vincent himself had a mixed response to this painting. After seeing Gauguin's and Bernard's self-portraits, Vincent declared to Theo that his "holds its own, I am sure of that." Compared with Gauguin's, his visage is "as grave, but less despairing."[67] Yet Vincent also confessed to Gauguin his dissatisfaction with his appearance in the work:

> [The self-portrait] has cost me a lot of trouble, yet I shall have to do it over again if I want to succeed in expressing what I mean. It will even be necessary for me to recover somewhat more from the stultifying influence of our so-called state of civilization in order to have a better model for a better picture.[68]

Vincent made these self-criticisms partly out of deference to Gauguin. His painting, after all, formed part of an exchange, and the student's self-portrait should not outstrip the master's. But Vincent must have sensed as well some of the very disquieting aspects of the canvas even if he cloaked this observation in his utopian language of nature versus "so-called civilization."

IV

Although Vincent's self-perception falters somewhat in the case of the *Self-Portrait as a Buddhist Monk,* such lapses were rare in the summer of 1888. One of the most startling revelations in Vincent's letters from Arles is the

extent of his self-awareness, ironic and otherwise, about his own art, advanced art in general, and his mental troubles. Far from a crazed fanatic insisting on his discovery of a new universal method of painting, Vincent had no difficulty realizing that the conventional viewer would find his canvases "ugly," "vulgar," "crude," "utterly repulsive," and "execrable." He also possessed a fine sense of his own paintings in relation to those of the Impressionists, as we can see from this passage with its casual yet perfectly apt comparison of his work to Sisley's:

> But what would Monsieur Tersteeg say about this picture [*The Night Café*] when he said before a Sisley—Sisley, the most discreet and gentle of the impressionists—"I can't help thinking that the artist who painted that was a little tipsy." If he saw my picture, he would say that it was delirium tremens in full swing.[69]

While he disdained the Tersteegs of the world, he could make his own equally unsparing judgments of his art. He recognized that his pictures often lacked a "clearness of touch" and found his figures "always detestable in my own eyes." In a letter to Bernard, he provides a merciless description of his paint handling:

> My brush stroke has no system at all. I hit the canvas with irregular touches of the brush, which I leave as they are. Patches of thickly laid-on color, spots of canvas left uncovered, here and there portions that are left absolutely unfinished, repetitions, savageries; in short, I am inclined to think that the result is so disquieting and irritating as to be a godsend to those people who have fixed preconceived ideas about technique. . . . [70]

And to Theo he could despair that he would ever attain a Poussinlike equilibrium:

> . . . I truly can't tell if I shall ever paint pictures that are peaceful and quietly worked out, for it seems to me it will always be headlong.[71]

Yet when he had attained a high level of mastery and classical control in a landscape such as *The Harvest*, he knew it. And he could single out this painting as a work that "kills" all the rest.

Vincent's reflections on his hyperactivity and his "madness" prove no less astute. Current diagnostic terms like "manic" and "bipolar" seem clumsily ahistorical when applied to a nineteenth-century figure such as Vincent. But the artist himself provides such an abundant testimony to both his relentless productivity and fear of depression that these labels spring to mind. He reports that he possesses an "extraordinary feverish energy," suffers from "unaccountable, involuntary fits of excitement," and has "a lover's insight or a lover's blindness for work just now."[72] Ideas come "swarming over" him. His concentration becomes "more intense," his hand "more sure." He has a "kind of concentrated power which only asks to spend itself in work."[73] Yet he fears that he will pay a heavy price for mania's self-transcendence:

> I have a terrible lucidity at moments, these days when nature is so beautiful, I am not conscious of myself any more, and the picture comes to me as in a dream. I am rather afraid that this will mean a reaction and a depression when the bad weather comes. . . . [74]

His prodigious output backs up his remarks. During June, July, and August, when his art reached its highest level, he averaged no less than three paintings and four drawings a week. And he did this while struggling with the Mistral, furnishing the Yellow House, maintaining his staggeringly voluminous correspondence, and voraciously reading poetry, novels, journals, and newspapers. Vincent also identifies the profligate spending that often accompanies manic episodes. Encouraged by his desire to transform the Yellow House into a haven for Gauguin, Vincent frequently exceeded his budget and confessed to an "exaltation that comes at me at certain moments, and then I run to extravagances."[75]

In the case of his "neurosis," Vincent waxed both philosophical and humorous. He could tell Bernard that the sun "beats down on one's head, and I haven't the slightest doubt that it makes one crazy. But as I was so to begin with, I only enjoy it."[76] He assumed that emotional instability amounted to an occupational hazard for artists. They were driven to madness either by their lonely and unconventional lives or took on its aspect by the singularity of their vision:

> Well, painters die or go mad with despair, or are paralyzed in their production, because nobody likes them personally.[77]

... the new painters, isolated, poor, treated like madmen, and because of this treatment actually becoming so . . . [78]

The great majority of the painters, because they aren't colorists in the true sense of the word, do not see these colors there, and they call a painter mad if he sees with eyes other than theirs.[79]

Vincent sought out information about mad artists in order to assure himself that he was not alone in possessing a "disordered heart" and to find figures with which to identify. Just as he tried in Holland to construct an avant-garde tradition without knowing about the Impressionists, so he sought out "cracked" painters of the past without knowing that he himself would become the mythical mad artist par excellence. His gallery of the insane included De Braekeler, Jules Dupré, and Monticelli, about whom he said that he was continuing his work "as if I were his son or his brother."[80] But the disturbed artist with whom he identified most strongly was the fifteenth-century Netherlandish painter Hugo van der Goes.

Vincent twice refers to Emil Wauters's 1877 history painting of *The Madness of Hugo van der Goes*. Van der Goes entered a monastery at the height of his career and five years later suffered a mental collapse. The prior of his monastery attempted to cure the artist by entertaining him with musical performances.[81] Wauters's picture recreates one of these therapeutic sessions and depicts a theatrically unshaven, wide-eyed, and hand-ringing van der Goes sitting in the foreground while behind him a smugly self-possessed priest conducts a choir. Vincent first mentions Wauters's canvas in late July, and his account of himself typically equates the condition of his paintings with the state of his psyche:

> Not only my pictures but I myself have become haggard of late, almost like Hugo van der Goes in the picture by Emil Wauters.
>
> Only, having got my whole beard carefully shaved off, I think I am as much like the very placid priest in the same picture as like the mad painter so intelligently portrayed therein.
>
> And I do not mind being rather between the two, for one must live. . . . [82]

Then, after exhausting himself in the days before Gauguin's arrival, Vincent once again compares himself to van der Goes in Wauters's painting:

I am not ill, but without the slightest doubt I'd get ill if I did not eat plenty of food and if I did not stop painting for a few days. As a matter of fact, I am again pretty nearly reduced to the madness of Hugo van der Goes in Emil Wauters' picture. And if it were not that I have almost a double nature, that of a monk and that of a painter, as it were, I should have been reduced, and that long ago, completely and utterly to the aforesaid condition.[83]

In these introspective asides, Vincent comes as close as he ever will to an explicit declaration that his self-image as a monk represented a bulwark against madness. We can assume that Vincent assigns to the "painter" half of his "double nature" his impulsiveness, his helplessness before his overwhelming sensations, and his uncontrollable urge to work. The monk, on the other hand, represents self-control and moderation.

But in choosing to identify with the fifteenth-century master, Vincent actually undermines his defensive opposition between painter and monk. Van der Goes was in fact both an artist and a brother *conversi* (a rank between a lay brother and a monk in the monastic order). Vincent also seems to foresee his own unfortunate fate in his identification. The two artists already had much in common. Both admired Thomas à Kempis's *Imitation of Christ*—a volume that provided Vincent with a conscious articulation of his unconscious identification with the Savior. The *Imitation of Christ*, in addition to recommending self-mortification, advised the devout to value the "humble peasant" over the "proud philosopher." And in their art both Vincent and van der Goes celebrated the expressive ugliness of peasant bodies and physiognomies. More important from the point of view of mental illness, both experienced their first breakdown only after they had reached adulthood and had produced a substantial oeuvre. Both, moreover, tried to injure themselves during episodes of mental disorder. Of course, Vincent may not have known all of the details of van der Goes's life and his identification may not, therefore, have been so premonitory. But the remark he makes right after the second allusion to Wauters's painting has an undeniably prophetic tone—so much so that one wonders whether he had not already experienced some minor seizures. It is no longer a question for him of whether he will go mad but only which symptoms will manifest themselves:

. . . I do not think that my madness could take the form of persecution mania, since
when in a state of excitement my feelings lead me rather to the contemplation of eter-
nity, and eternal life.[84]

We do not know whether Gauguin detected any signs of incipient mental ill-
ness in the *Self-Portrait as a Buddhist Monk*. The older artist, out of either
aloofness or bafflement, did not make any comment to Vincent about his self-
portrait. He did not even acknowledge receiving it in Pont-Aven as far as we
can tell from the surviving letters. This stands in sharp contrast to Vincent's
lavishly complimentary response to Gauguin's *Les Misérables*. Gauguin did,
however, bring the painting with him to Arles and later, in 1889, wrote Vincent
that his self-portrait was hanging in his Paris studio.

V

Gauguin's own contribution to the exchange, his self-portrait titled *Les
Misérables* [pl.4], was as double-edged as Vincent's. It was calculated to please
and to elicit sympathy yet, at the same time, contained private self-idealizing
imagery. It also represented Gauguin's conception of his own dual nature and
conveyed mixed as well as unanticipated messages. The original arrangement
had not involved a self-portrait at all. Vincent had, in fact, requested that Gau-
guin and Bernard paint each other. But Bernard felt too intimidated to attempt
a likeness of Gauguin. According to Vincent, Bernard said "he *dare not* do
Gauguin" and thought him "so great an artist" that he was "almost afraid."[85]
Gauguin's aura of authority must have been overpowering as the precocious
and contentious Bernard easily held his own with even his most distinguished
contemporaries. As an alternative, Bernard and Gauguin agreed to paint self-
portraits that would include a smaller image of the other within their canvases.
Even this compromise did not allay Bernard's sense of inferiority as he
cropped himself at the left of his painting and placed Gauguin's likeness in the
center. Gauguin, by contrast, simply relegated to a corner his roughly drawn
and small-scale profile of Bernard.[86]

One would have no idea of the connection between Gauguin's painting and
Victor Hugo's novel without the inscription, *"Les Misérables à l'ami Vincent,"*

and Gauguin's descriptions of the work. He first elucidated the iconography for Vincent:

> I feel the need to explain what I was seeking to do, not that you would be unable to infer it by yourself, but because I don't think I've achieved what I set out to do: the guise of an ill-dressed, powerful outlaw like Jean Valjean, which has its own internal nobility and gentleness. . . . And this Jean Valjean, oppressed by society and placed outside the law, with his love and his strength, does he not symbolize the plight of the Impressionist today?[87]

He then provided Schuffenecker with a less modest account:

> I have done a self-portrait for Vincent who asked me for it. I believe it is one of my best efforts: absolutely incomprehensible (upon my word) so abstract is it. First the head of a brigand, a Jean Valjean (*Les Misérables*), likewise personifying a disreputable impressionist painter burdened for ever with a chain for the world.[88]

Gauguin knew that Vincent admired Victor Hugo, and by invoking *Les Misérables* he attempted to ingratiate himself with his future collaborator in several ways. First, he established common literary ground with the bookish Vincent. Second, he underscored Vincent's generosity by creating an image of himself as a pitiful outcast who needed a kindly benefactor. And, finally, by presenting himself as a personification of the "plight of Impressionism today" Gauguin appealed to Vincent's desire to ameliorate the shared hardship of all advanced artists.

But Gauguin's allusions to Jean Valjean also flattered his own idealized self-image. As Gauguin indicates with his references to "nobility and gentleness" and "love and strength," Jean Valjean was much more than a ragged outlaw. The hero of *Les Misérables* actually strains credulity by his embodiment of such a wide spectrum of human traits. Within a few hundred pages, he evolves from an illiterate peasant with an extraordinary and brutish physical strength to an escaped prisoner, to a prosperous merchant with a vast knowledge of agronomy and manufacturing technology, to a beloved mayor, to the saintly protector of a sickly prostitute, and then back to convict status as a result of his own absolute sense of justice and honor. He expands in all direc-

tions the dialectical combination of the "sensitive" and the "savage" that Gauguin saw in himself and enunciated to Mette earlier in the year. And just as Gauguin insisted to his wife that his "savage" nature made it "dangerous" for him to see his children, so his impersonation of Jean Valjean must have served, intentionally or unintentionally, as a warning to Vincent.[89] His livid countenance, bristling hair, bladelike "Incan" nose, and wary, sidelong glance would make it clear that he had no intention of suppressing his willful and independent character.

Of course, nearly all of this was lost on Vincent. Although he had twice read *Les Misérables,* he had not opened the novel in five years. As we have seen, Vincent responded only to the pathos of Gauguin's advertisement for himself. He recognized Gauguin's "determination to make a melancholy effect."[90] But he took this quite literally and worried about Gauguin's health. He complained to Theo that Gauguin "has lived cheaply, yes, but he has got so ill by doing it that he can see no difference between a gay color and a dismal one."[91] Vincent actually preferred Bernard's self-portrait. Although markedly weaker than *Les Misérables*, Vincent found it "just the inner vision of a painter, a few abrupt tones, a few dark lines, but it has the distinction of a real, real Manet."[92] Vincent, however, put aside his private views in order to maintain good relations with his comrade in Pont-Aven. He informed Gauguin that he could not possibly accept his self-portrait as an exchange because it was so "important" and "beautiful."[93] Theo would regard it instead as payment for his first month in Arles. This gesture only prompted Gauguin to make his own two-step in the dance of deference. Despite his high regard for *Les Misérables*, he insisted in a letter to Theo that Vincent, with his "habitual good heart," had overvalued his picture. Its execution is "very summary," Gauguin argued, and it should not be considered a work for sale.[94]

Vincent's treatment of *Les Misérables* as little more than a fever chart prevents us from knowing his reaction to the picture's formal qualities. Gauguin himself had pronounced it so "abstract" as to be "incomprehensible" even to avant-garde sensibilities. And one would expect a sustained meditation from Vincent on his first exposure, in the form of an actual painting as opposed to drawings in letters, to the new directions in Gauguin's art. By "abstract" Gauguin meant not only the blazingly bright nonnaturalistic colors but also the ex-

tremely flat and spatially ambiguous background. The bouquets that surrounds Gauguin's head are intended to read as wallpaper patterns, and the profile of Bernard as a painting within a painting. But Gauguin makes no attempt to depict these elements illusionistically. The flowers, which are too sketchy and misaligned for a pattern, float on the surface of the canvas. And the portrait of Bernard, rendered with the simplest of outlines, appears more like graffiti than a picture protruding from a wall. Indeed, to twenty-first-century eyes, Gauguin's head, the nosegays, and Bernard's portrait seem more like pieces of collage than objects placed convincingly in depth.

Gauguin provided some clues to his intentions in the descriptions he gave first to Vincent and then to Schuffenecker:

> The face is colored by a rush of blood and the feverish tones surrounding the eyes suggest the fiery lava that inflames the souls of us painters. The delineation of the eyes and nose, like the flowers in Persian carpets, typifies an abstract symbolic art. The yellow floral background, like the wallpaper in a young girl's bedroom, signifies our artistic purity. . . . [95]
>
> . . . The drawing is altogether peculiar, being complete abstraction. The eyes, the mouth, the nose, are like the flowers of a Persian carpet, thus personifying the symbolical side. The color is a color remote from nature; imagine a confused collection of pottery all twisted by the furnace! All the reds and violets streaked by flames, like a furnace burning fiercely, the seat of a painter's mental struggles. The whole on a chrome background sprinkled with childish nosegays. Chamber of pure young girl. The impressionist is such an one, not yet sullied by the filthy kiss of the Fine Arts (School).[96]

Gauguin's characterization of his eyes and nose as delineated like "the flowers in Persian carpets" and, therefore, typical of an "abstract symbolic art" falls outside of the language Vincent used for his own paintings. The emphasis on line itself as an expressive vehicle grows out of Gauguin's shared concern with Bernard for an art of radical simplification. As Vincent reported, "Gauguin and Bernard talk now of 'painting like children.'"[97] But Gauguin's references to "color remote from nature" and "the reds and violets streaked by flowers, like a furnace burning fiercely," resembles Vincent's own description of his *Portrait of Patience Escalier*. In the letter to Theo in which Vincent mentions this painting,

he first declares that he "exaggerates" and uses color "more arbitrarily, in order to express myself forcibly."[98] And he gives as an example his portrait of the peasant from Camargue. Escalier is "terrible in the furnace of the height of harvest-time, as surrounded by the whole Midi. Hence the orange colors flashing like lightening, vivid as the red-hot iron, and hence the luminous tones of gold in the shadows."[99] Yet when Gauguin employs colors arbitrarily in *Les Misérables,* Vincent can only scold him for lapses in naturalism. Gauguin, he tells Theo, "must not do flesh with Prussian blue" because "then it ceases to be flesh; it becomes wood."[100] So great was Vincent's need to regard Gauguin as sickly that it blinded him to coloristic innovations similar to his own.

Vincent was equally nonresponsive about Gauguin's rather enigmatic explanation of the "yellow floral background" as the "wallpaper in a young girl's bedroom." What did Gauguin intend by this comment? The "young girl" may derive from the character of "Cossette," the innocent but downtrodden waif rescued by Jean Valjean. This would be consistent with the other remarks that appear to allude to *Les Misérables.* Gauguin's references, for example, to the "fiery lava that inflames the soul" and the "furnace" that is the "seat of the painter's mental struggles" recall Jean Valjean's great inner turmoil as he conducts titanic battles with his conscience at climactic points in the novel. Yet, to return to the mysterious female, it is Gauguin who poses in front of the floral background and Gauguin who personifies the impressionist "not yet sullied by the filthy kiss of the Fine Arts (School)." So he himself becomes the "pure young girl." In fact, he already seems to occupy Vincent's "boudoir of a really artistic woman." One has only to replace the "chrome background sprinkled with childish nosegays" with Vincent's chrome sunflowers covering the walls of the Yellow House.

What lay behind this feminine identification? Consciously, Gauguin had in mind several Symbolist tropes. The young girl's "purity" would correspond not only to the Post-Impressionist's innocence of academic technique but also to his pure consciousness, which, like Vincent's bonze, has eluded contamination by Western "decadence." Gauguin, by giving himself male and female attributes, would also have been conforming to the Symbolist reverence for the androgyne. Shortly after painting *Les Misérables,* Gauguin recommended to Madeleine Bernard that if "she wished to be *someone*" she must "consider

[her]self androgynous."[101] In this case, androgyny represented not so much an embrace of both sexes as a transcendence of all sexuality. But later Gauguin would cultivate an androgynous persona which involved a combination, not a canceling out, of gender traits. In Tahiti his long hair à la Buffalo Bill caused the islanders to call him man-woman *(taata-vahine)*. And in *Noa-Noa,* his account of his years in the South Pacific, he confessed both to his homoerotic desire for a young native and his wish to unburden himself of his masculinity. So one can see his implied equation of himself with a "pure young girl" in *Les Misérables* as an early example of his lifelong toying with conventional sexual roles.

On the unconscious level, Gauguin's feminization of himself would be an extension of the deep-seated identification with Aline that arose out of his mother-dominated childhood. It would also represent his unconscious desire to abandon the dominating role that he habitually adopted and that Vincent expected of him. Instead of becoming the "abbot" who would rule over the studio of the South, he would become a young girl who simply submitted to Vincent's wishes. Vincent appears to have harbored similar desires and, as we have seen, defended against them by turning Gauguin, not himself, into the female member of their partnership. In fact, Vincent's inability to really "see" *Les Misérables* and to respond to Gauguin's discourse on the picture may have stemmed from his own uneasiness about who would become the woman and who would become the man in Arles.

Although neither Gauguin nor Vincent saw the other's self-portrait before painting his own, they created works alike in their dialectical tensions. Both *Self-Portrait as a Buddhist Monk* and *Les Misérables* are riven with dualities: painter versus monk, outlaw versus saint, savage versus sensitive, madman versus "placid priest," master versus supplicant, and male versus female. Both artists literally tried to put the best "face" on their characters but could not help revealing disturbing aspects of themselves. All of these tensions, moreover, find a formal correlative in the bold oppositions of complementary colors that animate both works. It is too easy and ultimately distorting to see everything during the Arles period in the light of its tragic denouement. But viewed side by side these self-portraits seem to foretell the eventual clashes and final rupture of the partnership. They make one wonder how such indomitable personalities survived two weeks together, much less two months.

Figure 4.3 Paul Gauguin, *The Vision after the Sermon* (1888)

VI

In the same period during which Gauguin and Vincent painted their self-portraits, they worked on two other milestone pictures, *The Vision after the Sermon (Jacob Wrestling with the Angel)* [4.3] and *The Night Café* [4.4]. By comparing these paintings we can gain a better sense not only of the artists' shared thematic concerns but also of the ways in which the formal aspects of their art diverged and overlapped. Although the two works depict subjects that appear far apart, both canvases evoke extreme psychological states and do so with distinctly Post-Impressionist pictorial means.

The Vision after the Sermon stands out as a profound break in Gauguin's oeuvre. He had never before treated a religious subject, and he had never abandoned Impressionist conventions so drastically. The painting depicts Breton women with elaborate headdresses kneeling in prayer as they imagine

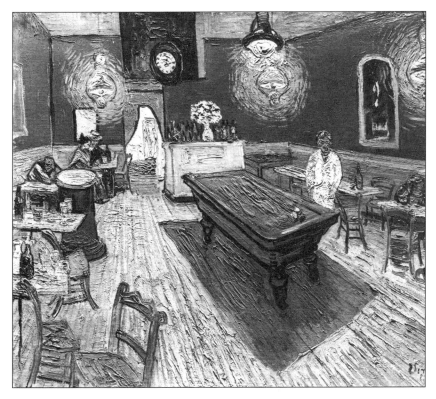

Figure 4.4 Vincent van Gogh, *The Night Café* (1888)

the Old Testament story of Jacob wrestling with the angel. Although Gauguin renders the foreground figures in a relatively naturalistic manner, he much more willfully rejects illusionism in the background. What should read as a green field with a tree in the middle and a pair of wrestlers in the distance becomes a wall of red paint bisected by the diagonal of a tree trunk and adorned with the cutout shapes of Jacob and the angel. On the other side of the trunk, an equally out-of-scale and nonperspectival cow hovers like a smaller version of the floating bovines in Courbet's *The Young Ladies of the Village.* Next to this pasted-on cow, the row of kneeling women, instead of receding into spatial depth, tilts up along the picture's edge as if conforming to the flatness of the red expanse. In a letter to Vincent, which included a sketch, Gauguin de-

scribed the painting and forthrightly acknowledged his violations of represen-
tational norms:

> . . . I have just finished a religious painting, very badly made but that interested me to do
> and that pleases me very much. . . . Groups of Breton woman are praying, their cos-
> tumes a very intense black, their bonnets a very luminous yellow-white. The two bon-
> nets at the right are like monstrous helmets. An apple tree crosses the canvas in somber
> violet and the foliage has been drawn in masses like clouds, in emerald green, and the in-
> terstices are the yellow-green of sunlight. The ground, pure vermilion. . . . The angel is
> dressed in violent ultramarine blue and Jacob in bottle green. The wings of the angel are
> pure chrome 1. The angel's hair is chrome 2, and the feet are flesh orange. I think I have
> achieved a great simplicity in the figures, very rustic and superstitious. The overall effect
> is very severe. The cow under the tree is tiny in comparison with reality and she bucks.
> For me in this painting the landscape and the fight only exist in the imagination of the
> people praying because of the sermon, which is why there is a contrast between the nat-
> ural people and the non-natural landscape which is out of proportion.[102]

Vincent's response has been lost, but he would have recognized various
sources for the picture that Gauguin left unmentioned. The tree, the wrestlers,
and the cow derive from Japanese prints (Hokusai's in particular), while the
cropping as well as the in situ viewpoint owe much to Degas. The thick
outlines, moreover, would have reminded Vincent of Bernard's and Anquetin's
Cloisonism. As for the religious content, Vincent might have reacted in the
same ambivalent way that he did to Bernard's interest in Biblical subjects. This
ranged from mild annoyance to vigorous exhortations—"roaring my loud-
est"—that Bernard return to "the possible, the logical, the true."[103]

But even if Vincent did not encourage Gauguin in this new direction, one
wants to know how his religiosity affected the formation of *The Vision*. The
presence in Pont-Aven of the very Catholic Emile Bernard and his equally de-
vout sister Madeleine substantially complicates this question. Emile and
Madeleine shared a great enthusiasm for Breton religious culture. Emile had
carefully studied Breton churches and shrines during extensive walking tours
of Brittany, and Madeleine had become so smitten with the region's folkways
that she frequently dressed in local costume. They also regularly attended ser-

vices at the church in Pont-Aven and may have brought Gauguin along with them. So it is very likely that Emile and Madeleine focused Gauguin's attention on the religious practices that inspired *The Vision*. Yet one can still detect the influence of Vincent's spiritual preoccupations in the language Gauguin uses in his correspondence. In a letter to Schuffenecker, Gauguin states:

> What an artist this Jesus, who sculpted in humanity itself, and what a bore this Solomon. . . .
> . . . In the absence of religious paintings, what beautiful thoughts form and color can evoke. How happily earthbound these pompous hacks are with their trompe l'oeil of nature. We alone sail on the phantom ship with all our whimsical imperfection. The infinite seems to us more tangible before an undefined object. . . . [104]

Here Gauguin appropriates remarks that Vincent had made to Bernard. He not only borrows the idea, which we have already noted, of Christ as an "artist" but also the denigration of Solomon. In the same letter to Bernard, Vincent had reviled the Old Testament figure as "a hypocritical heathen" who produced imitative architecture and inferior writings.[105] The references to the "infinite," though common enough in literary and artistic circles, may reflect Vincent's musings as well. Vincent had written to Bernard that a "a complete thing, a perfection, renders the infinite tangible to us."[106] And he described the celestial background to his *Portrait of Eugène Boch* as an "infinity" of the "richest, intensest blue."[107]

Gauguin occasionally employed religious metaphors in his letters to Vincent, as we see in a missive from September:

> It is a long Calvary to be traversed, the life of an artist, and perhaps that's what makes us live. The passion vivifies us and we die when it has no more nourishment [to give us]. Let's leave these paths filled with bushes of thorns, which nonetheless have their wild poetry.[108]

Although such statements appear heartfelt, one must wonder about their sincerity. Gauguin had every reason to "lay it on thick" with Vincent. If he hinted that he was anything but miserably ill and debt-ridden in Pont-Aven he would have lost his excuse for not coming to Arles and would have diminished

his status as a forlorn object of pity. What better way of maintaining Vincent's sympathy than by echoing his own rhetoric of the artist as a perpetually suffering Christlike figure?

One also has to question the tone of another religion-inflected remark that Gauguin made to Schuffenecker. In suggesting that Schuffenecker free himself from dependence on the model, he wrote:

> A bit of advice, don't copy too much from nature. Art is an abstraction; extract it from nature while dreaming before it and think more of the creation than of the result; this is the only way to ascend toward God in doing as our divine master does, creating. . . .
>
> . . . Come, have courage, may God take you in his holy care in crowning your efforts.[109]

Gauguin's devotional language in this letter sounds, if not mocking, at least playful. It is in keeping with the distance he puts between himself and the piety of the Breton women in *The Vision*. If Gauguin had been powerfully moved by a sermon in Pont-Aven, he might simply have painted an episode from the Old Testament. His artistic hero, Eugène Delacroix, had done just that in his own *Jacob Wrestling the Angel* in Saint-Sulpice. But Gauguin chose instead to create a work more concerned with observing than expressing belief. He turns the viewer into a sort of religious voyeur or anthropologist examining the collective rituals of an exotic culture. In a more straightforward religious painting the vision or miracle would loom large over the witnesses. Yet here, the visionary figures remain tiny while the devout become gigantic. The Breton women, with their "monstrous helmets" and "superstitious" manners, hold more interest than the content of their religious experience. And the picture's viewpoint underscores the impossibility of fully sharing or understanding their extreme fervor. Gauguin brings us up close to the women yet we look down at them from a vantage above the scene.

The attitude implicit in *The Vision* contrasts sharply with Vincent's. No matter how much he criticizes his past zealotry or conventional Christianity he never treated the phenomenon of religious faith as merely a curiosity. And even if he had completed his *Christ in the Garden of Gethsemane*, which may have served as one of the catalysts for *The Vision*, he would not have introduced the layers of

self-consciousness found in Gauguin's work. Vincent had been too consumed himself with religious passion to treat it ironically or condescend to it. In fact, the strongest nexus between Vincent and Gauguin's creation of *The Vision* may not have been the former's religiosity but *Les Misérables*. Biblical scholars regarded Jacob's fight with the angel as an allegory of man's struggle with his conscience, and Gauguin may have chosen this Old Testament subject because it served as a powerful metaphor for Jean Valjean's inner travails. Hugo, in fact, specifically invokes Jacob and the angel in a description of one of his hero's mental crises:

> The fearful struggle, of which we have recorded more than one phase, had begun again. Jacob's battle with the angel lasted only one night; but how often had Jean Valjean been darkly joined in mortal conflict with his own conscience! A desperate struggle: his foot slipping at moments and, at others, the ground seeming to give way beneath his feet. How stubbornly his conscience had fought against him![110]

Of course, Gauguin had a more immediate reason for depicting Jacob wrestling the angel. The story nicely paralleled the actual wrestling matches which formed a prominent part of the Breton religious festivals.

Just as Bernard played a larger role than Vincent in Gauguin's turn to religion, so he more directly provoked *The Vision*'s departures from realism. One need not accept Bernard's later claims that Gauguin "stole" his style to acknowledge the considerable influence of his *Breton Women in a Meadow* [5.8] on the older artist's masterwork. Bernard had already gone very far in simplifying his forms in Parisian canvases such as *Bridge at Asnières*. In Brittany he took the even more radical step of abandoning the traditional perspectival organization of his compositions. In *Breton Women in a Meadow,* the figures, which consist of local women in traditional bonnets, female tourists, priests, and young girls, remain affixed to a starkly flat green ground. Bernard makes no attempt to locate these figures within measurable distances of each other. Nor does he concern himself with properly adjusting their scale. Freed from perspectival strictures, everything floats on the surface, colliding and overlapping in a seemingly random manner. Gauguin introduced these pictorial liberties into his *Vision* along with the unbroken, Cloisonist contours and the abbreviated, caricatural notations for the facial features of the Breton women. But

one can still sense Vincent's presence in *The Vision* if only as a reinforcement of Gauguin's own inclinations. The bright, unmodulated, and "arbitrary" colors have deep affinities with Vincent's. Vincent would have especially appreciated the expressive power of the vermilion ground as well as the astringent contrasts of blacks and whites and reds and greens.

Indeed, a vivid red background, accentuated by green complementaries, constitutes one of the most prominent similarities between *The Vision* and Vincent's *Night Café*. In Gauguin's case, the zone of saturated vermilion provides a coloristic metaphor for the heightened quasi-mystical state of the Breton women's imagination. For Vincent, it evokes a psychological condition no less intense but of a much different order. After leaving the Hôtel-Restaurant Carrel, Vincent moved to the Café de la Gare, which served as the site for his painting. While taking his meals there he could observe street urchins, drunks, prostitutes, and pimps carrying on at all hours. Yet Vincent, as he reported to Theo, attempted to convey this dissolute atmosphere not through pitiless Toulouse-Lautrecian portraits of the café's denizens but by color contrasts alone:

> I have tried to express the terrible passions of humanity by means of red and green.
>
> The room is blood red and dark yellow with a green billiard table in the middle; there are four citron-yellow lamps with a glow of orange and green. Everywhere there is a clash and contrast of the most disparate reds and greens in the figures of little sleeping hooligans in the empty, dreary room, in violet and blue. The blood-red and the yellow-green of the billiard table, for instance, contrast with the soft tender Louis XV green of the counter, on which there is a pink nosegay. The white coat of the landlord, awake in a corner of that furnace, turns citron-yellow, or pale luminous green. . . .
>
> It is a color not locally true from the point of view of the delusive realist, but color suggesting some emotion of an ardent temperament.[111]
>
> In my picture of the "Night Café" I have tried to express the idea that the café is a place where one can ruin oneself, go mad or commit a crime. So I have tried to express, as it were the power of darkness in a low public house, by soft Louis XV green and malachite, contrasting with yellow-green and harsh blue-greens, and all this in an atmosphere like a devil's furnace of pale sulphur.[112]

One can tell from their own descriptions that both Gauguin and Vincent were well aware of the impact their canvases would make on the average Salon-goer. Gauguin regarded *The Vision* as "very badly made," while Vincent considered *The Night Café* "one of the ugliest [pictures] I have done."[113] They both, moreover, frankly characterized their colors as "violent" "clash[ing]," and "harsh."

In addition to the jarring coloristic effects, the two works share off-kilter compositions inspired by the angular thrust of Japanese art. In *The Night Café* the strong diagonal of the billiard table sets in motion the picture's asymmetries just as forcefully as the apple tree that cuts across *The Vision*. And *The Night Café*'s ghostly proprietor, like *The Vision*'s apparitional wrestlers, looms up not in the center of the painting but off to the right in an ambiguously defined middle ground. Similarly Japanese is the flatness and unmodulated quality of the red zones in each work. In *The Night Café* this pushes the four lamps, with their glowing halos, to the picture's surface.

Yet much separates *The Vision* and *The Night Café*. Perhaps the most significant difference involves spatial depth. Vincent reverts to the use of plunging perspectival lines that predates his exposure to such devices in the work of Degas and other Impressionists. Floorboards, wainscoting, tabletops, the billiard table, and even the pool cue align themselves along orthogonals rushing back towards the doorway in the rear. Although Vincent doesn't mention it in his descriptions, this headlong dive into space creates as powerful an expressionistic effect as the red and green complementaries. It becomes the visual equivalent of an irresistible urge and corresponds to the pull of those "terrible passions" that make the café dwellers want to "ruin [themselves], go mad or commit a crime." Gauguin, however, denies this release by flattening *The Vision*'s background. As a result, *The Vision* contains much more activity on the picture plane. In particular, Gauguin has created a series of circuits out of the curvilinear contours of the headdresses and their flaps. These lines extend into the tree trunk, where the ovoid shapes of the bonnet folds reappear in an oval formed by two branches. Although Vincent could leave juicy daubs of paint on the picture surface, he could never violate perspectival norms as completely as Bernard and Gauguin. And his lack of interest in Gauguin's Ingres-esque linear complexity would become a contentious sticking point.

Vincent and Gauguin also handle paint in dramatically different ways. Vincent in Arles had moved farther and farther away from either an Impressionist or Divisionist touch and had developed instead his directional and textural brush strokes. The floorboards of *The Night Café* provide a perfect example of these two types of paint handling. They follow the direction of the orthogonals and at the same time recreate the scuffed and scraped texture of the floors. Indeed, this love of paint's materiality nearly turns his paintings into bas-reliefs. The pool cue and balls, for example, seem as much molded and incised out of the thick impasto as rendered illusionistically. Gauguin, by contrast, employed a more subtle touch in *The Vision.* His strokes are smaller, thinner, and more consistent. And he more carefully models the foreground figures in light and shade. *The Vision,* moreover, uneasily combines incisive outlines with painterly passages while Vincent's Arles pictures effected a more complete marriage of painting and drawing. He no longer used underdrawings for his canvases, because he had come to believe that one "must attack drawing with the color itself."[114] Yet his drawings, with their dots, blobs, whorls, and scratches, had already become painterly. He only needed to extend the extremely varied, often fat line of his pen to his brush as he rapidly executed his paintings.

A fundamental split in creative methods underlay these differences in paint handling. Gauguin, as indicated in his advice to Schuffenecker, wished to free himself from the constraints of the subject and impose his own order on nature's banal details. Vincent, however, reported to Bernard his constant, almost therapeutic need for actualities:

> I won't sign this study, for I never work from memory. . . . And I cannot work without a model. I won't say that I don't turn my back on nature ruthlessly in order to turn a study into a picture, arranging the colors, enlarging and simplifying; but in the matter of form I am too afraid of departing from the possible and the true.
>
> I don't mean I won't do it after another ten years of painting studies, but to tell the honest truth, my attention is so fixed on what is possible and really exists that I hardly have the desire or the courage to strive for the ideal as it might result from my abstract studies. . . .

But in the meantime I am getting well acquainted with nature. I exaggerate, some-
times I make changes in a motif; but for all that, I do not invent the whole picture; on
the contrary, I find it all ready in nature, only it must be disentangled.[115]

Vincent even followed these empiricist principles in his rendering of the
hallucinatory *Night Café*. He stayed up for three nights working away at his
easel while sleeping during the day. A small testament to his devotion to the
"possible and the true" appears on the back wall where one can read the exact
time—a quarter past twelve—on the clock face.

Yet Gauguin, despite his talk of becoming a Divine Creator, can seem more
timid than Vincent. He must tell Vincent that the landscape and the fight in
The Vision are "non-natural" and "out of proportion" because "they only exist
in the imagination of the people praying." It is as if he cannot make a violent
departure from naturalism without the excuse of rendering a fantasy. Vincent,
by contrast, extends his "distortions" and "exaggerations" to the entire canvas,
not just the background. He puts into practice what Gauguin had somewhat
pretentiously claimed in a letter:

Yes, you are right to want painting to have a coloring evocative of poetic ideas, and in
that sense I agree with you, although with one difference: I am not acquainted with
any *poetic ideas*—I'm probably missing a sense. I find *everything* poetic. . . . [116]

Of course, Gauguin's division of his paintings into a richly modeled fore-
ground and an abstract background would become a hallmark of his art and
one of its most satisfying sources of tension. But at this point, Gauguin, prod-
ded by Bernard, had ventured into uncharted waters—into the flat, nonper-
spectival space of Modernism that could still shock fifty years later—and must
have felt the need to explain and justify.

VII

On the eve of Gauguin's arrival, Vincent had everything on the line and every-
thing at stake. The prospects for the Studio of the South, the Yellow House

and its decorations, the worthiness of his art, and his very character would be subject to Gauguin's judgment. All of this made Vincent even more manic than usual. He survived chiefly on two stimulants—coffee and alcohol—and pushed himself so relentlessly that at one point he had to sleep for sixteen consecutive hours. In an attempt to assuage his mania, he painted his room with the bed prominently displayed. As he wrote to Theo, *Van Gogh's Room* "ought to rest the brain, or rather the imagination. . . . The broad lines of the furniture again must express inviolable rest."[117] That the actual picture bristles with juxtaposed complementaries and skewed orthogonals shows how difficult it must have been for Vincent to calm his overactive mind. Thoughts of Gauguin also affected his choice of subject matter. As Ronald Pickvance has argued, *The Trinquataille Bridge*, *The Railroad Bridges*, and *The Tarascon Diligence* all represent different modes of transportation and can be seen as expressions of Vincent's desperate wish for Gauguin to make the trip to Arles.[118] In this context, the plummeting perspectival lines and multiple vanishing points of *The Trinquataille Bridge* and *The Railroad Bridge* emerge more clearly as pictorial metaphors for Vincent's yearnings. *The Trinquataille Bridge*'s obsessive linear networks appear especially evocative of Vincent's frustrated desire as none of the orthogonals converge. They become arms straining for a distant object they will never reach.

All of the factors that contributed to the failure of the collaboration—willfulness, quarreling, mental breakdown—had been recognized either implicitly or explicitly before Gauguin's arrival. As early as May, Vincent had described the projected collaboration as a "great risk."[119] And in the same letter in which Gauguin described his *Les Misérables,* a warning in itself, he added an unintentionally prophetic note about a recent newspaper report of a duel between two painters. One had challenged the other over a bad review and had died by pistol shot. Only three months later Vincent would characterize his relations with the older artist by saying, "Fortunately, Gauguin and I . . . are not yet armed with machine guns."[120]

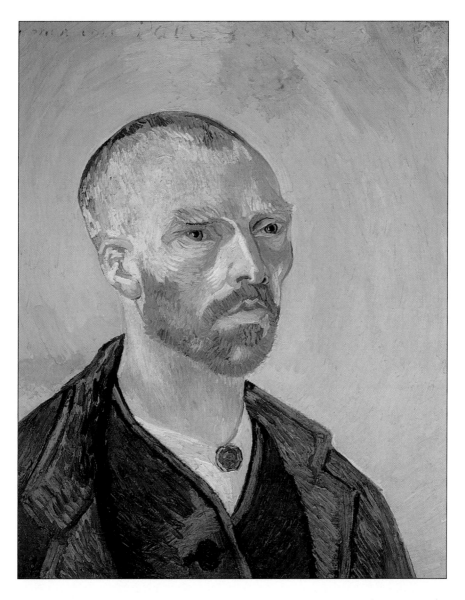

Plate 1 Vincent van Gogh, *Self Portrait Dedicated to Paul Gauguin*, 1888

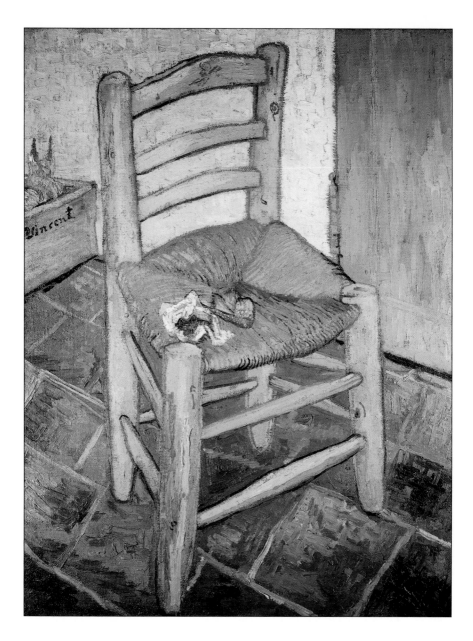

Plate 2 Vincent van Gogh, *Vincent's Chair*, 1888-1889

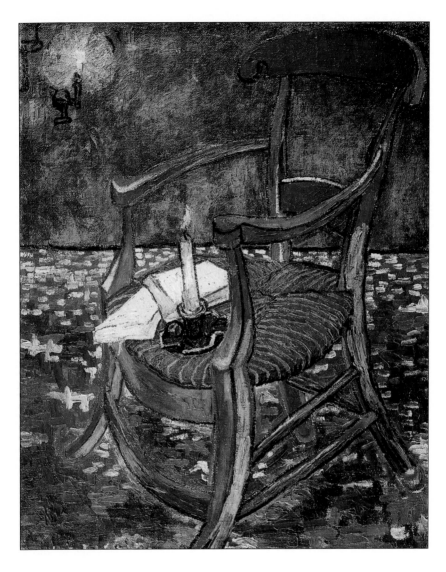

Plate 3 Vincent van Gogh, *Gauguin's Stuhl (mit Kerze)*, 1888

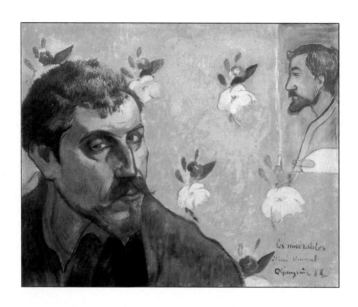

Plate 4 Paul Gauguin, *Les Misérables*

— 5 —

Electric Arguments

"Le Bon Vincent" and
"Le Grièche Gauguin"

I

Vincent's ear cutting casts a long shadow over every aspect of his sojourn with Gauguin. It endows casual remarks, subtle shifts in painterly technique, and even changes in the weather with teleological significance. Did Gauguin's spirited defense of Ingres push Vincent closer to a breakdown? Did newspaper articles on Jack the Ripper plant violent thoughts in his overstimulated brain? Did four days of nonstop rain drive him over the edge? Although a mental collapse and even a suicide attempt would seem probable, if not inevitable, outcomes of Vincent's already troubled history, the stubborn particulars of the ear cutting remain intractably mysterious. Why a razor? Why an ear? Why then? This compels a desperate search for clues in everything that went before and has inspired a dizzying profusion of theories. One psychologist has, in fact, identified no less than thirteen explanatory models for Vincent's bizarre act.[1] These range from the impact of the bull's severed ear in the local bullfights to an interpretation of the ear cutting as a symbolic self-castration. The scrutiny of every moment leading to the climactic event also makes the cohabitation of the Yellow House appear to have stretched over an epic period. Gauguin himself in his memoir, *Avant et après,* stated that it felt like a century. Yet, as art his-

torians are quick to point out, Gauguin spent little more than two months—from October 23 to December 26—in Arles.

One would like to free Vincent and Gauguin from this retrospective prison and see them in Arles fully engaged in their art and looking toward horizons unobstructed by the wreck of their collaboration. One wants as well to disentangle them from their overanalyzed relationship with its ponderous conflicts and role-playing—master versus student, father versus son, imagination versus nature—and understand them as autonomous beings whose lives transcended the drama in the Yellow House. It is possible to keep this overriding narrative at bay while considering a select number of works and artistic issues that preoccupied the two artists. But the tensions that contributed to Vincent's breakdown were present from the very beginning and colored nearly everything. One can draw a direct line from Vincent's self-mutilation to the disappointments he experienced during the very first week with Gauguin. Vincent, as one writer has remarked, was a ticking time bomb ready to go off.

We must recall Vincent's frenzied expectations. So much rode on the success of the collaboration that Vincent nearly fell ill in the days before Gauguin's arrival. He wanted Gauguin to like him, to admire his art, to be charmed by the Yellow House, and to fall so completely in love with Arles that he would stay forever as the head of the Studio of the South. This not only would bring personal satisfaction to Vincent and justify Theo's investment but would also usher in a new utopian era for advanced artists. Almost all of these hopes would be dashed at the outset with the gravest consequences for Vincent's psychic equilibrium. Yet one could argue that the arrangement was doomed before Gauguin ever set foot in Arles. As we have seen, Vincent could not even share an apartment with his long-suffering brother without making his sibling miserable. Why expect more indulgence from the rough-edged Gauguin?

After an exhausting two-day train ride, Gauguin arrived in Arles at 5:00 A.M. on the morning of Tuesday, October 23, 1888. He proceeded to the Café de la Gare where the proprietor, M. Ginoux, recognized him from his self-portrait, *Les Misérables*. Directed to the Yellow House by Ginoux, Gauguin would have knocked on Vincent's door in a less-than-elated mood. His initial reaction to Arles did not improve, as we can infer from Vincent's letters to Theo. Only four or five days later, Vincent reported Gauguin's distinctly invidious compar-

ison of Arles with Pont-Aven. The latter has a "more solemn character and [is] especially purer in its totality and more definite than the shriveled, scorched, trivial scenery of Provence."[2] Later, Vincent would quote Gauguin's even harsher dismissal of Arles as "the dirtiest hole in the South."[3] As for Vincent's paintings, Gauguin offered only a polite and vaguely positive response: "I do not yet know what Gauguin thinks of my decoration in general. I only know that there are already some studies which he really likes, like the sower, the sunflowers, and the bedroom."[4]

Gauguin's most devastating remarks, however, would have involved his desire to return to the Antilles. In Vincent's second letter after his friend's arrival he could already announce that Gauguin intended to save money in Arles in order to "settle in Martinique."[5] With this one statement Gauguin would have destroyed all of Vincent's dreams of a permanent Studio of the South. How could he attract artist-monks to his new monastery if the "abbot" had one foot out the door? All of his calculations, all of his pleading, and all of his furnishing and decoration of the Yellow House were for nought. There would be no artists' collective, no final cure for his loneliness, and no lasting solution to his financial problems.

Vincent put the best face on all of this for Theo's sake. He even adopted Gauguin's idea of a "studio of the Tropics" as his own. In a typically masochistic manner he championed the very cause that had ruined his utopian vision. "What Gauguin tells of the tropics seems marvelous to me," he wrote Theo, "surely the future of a great renaissance in painting lies there." Arles would now become merely a "way station" between Europe and sunnier, more exotic regions.[6] Vincent's embrace of the studio of the Tropics also nicely resolved his differences with Gauguin over the exact nature of an ideal community of artists. He wrote to Bernard to say that they were discussing the "terrible subject of an association of certain painters"[7]—"terrible" because of their disagreements about the commercial aspects of such an enterprise. Earlier in the year the important role of speculators in the older artist's scheme had so angered Vincent that he lashed out at "Gauguin and his Jewish bankers."[8] But with the collective displaced to the tropics these contentious issues fell away. Any "primitive" locale would by definition avoid the corruption of Paris and its avaricious dealers.

Gauguin suggested to Vincent and Theo that he would leave for Martinique in about a year's time. This appears, however, to have been an attempt to reassure Vincent and especially Theo that their strenuous efforts had not been in vain. In July 1888 he had told Mette that he would stay only six months in Arles and by December, after the mood in the Yellow House had become more turbulent, he wrote Schuffenecker that "if I would leave in May . . . I would become a nearly happy mortal."9 Yet at the same time that Gauguin's Martinique plan had thoroughly undermined the long-term prospects of the studio of the South, Vincent faced a more immediate worry. Fed up with Arles, Gauguin might simply return to Paris where Schuffenecker would welcome him. Gauguin's departure, whether sooner or later, remained a constant and troubling possibility.

In their first joint campaign Vincent and Gauguin took as their subject the ancient Roman burial ground called the Alyscamps (a linguistic variation on *Champs Elysée*). As a rule, Vincent shunned the conventionally picturesque or historical sites that attracted tourists. And in Arles he had avoided painting local monuments, such as the Roman theater and the medieval church of Saint-Trophime. Similarly, in Saint-Rémy he entirely ignored the celebrated Roman ruins only a few yards from the asylum. But he may have made an exception in the case of the Alyscamps in order to demonstrate to Gauguin that Arles, like Pont-Aven, had its own evocative past.

Among the paintings inspired by the Alyscamps, the two by Vincent and Gauguin that most resemble each other are the former's picture in a private collection in Lausanne [5.1] and the latter's in the Musée d'Orsay [5.2]. Both use a vertical format and depict a view receding toward the Romanesque church of Saint-Honorat, which sits at the end of a long avenue lined with sarcophagi, stone benches, and tall poplar trees. The two works also place figures in a distant middle ground and heighten the flaming autumnal foliage with orange-blue and red-green complementaries. Yet these canvases, despite their many similarities, reveal much of what separated Vincent's and Gauguin's artistic sensibilities.

Gauguin's *Les Alyscamps* achieves a more fully Post-Impressionist effect. It possesses a mysterious character and a timelessness lacking in Vincent's picture. Gauguin suppresses recognizable details. He avoids the conventional view down the avenue and shifts the vantage point slightly north to the bank of the

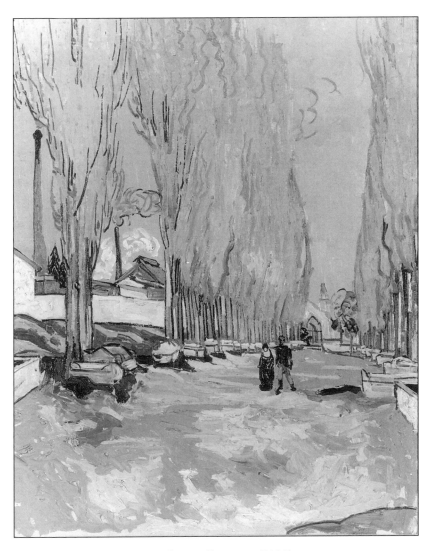

Figure 5.1 Vincent van Gogh, *Les Alyscamps* (1888)

Canal de Craponne that runs parallel to the Alyscamps. He then places three *Arlésiennes* in strangely hieratic and frontal poses on the canal bank. These figures, dressed in black, stare solemnly at the viewer from the middle distance. They stand below the lantern dome of Saint-Honorat, which Gauguin has accentuated by heightening and simplifying its supporting columns. Recontextualized

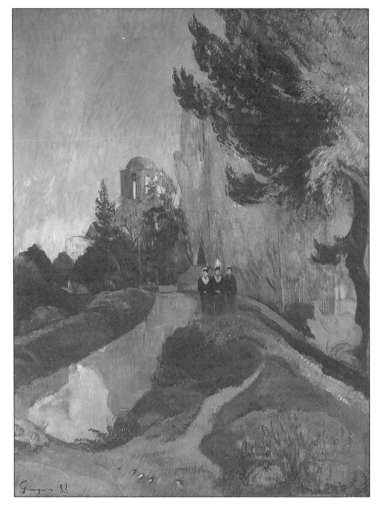

Figure 5.2 Paul Gauguin, *Les Alyscamps* (1888)

in this way, the scene no longer represents a Provençal tourist attraction but a mythical realm. The canal becomes a flowing river with all of the attendant poetic connotations. The ethereal Arlésiennes draw on the symbolic associations of the number three and seem to embody vestal virgins or the Fates. And the transfigured Saint-Honorat becomes an antique Tempietto-like shrine. Gau-

guin, in fact, gave this picture the facetiously Puvisesque title "Three Graces at the Temple of Venus."[10] This joking remark in a letter to Theo not only reveals Gauguin's mischievous attitude toward many motifs held dear by Vincent, but also his Symbolist ambition to lift subjects out of the everyday.

Vincent, by contrast, firmly grounds the viewer in contemporary realities. Instead of cropping out the industrial development that had transformed Arles in the previous decades, he prominently depicts the factories of the Paris-Lyons Méditerranée railroad line visible through the poplars. Vincent also infuses his painting with more dynamism. Smoke drifts from the smokestacks, the couple in the middle distance strolls toward us, and the rows of trees and sarcophagi measure out the perspectival recession with an insistent rhythm. Vincent, moreover, applies pigment quickly and thickly. Gauguin, on the other hand, mitigates the plunge of perspectival space by using a stable pyramidal composition that builds toward Saint-Honorat at its apex. And he further slows down the visual pace by repeating the soft, curvilinear forms of the dome, riverbank, and tree trunk and by painting in a darker palette with small, careful strokes.

In addition to the Lausanne picture, Vincent painted two horizontal versions of the Alyscamps while standing on the raised bank of the Canal de Craponne and peering down through the poplars. This vantage gives both canvases a surprisingly decorative quality as the view from above flattens out the avenue, and the poplars, cropped at both ends, become stripelike bands on the picture surface (Vincent, perhaps thinking of antiquity, compared them to pillars). But he counteracts these abstract elements by clearly delineating the orthogonals of the benches and sarcophagi, which shoot off toward the upper right in one picture and the upper left in the other. The clash of the vertical poplars marching across the picture and the strong diagonal of the avenue once again creates a sense of movement and nervous excitement that is at odds with the quiet somberness of Gauguin's painting. Vincent's depictions of the Alyscamps are not, however, without their own symbolic content. In two of them he includes a pair of lovers similar to those in the *Poet's Garden* series of mid-October. Those paintings tried to capture the spirit of amity between the poets Boccaccio and Petrarch and optimistically anticipated Vincent's and Gauguin's recreation of the legendary friendship. The appearance in the Alyscamps paintings of walking couples indicates that Vincent still clung to

the vestiges of his utopian hopes despite Gauguin's bombshell regarding Mar-
tinique. Not surprisingly, such figures quickly faded from his art and only
resurfaced much later in Auvers.

II

In their next joint venture, Vincent and Gauguin turned from landscape to the
figure, in the person of Madame Ginoux, the wife of the Café de la Gare's man-
ager. Gauguin drew her in black conté crayon [5.3], and Vincent painted her in
a canvas "slashed on in an hour [5.4]."[11] Once again, Gauguin created a more
frontal, stable, and rounded composition. He also rendered Madame Ginoux
with a volumetric modeling reminiscent of his treatment of the helmetlike
headdresses in the *Vision after the Sermon*. Vincent's version departs signifi-
cantly from Gauguin's and emphasizes the angularity of her dress and physiog-
nomy. He depicts her in a three-quarter view and takes a special delight in the
play of flat, jagged shapes created by the silhouettes of her costume and arm-
chair. Indeed the same model emerges so differently in the hands of the two
artists that the portraits barely resemble each other. Gauguin's Madame Gi-
noux has a lantern jaw, echoing the round bottom of her fichu, a broad nose,
and evenly curved brows, while Vincent's figure is all sharp edges with her tri-
angular chin, pointy nose, and arched brows.

Gauguin's drawing of Madame Ginoux served as a preliminary study for her
appearance in his painting *The Night Café* [5.5]. Here Gauguin takes Vincent's
canvas of the same subject as his starting point. Like Vincent, he boldly contrasts
the red wallpaper with the green baize of the billiard surface and makes jutting di-
agonals out of the edges of the pool and café tables. He also includes a sleeping
figure and still-life objects such as the blue seltzer bottle found in the earlier
work. But these elements aside, Gauguin has made an entirely new picture. It is
really an elaborate portrait of Madame Ginoux in situ. She presides over the fore-
ground while sitting at a marble café table and giving the viewer a sidelong
glance. Behind her one sees the unused billiard table and a friezelike row of cus-
tomers seated against the wall. In his much calmer composition, Gauguin has re-
jected all of Vincent's most powerful expressive devices. Gone are the extreme

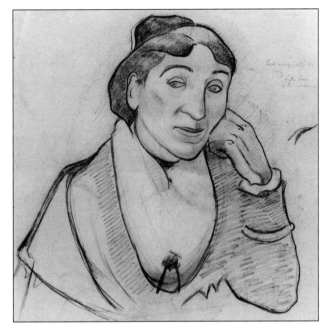

Figure 5.3 Paul Gauguin, *Madame Ginoux* (1888)

clash of complementaries, the vertiginous rush into space, and the hypnotic glow of the overhead lamps. Instead Gauguin neatly organizes the wall, dado, billiard table, and marble tabletops into stacked horizontal zones over which hang blue clouds of smoke. In addition, he stabilizes the foreground orthogonals, which belong more to Degas than to Vincent, by a series of vertical forms. Structure and order have replaced "delirium tremens in full swing."[12]

Yet more troubling to Vincent than the avoidance of his signature formal conceits would have been the picture's undercurrents of mockery toward some of his favorite subjects. If Gauguin's *Les Alyscamps* bordered on the pretentious, his *Night Café* risks a snickering prurience that makes clunkily obvious the "terrible passions of humanity" latent in Vincent's painting.[13] Contemporary viewers would have recognized the women sitting in the background as prostitutes. And Gauguin identifies them as such in a letter to Bernard. This

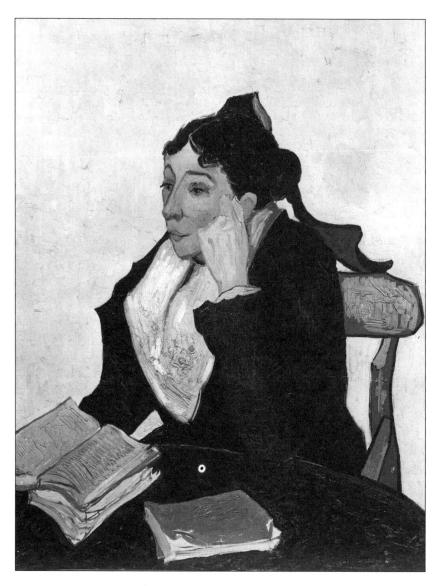

Figure 5.4 Vincent van Gogh, *Madame Ginoux* (1888)

Figure 5.5 Paul Gauguin, *The Night Café* (1888)

significantly alters the meaning of Madame Ginoux's expression. In the draw-
ing she appears both thoughtful and welcoming. But in the painting her smile
widens into a leer and her eyes narrow into a knowing, cynical look. She has
become the procuress for the girls behind her. And with whom are they drink-
ing? It is none other than Vincent's beloved postman, Roulin. Although Vin-
cent considered Roulin a hearty drinker, he also admired his down-to-earth
wisdom, his fervent Republican politics, and his position as the head of a large
family. To depict him carousing with whores undercuts Vincent's idealized im-
age of Roulin as a kindly patriarch who possessed a "silent gravity" and "ten-
derness."[14] Gauguin also places the Zouave lieutenant Milliet, Vincent's friend
and occasional drawing partner, next to a figure collapsed on a tabletop and
thereby associates him with the café's dissolute company. As is the case with

the easygoing Roulin, the setting isn't completely improbable, but it reduces Milliet to his most undignified level. Adding insult to injury, Gauguin renders all of these important figures in Vincent's visual novel of the South in an abbreviated, nearly caricatural manner far removed from Vincent's probing and generous approach.

If any of this offended Vincent, he didn't let on. In these first weeks he seemed determined to see everything in the best light and wrote that Gauguin's picture "promises to turn out beautiful."[15] Gauguin himself, however, sensed that something had gone awry. In a letter to Bernard, he stated that he liked his painting less than Vincent did and found the subject "not in my line." Gauguin then displaces criticism of the picture's prurient tone onto its formal qualities. The "local colors," not the prostitutes, are "vulgar" and the figure of Madame Ginoux fails not because she has become a leering procuress but because he has rendered her in much too "orthodox" a manner.[16] We will repeatedly encounter such blindness, on both Gauguin's and Vincent's part, to the hostile and competitive subtexts of Gauguin's paintings.

In the same letter to Bernard, Gauguin mentions another picture that he prefers and considers his "best canvas" of the year.[17] This was *Grape Gathering: Human Misery* [5.6]. Vincent and Gauguin had observed a vineyard in the sunset during a walk on Sunday, November 4. Vincent described the scene to Theo as a "red vineyard, all red like red wine. In the distance it turned to yellow, and then a green sky with the sun, the earth after the rain violet, sparkling yellow here and there where it caught the reflection of the setting sun."[18] Although this experience inspired both artists, they now proceeded along entirely different lines in their approach to a shared subject. While Vincent attempted to recreate the view of the vineyard and grape harvesters beneath the setting sun, Gauguin used the locale as merely the pretext for an imaginary composition. Not only did he ignore the actual details of the vineyard, but he introduced figures from Brittany. As he wrote to Bernard, "so much for *exactitude*."[19] (And so much for Vincent's attempts to interest him in local Arlesian types.)

The central figure, a red-haired young girl, sits on the ground with her elbows on her knees and her chin resting on clenched hands. Her face, with its

Figure 5.6　Paul Gauguin, *Grape Gathering: Human Misery* (1888)

"oriental" eyes, closely resembles that of the girl tempted by fruit in a still life of the previous summer. Here, she looks downward and broods darkly. In the vineyard behind her two peasant women in Breton garb bend down over their labors, and at her right another woman dressed in the costume of Le Pouldu stands erect and drops grapes into the apron at her waist. Gauguin has made an even more radically simplified composition than the one in *The Vision after the Sermon*. The vineyard consists of nothing more than triangular mounds of red and purple pigment, while a field of chrome yellow serves as the "sky." Virtually all topographical details have been suppressed and the space has been extremely flattened. Indeed, if one eliminated the figures, *Grape Gathering: Human Misery* might pass as an Abstract-Expressionist painting by Clyfford Still or Philip Guston. The figures themselves, though solidly modeled, are se-

verely ordered and limited. Gauguin places the girl and laboring peasants on the same central axis and aligns the standing figure with the left edge of the canvas.

What does this breakthrough work—in many ways more enigmatic and truly Symbolist than *The Vision after the Sermon*—signify? So much of our understanding of *Grape Gathering: Human Misery* depends on Gauguin's commentary and later art historical interpretations that it is instructive to see what the picture can tell us on its own. It is immediately apparent that the young girl has set herself apart from the other women. She does not work, wears more informal clothes, allows her hair to flow freely, and literally turns her back on the peasants behind her. Yet Gauguin's composition ties her closely to the laborers. The rounded forms of the two stooped harvesters, who very economically convey the dehumanizing anonymity, repetition, and strain of manual work, not only share the central vertical axis with the girl but also echo the round shapes of her knees and head. What is more, they are angled, like her, to the right (as is the clog on the left foot of the standing figure). So Gauguin has established a tension between the likely fate of the young girl and her own wishes. But she contemplates more than simply entering the ranks of peasant laborers. The theme of the harvest and the insistent black of the Breton costumes evoke the cycles of life and death. And one essential element of this cycle is sexuality. The young girl must meditate, then, on the loss of virginity, assumption of the roles of woman and mother, and all of the crushing duties these roles will entail. Sexual maturity, marriage, childbirth, and backbreaking work will "harvest" her as inevitably as the peasants harvest the grapes. And this death-in-life has its pictorial correlative in the juxtaposition of the figures' downward glances with the upward push of the pyramidal vineyard.

More than a month after completing *Grape Gathering: Human Misery*, Gauguin expanded on the picture's meaning in a letter to Schuffenecker:

> Do you notice in the *Vintage* a poor disconsolate being? It is not a nature deprived of intelligence of grace and of all the gifts of nature. It is a woman. Her two hands under her chin she thinks of few things, but feels the consolation of the earth (nothing but the earth) which the sun spreads with its red triangle. And a woman dressed in black goes by, looking at her like a sister . . . all is conventional and in French good and bad

are the words which express the state of things; black; mourning; why can't we come
to create the diverse harmonies corresponding to the state of our soul?[20]

By pointing out that the "disconsolate being" is not "deprived of intelli-
gence" Gauguin implies that the girl has accurately understood her pitiful con-
dition as a woman. But what exactly is the "consolation" she takes from the
"earth" that the "sun spreads with its red triangle"? It may appear excessively
Freudian to see this consolation as sexual and the "red triangle" as an allusion
to female genitalia, but Gauguin's later works justify such a reading. The red-
headed girl, in fact, constitutes the first in a series of related figural types who
come to represent tempted and fallen Eves in Gauguin's art. And Gauguin
makes the sexual connotations explicit by pairing her with an adolescent boy
in a lithograph of 1889. That the "woman dressed in black" looks at the girl
"like a sister" indicates the brooding figure's inexorable connection to the
peasants and to the life cycle from which she turns away. Gauguin's final re-
marks about the color black seem to argue that if convention has allowed black
to become an effective symbol of mourning then other colors might also pos-
sess equally powerful signifying functions.

Vincent, of course, had already recognized the symbolic potency of color,
and this raises the question of his influence on the formation of *Grape Gather-
ing: Human Misery*. Vincent did not need to instruct Gauguin on the expres-
sive capacity of color freed from representation. Gauguin had already demon-
strated his understanding of the dramatic force of nonnaturalistic color with
the lush vermilion background of the *Vision after the Sermon*. But Gauguin's
exposure to Vincent's theories and to the highly saturated hues of his Arles
paintings may have nudged him toward an even purer and more heightened
palette. Vincent may also have influenced Gauguin's paint handling in *Grape
Gathering: Human Misery*. Gauguin in a letter to Bernard describes the pig-
ment as "laid on thickly with a knife on coarse sack-cloth."[21] Although Gau-
guin generally disdained impasto effects, he moved closer in this instance to
Vincent's Monticelli-inspired style.

More striking than the formal traits that *Grape Gathering: Human Misery*
shares with Vincent's paintings are the affinities between Vincent's and Gau-
guin's conceptions of women. Vincent's *Sorrow*, in particular, could serve as a

prototype for Gauguin's canvas.[22] The naked Sien in Vincent's drawing and Gauguin's red-haired girl assume remarkably similar poses. Both crouch on the ground in a near-fetal position with their knees pulled up, their backs arched, and their heads resting on their hands. Both artists, moreover, have created visions of women's existence as enmeshed in natural cycles that destroy more than they enliven. While Vincent depicts Sien's pregnant belly and surrounds her with roots and wild flowers, he also includes leafless branches and renders her bone-thin body as if it were on the brink of collapse. Although the inscription "Sorrow" was already superfluous for an image that exudes nothing but pathos, Vincent added a line from Michelet to one version of the drawing: "How could there be on this earth a single, desperate woman." It is as if the anguished Sien has already lived out the gloomy future contemplated by Gauguin's "desolate being."

Vincent also anticipated Gauguin's standing peasant in black in his attachment to certain poems and literary passages. His first sermon drew on Christina Rosetti's "Uphill" in which a "woman, or figure in black," informs a pilgrim of life's constant hardships that end only in death.[23] And one of Vincent's favorite lines by Alfred de Musset, which he quoted in a letter from December 1888, declares, "Wherever I touched the earth—a miserable fellow in black sat down close to us, and looked at us like a brother."[24] Gauguin may have had this verse in mind when he stated that his own dark figure regards the red-haired girl "like a sister." He may have drawn as well on the declamatory tone of Michelet's lament when he wrote, "Do you notice in the *Vintage* a poor disconsolate being? It is not a nature deprived of grace and of all the gifts of nature. It is a woman."[25]

Harder to pin down than the affinities between the artists' works and attitudes is the precise nature of Vincent's influence on Gauguin. Did Gauguin see a version of *Sorrow* among Vincent's possessions in Arles? Did Vincent discuss his preoccupation with the image of a woman dressed in black, which included not only the figure in Christina Rosetti's poem but also a seventeenth-century portrait of a mourning woman in the Louvre and its novelistic description by Michelet? Or did conversations with Vincent affect Gauguin's *descriptions* of *Grape Harvesting: Human Misery* but not the work itself? No documents exist that might answer these questions with any certainty. Nor can

we rule out the possibility that the parallels were coincidental. Fin-de-siècle culture overflowed with notions of women as fatal creatures closely tied to nature. And Gauguin would eventually contribute his own share of *femmes fatales* to the armies of Sphinxes, Medusas, and Salomes produced by Symbolist artists.

Vincent may actually have exerted his greatest influence on the unconscious level of Gauguin's creative process. The "utterly bewitched" girl possesses two distinctive features associated with Vincent—red hair and slanted eyes, recalling those in *Self-Portrait as a Buddhist Monk*. Gauguin, who implicitly equated himself with a "pure young girl" in his description of *Les Misérables*, now feminized Vincent.[26] As we have seen, Vincent had already transformed Gauguin's sexuality when he thought of him as a "really artistic woman" while trying to turn his room in the Yellow House into a "boudoir."[27] Why would Gauguin return the favor? Some of the unconscious motives may have been the same. That is, Gauguin, like Vincent, would have wanted to feminize the other to allay fears of playing the submissive role in the partnership and to defend against homoerotic desires. But Gauguin may also have wanted to neutralize his competition. Vincent, far from threatening the "abbot's" artistic supremacy, has been reduced in *Grape Gathering: Human Misery* to a troubled young peasant girl. Picasso, who shared Gauguin's swagger, competitiveness, and Don Juanism, made a similar gesture toward a colleague who was both a close collaborator and a rival. He gave Braque, with whom he was nearly inseparable during the invention of Cubism, the humorous yet devilishly undermining title of "Madame Picasso."

III

Once again, Vincent betrayed no awareness of the barbs embedded in Gauguin's work. On the contrary, he praised *Grape Gathering: Human Misery* even more lavishly than he had *The Night Café*. It is "very fine and very unusual," "as beautiful as the Negresses," and will put his "Breton canvases a little in the shade."[28] He also thought so highly of the painting that he decided to work from memory himself. Gauguin had been encouraging him in this direction, and Vincent's remarks to Theo reflect the older artist's exhortations. Vincent,

who only a month before had vehemently declared to Bernard that he "cannot work without a model," now insisted on the superiority of paintings from memory and the imagination.[29] Such pictures "take on a more mysterious character," are "less awkward," and have "a more artistic look than studies from nature."[30]

By setting his own "studies from nature" against Gauguin's "things from the imagination" Vincent created an opposition that he himself recognized as simplistic.[31] In the letter to Bernard mentioned above he defended his need to study from the model but at the same time clearly acknowledged the obviously "mediated" character of his own art. His paintings were interpretations, not copies of the subject:

> I won't say that I don't turn my back on nature ruthlessly in order to turn a study into a picture, arranging the colors, enlarging and simplifying. . . . I exaggerate, sometimes I make changes in a motif; but for all that I do not invent the whole picture. . . . [32]

Vincent made these remarks in the context of his recent departure from his own practice. He had based a painting meant for Bernard on his recollection of a pimp and a prostitute in a café. Vincent had a low opinion of the canvas and would not sign it, "for I never work from memory."[33] This was inaccurate, however, not only because he had just painted such a picture but also in view of his account of *The Potato Eaters*. At the time, he had told Theo, "I paint this *from memory on the picture itself*. But you know yourself how many times I have painted these heads!"[34]

So Vincent could indeed "work from memory." What presented a more serious challenge was, in his words, "invent[ing] the whole picture." In Arles he had twice tried to paint a *Christ in the Garden of Gethsemane* only to scrape off the canvas each time. And when he attempted to put Gauguin's advice into practice by painting *Memory of a Garden in Etten* [5.7], he did not "invent" any motifs but drew instead on familiar imagery from his recent and past experience. The garden, in which two female figures stroll, combines memories of Etten, Neunen, and the public park in front of the Yellow House. The younger woman resembles Kee, his sister Wil, and Mme. Ginoux, while the older one bears a likeness to his mother, whose photograph he had received earlier in the

Figure 5.7 Vincent van Gogh, *Memory of a Garden at Etten* (1888)

year. The stooping servant, moreover, recalls countless bending peasant figures that Vincent drew in Holland.

In a long description of this painting for his sister Wil, Vincent emphasized the ways in which he used purely abstract means to capture the spirit of the figures and to create the visual equivalent of poetry:

> Here you are. I know this is hardly what one might call a likeness, but for me it renders the poetic character and the style of the garden as I feel it. All the same, let us suppose that the two ladies out for a walk are you and our mother; let us even suppose that there is not the least, absolutely not the least vulgar and fatuous resemblance—yet the deliberate choice of the color, the somber violet with the blotch of violent citron yellow of the dahlias, suggests Mother's personality to me.

Figure 5.8 Emile Bernard, *Breton Women in a Meadow* (1888)

The figure in the Scotch plaid with orange and green checks stands out against the somber green of the cypress, which contrast is further accentuated by the red parasol—this figure gives me an impression of you like those in Dickens's novels, a vaguely representative figure.

I don't know whether you can understand that one may make a poem only by arranging colors, in the same way that one can say comforting things in music.

In a similar manner the bizarre lines, purposely selected and multiplied, meandering all through the picture, may fail to give the garden a vulgar resemblance, but may present it to our minds as seen in a dream depicting its character, and at the same time stranger than it is in reality.[35]

To achieve these effects Vincent made his flattest and most decorative canvas to date. In a more typical work, the garden path would have aligned itself

along Vincent's beloved orthogonals and flown off toward a distant vanishing point. But here Vincent tames it into an arabesque that rhymes with the dominant curves of the composition. Nearly everything—the older woman's cloak, the cypresses, the cedar shrubs, and the bending maidservant—consists of curving contours that rise up in flamelike circuits on the picture surface. And Vincent has permitted no spatial release—no sky or horizon line—that might mitigate the "musical" effect of these "bizarre lines, purposely selected and multiplied."

Some of the phrases in Vincent's description—"poetic character and style" or "deliberate choice of the color"—have a Gauguinesque ring. But the picture itself appears surprisingly unlike the older artist's work up to that point. The paint handling, in particular, must have irritated Gauguin as he disliked both impasto and Seurat's "little dots." Vincent abandoned one of the triumphs of his Arles period—the marriage of drawing and painting—for a sort of fattened pointilism. Instead of using the directional and textural strokes of *The Sower* and *The Bedroom,* he applied thick daubs in polka-dot patterns over tightly demarcated patches of fabric and vegetation. The thick outlines in these passages recall Cloisonism more than Gauguin's art and reflect the presence in the Yellow House of Bernard's *Breton Women in a Meadow* [5.8]. Gauguin had brought the painting from Pont-Aven, and Vincent, who greatly admired it, executed a copy in watercolor.

Memory of a Garden in Etten most closely resembles Gauguin's own depiction of women strolling in a park, *Women of Arles* [5.9]. The canvas goes unmentioned in Vincent's and Gauguin's letters and is difficult to date, but Gauguin probably painted it while Vincent worked on his version of the subject. Gauguin tilts up the background even more radically than Vincent and crops and flattens the foreground pair of Arlésiennes in a manner that must have influenced the younger artist. As Gauguin's women protect themselves from the mistral with shawls, only heads and a hand emerge from what otherwise appear as overlapping, veil-like silhouettes. Vincent carries this over into his own canvas where he similarly cloaks Wil and his mother, crops them at the waist, disembodies their figures, fuses them into one shape, and places them in the same location in the lower left foreground. Vincent must also have picked up on the great swinging curve of lawn that extends from the top to the bottom of

Figure 5.9 Pul Gauguin, *Women of Arles* (1888)

Gauguin's painting. It establishes the curvilinear rhythm for his own "meandering" lines.

Yet, as is the case with the two artists' depictions of the Alyscamps, the differences multiply once one goes beyond a few compositional parallels. In contrast to Vincent's extremely busy paint handling Gauguin leaves fields of solid color largely uninflected. Gauguin also displays an attachment to strangeness for its own sake. The women appear mysterious and vaguely Arabian in their shawls, and instead of Vincent's relatively banal shrubs and flower beds Gauguin depicts a fountain and a reflecting pool. Even more unusual are such motifs as the insectlike bench that crawls over the top of the canvas, the weird conical shapes that represent straw packing to protect trees against frost, and the

facial features (perhaps a self-portrait) hidden in a large bush. But these bizarre touches do not prevent Gauguin from imposing a more rigorous structure on his picture. He organizes the figures around a simple doubling theme that begins with the pair of women in the foreground, continues by way of a two-pointed headdress to the female couple in the background, and culminates in the twinned cones on the right. All of these doubled elements, moreover, form verticals that combine with the fence to stabilize the picture's sinuous curves.

Vincent eventually wrote to Theo that he had "spoiled that thing that I did of the garden in Neunen."[36] Vincent fails to make clear why he considered it spoiled. The juxtaposition of viewpoints from above the garden and in front of the women certainly has a disjunctive but not particularly expressive effect. And the stooping servant gets lost in the undefined middle space. Vincent could not create the satisfying tension between a carefully modeled foreground figure and a flatter, more abstract background that Gauguin established in *Vision after the Sermon* and *Grape Gathering: Human Misery*. Drawing the figure also appears to have presented special problems for Vincent when he painted without a model. This may have been what he had in mind when he said that "you also need to practice for work from the imagination."[37]

IV

Despite his difficulties with *Memory of a Garden in Etten*, Vincent made three other "abstract studies" while Gauguin remained in Arles. The most ambitious of these, *The Dance Hall*, depicts the crowded and festive interior of the Folies Arlésienne. The influence of Cloisonism is even more evident in the extremely compressed space of this picture. Like Gauguin in *Vision after the Sermon*, Vincent places the viewer behind women with distinctive headdresses (in this case, the small cap with a sash of the *Arlésienne coiffe Mirielle*). But Vincent treats the heads in a much simpler and more schematic manner. The white-topped caps, shoulder-length curls of hair, and blue sashes of the women in the foreground are rendered with such thick outlines that they become almost totally abstract designs. The white ovals of the caps, in particular, form a pattern of large dots that serves as the counterpart to the floating globes of the gaslights in the upper half of the painting. Vincent uses the most mini-

mal notation for these orbs and reduces them to orange wafers on the picture surface. Among the revelers, he mostly avoids the problem of inventing physiognomies by showing the backs of heads or severely abbreviating faces. We can nonetheless recognize Madame Roulin's features at the right.

Vincent continued to portray crowd scenes in another work from memory, *Spectators at the Arena.* He had contemplated painting the local bullfights as early as April and now followed through with his idea. However, he handles the spectators in a much sketchier manner than the densely packed group in *The Dance Hall.* While Vincent pushes everything in the latter picture to the surface, in *Spectators at the Arena* he allows a perspectival sweep as the audience around the ring gradually shrinks in size to the tiniest of stenographic marks. Out of the welter of very loosely defined faces a few identifiable figures emerge. The postman Roulin sits in the stands with his wife and new baby. Madame Ginoux converses with another woman, and a female head borrowed from Bernard peers out at the lower left. Once again Vincent prefers to draw on available imagery rather than invent an original figure as Gauguin had in *Grape Gathering: Human Misery.*

The third picture, *Woman Reading a Novel,* proves exceptional in several ways. Vincent depicts only one person, drastically simplifies his composition, and creates a new image. Yet Bernard's influence persists. The reader, who bends over a novel, might have stepped out of *Breton Women in a Meadow.* Vincent not only employs curvilinear shapes and thick Cloisonist outlines but also places solid areas of lighter color within dark contours. This gives the figure the weightless, calligraphic transparency of so many of Bernard's works from 1888.

Among Vincent's four paintings from memory the most thoroughly worked out are *Memory of a Garden at Etten* and *The Dance Hall.* In these pictures we see Vincent and Gauguin going in opposite directions. While memory and imagination purify Gauguin's motifs and lead to more distilled compositions, Vincent reacts with a *horror vacui* that fills every inch of the canvas with ornamental patterning. It is as if the canvas becomes a decorative object substituting for the lost model in the real world. The patterning, moreover, has an incontinent wildness that reappears in the backgrounds of later, postbreakdown portraits of Madame Roulin, the Postman Roulin, and Dr. Rey. This type of pat-

terning contrasts in revealing ways with his Arles landscapes of gardens and flowering fields. Some of these, such as *Flowering Garden* (F340), erupt in such a rich array of dottings and daubings that the flowers lose their representational identities and read simply as brightly colored spots. But Vincent always supplies enough perspectival clues—the receding rows of plantings, the distant farmhouses, and segments of sky—to pull the viewer away from the opulent surface and back into a more conventional pictorial space. This fine balance between an explosive profusion of painterly notations and a convincing illusionism was a product of the mastery that Vincent achieved at certain points in 1888. As *Memory of a Garden at Etten* and *The Dance Hall* indicate, he could not regain such heights without a subject before him.

V

The painting by Vincent that displayed the best understanding of Gauguin's latest advances was not a work from the imagination but a return to the extremely familiar theme of the sower (although one could argue that the image of the sower had by now so thoroughly penetrated Vincent's mind that it belonged more to his imagination than to any real-world model). Around November 25, he reported to Theo that he had seen "an extraordinarily beautiful sunset of mysterious sickly citron color—Prussian blue cypresses against trees with dead leaves. . . . " This disquieting twilight view most likely provided the setting for his new sower as he describes the painting in the same letter and refers to the "immense citron-yellow disk for the sun" and the color of the tree and figure as "Prussian blue."[38] What immediately sets this *Sower* [5.10] apart is the crepuscular atmosphere that contrasts so sharply with the blazing sunlight of earlier versions. But Vincent also displays a new ability to simplify a composition and to organize a few central elements—tree, sower, and sun—in a way that concentrates their suggestive power. Although the tree cuts across the canvas in a manner reminiscent of Japanese prints, it recalls as well the tree trunk that divides fantasy from reality in *The Vision after the Sermon.* In this case, the more visionary elements appear in the lower, earthbound half. Vincent has turned the angular forms of both the tree and sower into dark, otherworldly silhouettes. And he has placed the sun over the sower's head so that it

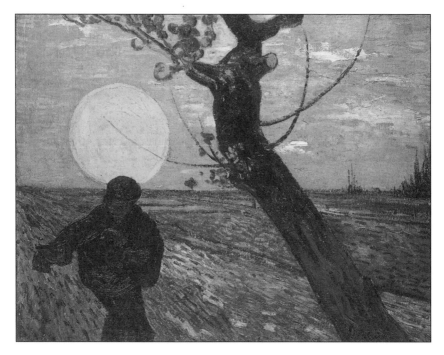

Figure 5.10 Vincent van Gogh, *The Sower* (1888)

becomes a large halo. Spiky, thornlike branches that pierce this "halo" further underscore the religious meanings already inherent in the subject. Yet, as in *Grape Gathering: Human Misery,* the symbolism never becomes so heavy-handed that it disrupts the picture's ambiguous tone. After first making a study, Vincent painted a more finished version that he regarded highly enough to sign. No other work merited this distinction during Gauguin's stay.

Having exhausted his desire to work from memory, Vincent eagerly turned to the project of making portraits of the entire Roulin family. His relief at escaping Gauguin's realm and returning to his own becomes palpable in his remarks to Theo: "I have just made portraits *of a whole family* . . . the man, his wife, the baby, the little boy, and the son of [seven]teen. . . . You know how I feel about this, how I feel in my element."[39] Vincent translated this enthusiasm into some

of the finest portraits of the entire Arles period. It was as if Vincent intended to show Gauguin what he could accomplish when painting on his own terms. Two of the most remarkable of these portraits depict the seventeen-year-old Armand Roulin. In one, Armand faces the viewer with a combination of fragility and a bluffing sangfroid. Freed from the mannered touch of *Memory of a Garden at Etten* and *The Dance Hall,* Vincent's paint handling attains here an unprecedented suavity and assurance. As Ronald Pickvance has pointed out, this picture comes much closer to fulfilling the description that Vincent assigned to Bernard's weaker *Self-Portrait:* "It is just the inner vision of a painter, a few abrupt tones, a few dark lines, but it has the distinction of a real, real Manet"[40]

This painterly finesse plays an essential role in the portrait's psychological acuity. Vincent has eschewed his customary complementaries for a moodier palette of yellows, light greens, and dark blues and has delicately drawn Armand's facial features. He subtly conveys the disequilibrium of adolescence by a series of carefully balanced diagonals. This begins with the jaunty angle of the hat brim, which becomes defused by the counterbalancing angles of the tie, collar, and the hat's peak. Vincent further reinforces Armand's self-containment by aligning his nose and mouth along a strong vertical axis that runs through the center of the canvas. The second portrait more frankly discloses Armand's vulnerability. Against a colder palette of dark blues and greens Armand appears in a three-quarter view that exposes his weak chin and sad eyes. This portrait does not have the immediately bravura impact but proves nearly as successful. Vincent maintains the high level of draftsmanship in the face and the masterful command of compositional elements, such as the hat with all of the triangular and wedge shapes that it generates.

Although Vincent landed back on his own artistic turf, he did not entirely abandon Gauguin's influence. The thinness of his paint handling in the portraits of Armand Roulin is much closer to Gauguin's, and in the portrait of the postman Roulin he simplifies the planes and builds up the image with firmer outlines and more controlled, Gauguinlike strokes. The series of Roulin family portraits also provided the last occasion for Vincent and Gauguin to work from the same model. This was Josephine Roulin, the postman's wife, whom Vincent painted frequently in December 1888 and January 1889. As Gauguin's portrait of

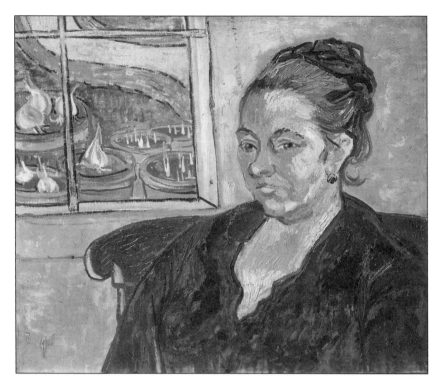

Figure 5.11 Vincent van Gogh, *Madame Roulin* (1888)

Madame Roulin [5.12] and Vincent's Winterthur version [5.11] share a similar horizontal format, one assumes that they were painted at the same time in late November and early December. But not all of the details coincide. In Gauguin's picture, Madame Roulin's costume and the placement of her hands more closely resemble her portrayal in Vincent's later *La Berceuse* (the cradle rocker) [5.13]. So it is likely that Gauguin worked on his portrait throughout December while Madame Roulin sat for both of Vincent's paintings.

Gauguin, not surprisingly, makes a more enigmatic figure out of Madame Roulin. He takes advantage of the gaslight that illuminated the Yellow House during the winter months and retains the lurid green tones on Madame Roulin's face and the exaggerated shadows that fall on her right cheek, the

Figure 5.12 Paul Gauguin, *Madame Roulin* (1888)

wall, and the doorjamb. He also rounds out and schematizes her face so that it
becomes a mask. All of these effects combined with her unseeing, hypnotized
gaze gives her a strangely diffident, almost Buddhalike presence. Vincent, by
contrast, renders her more straightforwardly with rapid brush strokes and a
simpler palette of red, green, and ocher. Yet Vincent has added his own inven-
tion in the form of a view out of a window next to Madame Roulin's head. It
looks out on flower pots of sprouting bulbs, which no doubt allude to the re-
cent birth of her daughter Marcelle Roulin. Behind the plants a winding path,
similar to the one in *Memory of a Garden at Etten,* snakes up parallel to the
picture plane.

The counterpart to Vincent's window in Gauguin's portrait is the section of
Blue Trees that frames Madame Roulin's head. In the recently finished *Blue
Trees,* Gauguin belatedly put into practice the famous advice that he had given

Figure 5.13 Vincent van Gogh, *La Berceuse* (1888)

the young painter Paul Sérusier in Pont-Aven. Defending the artist's absolute right to deploy color as he pleased, Gauguin told Sérusier, "How do you see the trees? They are yellow. Well then, put down yellow. And that shadow is rather blue. So render it with pure ultramarine. Those red leaves? Use vermilion."[41] In this case Gauguin not only gave the trees a nonnaturalistic color but also left them branchless and unmodeled so that they turn into undulating ribbons on the picture surface. Behind the trees one sees a flattened field and a bright yellow sky above a high horizon. In the foreground a young couple, partially obscured by the tree trunks, stare in different directions as if they have just had a confrontation.

Why did Gauguin choose this particular work as the backdrop for his portrait? On the formal level, he could rhyme the contours of Madame Roulin's arms and shoulders with the gentle curves of the path and patches of grass in the landscape. But Gauguin may also have used *Blue Trees* for yet another jibe at Vincent and his favorite Arlesian subjects. He has placed Madame Roulin's head over the couple in such a way that the figures become a hidden comment on her life and thoughts. As one would expect from Gauguin, the truth that "lies behind" Madame Roulin is witheringly unsentimental. He originally gave *Blue Trees* the title "Vous y passerez la belle," which roughly translates as "Your turn will come, my beauty."[42] The man, in other words, has warned the young woman that, however much she may resist now, her turn for sexual initiation will come. Like the red-haired girl in *Grape Gathering: Human Misery,* she must inevitably take her place in the life cycle. In the context of Madame Roulin's character, this allusion to sexual desire becomes especially mischievous and irreverent. Vincent had come to regard this mother of three as an idealized maternal figure and in his several versions of *La Berceuse* apotheosized her as a consoling Madonna.

VI

Although Gauguin's provocations remained largely disguised in *Madame Roulin,* they became much more overt in the work he made soon afterward, *Portrait of Vincent van Gogh Painting Sunflowers* [5.14]. At first glance, however, nothing seems amiss in this close-up view of Vincent painting his signa-

ture motif in the studio of the Yellow House. One can accept the description, which Gauguin gave to Theo, of the canvas as an "intimate" portrait of his friend as "the painter of sunflowers."[43] It is even possible to regard the picture as an homage to Vincent's mastery of his medium and his extreme attentiveness to his subject matter. In the ambiguous space of the portrait, Vincent seems to sit very near the sunflowers that Gauguin has placed on a deal chair next to the easel. Vincent's palette, in fact, appears to slide under one of the seed heads while his brush seems to touch simultaneously his canvas and a leaf of one of the sunflowers. This visual pun implies that Vincent's brush is so sure and magical that no gap exists between the subject itself and its representation in the painting. Gauguin also extends Vincent's right arm straight from his shoulder so that it follows the line of his intent gaze toward his brush and the flowers. The arm becomes a powerful link between artist, subject, and canvas and suggests that Vincent's visual impressions can instantly travel across this bridge to their realization in his painting. Indeed, artist and subject are so interconnected that Vincent, with his orange hair and blue-trimmed orange jacket, shares the same coloring as the orange sunflowers in their blue ceramic vase.

Yet details emerge that reveal that Gauguin has subtly diminished Vincent while aggrandizing himself. Vincent's brush, instead of possessing a potent size and heft, has been reduced to the thinness of a needle. It is so insubstantial that one barely perceives it. The canvas on which he works has been similarly negated as Gauguin turns its surface away from the viewer. Gauguin shows no such modesty about his own work and hangs one of his large landscapes, which resembles *Blue Trees,* on the wall behind Vincent and his easel. Gauguin has also chosen an unusual vantage above Vincent and has depicted him with a squinting, nearly stupefied expression. The content of the portrait, moreover, has given Gauguin the chance to challenge Vincent on his most prized ground—the painting of sunflowers. Gauguin does not waste the opportunity and depicts the flowers in a manner markedly different from Vincent. He exaggerates the size of the disks, strips them of their leaves, and makes them much more like giant eyes. The sunflowers, paradoxically, appear more open-eyed than Vincent himself. Finally, Gauguin shows that he can construct a taut composition out of the very wedge shapes—those "characteristic angularities" as Meyer Schapiro called them—favored by Vincent.[44] Gauguin introduces this

Figure 5.14 Paul Gauguin, *Vincent van Gogh Painting Sunflowers* (1888)

compositional note with the dominant "V" established by the tilted canvas and Vincent's bending torso. He then repeats the triangular forms in the negative space created by the easel and Vincent's right arm.

Extending his one-upmanship to a deeper level, Gauguin also reasserts the superiority of working from memory in *Portrait of Vincent van Gogh Painting Sunflowers.* He began the painting at the moment when Vincent had happily relinquished *"travailler de tête"* for his portraits of the Roulin family. So Gauguin's canvas amounts to a retort. Gauguin must have relished the irony of insinuating a defense of the imagination into a painting ostensibly celebrating an artist's intimate relationship with his subject. Although Gauguin had, of course, seen Vincent working before his easel many times, the latter did not pose for him. Vincent had not actually painted sunflowers since September (though in December he was painting the deal chair, on which the flowers sit,

for his symbolic self-portrait *Van Gogh's Chair*). Gauguin invented the picture based on several sketches and on his own imaginary conception. But Gauguin's rebuttal went beyond making the portrait itself an example of his methods. By hooding Vincent's eyes Gauguin suggests that he must turn inward to create his art. And he reinforces this notion by the bands in the framing landscape that seem to flow from Vincent's head to the canvas. By means of this compositional device, Gauguin insists that the genuine artist must bypass the subject before him and communicate his thoughts directly to his painting.

Vincent's initial response to the picture did not depart from the "see no evil" attitude he adopted during the first half of Gauguin's stay. He wrote to Theo on December 4 that Gauguin was "working on a portrait of me which I do not count among his useless undertakings."[45] About a year later, he referred to the painting again and only hinted at its more caustic aspects: "Have you seen that portrait that he did of me painting some sunflowers? Afterward my face got much brighter, but it was really me, very tired and charged with electricity as I was then."[46] However, in Gauguin's memoir, *Avant et après*, Vincent's reaction to the portrait is so literally violent that it sets off a chain of events leading to the ear-cutting:

. . . When the portrait was finished, he said to me, "It is certainly I, but it's I gone mad."

That very evening we went to the café. He took a light absinthe. Suddenly he flung the glass and its contents at my head. I avoided the blow and, taking him bodily in my arms, went out of the café, across the Place Victor Hugo. Not many minutes later Vincent found himself in his bed where, in a few seconds, he was asleep, not to awaken again till morning.

When he awoke, he said to me very calmly, "My dear Gauguin, I have a vague memory that I offended you last evening."

Answer: "I forgive you gladly and with all my heart, but yesterday's scene might occur again and if I were struck I might lose control of myself and give you a choking. So permit me to write your brother and tell him that I am coming back."

My God, what a day!

When evening had come and I bolted my dinner, I felt I must go out alone and take the air. . . . I heard behind me a well-known step, short, quick, irregular. I turned about on the instant as Vincent rushed toward me, an open razor in his hand. My look

at that moment must have had great power in it, for he stopped and, lowering his head, set off running towards home. . . .

With one bound I was in a good Arlesian hotel. . . .

I was so agitated that I could not get to sleep till about three in the morning, and I awoke rather late, at about half-past seven.

Reaching the square, I saw a great crowd collected. Near our house there were some gendarmes. . . .

This is what happened.

Van Gogh had gone back to the house and had immediately cut off his ear close to the head.[47]

Did *Vincent van Gogh Painting Sunflowers* really trigger the collapse of the Yellow House? Much in Gauguin's account remains doubtful as he wrote *Avant et après* fourteen years after his sojourn in Arles and had various axes to grind. His veracity would not matter if we had reliable information from other sources, but few letters survive from this period and they are difficult to date. In fact, the only detail in Gauguin's narrative that we can absolutely verify, besides the ear cutting, is his letter to Theo insisting that he must come back to Paris. Everything else—Vincent's reaction to the portrait, his hurling of the absinthe, his threatening Gauguin with a razor, and the sequence of these events—is subject to debate. We do know, however, that Gauguin's chronology definitely errs in at least one instance. He could not have written the letter to Theo announcing his return to Paris on the same day as the ear cutting. Another letter survives in which Gauguin tells Theo to treat his previous missive stating his desire to leave as if it were a "bad dream."[48] So some time must have passed between Gauguin's first urge to flee the Yellow House and the disaster that finally secured his departure.

Although the paucity of documentary evidence and, in particular, dated letters makes any history of the last two weeks in December speculative, the most convincing reconstruction proceeds as follows: Gauguin finishes *Vincent van Gogh Painting Sunflowers* on about December 14. Vincent may or may not have said, "It is certainly I, but it's I gone mad," and may or may not have hurled an absinthe at Gauguin. But he does something to prompt Gauguin to write Theo on December 14 or 15 that "Vincent and I can absolutely not live

together without trouble because of our temperamental incompatibility.
. . . He is a man of remarkable intelligence whom I greatly esteem and I leave
with regret, but I repeat, it is necessary."[49] Gauguin's discomfort prompts Vin-
cent in turn to write Theo on December 16 or 17 that "Gauguin was a little out
of sorts with the good town of Arles, the little yellow house where we work, and
especially with me." And he adds the sort of denial of his injured feelings that
we saw when Gauguin dragged his feet coming to Provence: "I am waiting for
him to make a decision with absolute serenity."[50] Gauguin does not leave after
all, and he and Vincent take a day trip on December 17 or 18 to the Musée
Fabre in Montpellier. On December 18 or 19, Gauguin writes Theo that he
must consider his trip to Paris as an "imaginary thing" and says that he is send-
ing him *Vincent van Gogh Painting Sunflowers.*[51] On the evening of December
23, Vincent may or may not have threatened Gauguin with a razor, but he defi-
nitely cut his ear and presented it to the prostitute Rachel around 11:30 P.M.

It obviously took more than Gauguin's portrait of Vincent to set relations in the
Yellow House on a downward spiral. But what were the causes? What brought
Vincent to the point of provoking Gauguin to leave? Gauguin's plan to return to
Martinique was certainly a major source of tension. But other factors conspired to
make the failure of the collaboration nearly inevitable. One of the most important
of these was a strong pattern in Vincent's relationships with the significant men in
his life. As we have seen, he would idealize them, attempt to merge with them, and
then angrily attack them. Vincent acted out this cycle with his father, with Theo,
and to a lesser extent with Mauve. He had already rehearsed much of it with Gau-
guin in epistolary form during the long waiting period for his arrival in Arles.

The idealization of Gauguin only increased once Vincent had a chance to hear
firsthand about his many exploits. And the letters to Theo return to the familiar
note of fawning admiration. Gauguin is "astonishing as a man" and a "very great
artist and a very excellent friend."[52] After Gauguin informed him more fully of
his past and showed him pictures of his family, Vincent could fill out his image of
Gauguin as a father figure with actual details. As an experienced father, for exam-
ple, Gauguin could shrug off the anxieties of childbirth: "He [Guillaumin] has a
child now but he was *terrified* by the confinement, and he says that he has the red
vision of it always before his eyes. But to this Gauguin aptly replied that he him-
self had seen it six times."[53] Vincent could also add seamanship to the list of

Gauguin's vaunted manly attributes: "I knew well that Gauguin had made sea voyages, but I did not know that he was a regular mariner. He has passed through all the difficulties, and has been a real able seaman and a true sailor. This gives me an awful respect for him and still more absolute confidence in his personality."[54] Gauguin triumphed in the sexual realm as well. Vincent reports that the older artist, who is "married . . . but doesn't look it very much," has been "very successful with the *Arlésiennes*."[55] To Bernard, he remarked that "with Gauguin blood and sex prevail over ambition."[56]

Yet the priapic seaman and veteran father could also play a maternal role. According to *Avant et après,* Gauguin cooked for Vincent and with "much gentle coaxing" organized the chaotic affairs of the Yellow House:

> In the first place, everywhere and in everything I found a disorder that shocked me. His color-box could hardly contain all these tubes, crowded together and never closed. . . . From the very first month I saw that our common finances were taking on the same appearance of disorder. What was I to do? The situation was delicate, as the cash-box was only very modestly filled. . . . I was obliged to speak, at the risk of wounding that very great susceptibility of his. It was thus with many precautions and much gentle coaxing, of a sort very foreign to my nature, that I approached the question. I must confess that I succeeded far more easily than I should have supposed.
>
> We kept a box—so much for hygienic excursions at night, so much for tobacco, so much for incidental expenses, including rent. On top of it lay a scrap of paper and a pencil for us to write down virtuously what each took from this chest. In another box was the rest of the money, divided into four parts, to pay for our food each week. We gave up our little restaurant, and I did the cooking, on a gas stove, while Vincent laid in the provisions, not going very far from the house.[57]

Vincent was so impressed with Gauguin as chef that he exclaimed to Theo: "he knows how to cook *perfectly*."[58]

But even more comforting to Vincent than Gauguin in a parental role was Gauguin as an ideal companion with whom he could share every aspect of his existence. He once begged Theo to become an artist and insisted on the total absence of any "difference or divergence, much less a contrast between you and me."[59] Vincent and Theo would paint side by side in the fields, walk

together "behind the plow and shepherd," and "let the storm that blows across the heath" batter them both.[60] Although Theo wisely declined this request, Vincent could now fulfill his fantasy with Gauguin. Vincent's letters to Theo make it seem as if the two artists functioned as a single unit:

> Our days pass in working, working all the time, in the evening we are dead beat and go off to the café, and after that, early to bed! Such is our life. . . .
>
> I think that we shall end up spending our evenings drawing and writing, there is more work than we can manage.
>
> It does me a tremendous amount of good to have such intelligent company as Gauguin's and to see him work.[61]

Once Vincent had gained a comrade, however, boundary problems invariably arose. When he shared an apartment with Theo he engulfed his brother with the mess of his studio, his endless discussions on art, and his constant physical presence. In Arles he not only engaged Gauguin in ceaseless debates, but also dared to inject himself into Gauguin's painting process. Clearly irritated, Gauguin wrote to Bernard that Vincent "likes my paintings very much, but while I am doing them he always finds that I am doing this or that wrong."[62] In Paris Theo could not even stop his brother's rants by going to bed, as Vincent would simply pull up a chair and keep talking. Similarly, in the Yellow House Vincent would not let ordinary waking and sleeping hours constrain his intimacy with his friend. As Gauguin recounts in *Avant et après*, he would sometimes find Vincent standing over his bed:

> During the latter days of my stay, Vincent would become excessively rough and noisy, and then silent. On several nights I surprised him in the act of getting up and coming over to my bed. To what can I attribute my awakening just at that moment?
>
> At all events, it was enough for me to say to him quite sternly, "What's the matter with you Vincent?" for him to go back to bed without a word and fall into a heavy sleep.[63]

What made Vincent approach the sleeping Gauguin? Sexual desire? Anger? The need to reassure himself that Gauguin had not left? Like the ear cutting, such an enigmatic act must condense a multitude of meanings and impulses.

VII

The wish to find a double, which so profoundly affected Vincent's relationship with Gauguin, nearly became conscious after the trip to Montpellier. Vincent had seen Delacroix's portrait of Alfred Bruyas and had discovered in this red-haired figure an uncanny resemblance to himself and to Theo. So striking was the similarity that it reminded Vincent of the line mentioned above from Alfred de Musset's poem "A December's Night"—"Wherever I touched the earth—a miserable fellow in black sat down close to us, and looked at us like a brother." It would be difficult to find a better expression than this verse of the enduring presence in Vincent's unconscious of the original double—the first Vincent. And each phrase lends itself to interpretation along these lines. "Wherever I touched the earth" recalls the descent into the grave and the peasants' working of the earth that so preoccupied Vincent. "A miserable fellow in black" aptly describes the pitiful, stillborn infant wrapped in the blackness of death. "Sat down close to us" suggests the nearness of the first Vincent's grave to the van Gogh parsonage, the closeness of the blood tie, and the identical birthdays. And finally, "looked at us like a brother" would allude, of course, to the first Vincent's actual status as an older brother. The verse's sense also readily discloses an unconscious meaning. It is Vincent's lament that "wherever he goes" he will always have his perfect, sinless namesake as the harsh measure of his own failure. In order to transcend his lowly state Vincent must fuse his identity with this special being.

Vincent had many reasons for regarding Bruyas as an exalted double. Although the physical resemblance did not go much further than red hair, a red beard, and a gaunt expression, they shared important temperamental traits and artistic ideals. Tubercular, neurasthenic, and introspective, Bruyas became fascinated with the ability of portraiture to capture different emotions. As a result of this interest he commissioned no fewer than thirty-four portraits of himself by a variety of artists including Couture and Courbet as well as Delacroix. Vincent would have felt a great affinity with his high regard for the art of portraiture and would have been especially impressed by Verdier's depiction of Bruyas as Christ covered with thorns. This odd work anticipated Vincent's own expression of his Christ identification in his copy of Delacroix's *Pietà*,

where he gave Christ his own red hair and beard. Bruyas had also fulfilled Vincent's dream of dedicating his life to the support and protection of artists. As the son of a financier, Bruyas had the means to distinguish himself as a generous patron and benefactor. It was Bruyas's extensive collection of paintings, drawings, and sculpture, given to the Musée Fabre in 1868, that Vincent and Gauguin saw in Montpellier. Yet Vincent's need to identify with idealized personages did not stop with Bruyas. He extended the string of likenesses to include Tasso in Delacroix's *Tasso in the Madhouse.* According to Vincent, the figure of the poet "must have some affinity with this fine portrait of [Bruyas]."[64] In this way, Vincent made a further acknowledgement of his own mental disorders as he had implicitly equated himself not only with the nervous Bruyas but also the mad Tasso.

If Delacroix's portrait of Bruyas and Alfred de Musset's "A December Night" brought Vincent closer to a recognition of his desire for a double, Guy de Maupassant's short story "Le Horla" would have confronted him with every aspect of this fantasy. Although Vincent makes only two references to it in letters in January of 1889, he was a great admirer of Maupassant and most likely read the story when it was published in 1887. Gauguin, moreover, wrote in a page of his notebook from the Arles period the words "Orla (Maupassant)," which indicate that Vincent discussed it with him.[65] "Le Horla" (Norman dialect for "the stranger") takes on a special meaning when read in the context of the arrangement in the Yellow House. It could be seen from either Vincent's or Gauguin's point of view as a nightmare vision of every fear and desire inspired by sharing close quarters with another man.

The story involves a solitary bachelor living in a large country house, who becomes convinced that an invisible but palpable being is gradually taking over his life. At first he only feels weak, melancholic, and full of ominous thoughts. He has repeated nightmares of someone kneeling on his chest and strangling him as he lies in his bed. These terrifying dreams evolve into a succubuslike fantasy of someone "squatting on top of me, pressing his mouth against mine and drinking my life through my lips." Then a series of events make him even more convinced of the actual presence of someone in his room. Upon going to bed he leaves a full carafe of water on his night table only to find it empty when he awakens. In his garden he sees a rose plucked by an invisible hand. A page

in a book turns by itself as if the invisible being were sitting in his armchair and reading. He feels controlled by the will of another. When he wants to stand, the "horla"—the name the creature gives for himself through a disembodied voice—forces him to remain riveted to his seat. When he attempts to escape to nearby Rouen, the horla makes him shout to his coachman, "Drive home." Finally, at his wit's end, the hero tries to trap the horla by installing an iron door in his bedroom and placing iron shutters on his windows. Once the bachelor has lured the horla inside, he squeezes out the door, locks it, and sets his house on fire. After realizing that despite the destruction of his house and the immolation of his servants, the horla may still survive, the bachelor concludes that he must kill himself.

Although "Le Horla" seems at first only to fantastically exaggerate the encroachments of an irritating roommate, it goes deeper and captures the ambivalence underlying Vincent's desire to merge with idealized figures such as Gauguin and the first Vincent. For the horla, though sinister, has achieved a superior state of evolution. In fact, the bachelor's comparison of himself with the "spiritual" creature comes remarkably close to the ways in which Vincent would have seen his own flawed self in relation to his angelic, stillborn namesake:

Why are we unable to see him, as we can see all other beings created before us? Because his constitution is more perfect, his body more delicate and complete than ours—ours which is so weak, so clumsily conceived, encumbered with organs that are always tired and strained like an over-complicated mechanism; ours which lives like a plant or an animal, feeding laboriously on air, grass and meat, a living machine subject to disease, deformity and decay, short-winded, ill-regulated, simple and complex, ingeniously ill-made, crudely and delicately constructed, a rough model of a being which might become intelligent and impressive.[66]

Yet to fall under the sway of a "more perfect" character is to risk losing one's own identity. And "Le Horla" powerfully dramatizes the fears and hostility that accompanied Vincent's desire to submit to Gauguin as an "astonishing" man and a "very great artist." The story articulates in particular the fear that submission on one level will lead to submission at every level. The horla begins by violating only the bachelor's physical surroundings, but ends up enter-

ing and controlling the most intimate recesses of his mind. Maupassant's hero, unlike Vincent, makes no acknowledgement of his desire to submit. But the bachelor's paranoid vehemence disguises his actual longings:

> Yesterday, I had a terrible evening. He no longer shows himself but I can feel him near me, spying on me, watching me, penetrating me, dominating me. . . .
>
> Oh, yes, I shall obey him, follow his impulses, carry out all his wishes, make myself humble, servile, submissive. He has the upper hand. But a time will come. . . . [67]

That the bachelor also fears sexually submitting to the horla becomes clear after a close reading of the dreaded nightmare. When fully described, it appears as a thinly veiled account of a violent homoerotic encounter:

> Last night I felt somebody squatting on top of me, pressing his mouth against mine and drinking my life through my lips. Yes he was draining it out of my throat like a leech. Then he got off me, sated, and I woke up so bruised and battered and exhausted that I couldn't move.[68]

The bachelor reacts to these threats to his autonomy with a homicidal rage. In one passage, he tries to attack the horla while he sits reading. The bachelor's conviction that a ghostly presence occupies an empty chair eerily anticipates Vincent's own use of empty chairs for his symbolic portraits of himself and Gauguin:

> My armchair was empty, seemed empty; but I realized that *he* was there, sitting in my place, reading. With one wild bound, like the bound of a maddened animal about to tear its trainer to pieces, I sprang across the room to seize him, throttle him, kill him. . . . But before I reached it my chair tipped over as if someone had fled from me. . . . [69]

Ultimately, as in the case with Vincent, the bachelor turns these aggressive impulses on himself. He sets fire to his beloved house on the Seine and convinces himself that he must commit suicide.

The extent to which Vincent recognized himself in the character of the bachelor remains difficult to determine. He first mentions "Le Horla" in a

doleful post-ear-cutting letter to Gauguin that combines regret over his possible role in the collapse with suspicion that Gauguin's departure was "premeditated." The allusion to Maupassant's story appears within the context of Vincent's thoughts about his portrait of Madame Roulin as a cradle rocker *(La Berceuse)* and his regressive yearnings for consolation:

> In my mental or nervous fever or madness, I do not know too well how to say or name it, my thoughts have sailed on quite a few seas. I have dreamed as far as the flying dutchman [*vasseau fantôme Hollandaise*] and as far as the *horla* and it seems that I then sing . . . an old nursery song in dreaming of what the cradle rockers sang . . . [italics mine].[70]

In a letter to Theo written about a week later, he tried to take a more philosophical attitude toward his mental ailments:

> Old Gauguin and I understand each other basically, and if we are a bit mad, what of it? Aren't we also thoroughly artists enough to contradict suspicions on that score by what we say with the brush?
>
> Perhaps someday everyone will have neuroses, *le horla*, St. Vitus dance, or something else [italics mine].[71]

Is he implying that he had his own "le horla" in the form of his doubts and suspicions about Gauguin? The dismissive linking of "le horla" with "St. Vitas dance" makes it hard to say. But regardless of Vincent's awareness of his affinities with the bachelor, Maupassant's story gives us vivid imaginative access to one source of Vincent's behavior toward Gauguin. The urge to collapse boundaries leads to a threatened sense of self. This triggers attacks on the other that are then directed masochistically against the self.

VIII

Gauguin as father, mother, and the first Vincent became the target of various types of unconscious ambivalence. But many clashes took place on a much more conscious level. Not surprisingly, the most prominent of these involved arguments about art. Initially, it was a matter of seeing Arles through differ-

ent artistic prisms, as Gauguin explained to Bernard in a letter from early November:

> It's odd that Vincent feels the influence of Daumier here; I, on the contrary, see the Puvis (de Chavannes) subjects in their Japanese colorings. Women here with their elegant coiffure have a Greek beauty. Their shawls, falling in folds like the primitives, are, I say, like Greek friezes.[72]

Gradually, the differences became more pointed as Gauguin reports to Bernard several weeks later:

> I am at Arles quite out of my element, so petty and shabby do I find the scenery and the people. Vincent and I do not find ourselves in general agreement, especially in painting. He admires Daumier, Daubigny, Ziem and the great Rousseau, all people I cannot endure. On the other hand, he detests Ingres, Raphael, Degas, all people whom I admire; I answer "Corporal, you're right," for the sake of peace. . . . He is romantic while I am inclined towards a primitive state. When it comes to color he is interested in the accidents of the pigment, as with Monticelli; whereas I detest this messing about in the medium.[73]

Avant et après reiterates these polarized attitudes:

> Despite my efforts to discern, in that chaotic brain, some logical reasons for his critical views, I was unable to account for all the contradictions between his painting and his opinions. For instance, he felt boundless admiration for Meissonier and profoundly hated Ingres. Degas was his despair and Cézanne was nothing but a humbug. The thought of Monticelli made him cry.[74]

All of these statements are incorrect to some degree, and a few are so willfully wrong that one wonders about Gauguin's intentions. Vincent certainly felt "the influence of Daumier" in Arles, but he also saw it in terms of Puvis. Gauguin's "contrary" opinion, in fact, only echoes what Vincent had written Theo a month before, both about Puvis and the Greek aspects of the Arlésiennes: "when you have seen the cypresses and the oleanders here, and the sun

. . . then you will think even more often of the beautiful 'Doux pays' by Puvis Chavannes, and many other pictures of his. . . . There is still a great deal of Greece all through. . . . there is a Venus of Arles just as there is a Venus of Lesbos."[75] Far from "detesting" Degas, Vincent had in July described a Degas nude as a "complete thing, a perfection," that "renders the infinite tangible."[76] And in August he had defended Degas to Bernard as a "virile" artist despite his lawyerlike habits.[77] As for Cézanne, instead of regarding him as "nothing but a humbug," he repeatedly praised him and aspired to know Provence as "intimately" as the master from Aix.[78] Gauguin even falsifies his own tastes. He hardly detested Daumier and was significantly influenced by the Barbizon School paintings in Gustave Arosa's collection. But perhaps the most misleading aspect of Gauguin's account is his omission of Delacroix. Both artists admired the great colorist and discussed him extensively in Arles.

Gauguin created this artificial gap between his own and Vincent's tastes in order to accentuate the differences in their painting and to lay exclusive claim to a distinguished artistic lineage. By opposing Raphael, Ingres, Degas, and Puvis to Daumier, the Barbizon School, and Monticelli, Gauguin placed his own emphasis on line, imagination, and the exotic over Vincent's concern with painterly expressionism, fidelity to the subject, and the rendering of humble figures and settings. The grouping of Raphael, Ingres, and Degas was, of course, far from arbitrary. All were celebrated draftsmen, immensely calculating and precise in their compositions and capable of creating exalted pictorial realms that did not slavishly copy but distilled and manipulated reality. Ingres had famously worshipped Raphael as Degas had in turn made a cult of Ingres. Puvis fell comfortably into this group as he shared the use of incisive contours, carefully controlled compositions, and, in his recreation of the antique world, a sovereign freedom from the constraints of any particular site or model. All four artists, moreover, cared little for the effects of thick and spontaneous paint handling. Gauguin's "elective affinities" also reflect more fundamental differences between his own and Vincent's artistic sensibilities. Gauguin, as he would later confess to his daughter Aline, was a democrat in politics but an aristocrat in art. He believed in hierarchies—"nobility, beauty, delicate tastes"—and felt that "art is only for the minority."[79] Vincent, by contrast, was both more inclusive in his enthusiasms for a wide variety of artists and more expansive in his ambi-

tions to create an art that would find the "infinite" in the ordinary and would console the many, not just connoisseurs.

Vincent, for his part, more freely acknowledged the emotional toll taken by their arguments. After the visit to Montpellier he told Theo, "Gauguin and I talked a lot about Delacroix, Rembrandt, etc. Our arguments are terribly *electric,* sometimes we come out of them with our heads as exhausted as a used electric battery."[80] And in 1889 he recalled that "Gauguin and I talked about [portraiture] and other analogous questions until our nerves were so strained there wasn't a spark of vital warmth left in us."[81] Indeed, these discussions so affected Vincent that when Dr. Rey asked Gauguin what might have overexcited his friend to the point of cutting his ear, Gauguin replied "a question of painting."[82] Of course, Gauguin may have said this because it was the least incriminating response, but Vincent's own words testify to the psychic burden of his aesthetic disputes.

Vincent would have chafed, however, at more than Gauguin's inability to appreciate Rousseau and Monticelli. To the extent that Vincent harbored competitive feelings toward Gauguin he would have been frustrated on two fronts. Gauguin had challenged him on his own terrain no fewer than eight times by painting the Alyscamps, the vineyard, Madame Ginoux, the Night Café, women in the public garden, Madame Roulin, and washerwomen on the Roubine du Roi canal. Vincent must have worried that Gauguin would show the world that he could take on each of Vincent's signature motifs and outdo him. Equally disturbing would have been Gauguin's success in selling his work. Just before his arrival in Arles, Theo had sold one of Gauguin's large Pont-Aven pictures and in November sold three more in a successful exhibition of paintings and ceramics at Boussod & Valadon. Especially pleasing was Degas's purchase of a work and his enthusiasm for Gauguin's paintings in general. Gauguin wrote Bernard, "Degas is going to buy the one of the two Breton women at les Avins. I consider that the greatest possible compliment; as you know, I have the utmost confidence in Degas's judgment—besides, it's an excellent starting point commercially. All Degas's friends have confidence in him."[83] Gauguin also received invitations to exhibit with the progressive artists' association, Les XX, in Brussels and at the offices of the *Revue Indépendente.* He accepted the Vingtestes and indulged in a sardonic rejection to Félix

Fénéon at the *Revue Indépendente,* whom he thought was secretly favoring the Divisionists. Vincent responded to all of this in a typically masochistic manner. If Gauguin's paintings had gained wider recognition, then he would instruct Theo to ensure that his own work enjoyed as little visibility as possible: "Let's quietly postpone exhibiting until I have some thirty size 30 canvases. Then we are going to exhibit them only once in your apartment for our friends, and even then without exercising any pressure. And don't let's do anything else."[84]

Although the meteorological explanation for the disturbances in the Yellow House is the least sensational, the weather definitely played an important role.[85] From the beginning of November until December 23, Arles saw more than twenty days of rain; ten times the average rainfall poured down in December. And by the time Vincent cut his ear, it had been raining four days in a row. The gloom of the rain, the late fall chill, the cramped quarters of the Yellow House, and the irritation at being deprived of plein air subjects would all have combined to drive both painters to distraction. One can imagine Vincent and Gauguin sitting endlessly in the claustrophobic studio with no other choice but to argue. Unable to roam through the landscape, Vincent would have been particularly restless and agitated.

IX

But what about cutting through this thicket of overdetermined causes and laying the blame squarely at Gauguin's door? It has always been tempting to regard the monumentally selfish and arrogant Gauguin as the primary catalyst of Vincent's self-destruction. To what extent does he bear responsibility for Vincent's ear cutting? Ironically, Gauguin brought suspicion on himself by protesting too much about his innocence in *Avant et après*. First, he acknowledges the accusation that his powerful personality may have overwhelmed both Vincent and Theo:

> It so happens that several men who have been a good deal in my company and in the habit of discussing things with me have gone mad.
>
> This was true of the two van Gogh brothers, and certain malicious persons and others have childishly attributed their madness to me.[86]

Then he thoroughly acquits himself of any wrongdoing. Of his confrontation with Vincent on the fateful night, he asks:

> Was I negligent on this occasion? Should I have disarmed him and tried to calm him?
> I have often questioned my conscience about this, but I have never found anything to
> reproach myself with. Let him who will fling the stone at me.[87]

His defensive tone and his use of transparent inventions to exculpate himself have made Gauguin seem more guilty in *Avant et après* than if he had said nothing.

In evaluating Gauguin's role, one must distinguish between his actual behavior and what he had come to represent for Vincent. As the object of all sorts of transferred emotions—father, mother, first Vincent, revered Master, abbot of the Studio of the South, etc.—Gauguin could not help but provoke extremely ambivalent responses. And given Vincent's history with more mild-mannered parental figures such as his father and Theo, it would have been surprising if he had *not* erupted. Gauguin might have given Vincent more peace of mind if he had promised to stay in Arles indefinitely, but he could not be expected to sacrifice his own plans in order to preserve Vincent's precarious mental health. It is also perfectly possible that Vincent would have had his breakdown if Gauguin had not come at all. His isolation, manic exertions, excessive drinking (particularly of absinthe), disappointment with not selling, anticipation of Christmas, and his apprehensions about Theo's engagement may well have been enough to trigger a seizure. The engagement, which occurred in late December, would have been especially troubling as Vincent must have feared the diversion of Theo's emotional and financial support toward his new wife.

Nor can one convincingly claim that Gauguin's advocacy of working from the imagination had a devastating effect. Even if Gauguin had carried out his instruction in a brutally authoritarian manner, which contradicts the reports of Laval, Sérusier, and others, and even if drawing on memory and the imagination brought Vincent dangerously close to the disturbing contents of his unconscious, he safely returned to familiar ground by painting the Roulin family in December. What is more, the symbolic portraits *Van Gogh's Chair* and *Gau-*

guin's Chair, which Vincent started in late November, show him coming to terms in a masterful way with Gauguin's differing creative practices.

Instead of a bullying egoist Gauguin emerges from the surviving letters as surprisingly sensitive and concerned. Theo most likely warned him beforehand of Vincent's instability, and one of Gauguin's first missives from Arles adopts a solicitous tone as he informs Theo that "your brother is in effect a little agitated and I hope to calm him bit by bit."[88] In mid-November Gauguin reports that "the good Vincent and the *grièche* [prickly] Gauguin always do good housework and eat in the house from the little kitchen that they have made themselves."[89] By referring to Vincent as *"bon"* and himself as *"grièche"* he anticipates with remarkable good humor and self-awareness the myth that would persist throughout the next century of the saintly van Gogh contending with the roguish Gauguin. However, the letter that reveals Gauguin in the most sympathetic light is the one he sent to Schuffenecker after Vincent's initial flare-up:

> You are waiting for me with open arms. I thank you but unfortunately I am not coming yet. I am in a very awkward position here. I owe a great deal to [Theo] van Gogh and Vincent, and although there is a certain amount of discord, I can't hold a grudge against an excellent heart that is ill, that is suffering, and that needs me. Remember the life of Edgar Poe, whose troubles and state of nerves led him to become an alcoholic. One day I'll explain to you in detail. At any rate I am staying here, but my departure is always latent. . . . [90]

Gauguin may not have responded to all of Vincent's needs, but no one truly monstrous would write, "I can't hold a grudge against an excellent heart that is ill, that is suffering, and that needs me."

If Gauguin did not push Vincent into madness, how did he acquit himself in the face of his friend's deteriorating sanity? In order to answer this question we must construct a better picture of the last days of the collaboration in the Yellow House. Vincent, who apparently suffered from amnesia, never recounted in any detail the circumstances that led up to his self-mutilation. But shortly after returning to Paris, Gauguin told Bernard of the drama he had just witnessed. Bernard then related what he had heard from Gauguin to the critic

Albert Aurier. Although Bernard's letter to Aurier offers only a secondhand re-
port, it constitutes one of the most important sources of information about the
events surrounding the ear cutting:

> . . . I rushed to see Gauguin who told me this: "The day before I left [Arles], Vincent
> ran after me—it was at night—and I turned around, for Vincent had been behaving
> strangely for some time and I was on my guard. He then said to me: 'You are taciturn,
> but I shall be likewise.' I went to sleep in a hotel and when I returned the entire popu-
> lation of Arles was in front of our house. It was then that the gendarmes arrested me,
> for the house was full of blood. This is what happened: Vincent had gone back after I
> left, had taken a razor and cut off his ear. He had then covered his head with a large
> beret and had gone to a brothel to give his ear to one of the inmates, telling her: 'Verily
> I say unto you, you will remember me.'
>
> " . . . Vincent was taken to the hospital; his condition is worse. He wants to be
> quartered with the other patients, refuses assistance from the nurse, and washed him-
> self in the coal bin. One might almost think that he pursues Biblical mortifications.
> They were forced to shut him up in a room by himself.
>
> " . . . ever since the question arose of my leaving Arles he had been so queer that I
> hardly breathed any more. He even said to me: 'You are going to leave,' and when I
> said 'Yes,' he tore a sentence from a newspaper and put it into my hand: 'The mur-
> derer had fled.'"[91]

Where is the hurled absinthe? Where, more importantly, is the razor Vincent
held menacingly in his hand as he approached Gauguin? The absence of these
crucial details from the account closest in time to the tragedy suggests that
Gauguin invented them fifteen years later when he wrote *Avant et après*. He
would have done so in order to make himself appear the victim of Vincent's
crazed aggression and to justify his hasty departure from Arles. At the same
time, Bernard's letter makes it clear that Vincent acted in a disturbed manner
both before and after the ear cutting and that Gauguin's abandonment of the
Yellow House constituted a central element in his breakdown.

Vincent's utterances, though strange, are not completely enigmatic. His re-
mark—"you are taciturn, but I shall be likewise"—sounds as if he were trying
rather pathetically to deny his need for Gauguin. He says, in effect, "if you can

withhold your speech and, by implication, your presence in Arles, then I can suppress my attachment to you as well." "The murderer had fled" contains several meanings. On the one hand, it refers to Gauguin as someone who, by fleeing Arles, had "murdered" the Studio of the South and all of the emotion that Vincent had invested in his utopian project. On the other, it projects, in a paranoid "Le Horla"-like fashion Vincent's rage onto Gauguin. Gauguin, not Vincent, cares so much about the other that he harbors a murderous hostility.

Bernard's letter also supports the view that Vincent experienced a regression to his earlier religious mania. The New Testament language he uses with the prostitute—"Verily I say unto you, you will remember me"—recalls the glossolalia-like effusions of his letters of 1876. And washing himself in the coal bin, which Gauguin himself compares to "Biblical mortifications," repeats the extremely masochistic behavior of the Borinage period. One can see the beginning of this regression in a slip that Vincent makes in his letter describing the trip to Montpellier. Significantly, it occurs in the sentence that follows Vincent's characterization of his arguments with Gauguin about Delacroix and Rembrandt as "terribly *electric*." He goes on to write, "We were in the midst of magic, for as Fromentin says so well: Rembrandt is above all a magician." Then, as if unable to contain himself, he interpolates between this and the next, more logical line, the non sequitur "and Delacroix a man of god of the thunder of god and of telling someone to screw off [*foutre la paix*] in the name of god."[92]

The approach of Christmas would only have exacerbated these tendencies. As we have seen, Christmas evoked extremely volatile emotions in Vincent and he had twice before chosen that time of year to precipitate a crisis. The ear cutting took place only two days before Christmas and on a Sunday. Exactly one year later, he would again suffer an attack. Like the collapse in Arles, Vincent's subsequent fits involved what he spoke of as "religious exaltation."[93]

Although Gauguin's memoirs apparently placed a nonexistent weapon in Vincent's hand, it is still possible that he acted in a violent manner. Vincent had once struck a fellow student in the training school for evangelists, and during later attacks he fervently believed that he was being poisoned. Similarly paranoid reactions to the "murderer" Gauguin may have prompted him to act in a threatening manner. In 1890, when Vincent had suggested that he might join Gauguin and Meyer de Haan in Le Pouldu, Gauguin reacted with shock

to the idea and remarked to the innkeeper, Marie Henry, that Vincent had "wanted to kill him."[94] But the moral question for Gauguin does not depend so much on the degree of Vincent's overt aggression before the ear cutting. Vincent had obviously become very disturbed. What matters is Gauguin's decision to leave his friend when the injured artist could not harm anyone and suffered miserably in the local hospital. In *Avant et après* Gauguin says that he told the police inspector, "Be kind enough, Monsieur, to awaken this man with great care, and if he asks for me tell him I have left for Paris: the sight of me might prove fatal to him."[95] Vincent, however, gave the lie to this excuse when he wrote to Theo in January, "How can Gauguin pretend that he was afraid of upsetting me by his presence, when he can hardly deny that he knew I kept asking for him continually, and that he was told over and over again that I insisted on seeing him at once."[96]

In fleeing Arles, Gauguin may have given in to an unconscious urge to abandon Vincent as he had been "abandoned" by his father's premature death. If so, it would have been just one of many leave-takings—from wife, family, and Europe—that allowed Gauguin to rework the trauma of Clovis's sudden absence. Yet it is hard to take too censorious a view of Gauguin when one realizes that Theo himself left his brother in Arles after visiting with him for only a day. Gauguin wired Theo on December 24, and he arrived on Christmas morning only to return to Paris with Gauguin on the 26th. Theo's brief stay becomes all the more curious after reading his moving description to his fiancée of Vincent's condition. Although he had only cut his earlobe, Vincent was critically weakened by the loss of blood:

> There were moments while I was with him when he was well; but very soon after he fell back into his worries about philosophy and theology. It was painfully sad to witness, for at times all his suffering overwhelmed him and he tried to weep but he could not; poor fighter and poor, poor sufferer; for the moment nobody can do anything to relieve his sorrow, and yet he feels deeply and strongly. If he might have found somebody to whom he could have disclosed his heart it would perhaps never have gone thus far. . . . There is little hope, but during his life he has done more than many others, and has suffered and struggled more than most people could have done. If it must be that he dies, so be it, but my heart breaks when I think of it.[97]

Theo arranged for the Reverend Frédéric Salles, pastor of the Reformed Protestant Church, to look after Vincent. But Theo nevertheless boarded the train to Paris thinking that his brother might die at any minute. It seems that Gauguin was not the only one so unsettled by Vincent's disintegration that he could not bear to linger with him.

<p style="text-align:center">X</p>

Of all the paintings produced in Arles those that go furthest in capturing the dynamics of the collaboration are *Van Gogh's Chair* [pl.2] and *Gauguin's Chair* [pl.3]. One can find embodied in the two pictures themes of attachment, loss, rivalry, oedipal ambivalence, and masochism. Given the immense amount of psychoanalytic attention lavished on the two works, it is tempting to proceed directly to a discussion of these unconscious issues.[98] But the symbolism that Vincent *consciously* orchestrated is complex enough and merits a full examination in its own right.

Vincent first mentioned the paintings in a letter to Theo a month after Gauguin's arrival:

> Fortunately for me, I know well enough what I want, and am basically utterly indifferent to the criticism that I work too hurriedly. In answer to that I have done some things *even more* hurriedly. . . .
>
> Meanwhile I can at all events tell you that the last two studies are odd enough.
>
> Size 30 canvases, a wooden rush-bottomed chair all yellow on red tiles against a wall (daytime).
>
> Then Gauguin's armchair, red and green night effect, walls and floor red and green again, on the seat two novels and a candle, on thick canvas with a thick impasto.[99]

Vincent's description of the pictures as "odd enough" indicates that he himself sensed the presence of powerful unconscious forces shaping the imagery. The rapid execution also suggests that the paintings had a free-associative quality. But there was nothing impulsive about Vincent's designation of *Gauguin's Chair* as a "night effect." In the same letter, he says that Gauguin had convinced him that he should vary his work from the model and "compose

from memory." So it was fitting that night, the realm of dreams and fantasy, would belong to Gauguin.

Vincent next refers to the paintings in a post-ear-cutting letter to Theo:

> It will always be a pity, in spite of everything, that Gauguin and I were perhaps too quick to give up the question of Rembrandt and light which we had broached. . . .
>
> I should like De Haan to see a study of mine of a lighted candle and two novels (one yellow, the other pink) lying on an empty armchair (really Gauguin's chair), a size 30 canvas, in red and green. I have just been working again today on its pendant, my own empty chair, a white deal chair with a pipe and a tobacco pouch. In these two studies, as in others, I have tried for an effect of light by means of clear color. . . . [100]

Vincent now definitely identifies the deal chair as his own and as a pendant to Gauguin's. He also adopts a more explicitly mournful tone in his regret that he and Gauguin never resolved their disagreement over Rembrandt and in his description of both chairs as "empty" even though they contain still-life objects.

The final reference to the symbolic portraits appears in a letter to Albert Aurier responding to his favorable article about Vincent's paintings. Vincent, concerned that Gauguin was more deserving of such praise, took pains to acknowledge his influence:

> Gauguin, that curious artist. . . . A few days before parting company, when my disease forced me to go into a lunatic asylum, I tried to paint "his empty seat."
>
> It is a study of his armchair of somber reddish-brown wood, the seat of greenish straw, and in the absent one's place a lighted torch and modern novels.
>
> If an opportunity presents itself, be so kind as to have a look at this study, by way of a memento of him; it is done entirely in broken tones of green and red. Then you will perceive that your article would have been fairer, and consequently more powerful, I think, if, when discussing the question of the future of "tropical painting" and of colors, you had done justice to Gauguin and Monticelli before speaking of me. [101]

Vincent's anxiety about setting the record straight disguises his actual sentiments. But a genuinely elegiac note persists, and Vincent seems to have forgotten

that he composed this "memento" for the "absent one" a full month before Gauguin's departure. Then again, Gauguin, after announcing his intention to return to Martinique, had, in a sense, already departed. And in the first letter in which Vincent mentions the paintings, he already hopes that he and Gauguin "shall always remain friends" despite the latter's inevitable search for a tropical studio.

What Vincent's letters do not disclose is the richly evocative quality of the paintings. At every level, from the iconographical to the compositional to the coloristic, they define both artists' characters and creative methods. And they do all of this in a deceptively straightforward and informal manner. Vincent's plain deal chair sits in a humble, rustic interior that includes a box of onions in the background. He has placed on the seat what amounts to his attributes—the simple pipe and tobacco pouch always by his side. Gauguin's chair, by contrast, is elegantly carved and upholstered and rests on a carpet in a room illuminated by gaslight. In this way, Vincent opposes his myth of himself as a peasant painter rooted in nature to the image of the worldly and dandified Gauguin, who had once worked at the Bourse and had lived in a fine apartment in the sixteenth arrondissement.

But Vincent does much more than juxtapose his and Gauguin's public personae. He also ingeniously sets Gauguin's love of mystery against a celebration of his own stubborn empiricism. One can view all of the objects in *Gauguin's Chair* in terms of his emphasis on creating, as opposed to copying, reality. The two books—the "modern novels," as Vincent refers to them in his letters—are by definition works of imagination and invention. Both the candle and the gaslight, moreover, serve as symbols of the spark of inspiration. The gas lamp, in particular, reinforces the image of Gauguin as dependent, not on natural light, but on his own shining autonomous intellect. Vincent's chair, on the other hand, is painted with thick impasto and suffused with the "high yellow note" of his summer in Arles. It basks in the daylight that permits us to grasp the world in all of its actuality. And although the chair is not literally down to earth, the network of lines formed by the tiles securely anchors it to the floor. This contrasts sharply with Gauguin's chair, which seems to float on an aqueous oriental carpet. Finally, Vincent has made the background of *Gauguin's Chair* flat and abstract while locating his own within an insistent perspectival system typical of his work.

By painting *Van Gogh's Chair* and *Gauguin's Chair* Vincent finally answered many of the challenges posed by Gauguin's Arlesian works. Vincent put his own characteristic style and method on an equal footing with Gauguin's and, at the same time, demonstrated that he could paint *de tête* just as well as the Master. Gauguin's work on his portrait of Vincent during this period would only have strengthened the latter's competitive urges. In fact, the motif of a still-life object on a chair had originated in Gauguin's oeuvre and had resurfaced with the vase on a chair in *Vincent van Gogh Painting Sunflowers.* So Vincent, reversing the usual arrangement, now poached from Gauguin's stock of ideas. He could also take revenge on all of the jibes embedded in Gauguin's paintings by deploying the very stylistic devices that Gauguin disdained—thick impasto and red and green complementaries—in *Gauguin's Chair.* Ironically, Vincent painted both works on the coarse jute canvas that Gauguin bought in Arles and encouraged him to use. Gauguin delighted in the canvas's thick weave, which lent his thinly painted surfaces a uniformly rough and "primitive" texture. But emphasizing the pronounced texture of the *support* totally negated Vincent's concerns with sumptuous painterly effects. And Vincent, as if to repudiate Gauguin in turn, completely concealed the jute weave under his rich impasto.

This competitive engagement with Gauguin deepened Vincent's already intense oedipal ambivalence toward the older artist. The extent to which Gauguin had become a loved and hated father for Vincent can be seen in his iconographical choices. Nearly every element in the symbolic portraits refers to imagery not only related in general to his father, Theodorus, but also specifically to his absence and to Vincent's rivalry with him. The empty chair itself had associations for Vincent with both a temporary absence and its most extreme form—death. While studying for the ministry, Vincent reached out to his father for assistance and once broke into tears at the sight of his abandoned chair. As he wrote to Theo, "I came home to my room and saw father's chair still standing near the little table on which the books and copy books of the day before were still lying, though I know that we shall see each other again pretty soon, I cried like a child."[102] Then in 1882 the image became a poignant symbol of mortality after Vincent discovered Luke Fildes's woodcut *Charles Dickens' Empty Chair.* This print greatly impressed Vincent, and he explained to

Theo that Fildes had entered Dickens's room on the day he died and had been inspired to evoke his death by that "touching drawing *The Empty Chair.*"[103] The objects on Vincent's chair also directly allude to Theodorus and to his death, as Vincent painted a still life of his father's tobacco pouch and pipe soon after he died. As we have seen, this painting combined ambivalence with masochism. Several months later, Vincent painted over the still life and thereby nullified both his commemoration of his father and his own creation.

But the work that most dramatically anticipates the oedipal themes informing the two chair paintings is *Still Life with Open Bible, Candlestick and Novel* [1.3]. Another canvas painted in the wake of Theodorus's death, this still life depicts his Bible resting on a table next to Vincent's paperback copy of Zola's *Joie de Vivre.* Theodorus had strongly disapproved of Vincent's enthusiasm for godless French novels, and by placing *Joie de Vivre* near the Bible Vincent clearly defied his authority, if only posthumously. The picture seems to declare that modern novels and the vision they represent not only equal but surpass the holy texts from which Theodorus preached as a minister. The lightness and vibrant yellow of the paperback, not to mention its title, make the heavy, dun-colored Bible, opened to the Old Testament prophet Isaiah, appear all the more unbearably stultifying. Yet, as we have noted, Vincent could not attack his father without simultaneously punishing himself. Vincent's book is tattered, less substantial, and perched precariously on the edge of the table, while Theodorus's tome is larger, heavier, and has its patriarchal massiveness reinforced by the phallic candlestick at its side.

Van Gogh's Chair and *Gauguin's Chair* reenact the confrontation implicit in *Still Life with Open Bible, Candlestick and Novel* with much the same combination of oedipal aggression and masochistic self-abasement. Vincent stands up to Gauguin in ways that we have discussed and, at the same time, identifies with his father by claiming his still-life objects—the pipe and tobacco pouch— as his own. But he also diminishes himself while aggrandizing Gauguin. Once again Vincent's symbol is yellow, simpler, more worn, and cheaper than his counterpart's. And once again he endows his rival with more phallic potency. Theodorus's candle and book now belong to Gauguin. The phallic nature of the candle has been enhanced by the two novels, which become the equivalent of testicles, and by the placement of the candlestick toward the edge of the seat

where the groin would rest. The similar location of the pipe and tobacco pouch on the other chair forces a comparison all to Vincent's disadvantage. His testicles—the tobacco pouch—and his phallus—the dead pipe—are smaller, more flaccid, and, literally, less inflamed than Gauguin's solid books and jutting, lit candle.

The emptiness of both chairs provides yet another mixture of ambivalence and self-punishment. An empty chair presents a richly ambiguous image. It can signify the sad loss of a beloved figure or the triumphant dethroning of a hated one. By portraying Gauguin's chair as empty while he still remained only a few feet away in the studio, Vincent both expressed his longing for his friend and held up a constant accusatory reminder of his plan to abandon the Yellow House. The empty chair, moreover, signified death for Vincent, and in his depiction of Gauguin's *"place vide"* he could symbolically murder and castrate his rival (castration and death being nearly interchangeable in the unconscious).[104] Yet, true to form, Vincent's masochism proves as strong as his hostility. He applies the same harsh punishment to himself and empties out his own chair just as he would eventually mutilate and kill himself.

It is possible that Vincent consciously endowed *Gauguin's Chair* with phallic properties. It would have been in keeping with his evocation of Gauguin's virile creative powers. Schuffenecker touched on this sense of Gauguin's prowess when he praised his friend's artistic "fecundity."[105] And Vincent made a more explicit connection between painting and phallic power in his advice to Bernard that restraining from sexual activity would make his art more "spermatic."[106] Furthermore, the candle serves as a substitute for the penis in French idioms *("tenir la chandelle"),* popular songs, and literary passages.[107] But Vincent could not have consciously intended the phallic nature of Gauguin's candle without at the same time realizing that he had given himself a diminished phallus. This surpasses even Vincent's enormous capacity for self-imposed humiliation.

Although Vincent overloaded *Gauguin's Chair* with patriarchal and phallic symbolism, it would be a mistake to view it only in masculine terms. It possesses various feminine aspects from its broad-bottomed upholstered seat and its curvilinear shapes to its greater refinement and embracing arms. Vincent would also have associated it with that most maternal of figures, Madame

Roulin. She sat in the same chair in the early December portraits by both artists and in Vincent's *La Berceuse*. The chair's bisexuality would have had several meanings for Vincent. It would have extended the feminizing of the older artist that had already emerged in the *Poet's Garden* series and in his decorations for Gauguin's room. In those cases, Vincent defended against his homoerotic urges and assigned the submissive, feminine role in the relationship to Gauguin, not himself. In *Gauguin's Chair* his defensive maneuvers would have widened to include reassurances against castration. By endowing the feminine chair with a phallus Vincent turned it into a phallic mother. The fantasy of the phallic mother originates in the young boy's wish to deny that anyone might lack a penis and his corresponding belief that everyone, including his mother, possesses genitals like his own. The need for these defensive measures would have been especially heightened by Vincent's competition with Gauguin. His desire to triumph over the father-figure Gauguin would have been accompanied by the terror of retaliatory castration. Indeed, Vincent's diminishment of his own symbolic phallus indicates that he preferred to inflict on himself what he feared would be meted out by his rival.

Gauguin's Chair was neither the first nor the last of Vincent's works to use phallic imagery and sonorous red-green complementaries to evoke genital trauma. Vincent had combined these elements in another nocturnal scene, *The Night Café*, where one finds the same complementaries coupled with the phallic configuration of a cue and billiard balls at the groin level of the café owner. Vincent spoke of the painting as an attempt to express "the terrible passions of humanity in red and green" in a setting where "one can ruin oneself, run mad, or commit a crime . . . a devil's furnace."[108] This febrile language expresses Vincent's unconscious fear that by yielding to "terrible passions" he will castrate another—"commit a crime"—or become castrated—"ruin oneself." If Vincent did in fact throw an absinthe at Gauguin in a night café, he would have fulfilled his own fantasy. But it is significant that he would have done so only after entering into an oedipal struggle with a powerful father figure. The combination of phallic imagery and a red-green palette appears again in *A Corner of the Asylum* painted in Saint-Rémy. Vincent describes the picture's color scheme as producing "something of the sensation of anguish."[109] The unconscious source of this anguish is not hard to locate. Vincent has prominently

depicted a dramatic symbol of castration in the form of a lightening-struck tree with its large trunk sawed off. Vincent, sensing its significance himself, saw the tree as a "somber giant—like a defeated proud man."[110]

If *Gauguin's Chair* both provoked and warded off such oedipal fears, it also expressed more primal, pre-oedipal yearnings in its close connection with *La Berceuse* (the cradle rocker). This painting, which Vincent started in late December, contains explicit as well as implicit references to maternal warmth. Madame Roulin, who had recently given birth to a baby girl, holds ropes attached to the child's cradle. Vincent has placed her in the center of the composition, rendered her ample, rounded forms in a hieratic manner, and arranged her clasped hands so that she might be praying. All of this helps to transform the ordinary Madame Roulin into a secular Madonna who will provide consolation to forlorn souls. Vincent consciously strove for this effect and directly linked Gauguin to his vision of Madame Roulin as a source of motherly solace and comfort:

> I have just said to Gauguin about this picture that when he and I were talking about the fishermen of Iceland and of their mournful isolation, exposed to all dangers alone on the sad seas—I have just said to Gauguin that following those intimate talks of ours the idea came to me to paint a picture in such a way that sailors, who are at once children and martyrs, seeing it in the cabin of their Icelandic fishing boat would feel the old sense of being rocked come over them and remember their own lullabies.[111]

It does not require great psychological acuity to see that Vincent was speaking of himself when he referred to the "mournful isolation" of the Icelandic fishermen who are "children and martyrs." Gauguin, by depriving him of "intimate talks," would only make this loneliness more desperate.

Yet Vincent, by giving *Gauguin's Chair* feminine traits, may have done more than express his own need for a nurturing maternal figure. In many respects his symbolic portrait presents a psychologically astute account of Gauguin's character. Gauguin, whose father died when he was one year old, grew up in a world dominated by his mother. This appears to have left him with a strong early identification with her and a need to compensate for his feminine nature with arrogance, swagger, and Don Juanism. Gauguin the "savage" always risks

succumbing to Gauguin the "sensitive." And Vincent suggests the precariousness of Gauguin's masculinity not only by depicting his symbolic phallus as propped up by the ornate chair but also by placing the candle and books dangerously close to the edge of the seat. That Gauguin himself sometimes longed to shake off the burden of his overwrought masculinity is revealed in *Noa Noa*. After admiring the androgyny of Tahitian natives, he speaks of his "weariness of the male role, having always to be strong, protective; shoulders that are a heavy load. To be for a minute the weak being who loves and obeys."[112]

XI

The difficulty that we have encountered in distinguishing the conscious from the unconscious in Vincent's and Gauguin's works reflects both their psychological sophistication and the spirit of fin-de-siècle culture. It cannot be a complete historical accident that Gauguin painted *Grape Gathering: Human Misery* and Vincent created his symbolic portraits during the same period in which Freud made his first discoveries regarding the role of sexuality in mental life. Indeed, the art historian T. J. Clark has found the paintings of another Post-Impressionist, Paul Cézanne, so congruent with the development of psychoanalytic ideas that he titled an essay "Freud's Cézanne."[113] Gauguin proves more startlingly proto-Freudian in his concerns with the "mysterious centers of thought," the return to child-like states, and his own explorations in the sexual realm.[114] He even concluded his musings about the origins of artistic inspiration by stating, "Perhaps it is unconscious."[115] But Vincent had his own affinities with Freud in his relentless introspection and in his ability to see colors, forms, and objects as symbols of inner experience.

Recovering in Arles, Vincent wrote to Theo that "what would reassure me . . . would be to see that Gauguin and I had not exhausted our brains for nothing, but that some good canvases have come out of it."[116] Art historians have shared this sentiment and have tried to safeguard Vincent's and Gauguin's artistic endeavors in Arles from becoming tarnished by the tragic denouement of the ear cutting. That "some good canvases" emerged from the collaboration in the Yellow House no one can doubt. What is more difficult to assess is the extent and precise nature of the influence Vincent and Gauguin exerted on

each other. Obviously, the collaboration in Arles provided both artists with new subject matter. But how did the experience affect their stylistic development? Would the art of either man have taken a significantly different turn if Gauguin had never come to Arles?

In the case of Gauguin's legacy, one can argue that he left Vincent more open to working from the imagination and more predisposed to emphasize line. Vincent said as much himself in his reply to Theo's criticism that paintings such as *The Starry Night*, with its flamelike cypress and swirling nebulae, placed the "search for style" over "true sentiment."[117] Vincent countered by declaring that he felt "strongly inclined to seek style, if you like, but by that I mean a more virile, deliberate drawing. I can't help it if that makes me more like Bernard or Gauguin."[118] But notice Vincent's mention of Bernard. Both during Gauguin's stay in Arles and afterward Bernard's role in shaping Vincent's "abstractions" was always at least as important as Gauguin's, if not more so. Gauguin, however, would have been more directly responsible for encouraging the greater concentration and suggestive power of the motifs in Vincent's *Sower* and in the symbolic portraits. *Avant et après* might have shed some light on these subtle questions of Gauguin's influence on Vincent. But Gauguin's remarks are typically self-serving and unreliable. He makes the extravagantly inaccurate claim that he "enlightened" Vincent who was "floundering about" in Arles under the influence of the "Neo-Impressionist school."[119]

It is even harder to pin down Vincent's effect on Gauguin. Gauguin, of course, acknowledged no such influence and rather grandiosely wrote in *Avant et après* that he owed Vincent only the "consciousness of having been useful to him" and the "confirmation of my own original ideas about painting."[120] At best, one can claim that Vincent reinforced tendencies already present in Gauguin's art. Exposure to Vincent's pure and high-keyed colors would have hastened the brightening of Gauguin's own palette. And listening to Vincent's recollections of his years training for the ministry and working as an evangelist would have increased Gauguin's fascination with Christian imagery and ritual. But the inspiration that Gauguin derived from Vincent for paintings such as the *Yellow Christ* and the *Breton Calvary* could only have been partial and indirect. Gauguin's treatment of religious subjects began before Arles with *The Vision after the Sermon*, and Bernard's religiosity had as

much impact as Vincent's. Vincent, moreover, had by this time become a staunch opponent of conventional religious imagery in advanced art. His November 1889 letter to Bernard denounces in the harshest terms Bernard's depictions of scenes from the life of Christ as a "mystification," "counterfeit," "affected," and a "nightmare."[121]

Perhaps the most challenging task is to see past the polarized roles promoted by myth and by the artists themselves. Gauguin was not simply the arrogant and insensitive Master relentlessly imposing painting from the imagination on his troubled disciple. Nor was Vincent simply the submissive student struggling with an alien technique while suffering from increasingly pronounced mental disorders. Gauguin, for one thing, had his own vulnerabilities. He had recently turned forty alone in Pont-Aven, separated from his wife and children, sick, in debt, and with no assurance of survival, much less success, as a painter. In Arles he was out of his element, saddled with an agitated companion, and compelled to maintain an uncharacteristically manic pace side by side with Vincent. At the same time, Vincent had his unexpected strengths. It was the "mad" Vincent, after all, who wrested from their turbulent relationship the most memorable works produced in Arles by either painter—*Van Gogh's Chair* and *Gauguin's Chair*.

6

Aftermath

I

Despite Vincent's considerable introspective powers and his acute self-aware-ness, he never fully confronted either the possible meanings or the seriousness of his ear cutting. He appears to have been completely amnesiac about his thoughts and actions immediately before, during, and after his self-mutilation but this does not explain his inability to come to terms with the drastic nature of what occurred. He could not help knowing how severely he had sliced his ear, and much of what happened on the night of December 23, including many of the lurid details, would have been related to him by Theo, Joseph Roulin, Rev-erend Salles, and his physician, Dr. Rey. Instead of wondering how he could have acted in such a sensationally aberrant manner—inflicting a nearly fatal in-jury on himself, presenting a severed ear as a gift to a prostitute, returning to the Yellow House to sleep in his own blood—Vincent did everything possible to minimize his mental collapse. In his letters to Theo he characterizes his break-down in remarkably euphemistic terms as merely a "trifle" and "simply an artist's fit."[1] And he became particularly exercised at the fact that Theo had to make the trip to Arles since "after all no harm came to me, and there was no rea-son why you should be upset."[2] The closest he could come to acknowledging the disturbing reality of his seizure was to speak of it in a speculative mode. "*Suppose* that I was as wild as anything," he muses at one point and, at another, allows that he was "after all *probably* the primary cause of it all" (italics mine).[3]

193

Vincent obviously wanted to convince himself and Theo that the ear cutting and his weeklong recovery in the Arles hospital amounted only to a temporary setback to his work in the South. So he sacrificed an honest examination of the bizarre events to his desperate hopefulness. But if Vincent refused to scrutinize the ear cutting itself, he was more perceptive and clearheaded about its causes. In a letter to Theo written three weeks after the incident he explicitly identified the importance of Gauguin's looming departure: "I feel remorse too when I think of the trouble that, however involuntarily, I on my part caused Gauguin. But up to the last days I saw one thing only, that he was working with his mind divided between his desire to go to Paris to carry out his plans, and his life in Arles."[4]

Vincent's attitude toward Gauguin in the months after his return to Paris displayed the same extreme ambivalence exhibited in the previous year. On the one hand, he wrote Gauguin as soon as he could to reassure him of his "very deep and sincere friendship" and to wish him "prosperity in Paris."[5] He also continued to hold out the possibility of working again with Gauguin and insisted that the "best thing" for him would be to return to Arles.[6] On the other hand, he nursed a host of grievances both minor and major. These came bursting to the surface in a long splenetic letter to Theo January 17. The letter is worth examining in detail as it reveals not only the depths of Vincent's rage against Gauguin and the extent of his disappointment over the failure of the Studio of the South, but also his sense of Gauguin's character.

The letter begins with an accounting of the additional expenses incurred as a result of the ear cutting and Vincent's lament over his penniless state. As the funds that Vincent had expected from Theo on the tenth did not arrive until the 17th, he has had "a most rigorous fast, the more painful because I cannot recover under such conditions."[7] This remark enunciates the theme of deprivation and neglect. Neither Theo nor Gauguin has properly understood his needs and desires. Vincent also wants to shift the blame for all the difficulties created by his self-injury away from himself and onto someone else. How mortifying it must have been for Vincent to have made such an effort to bring Gauguin to Arles, to have extended Theo's precarious financial support even further, and to have invested so many hopes in the Yellow House, only to see it all fall to pieces as a result of his own mental imbalance.

Unable to face the responsibility for such an enormous defeat Vincent transfers much of his guilt and self-hatred onto Gauguin. His anger at Gauguin for abandoning him is interlaced with attempts to turn him into the scapegoat. Gauguin, not Vincent, is profligate, irrational, and self-destructive. The underlying assumption of many of these remarks is the quite fantastic view that if Gauguin had only refrained from wiring Theo and taken Vincent's ear cutting in stride, everything in the Yellow House would have returned to normal. Gauguin's eminently justified, indeed obligatory, decision to contact Theo comes in for particular abuse:

> Now we come to the expenses caused you by Gauguin's telegram, which I have already expressly reproached him for sending.
>
> Are the expenses thus mistakenly incurred less than 200 fr.? Does Gauguin himself claim that it was a brilliant step to take? Look here, I won't say more about the absurdity of this measure, suppose that I was as wild as anything, then why wasn't our illustrious partner more collected?

But for Vincent this is only one example of Gauguin's lack of judgement. His impulsiveness in wiring Theo is consistent with his deluded plans for an artists' collective and his generally loose grip on reality:

> If that [the Arles arrangement] does not attain the heights of the grandiose prospectuses for the association of artists which he proposed, and you know how he clings to it, if it does not attain the heights of his other castles in the air—then why not consider him as not responsible for the trouble and waste which his blindness may have caused both you and me? . . .
>
> If Gauguin stayed in Paris for a while to examine himself thoroughly, or have himself examined by a specialist, I don't honestly know what the result might be.
>
> On various occasions I have seen him do things which you and I would not let ourselves do, because we have consciences that feel differently about things. I have heard one or two things said of him, but having seen him at very, very close quarters, I think that he is carried away by his imagination, perhaps by pride, but . . . practically irresponsible.

Vincent's tortured double negative—"why not consider him as not responsible"—points to the intensity of his need to blur the very issue of his own re-

sponsibility for the "trouble and waste" he has caused Theo. Elsewhere he displaces this question onto his finances and attempts to exculpate himself by stating, "In this letter I have tried to show you the difference between my net expenses, directly my own, and those for which I am less responsible." Vincent also renders ambiguous the question of who is truly mad by suggesting that Gauguin, not himself, should be "examined by a specialist."

Vincent reiterates the charge of Gauguin's reckless impulsiveness and penchant for fantasy while intertwining it with accusations of his betrayal not only of himself but also of the cause of advanced painting. Vincent returns to this criticism even when he tries to praise Gauguin:

> One good quality he has is the marvelous way he can apportion expenses from day to day.
>
> While I am often absent-minded, preoccupied with aiming at *the goal*, he has far more money sense for each separate day than I have. But his weakness is that by a sudden freak or animal impulse he upsets everything he has arranged.
>
> Now do you stay at your post once you have taken it, or do you desert it? I do not judge anyone in this, hoping not to be condemned myself in cases when my strength might fail me, but if Gauguin has so much real virtue, and such capacity for charity, how is he going to employ himself? . . .
>
> From time to time he and I have exchanged ideas about French art, and impressionism. . . .
>
> It seems to me impossible, or at least pretty improbable, that impressionism will organize and steady itself now.
>
> Why shouldn't what happened in England at the time of the Pre-Raphaelites happen here?
>
> The union broke up.
>
> Perhaps I take all these things too much to heart and perhaps they sadden me too much. Has Gauguin ever read *Tartarin* in the Alps, and does he remember Tartarin's illustrious companion from Tarascon, who had such imagination that he imagined in a flash a complete imaginary Switzerland?
>
> Does he remember the knot in a rope found high up in the Alps after the fall?
>
> And you who want to know how things happened, have you read *Tartarin* all the way through?
>
> That will teach you to know your Gauguin pretty well.

When Vincent asks whether Gauguin has ever read *"Tartarin* in the Alps,"
he alludes to a novel by one of his favorite authors, Alphonse Daudet. Daudet's
humorous and sharply observed stories set in Provence provided a literary fil-
ter through which Vincent viewed the South. In Daudet Vincent found not
only an intimate glimpse into the exotic world of the Midi but also descriptions
of landscape and local sites that display a painterly sensitivity to form and
color. *Tartarin on the Alps* continues the adventures of the short, fat, and
boastful Tartarin of Tarascon, who prides himself on, among other things, his
entirely fictional prowess as a "lion hunter."

Tartarin, now president of the Tarascon Alpine Club, has come to Switzer-
land to climb an actual mountain, as opposed to the low-lying peaks of the
nearby Alpilles. Looking for a guide, he is directed to an expert climber who
knows "every mountain—in Switzerland, Savoy, the Tyrol, and India, in the
whole world."[8] This "incomparable guide" turns out to be none other than
Tartarin's fellow *Tarasconnais,* Bompard.[9] Bompard, an even greater fabulist
than Tartarin, reassures his friend that he need not fear scaling the Alpine
heights as the whole of Switzerland is an elaborately orchestrated fake. Relying
on a conceit that cleverly anticipates present-day theme parks, Bompard in-
forms Tartarin that a vast company has constructed Switzerland's mountains,
glaciers, lakes, and forests and has even populated them with employees in col-
orful costume in order to exploit the tourists. Every effect, according to Bom-
pard, is "machined like the floor beneath the stage in the Opera."[10] Bompard
therefore is Vincent's "illustrious companion from Tarascon who had such
imagination that he imagined in a flash a complete imaginary Switzerland."

Eventually, Tartarin and Bompard find themselves about to ascend Mount
Blanc. After hearing of an accident on the Matterhorn in which a guide cut
the rope to lose some climbers but save others, Tartarin and Bompard show-
ily take an oath never to cut the line between them and to live or die together.
Their pledge is put to the test when they end up dangling on either side of a
ridge. As neither can see the other, they both cut the rope—Bompard with his
hunting knife and Tartarin with his ice-axe—and flee in opposite directions.
Bompard, who is discovered first, tells a tall tale about his heroic efforts to
save Tartarin. But when a search party finds the rope it is "curiously enough
. . . cut as with a sharp instrument, so as to leave two ends."[11] This is what

Vincent mistakenly recalls as the "knot in a rope found high up in the Alps after the fall." Both Bompard and Tartarin make their way back to Tarascon, each thinking he has killed his friend. Tartarin, in particular, "anticipated in all eyes and on every lip: 'Cain, where is thy brother?'"[12] They are comically reunited at the Alpine Club when Tartarin unexpectedly returns after Bompard has flamboyantly eulogized his friend and displayed some of his scattered "remains."

Vincent clearly wanted to make Gauguin out to be a Bompard who is both carried away with his own fantastic notions and profoundly disloyal. Gauguin's Bompard-like inventions encompass everything from his unrealistic plans for a syndicate of artists and dealers, which so much resembles the gigantic yet illusory Swiss conglomerate, to what Vincent characterizes as his "fine, free and absolutely complete imaginary conception of the South,"[13] to the very paintings he makes, with their emphasis on imagination over reality. Gauguin, moreover, acted in a Bompard-like manner in giving Vincent a false courage about scaling the dangerous heights of "abstract" art. But, even worse, he resembles Bompard by having pledged to stick by Vincent in the Yellow House only to sever his ties and run off at the first sign of trouble.

What Vincent has curiously forgotten is that Bompard and Tartarin possess nearly equal talents for dissembling and end up betraying each other. Bompard, in fact, is no more a Judas than Tartarin and does not really serve Vincent's purposes as a villain with whom he can equate Gauguin. Why, then, did he seize on *Tartarin on the Alps* as the literary parallel to his travail in Arles? Vincent may have been unconsciously attracted to the story because it touched on his fantasy of merging with a double. Vincent would have liked to share identities with Gauguin and to feel that they were emotionally and artistically tied together. Braque actually used this very metaphor to describe his symbiotic relationship with Picasso when they formulated Cubism:

> In that period, I was closely linked with Picasso. In spite of our very different temperaments, we were guided by a common idea. Picasso is Spanish, and I am French—everyone knows the difference that involves; but during those years, the differences didn't count. . . . We lived in Montmartre, we saw each other every day, we talked. . . .
>
> It was a little like being roped together on a mountain. . . . [14]

As Braque describes it, he and Picasso participated in exactly the sort of twinship that Vincent attempted but failed to establish with Gauguin.

Tartarin on the Alps would also have engaged Vincent's unconscious fantasies about his stillborn brother. Tartarin and Bompard's mutual betrayal on the Alpine slopes would have simultaneously aroused and relieved his guilt over having "killed" the first Vincent. Tartarin believes that he has allowed his double to plunge into the depths of a crevasse and fears the accusation "Cain, where is thy brother?" Yet both "brothers" seem to die, both are equally guilty, and both are magically resurrected.

In addition to charging Gauguin with a Bompard-like lack of trustworthiness, Vincent argues that Gauguin has acted against his own self-interest by leaving Arles:

> He is physically stronger than we are, so his passions must be much stronger than ours. Then he is a father, he has a wife and children in Denmark, and at the same time he wants to go to the other end of the earth, to Martinique. It is frightful, all the welter of incompatible desires and needs which this must cause him. I took the liberty of assuring him that if he had kept quite here with us, working here at Arles without wasting money, and earning, since you were looking after his pictures, his wife would certainly have written to him, and would have approved of his stability. There is more besides; he had been in pain and seriously ill, and the thing was to discover the disease and the remedy. Now here his pains had already ceased.[15]

In this accounting, Gauguin's departure has threatened his health, imperiled his finances, and ruined an opportunity to gain his wife's respect. Vincent, then, is not the only one who has injured himself, upset his budget, and disappointed his family.

Although Vincent has projected various of his own traits onto Gauguin, he was not necessarily inaccurate in his assessment of his friend's personality. Gauguin did harbor a "welter of incompatible desires and needs," and he did possess a talent for building castles in the sky. He would, in fact, soon place his hopes in the promises of the very Bompard-like figure of Dr. Charlopin. Charlopin, an inventor waiting for payment on a patent supposedly worth twelve million francs, would agree in 1890 to purchase thirty-eight of Gauguin's

works for five thousand francs. For months, Gauguin clung fiercely to this prospect only to see it conclude with a bounced check. This susceptibility to pipe dreams, which might have been a liability, actually served as a psychic survival mechanism during the many periods of despair in his life. Gauguin could also act in an impetuous and self-destructive manner. He was capable, in Vincent's words, of disrupting "everything he has arranged" by a "sudden freak or animal impulse." In 1894, for example, he insisted on prolonging a fight with sailors in the Breton town of Corncarneau. This completely avoidable scrape resulted in a fractured leg that troubled Gauguin for the rest of his life.

What pervades Vincent's letter as much as these defensive characterizations of Gauguin is his sense of loss. He sadly reports Roulin's imminent departure for his new post in Marseilles, which will keep him away from his family for months. The adjective—"heartbroken"—that Vincent uses to describe Roulin and his wife could apply equally to himself. Soon after, Vincent mentions *Van Gogh's Chair* and *Gauguin's Chair* in a context that underscores his mournful state. He begins with a discussion of Rembrandt and the treatment of light in a drawing by Meyer De Haan. Vincent then compares the Rembrandtesque light in De Haan's charcoal sketch with the light effects created by "clear color" in the symbolic portraits. The conscious pretext for this transition is Vincent's belief that complementaries can produce a luminosity as intense as the contrast between black and white. But the unconscious thread that links his remarks reveals itself in the subject of De Haan's drawing. He has depicted a pallbearer standing in front of an "open tomb." This epistolary "free association" provides further evidence that the empty chair signified death for Vincent. In this case, it is not Dickens who has died, but Vincent's relationship with Gauguin.

A few lines further down, Vincent bluntly refers to the "queer phenomenon of Gauguin's behavior in choosing not to speak to me again and clearing out." The rage triggered by this abandonment only emerges with full force toward the end of the letter:

> And now discussing the situation in all boldness, there is nothing to prevent our seeing him [Gauguin] as the little Bonaparte tiger of impressionism as far as . . . I don't quite know how to say it, his vanishing, say, from Arles would be compatible or analo-

gous to the return from Egypt of the aforesaid Little Corporal, who also presented himself in Paris afterward and who always left the armies in the lurch.

Fortunately Gauguin and I and other painters are not yet armed with machine guns and other very destructive implements of war. I for one am quite decided to go on being armed with nothing but my brush and my pen.

But with a good deal of clatter, Gauguin has nonetheless demanded in his last letter "his masks and fencing gloves" hidden in the little closet in my little yellow house.

I shall hasten to send him his toys by parcel post.

Hoping that he will never use more serious weapons.

Vincent's comparison of Gauguin's "vanishing" from Arles with Napoleon's return to Paris from the Egyptian campaign shows the full scope of his hurt and anger. It is especially striking if one realizes that Vincent plays the role of the French army in his analogy. Napoleon left his troops demoralized, cut in half by heat, disease, and battle, and surrounded by hostile Turks. Bonaparte also organized his departure in a cowardly and duplicitous manner. Just as Gauguin boarded the train to Paris without speaking to Vincent, so Napoleon sailed to France without having the courage to appoint his successor, General Kléber, face to face. But once again Vincent muddies the question of responsibility. While Napoleon's blunders and miscalculations led to disaster in Egypt, it was Vincent, not Gauguin, who injured himself and made the collaboration in the Yellow House untenable. And once again Vincent projects his own emotions onto Gauguin. Although Vincent seethes with rage, he disavows his own aggressive impulses and declares that "I for one am quite decided to go on being armed with nothing but my brush and my pen." While he sees himself as the harmless innocent, he characterizes Gauguin as the hostile "little Bonaparte" who makes noisy demands and may "use more serious weapons."

Vincent's letter of January 17 had a cathartic effect. His subsequent remarks about Gauguin adopt a much softer tone and he never again speaks so harshly. Only five days later, he tells Theo that he wants to copy a sunflower still life for Gauguin. In the January 17 letter he had mentioned Gauguin's intention to take one of the original sunflower canvases in exchange for studies left behind in Arles. This had provoked a furious blast from Vincent. He refused to give up his sunflowers and even considered giving back Gauguin's *Les Misérables*

and reclaiming his *Self-Portrait as a Buddhist Monk* as part of a complete nulli-
fication of their previous exchanges. But now Vincent will redo one of his sig-
nature works because he would "very much like to give Gauguin real plea-
sure."[16] These warm feelings remained until Vincent's death, and several times
he went so far as to write Gauguin about joining him in Brittany only to be po-
litely rebuffed.

II

If Vincent took three weeks to allow his violent emotions to erupt, Gauguin
plunged into a violent spectacle only two days after he arrived in Paris. At dawn
on December 28, he witnessed the execution of the murderer Prado. This inci-
dent, which Gauguin recounted in *Avant et après,* proved even more grisly
than one might expect. The guillotine at first missed Prado's neck and cut into
his nose. The prisoner, writhing in pain, had to be forced back down on the
board before the blade finally decapitated him. Why, after having his fill of
bloody scenes in Arles, would Gauguin have sought out such a horror? And
why would he have sought it so eagerly? In *Avant et après* he recalls how he
broke through a line of gendarmes to get to the inner circle ("when I want
something I am very obstinate").[17] Several possibilities present themselves.
There is no question that Gauguin would have strongly associated Vincent
with the execution. Not only did it occur very soon after the ear cutting but
Vincent and Gauguin had discussed the case of Prado and of another cele-
brated murderer, Pransini. Both men, according to Vincent, had frequented
the Parisian café Le Tambourin, where Vincent had exhibited his works. If
Gauguin had been terrified by the sight of the near-dead Vincent curled up in
his bloody sheets, he may have had the counterphobic desire to reassure him-
self of his courage by taking an unflinching look at Prado's execution. He may
also have wanted to glory in his own innocence and another's guilt. According
to *Avant et après,* the police superintendent investigating the ear cutting ini-
tially suspected Gauguin of murdering his friend. Gauguin would have wanted
to undo this unpleasant experience as well as distance himself from whatever
actual scruples he had about his behavior in Arles. On a deeper level, Gauguin
may have identified with both the executioner and his victim. On the one hand,

by watching the state kill a man, he could vicariously release some of his pent-up aggression toward Vincent. On the other, by identifying with Prado he could vicariously atone for the guilt he felt about precipitating Vincent's breakdown and abandoning the Yellow House.

That Vincent's ear cutting and the Prado execution lingered in Gauguin's mind as related events is shown by a strange ceramic [6.1] that he made several weeks later. He modeled a jug in the shape of his head with his neck as the base, a stirrup handle protruding from the back, and an opening at the top that seems to burrow into his brain. All of this would have been unsettling enough, but Gauguin added details that made the jug even more disturbing. His eyes are closed; he has no ears; and a red glaze drips down like blood over his features. Within one work he has become both the bloody, earless Vincent and the guillotined Prado. What lay behind such an enigmatic creation? Despite its oddness, Gauguin's jug draws on a wealth of stylistic and iconographic traditions. The severed head, whether of St. John or of Orpheus, was a recurrent motif in Romantic and Symbolist art. For Gauguin it would have represented, among other things, the spirit released from constricting material attachments. The untethered head with its eyes closed, shutting out banal reality, sails freely into the empyrean of its own imagination. The ceramic also alludes to the related image of Christ crowned with thorns and turns Gauguin into a misunderstood visionary who suffers mightily for his artistic ideals. Gauguin, however, combines these references to saintly figures such as Christ, St. John, and Vincent with an evocation of the outlaw Prado. This paradoxical mixture reveals the jug's roots in Gauguin's identification with Victor Hugo's holy criminal Jean Valjean. One can, in fact, see the self-portrait jug as evolving out of Gauguin's *Les Misérables,* which he described as "a vague memory of pottery twisted by a fierce fire! All the reds and violets streaked by flashes of fire like a furnace blazing."[18] Gauguin has, moreover, paralleled these contradictions on the iconographical level with a juxtaposition of clashing formal sources. He has drawn on both the "sensitive" tradition of severed heads in Western art and on such "savage" prototypes as Moche portrait pots from Peru and the dripping glazes of fifteenth-century Japanese ceramics.

But how did Gauguin's experiences in the Yellow House determine the creation of the jug? Why would Gauguin have wanted to transform himself into

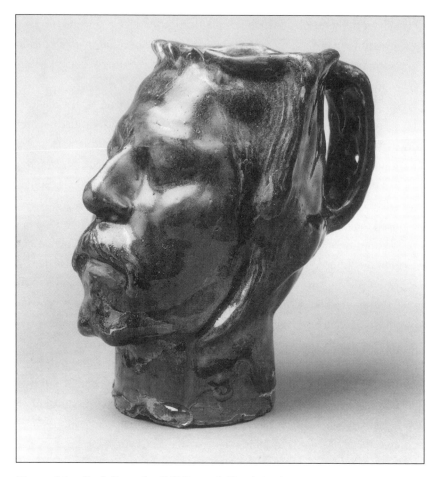

Figure 6.1 Paul Gauguin, *Self-Portrait Jug* (1889)

the mutilated Vincent? On one level, he appears to have been wrestling with his guilt over the collaboration's catastrophic denouement. He seems to protest that he, not Vincent, was the pitiful, injured victim. Yet the self-portrait jug involves more than an attempt to deflect criticism of his actions in Arles. He has masterfully reworked the trauma of the ear cutting for his own artistic ends. And by cannibalizing Vincent he could repair the loss of the relationship while

at the same time taking over some of his friend's aura as a Christ-like figure. Bernard's letter to Albert Aurier, written a few weeks before Gauguin molded the jug, reveals the extent to which Vincent had already taken on Christ-like qualities among those who knew him:

> Moved by the most profound mysticism, reading the Bible and delivering sermons in all kinds of bawdy places to the most contemptible people, my dear friend had come to believe himself a Christ, a God. His life of suffering and martyrdom seems to me such as to make of this astonishing intellect a being of the *beyond*. . . . Thwarted, rejected by the world, he began to live like a saint. . . . [19]

The self-portrait jug was only the first of a series of works created in 1889 in which Gauguin both depicted and impersonated Christ and alluded to Vincent. Two of these, *The Yellow Christ* and *Breton Calvary: The Green Christ,* make oblique references. The former resembles *The Vision after the Sermon* in its over-the-shoulder view of pious Breton women in traditional costume seated before the object of their devotion. In this case, they are arranged around a roadside Calvary that Gauguin has invented by borrowing the form of an eighteenth-century crucifix hanging in the chapel of Trémalo, near Pont-Aven. The painting evokes Vincent only in its religiosity and in the striking yellow color of the Christ on the cross set against a chrome and ocher background. *Breton Calvary: The Green Christ* is equally indirect in its connection to Vincent's oeuvre. Here, Gauguin has placed a Breton peasant woman in front of an actual sandstone sculpture of a *Lamentation* that stands close by the church at Nizon. The woman, whose bending posture echoes the arcing torso of the dead Christ, pulls on a rope attached to an unseen object. This recalls Madame Roulin, who clasps a rope tied to the unseen cradle in *La Berceuse*. Although neither the peasant's actions nor the meaning of the quotation is entirely clear, Gauguin may have associated the consoling function of *La Berceuse* with the three Marys holding the crucified Christ in the Calvary. By the time Gauguin comes to paint his *Self-Portrait in Front of the Yellow Christ* in late 1889, traces of Vincent have thinned out, and Gauguin has fully absorbed the image of Christ into his self-mythology as a "sensitive" and a "savage."

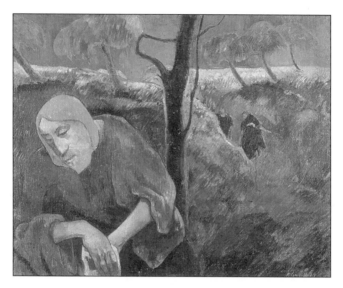

Figure 6.2 Paul Gauguin, *Agony in the Garden* (1889)

However, one work in this group, *Agony in the Garden* [6.2], dramatically reflects Gauguin's involvement with Vincent. For the first time Gauguin drops the anthropological distancing from his religious subjects and in a relatively straightforward manner depicts a poignantly anguished Christ in Gethsemane. As Judas and the soldiers approach in the distance, Christ stands desolately in the gray-green gloom of the olive groves with his back bent, head bowed, and arms pulled in at his side. He forms a figure closed in on itself—a concavity of suffering. Gauguin has made an especially pathetic detail out of Christ's eyes, which are puffy and half-opened as if brimming with tears. His bony hands hang limply and one holds a handkerchief into which he has been weeping. The divine purpose of this human suffering emerges in the landscape composition. While a central tree trunk splits the canvas between Christ and his betrayer, the other trees seem blown by a great providential wind that bends them in the same direction as the crestfallen Jesus. But in the central tree, a crooked branch—the symbol of Judas—turns in the opposite direction and cuts across an upright limb to form a cross.

Even more surprising than the elimination of mediating figures, such as "superstitious" Breton peasants, from *Agony in the Garden* is Gauguin's decision to give Christ his own features. He had implied an identification with Christ in the self-portrait jug, but now makes this absolutely explicit. Once again Gauguin has taken over his friend's role as "a Christ, a God." But asserting an identification with the Savior is only one of *Agony in the Garden*'s many links with Vincent. Gauguin would have known about his friend's two failed attempts to paint the same subject in Arles. He may also have associated Vincent's ear cutting with an incident that follows immediately after the scene he has depicted. Once Judas has led the soldiers into the garden, Simon-Peter draws his sword to protect Jesus and cuts off the right ear of Malchus, a servant of the High Priest. Giotto, among others, had prominently included this gruesome detail in representations of the *Betrayal*. Gauguin has, moreover, placed Christ in the same lower left-hand location as his self-portrait in *Les Misérables*. Gauguin had exchanged this work, in which he takes on the similarly martyred identity of Jean Valjean, for Vincent's self-portrait almost exactly a year before painting *Agony in the Garden*.

Gauguin signals his recognition of *Agony in the Garden*'s ties to Vincent by giving his Christ bright red hair. He also protests his innocence yet again. The very subject of *Agony in the Garden* raises the question of who played the Judas in Arles. Gauguin answers it in this painting by asserting that he was as much the betrayed innocent as his collaborator in the Yellow House. As in the self-portrait jug, he exculpates himself by identifying with Vincent. That Gauguin was in fact suspected of acting in a treacherous manner is indicated by Bernard's contemporaneous *Christ in the Garden of Olives*. Bernard has given Gauguin's features to his Judas. Gauguin himself recognized this and forgave it ("I see a head of Judas which slightly resembles me in the photo. Don't be alarmed. I shall not take offense."[20]). Given the actual circumstances in Arles, how could Gauguin so easily take over Vincent's role as the injured party? On the unconscious level, Gauguin may have felt that his father's premature death made *him* the eternally abandoned one. Vincent, by suddenly succumbing to his mental illness, had "abandoned" Gauguin just as Clovis had "abandoned" the one-year-old Paul by suffering his fatal aneurysm. Christ's extreme vulnerability in *Agony in the Garden* testifies to the depths of Gauguin's feelings in

the matter. Only very late self-portraits by the disease-ridden artist such as *Near Golgotha* of 1896 disclose such weakness. Of course, the polarities of Gauguin's personality remain in play. He admits fragility in *Agony in the Garden*, but only after turning himself into the Son of God.

Although memories of the Yellow House haunt *Agony in the Garden*, many other concerns shaped the painting. As Bernard's contemporaneous *Christ in the Garden of Olives* as well as his *Adoration of the Magi* and *Christ Carrying the Cross* reveal, religious themes had become an urgent preoccupation of Symbolist art in the late 1880s. In fact, the *Nabis*, a group of artists influenced by Gauguin and devoted to Theosophy, Rosicrucianism, and the occult, was founded in 1888. Gauguin did not share their programmatic approach to religious symbolism, but was nonetheless engaged in his own way with respiritualizing a materialist and decadent Western culture. It would be a mistake, therefore, to consider Gauguin's religious works as merely voyeuristic depictions of picturesque rituals or as examples of self-aggrandizing role-playing. And one can read a detail in *Agony in the Garden* such as Christ's flaming vermilion hair as an allusion not only to Vincent but also to the supernatural character of the scene and to the bloody Passion about to ensue.

Gauguin's dire personal circumstances also informed *Agony in the Garden*. His ill health, meager sales, and the poor critical reception of his work left him paralyzed with depression. His melancholic desperation rings out from a letter to Bernard in November 1889:

> As for me, of all my efforts this year, nothing remains but howls from Paris which penetrate here and discourage me to such a degree that I dare not paint any more, and can only drag my old body about on the sea shore of Le Pouldu in the bleak North wind. Mechanically I make a few studies (if you can call brush strokes in accord with the eye, studies). But the soul of me is absent and is mournfully regarding the pit which gapes in front of it—the pit in which I see the desolate family deprived of paternal support—and no heart on which to unload my suffering.
>
> Since January my sales have totalled 925 francs. At the age of 42, to live on that, buy colors, etc., is enough to daunt the stoutest heart. It is not so much the privations now as that the future difficulties loom so high when we are low. In face of the impossibility of living, even meanly, I do not know what to do.[21]

Gauguin sounds an equally despondent note in his remarks to Schuffenecker at the beginning of 1890:

> There are moments when I ask myself whether I wouldn't do better to bash my brains in: you must admit its enough to make one give up in despair. I have never been so discouraged as I am at present, moreover I am working very little, telling myself "What's the use and for what result?"[22]

One particular sore point for Gauguin was Theo's disappointment with his recent canvases and his refusal to support an exhibition at Volpini's Café des Beaux Arts. Gauguin and Schuffenecker had tried to generate some interest in their works during the Universal Exposition of 1889 by organizing a hanging of "Impressionist and Synthetist" paintings in a café near the official art section. Although neither Mr. Volpini, the owner, nor his patrons had any special interest in avant-garde art, Schuffenecker convinced Volpini to cover his walls with paintings instead of expensive mirrored paneling. Theo initially agreed to lend Vincent's works, but then relented. He must have found the setting incongruous and undignified. His description of the exhibition drips with disdain, and he remarks to Vincent that the whole scheme "gave one somewhat the impression of going to the Universal Exhibition by the back stairs."[23]

Vincent defended Gauguin's wish to show his works in a café as he himself had "this crime on my conscience twice over, as I exhibited at the Tambourin and at the Avenue de Clichy."[24] But he displayed no such sympathy for Gauguin's and Bernard's religious paintings. As we have seen, Vincent railed against such works in his letters. Bernard's recent paintings, photographs of which he had sent to Vincent in November 1889, provoked an especially thunderous response:

> Now look here, I am too charmed by the landscape in the "Adoration of the Magi" to venture to criticize, but it is nevertheless too much of an impossibility to imagine a confinement like that right on the road, the mother starting to pray instead of giving suck; then there are those fat ecclesiastical frogs kneeling down as though in a fit of epilepsy, God knows how, and why!

No, I can't think such a thing sound, but personally, if I am capable of spiritual ec-stasy, I adore Truth, the possible . . . are you going to revive medieval tapestries for us? Now honestly, is this a sincere conviction? No! you can do better than that, and you know you must seek after the possible, the logical, the true. . . .

An "Annunciation," of what? I see figures of angels—dear me, quite elegant—a ter-race with two cypresses which I like very much; there is an enormous amount of air, of brightness in it; but once this first impression is past, I ask myself whether it is a mystifi-cation, and those secondary figures no longer mean anything to me.

But it will be enough if you will just understand that I am yearning to know such things of yours as that picture which Gauguin has [*Breton Women in a Meadow*], those Breton women strolling in a meadow, so beautifully ordered, so naively distinguished in color. And you will trade this for what is—must I say the word?—counterfeit, affected! . . .

And when I compare such a thing with that nightmare of a "Christ in the Garden of Olives," good Lord, I mourn over it, and so with the present letter I ask you again, roar-ing my loudest, and calling you all kinds of names with the full power of my lungs—to be so kind as to become your own self again a little.

The "Christ Carrying His Cross" is appalling. Are those patches of color in it harmo-nious? I won't forgive you the spuriousness—yes, certainly, *spuriousness*—in the com-position.

As you know, once or twice, while Gauguin was in Arles, I gave myself free rein with abstractions, for instance in the "Woman Rocking," in the "Woman Reading a Novel," black in a yellow library; and at the time abstraction seemed to me a charming path. But it is enchanted ground, old man, and one soon finds oneself up against a stone wall.

I won't say that one might not venture on it after a virile lifetime of research, of a hand-to-hand struggle with nature, but I personally don't want to bother my head with such things. I have been slaving away on nature the whole year, hardly thinking of im-pressionism or of this, that and the other. And yet, once again I let myself go reaching for stars that are too big—a new failure—and I have had enough of it. . . .

If I have not written you for a long while, it is because, as I had to struggle against my illness, I hardly felt inclined to enter into discussions—and I found danger in those abstractions.[25]

By this time Vincent had experienced several new attacks, had lost the Yel-low House, had languished for weeks in the Arles hospital, and had come to

the asylum in Saint-Rémy. Religious subject matter would have disturbed him for several reasons. One of the most bothersome and dismaying aspects of his seizures were the irrational religious notions that overwhelmed him. As he tells Theo, there are "moments when I am twisted by enthusiasm or madness or prophecy, like a Greek oracle on the tripod."[26] And on another occasion, he reports that his attacks "tend to take on an absurd religious turn."[27] Vincent found these symptoms particularly galling because he prided himself on having made the psychologically and intellectually mature step of abandoning the religious zealotry of his youth: "I am astonished," he remarks to Theo, "that with the modern ideas that I have, and being so ardent an admirer of Zola and de Goncourt and caring for things of art as I do, that I have attacks such as a superstitious man might have and that I get perverted and frightful ideas about religion such as never came into my head in the North."[28] So, under the shadow of his mental instability, he must avoid the regressive pull of dangerously abstract religious pictures. And with his illness on his mind, it cannot be accidental that he describes Bernard's "fat ecclesiastical frogs" as kneeling down "as though in a fit of epilepsy."

A more fundamental source of Vincent's resistance to both Christian imagery and "abstraction" may have been the Protestant culture that shaped his sensibility as a child in an especially religious home and as an aspiring minister. Dutch Reformed Protestant belief emphasized nature, community, and virtuous labor over contemplation of the supernatural, the suffering of martyrs, and the interior recesses of the soul. Certain "modernist" Dutch theologians, moreover, claimed that an art grounded in the beauties of the natural world permitted a better access to divinity than the literal depictions of Christian subjects. All of this, as Debora Silverman has recently argued, would have put Vincent profoundly at odds with Gauguin's notions of spirituality, which were informed by his quite different religious education.[29] Gauguin spent five years in a Catholic school attached to the Saint-Mesmin seminary in Orléans. In this institution, run by the influential Bishop Dupanloup, the young Gauguin would have imbibed a Catholic vision of earthly existence as a sinful "vale of tears" that the devout must transcend through an inward journey of self-interrogation. To Gauguin's conception of a "vertical" spirituality—that is, a reaching up to god and plunging down into the soul—van Gogh would have

vigorously counterposed his "horizontal" vision of God's immanence in nature's glories and in honest work.

In the case of *Agony in the Garden,* Vincent may also have chafed at Gauguin's seemingly shameless externalization of a fantasy that he shared himself but kept more hidden. His anger at Gauguin would have been an attempt to disavow the grandiosity of his own very powerful identification with Christ. That Vincent struggled mightily with the exalted side of his polarized self-image can be seen in such defensive measures as his identification with lowly peasants, his reluctance to exhibit his works, and his surprising ambivalence toward the first signs of critical and financial success.[30]

Yet, for all of his fulminations, Vincent's actual practice after the ear cutting often contradicts his avowals of exclusive attachment to "the possible, the logical, the true." Although he does not invent religious subjects, he makes paintings after prints of Delacroix's *Pietà* and *The Good Samaritan* and Rembrandt's *The Raising of Lazarus.* Given his beleaguered state, he must have chosen these images for the themes of succor and resurrection that runs through them. Before having seen Gauguin's *Agony in the Garden,* he had already partially disclosed his own identification with a suffering Christ by giving his red hair to the figure of Jesus in the *Pietà.* But Vincent's interest in "abstraction" involves more than copying works by comfortingly familiar and admired artists. In his five versions of *La Berceuse* and in his portraits of Joseph Roulin and Dr. Felix Rey, he makes out of the background a hallucinogenic wallpaper that teems with floral swirls, arabesques, and splatterings of thick dots. Vincent also introduces undulating linear rhythms into his landscapes as if inspired by the actual topography of the Alpilles, which have unusually wavy, roller-coaster-like contours. In these canvases the dominant curvilinear movement often begins with the swaying branches of olive trees or cypresses and then extends to fields, mountains, and even clouds. All of Vincent's urges toward "abstraction" converge on *Starry Night,* where Vincent has created a "night effect," like *Gauguin's Chair,* from borrowed and invented landscape motifs. This implicitly spiritual painting, which articulates Vincent's naturalized religion by equating a church steeple with a cypress, combines roiling nebulae with a collapse not just of perspectival space but of the infinite distances between man and the heavens.

As we have seen, Theo noticed these abstracting tendencies and criticized Vincent for placing "style" over the "true sentiment of things."[31] Vincent defended himself by stating that he had sought "a more virile, deliberate drawing."[32] Vincent "can't help it" if that makes him "more like Bernard or Gauguin."[33] These remarks are of a piece with the contradictory attitudes that emerge from his letter to Bernard. On the one hand, he assails Bernard's departures from "nature" and the "True." Yet, on the other, he praises Bernard's formally audacious and boldly nonnaturalistic *Breton Women in a Meadow*, which Gauguin had brought to Arles. Despite Vincent's vehement advocacy of a "hand-to-hand struggle with nature," his painting would never again exhibit the same passion for the materiality of individual objects. His textural brushstrokes and his marriage of painting and drawing would be subordinated to an all-over linearity and a more systematic touch. In March of 1889 Theo described the canvases from Arles hanging in his apartment as possessing "such an intensity of truth, of the true countryside in them . . . that they give the impression of having been reaped directly from the fields."[34] But even as Theo wrote these words Vincent had moved in a different direction.

III

Vincent regarded his series of olive orchards as a refutation of Bernard's and Gauguin's depictions of Christ in Gethsemane. He tells Theo that he has been "working in the olive groves, because their Christs in the Garden, with nothing really observed, have gotten on my nerves."[35] Bernard, he suggests, "has probably never seen an olive tree."[36] Vincent, by contrast, will render "a rather hard and coarse reality beside their abstractions."[37] His landscapes will "smell of the earth."[38] Yet once again what he actually paints is more complicated and paradoxical. He wants the olive trees to serve as expressive vehicles for the evocation of extreme emotional states. The trees will have the "exact proportions of the human figure" and will prove to Bernard and Gauguin that one can "give an impression of anguish without aiming at the historic Garden of Gethsemane."[39] And, indeed, one can see in the twists and turns of branches and trunks the writhing of an agonized soul. In order to enhance the haptic effect of

the tree limbs Vincent suppresses the variety and thickness of his paint handling and uses instead shorter, directional strokes.

By choosing to depict olive trees Vincent returned to very potent symbolic ground. Even without the figure of Christ the subject would have been closely associated in his mind with the theme of betrayal. He had first essayed a Christ in the Garden of Olives while waiting for Gauguin to arrive in Arles. At that time, the unconscious meaning of the painting was clear. Vincent as Christ might suffer betrayal by Gauguin as a Judas who fails to come to Arles or who abandons the Yellow House. Given what actually happened in Arles and given Gauguin's own depiction of himself as Christ in Gethsemane, Vincent's reengagement with the subject would have offered him the opportunity to set the record straight. Although his dispute with Gauguin ostensibly concerns the question of "abstraction" versus "nature," the underlying debate involves the rightful ownership of the role of Jesus. By reclaiming the olive trees as a pictorial motif Vincent recovers his status as the betrayed Christ. He also resolves in his art his disappointment over the collapse of the Studio of the South, just as Gauguin mastered the trauma of the ear cutting through his self-portrait jug.

Even before sending a sketch of his *Agony in the Garden,* Gauguin suspected that Vincent might find his recent work "mannered." In anticipation of this, he attacks, in a letter of late October, the very distinctions between the "abstract" and the "true" that preoccupy Vincent. Sounding like a post-structuralist *avant la lettre,* he states, "All this is perhaps *mannered,* but what is natural in art? Ever since the most distant times, *everything* in art has been completely deliberate, a product of convention."[40] He goes on to argue in a culturally relativist vein that a Japanese, a savage, and a Parisian will all see things differently but none is more "mannered" or "natural" than the other. Gauguin may have felt overly sensitive about this issue because many of his canvases in 1889 did in fact fit the description against which he protested. Like Vincent in Saint-Rémy he began in Le Pouldu to organize forms into curvilinear patterns. But Gauguin's rhythms were less agitated. The long organic curve of a wooden hoe or the contour of a seaside cliff establishes the cursive note that pervades a painting. What makes these works seem "mannered" in terms of Gauguin's own oeuvre is his treatment of the human figure. Instead of establishing his customary tension between sculpturally modeled foreground figures and flat shapes in the background, Gauguin

allows the bodies of his Breton peasants to become attenuated and rubbery. They are absorbed into the network of languid, often drooping, lines and become flaccid themselves. No longer can one sense bone and muscle beneath their costumes. Gauguin, in his description of his *Seaweed Gatherers,* recognized this himself and spoke of "exaggerating certain rigidities of posture."[41] Theo found such figures much too stylized and complained that he preferred "a Breton woman of the countryside to a Breton woman with the gestures of a Japanese."[42] But for Vincent, Gauguin's formal experimentation would have been much less troubling than his turn to conventional religious content.

What is remarkable about the nearly parallel development in Vincent's and Gauguin's art in 1889 is that it occurred independently. Gauguin, who spent most of the year in Brittany, would not have had an opportunity to view Vincent's recent work until he returned to Paris in February 1890. Vincent, for his part, would only have seen a few sketches in Gauguin's letters from late fall. Nor did their correspondence provide much of an exchange of artistic ideas as it had diminished to no more than a dozen letters passed between them over the course of the year. On Vincent's side, at least, this was not so much a matter of indifference as of the distractions and preoccupations created by his mental illness. Far from forgetting about the older artist, Vincent repeatedly informed Theo that he was constantly thinking of Gauguin and wondering about his work in Brittany. And when Albert Aurier's article praising Vincent appeared in the *Mercure de France* in January, Vincent made sure to write the author and insist on his debt to Gauguin and Gauguin's more important role in creating the new art.

As if to compensate for his friend's absence, Vincent turned in February 1890 to a drawing of Madame Ginoux [5.3] that Gauguin had left in Arles. He made five copies of the work in oil [6.3] and intended to give versions to Madame Ginoux herself, to Theo, and to Gauguin. After Gauguin finally saw one of the copies in May, he wrote to Vincent expressing his admiration:

I have seen the canvas of Mme Ginoux. Very beautiful and very strange. I like it better than my drawing. In spite of your condition you have never worked with such degree of *equilibrium* while preserving the initial impression and the inner warmth which are indispensable for a *work of art*, especially at a time like ours when art is becoming something based on cold calculations established in advance.[43]

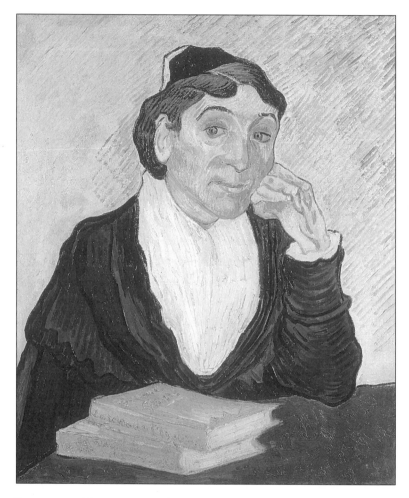

Figure 6.3 Vincent van Gogh, Copy after Gauguin's Drawing of
Madame Ginoux (1890)

In his reply, Vincent thanked Gauguin and explained something of his
intentions:

And it gives me enormous pleasure when you say the Arlésienne's portrait, which was
based strictly on your drawing, is to your liking. I tried to be religiously faithful to your
drawing, while nevertheless taking the liberty of interpreting through the medium of

color the sober character and style of the drawing in question. It is a synthesis of the Arlésiennes, if you like; as syntheses of the Arlésiennes are rare, take this as a work belonging to you and me as a summary of our months of work together. For my part I paid for doing it with another month of illness, but I also know that it is a canvas which will be understood by you and by a very few others, as we would wish it to be understood.[44]

With typical self-awareness, Vincent himself establishes the psychological importance of the painting by saying that it cost him "another month of illness." The attack to which he refers occurred in late February. About a week after starting the copies of Gauguin's drawing, Vincent traveled to Arles to visit Madame Ginoux and give her one of the versions of the portrait. During this trip Vincent suffered such a severe breakdown that Dr. Peyron, the psychiatrist at the Saint-Rémy asylum, had to dispatch two men to bring him back in a carriage. This was the beginning of a long period of mental distress that actually lasted *two* months, from February 22 to April 24.

Why did Vincent decide to work from Gauguin's drawing in February 1890? Much had occurred since the beginning of the year. Theo had become a father on January 31 with the birth of a son, Vincent, named after his artist uncle; Aurier's article had appeared; Gauguin had arrived in Paris from Brittany; one of Vincent's pictures displayed at Les XX exhibition in Brussels had sold for 400 francs; and, more obviously relevant, Vincent had become very concerned about Madame Ginoux's ailing health. Vincent, moreover, had trouble obtaining models in the asylum and could use the drawing as a substitute. But none of this explains the specific role of Vincent's relationship with Gauguin in his decision to make the copies and his execution of the copies themselves. One possibility is that Vincent made the portrait as a protection against loss. The birth of his nephew would have created both conscious and unconscious fears for Vincent. On the conscious level, he knew that Theo would have fewer emotional and financial resources with which to support him. On the unconscious level, little Vincent's birth would have reawakened infantile anxieties about displacement in his mother's affection by the arrival of siblings. That Vincent began copying Gauguin's drawing at the same time that he painted a blossoming almond tree to commemorate his nephew's birth points to the unconscious links between the events. Seen in this context, Vincent's *L'Arlési-*

enne would have been a reparative measure. Madame Ginoux, threatened by illness, would return to the healthy state she enjoyed in 1888, while memories of Gauguin's companionship during the same period would be resurrected. Vincent's desire to remain "religiously faithful" to the original would have been consistent with his attempts in 1889 to recover the lost Gauguin by assimilating his stylistic traits.

Yet an examination of the original circumstances in which Gauguin made the drawing complicates the situation even further. As we have seen, Gauguin made his portrait of Madame Ginoux, the wife of the owner of the Café de la Gare, as a preliminary sketch for her inclusion in his *Night Café*. In the painting, Gauguin subtly mocks Madame Ginoux, and by implication Vincent, by transforming her expression from a thoughtful smile to an insinuating leer. This detail combined with the presence of prostitutes in the background turns Madame Ginoux into a procuress. Gauguin not only had invaded Vincent's artistic turf by making his own version of a Night Café but had also poked lewd fun at a figure for whom Vincent had great affection. So Vincent's decision in 1890 to work from Gauguin's drawing would have been an attempt, like his olive orchards, to reclaim a subject that had been stolen and misused. What is more, he could assuage his anxieties regarding his nephew's birth by restoring Madame Ginoux as the good mother, not the shifty figure who presides over sexual duplicity. Finally, Vincent may have unconsciously intended to give Gauguin one of the copies as a covert self-portrait. His wish to assume a feminine role in relation to Gauguin had informed his *Self-Portrait as a Buddhist Monk* and his symbolic presentation of himself in *Van Gogh's Chair*. In this case, his competitive attempt to make a "better" version of Gauguin's original would have been accompanied by a masochistic insistence on his feminine identification.

Vincent's sharply conflicting motives for making the copies must have contributed to their awkwardness. He had particular difficulty with Madame Ginoux's expression, which fluctuates from a smile to a simper to a grimace. Interestingly, his worst stumble comes in a letter to Wil where he attempts to sketch the version intended for Gauguin. He makes such a botch of the mouth that it reads as little more than a wide gash across a pained face. Vincent also masculinizes Madame Ginoux in the paintings and renders her head and

hand as far more rough and bony than they appear in the original. Nor does he really respect Gauguin's drawing style. He replaces Gauguin's incisive, rhyming contours with a jagged, notched line more characteristic of his own painting. When Gauguin praised Vincent's "equilibrium" he was not admiring his steady draftsmanship but his more controlled brushwork. Gauguin always disdained Vincent's thick impasto and must have considered it symptomatic of his mental instability. In the *L'Arlésienne,* however, Vincent has disciplined his wild touch into neatly parallel strokes. This is why Gauguin finds it admirable that Vincent could produce the canvas "in spite of [his] condition."

In the same letter in which Vincent thanks Gauguin for his praise of *L'Arlésienne* he mentions coming to Le Pouldu to paint "a marine or two."[45] Gauguin's reply, which is contained in his last surviving letter to Vincent, firmly counters this suggestion:

. . . Your idea of coming to Le Pouldu in Brittany seems excellent to me if it were realizable. For de Haan and I are in a small hole far from the town, without any means of communication other than a hired carriage. And for a sick person who sometimes needs a doctor that is dangerous. At Pont-Aven it is another matter; there is a doctor and people. Besides, if I manage to arrange my project for going to Madagascar, I shall not be here at the beginning of September, nor will de Haan, who is going to return to Holland. There in all frankness is the situation: and yet God knows with what pleasure I should have liked to see friend Vincent near to us.[46]

Gauguin's argument, which he had used once before to discourage Vincent, has its merits. Vincent did require a doctor nearby. But, reading between the lines, one can detect Gauguin's strong resistance to once again sharing close quarters with Vincent. His too hearty affirmations of the "excellence" of the plan and the "pleasure" of seeing "friend Vincent near us" give the game away. Vincent wasn't heartbroken at this rejection. He described the letter to Theo as "gloomy" and accurately identified the Madagascar plan as largely a product of idleness and desperation.[47] Although Vincent entertained the possibility of following Gauguin to the tropics, he had a realistic sense of the scheme's practical difficulties and didn't take its prospects very seriously. Yet, to the very

end, the asymmetry in their relationship persisted. Vincent pushed for more intimacy while Gauguin cooled the temperature.

IV

Upon learning at some point in August of Vincent's death on July 29, 1890, Gauguin showed remarkable sangfroid. In a letter to Bernard, he spends a paragraph complaining about the Charlopin deal before getting around to their friend's suicide. When he does touch on it, he remains completely unruffled:

> I have had the news of Vincent's death, and am glad that you were present at the funeral.
>
> Distressing as this death is, I cannot grieve overmuch, as I foresaw it, and knew how the poor fellow suffered in struggling with his madness. To die at this moment is a piece of good fortune for him, it marks the end of his sufferings; if he awakens in another life, he will reap the reward of his good conduct in this world (according to the Buddha). He died in the knowledge of not having been abandoned by his brother and of having been understood by a few artists. . . . [48]

Gauguin's surprising indifference, combined with the grandiose touch of claiming foreknowledge of the suicide, raises the question of what Vincent actually meant to him as a man and an artist. The answer, of course, is not a simple one. Gauguin, like Vincent, harbored multiple and contradictory attitudes toward his friend. Even if Gauguin's ambivalence was less ardent than Vincent's, his emotions ranged along a wide spectrum. Unfortunately, Gauguin's dry and ironic tone in his much less voluminous correspondence makes it more difficult to chart this spectrum.

On the negative side, we find Gauguin doing little to promote Vincent's work and, in one case, actually opposing its wider exposure. In Gauguin's original list of paintings for the Café Volpini exhibition, he marked Vincent down for only six pictures while assigning ten each to himself, Bernard, and Schuffenecker. More surprisingly, when Bernard began planning a retrospective of Vincent's paintings after his death, Gauguin argued strenuously against it:

... I have received [a letter] from Sérusier telling me that you are organizing an exhibition of Vincent's works. What stupidity. You know I like Vincent's art. But given the folly of the public, it is quite the wrong time to remind them of Vincent and his madness just when his brother is in the same boat. Many people say that our painting is all mad. It will do us harm without doing Vincent any good. However, go on, but it is *idiotic*.[49]

Gauguin refers, here, to Theo's own mental collapse in the wake of his brother's death. This and the already growing legend of Vincent's madness aroused Gauguin's fears that their reputation for insanity would be contagious. Bernard did not share these apprehensions and mounted the exhibition in April of 1892.

Gauguin also undercut Vincent by vastly exaggerating his part in his friend's artistic development. According to *Avant et après,* Gauguin found Vincent in Arles struggling with a Divisionist style totally unsuited to his artistic character. In Gauguin's blinkered account, "the sound of the trumpet" was missing from his paintings.[50] But under Gauguin's tutelage Vincent liberated himself from "all these yellows on violets, all this work in complementary colors" and made "astonishing progress."[51] So profound was Gauguin's impact that Vincent thanked him "every day."[52] And the notion that the influence might have run in the opposite direction was risible. As Gauguin writes in his memoir, "When I read this remark, 'Gauguin's drawing somewhat recalls that of van Gogh,' I smile."[53] Gauguin could hardly have concocted a more inaccurate version of events. Vincent had, in fact, worked through Pointillism in 1887 and by the spring and summer of 1888 had already hit his "high yellow note" in masterful canvases such as his *Sunflowers, Harvest: The Blue Cart,* and *The Night Café.* Why would Gauguin so willfully deny this reality? His distortions are partly explained by his long experience with vexing challenges to his originality. The critic Félix Fénéon had in various reviews found traces of Anquetin, Bernard, Cézanne, and others in his paintings. Aurier's article on Vincent had come out a year before his essay on Gauguin, thereby giving Vincent precedence in the public imagination. And in 1891 Gauguin had a messy falling out with Bernard over who had initiated Symbolist art. From that point onward both would vigorously dispute the others' claim to the role of chief innovator

in the School of Pont-Aven. All of this made Gauguin very anxious about preserving his reputation as the leader of the new movement. It explains, if not forgives, his ludicrous slighting of Vincent's actual accomplishments before he arrived in Arles.

Yet Gauguin's public writings on Vincent are for the most part highly sympathetic. In an article of 1894 in *Essais d'Art libre* he lovingly recalls the paintings hanging in his room in Arles—"sunflowers with purple eyes stand out against a yellow background, the ends of their stalks bathe in a yellow pot on a yellow table."[54] One of the canvases, a still life of "two enormous, worn-out, shapeless" shoes, leads to a recounting of Vincent's travels on foot and his saintly devotion to the miners in the Borinage.[55] He singles out an incident in which Vincent nursed a "terribly mutilated" victim of a fire damp explosion for forty days, paid for his medicine, and brought about a miraculous cure.[56] Instead of adopting a sentimentally reverent tone, Gauguin mocks the disdain and incomprehension of Vincent's behavior by repeating the sardonic refrain, "Beyond the shadow of a doubt, that man was mad."[57]

In another vignette in *Diverses choses,* Gauguin was perhaps the very first to anticipate the monumental irony, endlessly remarked upon in the twentieth century, of Vincent's paintings selling for vast sums after his death. He vividly describes an impoverished Vincent tramping about the wintry Parisian streets in his bizarre dress: "everything bristles—coat, cap, and beard."[58] Vincent manages to sell a small still life of pink crayfish for five francs. But just before reaching his lodgings he sees a prostitute, takes pity on her, and hands over his newly earned francs. Gauguin then imagines the same still life up for auction years later: "Four hundred francs for *The Pink Crayfish*, four hundred fifty, five hundred. Come come, gentlemen, its worth more than that . . . Sold."[59] If Gauguin's praise of Vincent's paintings has a weakness, it is his perpetuation of the notion, already enunciated in Aurier's article, of Vincent's art as a pure product of spontaneous emotions. In keeping with Aurier's image of Vincent as an erupting volcano, Gauguin has Vincent possessing "an extraordinary idea of the Midi, to be expressed in bursts of flame."[60]

In spite of all of his reservations in *Avant et après*, Gauguin certainly had the capacity to admire Vincent's art. He owned as many as ten of his works and was known to display some of them prominently in his studio. Yet the precise

nature of Gauguin's appreciation is difficult to gauge. Many of the works in his collection were not chosen by him but given or received in exchanges. On one occasion, however, he makes his enthusiasm very clear and specific. In a letter of 1890 to Vincent, he reports on the warm reception of his works at the Salon des Independents and singles out one painting in particular for praise:

> I have studied with great attention the work you have done since we parted; first at your brother's and then at the show of the Independents. It is particularly at this last place that one can well judge what you are doing, partly because your pictures are hung together, partly because they are surrounded by other things. I want to pay you my sincere compliments. To many artists you are the most remarkable one in the whole exhibition. Among those who work from nature, you are the *only one who thinks*. I have talked about it with your brother and there is one canvas that I should like to *exchange with you for anything of mine you choose*. The one I mean is a mountainous landscape; two very small travelers seem to be climbing in search of the unknown. There is in it an emotion like in Delacroix, with very suggestive colors. Here and there some red notes, like lights, and the whole in a violet harmony. It's beautiful and impressive. I've talked at length about it with Aurier, Bernard, and many others. All congratulate you.[61]

Gauguin refers to *The Ravine* [6.4], painted in December of 1889. It is not hard to see why the picture appealed to him. The all-over curvilinearity typical of Vincent's Saint-Rémy works has been pushed even further so that the painting becomes a tapestry of fluid arabesques. Everything from the contours of the rocky landscape to the cascading stream to the flamelike red plants noticed by Gauguin falls into flowing patterns. In Arles Vincent often chose to paint cultivated fields because their borders and furrows created orthogonals that penetrated into a measured space. Here, he shows little concern for depicting spatial recession as the face of a mountain blocks off a distant view, and the hillsides of the ravine form an "X" shape that lies close to the picture plane. Vincent has placed the two "small travelers" near the intersection of this "X" and just above a skull-like cavern. The strange openings in this rock formation, which evoke eye sockets or mouths or wombs, must have made Gauguin think of the "search for the unknown." This mysterious quality was one of the reasons Gauguin said that "among those who work from

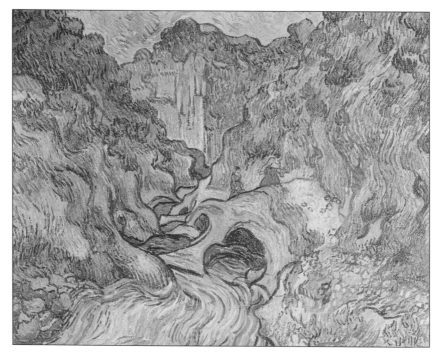

Figure 6.4 Vincent van Gogh, *The Ravine* (1888)

nature" Vincent was "the *only one who thinks*." He meant that Vincent, in-
stead of slavishly copying his subject, transformed it according to his imagina-
tion and his pictorial sensibility. It is a more accurate description of his
method than the mythical image of Vincent directly transferring his frenzied
passions from his brain to the canvas.

One indication that Vincent made a deeper emotional impression on Gau-
guin than his response to the suicide suggests was his close relationship with
Meyer De Haan. Gauguin would have associated De Haan with Vincent for
many reasons. Nearly the same age, both men were Dutch, red-haired, multi-
lingual, and well-read. De Haan, in fact, knew of Vincent through his friend-
ship with Theo and met Gauguin in Theo's apartment in Paris. De Haan,
moreover, had an allowance from wealthy relatives in Amsterdam that permit-

ted him to play a role similar to Vincent's as Gauguin's financial supporter as well as his student. All of this points to the probability that Gauguin, when he agreed to spend months together with De Haan in Brittany in 1889 and 1890, was motivated, at least in part, by a desire to reenact the collaboration in the Yellow House. And it is likely that Gauguin transferred onto De Haan feelings that he had harbored toward the other Dutchman.[62]

It comes as a surprise, then, to see how Gauguin depicts De Haan in several symbolic portraits. On the one hand, Gauguin has given him almond-shaped, "oriental" eyes resembling those in Vincent's *Self-Portrait as a Buddhist Monk*. Yet, on the other, he has depicted De Haan in a very unVincent-like way as an animalistic and diabolical figure. In *Portrait of Meyer De Haan*, the sitter supports his chin with a cloven, pawlike hand while staring at Milton's *Paradise Lost* and Carlyle's *Sartor Resartus*. Both volumes prominently feature either Satan himself or a devilish hero (Carlyle's *Herr Teufelsdröckh* [Sir Devil's Dung]). De Haan's eyes are slanted and covetous like those of the girl in *Still Life* of 1888, and he appears as tempted by the books as she is by a bowl of fruit. In *Nirvana*, De Haan's head is framed by two female figures in extreme states of anguish and abandon. Sitting with a snakelike plant slithering though his hand, he seems to have set in motion this cycle of lust and despair. De Haan's "oriental" eyes become more explicitly those of a demonic seducer when Gauguin transfers them to the figure of a fox in the wood carving *Be in Love, You Will Be Happy* and in the painting *The Loss of Virginity*. Gauguin explained to Bernard that this animal was an "Indian symbol of perversity," and in both works the predator is either about to or has already ravished a young girl.[63]

How much do these images have to do with Vincent and how much with De Haan? They certainly reflect aspects of De Haan's character. Although De Haan, with his hunchback and dwarfish stature, was an extremely improbable lady's man, he nonetheless conducted a successful affair with Marie Henry, the comely owner of the inn at Le Pouldu. De Haan also devoted himself to the study of religious, philosophical, and esoteric matters. The portraits, therefore, have some basis in reality as De Haan could be viewed as an actual seducer as well as a purveyor of subversive knowledge. Yet it is possible to see in these enigmatic works vestiges of Gauguin's unconscious fantasies about Vin-

cent during his stay in the Yellow House. Given his strong feminine identifica-
tion and his longings for his absent father, Gauguin may have unconsciously
wished to play the passive female to Vincent's rapacious male. He would be-
come the helpless girl carried off by the fox Vincent in *Be in Love, You Will Be
Happy* and the deflowered maiden lying naked and exposed in an open field in
The Loss of Virginity. This fantasy, in which Gauguin gives up the autonomy
and control so important to his conscious self-image, would have resurfaced in
the depictions of De Haan because it could be safely displaced onto another
figure and removed in time from the period of the collaboration in Arles.

If Gauguin did, in fact, harbor such unconscious desires toward Vincent it
adds yet another clue to the mystery of the ear cutting and the collapse of the
Studio of the South. Gauguin may have defended against his homoerotic urges
by adopting an especially aloof and combative manner. This would have exac-
erbated Vincent's already troubled mental state and contributed to the condi-
tions that precipitated his self-mutilation. Gauguin's fantasy of yielding sexu-
ally to Vincent also places in a new light his claim that Vincent nearly attacked
him with a razor. This charge has often been dismissed as an invention devised
by Gauguin to justify his abandonment of the Yellow House. But Gauguin may
have projected his defensive aggression onto Vincent and as a result exagger-
ated, either at the time or retrospectively, the violent intentions of his friend's
confusing behavior. Finally, Gauguin's difficulty in mastering the "unruly ho-
mosexual feeling" in the relationship would help explain his hasty departure
from Arles despite Vincent's suffering and his requests for him to stay.[64]

A further testament to Vincent's psychological importance for Gauguin
was the series of sunflower still lifes he painted in 1901. Gauguin reveals Vin-
cent's enduring significance not only in his choice of subject matter but also
in his timing. He wrote his friend Daniel de Monfried requesting sunflower
seeds in October 1898, almost exactly ten years after he arrived in the Yellow
House and found paintings of sunflowers on the walls of his room. Yet the
four still lifes are far from simply nostalgic celebrations of Vincent's best-
known works. Gauguin, in fact, returns to the competitive spirit that ani-
mated him in Arles and challenges Vincent's oeuvre on several levels. In two
of the still lifes he places the sunflowers on a chair and thereby recalls *Van
Gogh's Chair* and *Gauguin's Chair*. The unusual motif of displaying still-life

objects on a chair had originated in Gauguin's art as early as 1880, and he now reclaims it. He had specifically placed *tournesols* on a chair once before in his *Portrait of Vincent van Gogh Painting Sunflowers.* Vincent, however, never made such a still life, and the idea would not be fully realized until Gauguin painted these canvases.

Gauguin devised very similar formats for the two versions of *Sunflowers on an Armchair.* In both, the flowers are contained in a large, lumpish wicker basket placed on a wooden colonial armchair. Although the chair is not as ornate or comfortable as the one in *Gauguin's Chair,* it has a curvilinear shape and turned legs. A white cloth has been draped over the chair as a backdrop, and a view out of a window is visible in the upper right. What distinguishes the two works is their dramatically different lighting, which once again recalls Vincent's symbolic portraits with their "day" and "night" effects. In the Zurich picture, the window looks out on bathers and a canoe on a sunlit stretch of water. In the Hermitage variant [6.5], the lighting is much darker and, instead of a coruscating seascape, the head of a Tahitian woman appears in the window. Not surprisingly, the sunflowers in the nighttime setting, the realm of dreams and fantasy that Vincent assigned to Gauguin, radically transforms Vincent's signature motif. The very idea of placing sunflowers in shadow, which cuts them off from their eponymous source of sustenance, willfully negates Vincent's intentions. But the chiaroscuro provides Gauguin with a suitably mysterious atmosphere for his manipulation of two other elements of the painting. He turns one of the seed heads into a large "eye flower" reminiscent of the giant floating eyeballs of his friend Odilon Redon. This mystical orb hovers above the chair in the same upper zone as the view of the Tahitian woman. Like the stemless eye flower, her head—which the window sill cuts off at the neck—appears as a disembodied representative of the spiritual world. Both eye and head, moreover, stare out at the viewer as if insisting on the artifice Gauguin has employed for this "natural" subject. The bust of the Tahitian especially embodies this contradiction as the ambiguous window frame permits one to read her head as either a real object seen through a window or an illusory portrait hanging on the wall.

Although Gauguin's two other sunflower still lifes do not confront Vincent's art as directly, they continue to offer an entirely different conception of the sub-

Figure 6.5 Paul Gauguin, *Still Life with Sunflowers on an Armchair*
(1901)

ject. Vincent, in his Northern Romantic manner, focuses almost exclusively on
the flowers themselves and makes out of the microcosm of the seed head a
cosmic macrocosm. But Gauguin adopts a much more hybrid approach. The
sunflowers become just one part of a bricolage of European, South Pacific, and
synthetic elements. Coexisting with tropical fruit in *Still Life with Sunflowers
and Mangoes,* the European flowers sprout from a vessel that combines carved
Polynesian figures with a Western vase shape. *Still Life with Hope* makes Gau-
guin's eclecticism even more explicit as he sets the flowers in a Maoriesque con-
tainer (perhaps carved by Gauguin himself), but displays photos of works by
Degas and Puvis de Chavannes on the wall behind them. Puvis's *Hope,* which
depicts a flower-bearing young girl in front of a graveyard, amplifies the symbol-
ism of revival and rejuvenation already inherent in the sunflowers. In addition to
their iconographic differences, Gauguin and Vincent also depart, as one might

expect, in their painterly concerns. Vincent loves to deploy thick impasto to create a textural equivalent of the nubby surface of the seed heads. Gauguin, by contrast, makes more varied and subtler variations on the flowers' positions—they arc, droop, turn three-quarters, and face frontally. And he is more interested in splaying out the petals so that they become fingerlike appendages.

Gauguin remained preoccupied with Vincent as he composed *Avant et après* in the winter of 1902—1903 and took stock of his life in the face of the debilitating ailments that would soon kill him. The final echo of Vincent in Gauguin's art appears ambiguously and obliquely in *Barbarian Tales* of 1902. Gauguin has resurrected Meyer De Haan, who assumes a pose similar to the one in his portrait except that now he has a pawlike foot as well as a pawlike hand. In a lush tropical setting, he stares out once again with "oriental" eyes and presides over the seated gathering of two Polynesian women, one dark haired and the other redheaded. Gauguin has multiplied the allusions to Vincent by including two redheads (De Haan and Tohotaua, a native Marquesan model) and by arranging the dark-haired woman in the cross-legged pose of Buddha. She sits next to De Haan and reinforces the connections he already has with Vincent's *Self-Portrait as a Buddhist Monk.* One can only speculate about the unconscious presence of Vincent in this obscure work. But it seems that Gauguin has externalized the two extremes of his unconscious attitudes toward his friend. He has castrated and feminized him in the form of Tohotaua and, at the same time, preserved the fantasy of submitting to him in his guise as the satanic De Haan.

V

In 1893, only three years after Vincent's death, his work was displayed with Gauguin's in the Frie Udstilig [Open Exhibition] in Copenhagen. The logic behind this pairing consisted of little more than the organizers' fortuitous connections with Mette Gauguin and Theo's widow and the fact that the two artists had known each other and represented new trends in advanced art. But the exhibition, which received surprisingly sympathetic reviews in the liberal press, initiated the long tradition of coupling the two *artistes maudits.* Fairly quickly their differences became more salient than their similarities. The

"good Vincent" set against the "bad Gauguin" officially entered the critical literature in 1911 with Bernard's preface to the publication of *Lettres de Vincent van Gogh à Emile Bernard.* Bernard, still smarting from Gauguin's refusal to acknowledge his pioneering role in the creation of Symbolist art, placed the blame for the failure of the Studio of the South squarely on his former mentor's shoulders. On the artistic level, one finds Maurice Denis in 1909 distinguishing between the two artists' styles of antinaturalism by contrasting Vincent's "subjective deformation" with Gauguin's "decorative deformation" of reality.[65] While Vincent paints as an "exasperated romantic" who takes an "aggressive attitude toward nature," Gauguin displays a classical concern for "rigorous logic" and the "artifices of composition."[66]

From this point onward the set of oppositions—innocence versus worldliness, reality versus imagination, spontaneity versus calculation, sincerity versus artifice—proliferated nearly endlessly in the art-historical literature as well as in popular culture. Yet one must remember that, long before Bernard and Denis weighed in, both artists had themselves begun to construct these mythical antinomies. As we have seen, Gauguin jokingly referred to *"le bon Vincent et le grièche Gauguin"* in one of his letters to Theo from Arles.[67] Vincent had painted his symbolic portraits, *Van Gogh's Chair* and *Gauguin's Chair,* which were organized around various dualities—day and night, country and city, fantasy and empiricism. And Gauguin had spelled out, in greatly exaggerated terms, his aesthetic differences with Vincent in a letter to Bernard: "He admires Daumier, Daubigny, Ziem and the great Rousseau, all people I cannot endure. On the other hand, he detests Ingres, Raphael, Degas all people whom I admire."[68] Gauguin even anticipated Denis with his characterization of Vincent as a "romantic."[69] *Avant et après* abbreviated but did not temper his caricatural descriptions.

The enduring power of these dualities largely depends on how easily they seem to apply to both the artist and his art. Gauguin can be judged as "calculating" in his dealings with people as well as in his design of paintings, while Vincent can be admired as "sincere" in his personal manner as well as in his brushwork. Contemporary art historians remain suspicious of every term in this equation—from the forced binary oppositions to the lazy conflation of personality and artistic style. Yet the mythical dualities have an unintended dialectical

effect. They have become so entrenched that one yearns to look around their corners—to recognize that Vincent's painting could be as premeditated as any in the nineteenth century and that Gauguin's life had its ethical nuances and complexities. This need not lead to complete revisionism. Even the most energetic contrarian will have difficulty turning Gauguin into a saint. But the desire to unlock Vincent and Gauguin from their timeless coupling as the Angel and Devil of Post-Impressionism can only encourage a wider and more accurate view of a relationship that was not always turbulent or conflicted. It brings us closer, for example, to understanding Vincent's paradoxical remarks about Gauguin. He could, in one instance, describe Gauguin to Theo as someone who does "things which you and I would not let ourselves do, because we have consciences." Yet, in another context, he could declare that his friend was "worth even more as a man than an artist" or insist even further that Gauguin "likes to make one feel that a good picture is equivalent to a good deed; not that he says so, but it is difficult to be on intimate terms with him without being aware of a certain moral responsibility."[70]

Chronology

1848

June 7 Paul Gauguin born in Paris to Clovis Gauguin and Aline Chazal.

1852

March 30 The "first" Vincent van Gogh is stillborn.

1853

March 30 Vincent van Gogh born in Zundert to the Reverend Theodorus van Gogh and Anna Carbentus

1887

November Van Gogh and Gauguin in Paris, probably meet for the first time and exchange paintings.

December Theo van Gogh exhibits four of Gauguin's paintings and five ceramics at 19 Boulevard Montmartre.

1888

End of January–
early February Gauguin leaves Paris for Pont-Aven, Brittany.

February 19 Van Gogh leaves Paris by train for Arles.

May 1 Van Gogh rents the "Yellow House" on 2 Place Lamartine, but will remain at the Hôtel-Restaurant Carrel until he completes renovations.

May 28 Van Gogh writes letter to Gauguin proposing that he join him in Arles.

June 29	Theo informs Vincent that Gauguin has agreed to the proposal that he come to Arles. Gauguin will receive 150 francs in exchange for one painting a month. But Gauguin remains in Brittany.
Early August	Emile Bernard and Charles Laval in Pont-Aven with Gauguin.
September 16	Van Gogh sleeps in the Yellow House for the first time.
October 4	Van Gogh receives Bernard's *Self-Portrait* and Gauguin's *Self-Portrait: Les Misérables* and sends his *Self-Portrait as a Buddhist Monk* to Pont-Aven in exchange.
October 23	Gauguin arrives in Arles.
November 23	Van Gogh begins *Van Gogh's Chair* and *Gauguin's Chair*.
December 14	Gauguin writes to Theo saying that he must return to Paris.
December 17–18	Gauguin and van Gogh visit Montpellier to see the Alfred Bruyas collection in the Musée Fabre.
December 18–19	Gauguin writes to Theo to tell him to consider his journey to Paris an "imaginary thing," and his recent letter a "bad dream."
December 23	Van Gogh cuts off lower part of his ear and presents it to Rachel at the *maison de tolérance* and returns to the Yellow House.
December 24	Gauguin wires Theo to come to Arles. Theo arrives and visits Vincent in the hospital in Arles where his condition is considered critical.
December 26	Theo and Gauguin return to Paris.
December 28	Gauguin witnesses the execution of the criminal, Prado.

1889

January	Gauguin probably creates his *Self-Portrait Jug* in this month.
January 7	Van Gogh leaves the Arles hospital and returns to the Yellow House. But he is hospitalized again for ten days, February 7–17.
February 25	In response to a petition signed by van Gogh's neighbors, the police close the Yellow House. Van Gogh returns to the hospital.
April 17	Theo marries Johanna Bonger.
May 8	Van Gogh leaves Arles for the asylum at Saint-Rémy.
June–October	Gauguin exhibits seventeen works at Volpini's Café des Arts. Bernard, Laval, Schuffenecker, and others also display canvases. But van Gogh, on Theo's advice, declines to participate in the exhibition.
June–December	Van Gogh completes fifteen paintings of olive orchards during this period.

July and August	Gauguin works in Le Pouldu, Brittany, with Meyer De Haan. He paints *Agony in the Garden* during these months.
November 22	Van Gogh writes to Gauguin and to Bernard to criticize the religious imagery in their new paintings.
December 23	Exactly one year after the ear-cutting incident, van Gogh suffers another attack.

1890

January	Albert Aurier's article on van Gogh, "Les Isolés: Vincent van Gogh" appears in the first number of *Le Mercure de France*.
January 31	Birth of van Gogh's nephew, also named Vincent, to Theo and Johanna Bonger.
January–February	Van Gogh makes four versions of *L'Arlésienne* after Gauguin's 1888 drawing of Madame Ginoux.
February 7	Gauguin returns to Paris and moves in with Schuffenecker.
February 10	Van Gogh offers to exchange two copies of his *Sunflowers* and a copy of *La Berceuse* for one of Gauguin's works.
February 22	Van Gogh visits Arles in order to give a version of *L'Arlésienne* to Madame Ginoux and suffers a severe attack.
March 20	Gauguin admires van Gogh's paintings at the Salon des Indépendants and proposes an exchange of one of his works for van Gogh's *The Ravine*.
May 16	Van Gogh leaves Saint-Rémy for Paris.
May 20	Van Gogh leaves Paris for Auvers.
Early June	Gauguin leaves Paris for Le Pouldu with Meyer de Haan.
July 27	Van Gogh shoots himself in the chest.
July 29	Van Gogh dies.

1891

January 25	Theo van Gogh dies.
March	Albert Aurier publishes "Le Symbolisme en peinture: Paul Gauguin" in *Le Mecure de France*.
April 1	Gauguin leaves Marseilles for Tahiti.

1892

| April | Bernard mounts a retrospective of van Gogh's works at Le Barc de Boutteville gallery. |

1893

March 26 Paintings by van Gogh and Gauguin are displayed at the Free Exhibition of Modern Art in Copenhagen.

1901

September Gauguin paints two versions of *Still Life with Sunflowers on an Armchair.*

1902

December Gauguin works on his memoir, *Avant et après,* which contains an account of his stay in the Yellow House.

1903

May 8 Gauguin dies in the Marquesas.

Note: I have based this chronology largely on those found in Richard Brettell et al., *The Art of Paul Gauguin* (Washington, D.C., 1988), and Ronald Pickvance, *Van Gogh in Arles* (New York, 1984) and *Van Gogh in Saint Rémy and Auvers* (New York, 1986). The reader should consult those volumes for a more detailed and extensive dating of significant events.

Notes

Abbreviations of Frequently Cited Sources

Complete Letters	Van Gogh-Bonger, J., ed., *The Complete Letters of Vincent van Gogh,* 3 vols. Boston, 1978.
L	Letter to his brother Theodorus (Theo)
W	Letter to his sister Wilhelmien (Wil)
B	Letter to Emile Bernard
T	Letter from his brother Theodorus (Theo)
Malingue	Malingue, Maurice, ed. *Paul Gauguin: Letters to his Wife and Friends.* Translated by Henry J. Stenning. London, 1946.
Merlhès, 1984	Merlhès, Victor, ed. *Correspondance de Paul Gauguin: Documents, témoignages, 1873–1888.* Paris, 1984.
Merlhès, 1989	Merlhès, Victor, ed. *Paul Gauguin et Vincent van Gogh, 1887–1888: Lettres retrouvées, sources ignorées.* Taravao, Tahiti, 1989.
Thomson, 1993	Thomson, Belinda, ed. *Gauguin by Himself.* Boston, 1993.

Chapter One

1. L11a.
2. "Vincent's Sermon" is printed in its entirety in *Complete Letters,* vol. I, pp. 87–91.
3. L82a.
4. L73.
5. L83, 87a.

6. L94.
7. L94a.
8. L122a.
9. L86.
10. L122a.
11. L135, 136.
12. L133.
13. L133.
14. L133.
15. L130.
16. L129.
17. L129.
18. L132, 133.
19. L133.
20. L132.
21. L133.
22. L134.
23. L136.
24. L136.
25. L154.
26. L154.
27. L193.
28. L164.
29. L164.
30. L164.
31. L164.
32. L154.
33. L155.
34. L154.
35. 155.
36. L154.
37. L154.
38. L157.
39. L166.
40. L166.
41. L79.
42. L213, 253.
43. L262.
44. L164.
45. L161.
46. L204.
47. L204.
48. L169.

49. L164.
50. L167.
51. L169.
52. L164.
53. L164.
54. L164.
55. L164.
56. L212.
57. L164.
58. L201.
59. L346.
60. L192.
61. L219.
62. L195.
63. L195.
64. L219.
65. L338.
66. L339.
67. L358.
68. L363a.
69. L360.
70. L358, 362.
71. L388.
72. L379.
73. L358.
74. L358, 379.
75. L358.
76. L358.
77. L355a.
78. L360.
79. R44.
80. Carol Zemel, *Van Gogh's Progress: Utopia, Modernity, and Late-Nineteenth-Century Art* (Berkeley, 1997), p. 85.
81. R44.
82. L411.
83. L411.
84. L506.
85. L404.
86. L404.
87. L404.
88. L405.
89. L405.
90. R4.

91. L418.

92. *Picasso on Art: A Selection of Views,* ed. Dore Ashton (New York, 1972), p. 104.

93. L404.

94. R43.

95. L398.

96. L297.

97. Albert J. Lubin, *Stranger on the Earth: A Psychological Biography of Vincent van Gogh* (New York, 1972).

98. 377.

99. 386.

100. L459.

101. L435b.

Chapter Two

1. See, for example, L218: "I want to progress so far that people say of my work, He feels deeply. . . . "

2. Paul Gauguin, *The Writings of a Savage,* ed. Daniel Guérin, trans. Eleanor Leviuex (New York, 1990), p. 233.

3. *Avant et après* in Wayne Andersen, *Gauguin's Paradise Lost* (New York, 1971), p. x.

4. Gauguin, 1990, p. 232.

5. Ibid., p. 232.

6. Ibid., pp. 233–235.

7. Ibid., p. 235.

8. Ibid., p. 234.

9. David Sweetman, *Paul Gauguin: A Life* (New York, 1995), p. 41.

10. Octave Mirbeau, "Paul Gauguin," *L'Echo de Paris,* February 16, 1891, in Andersen, pp. 150–151.

11. Merlhès, 1984, no. 79.

12. W. Somerset Maugham, *The Moon and Sixpence* (New York, 1944), p. 52.

13. Gauguin to Pissarro, Copenhagen (spring 1885), in John Rewald, *The History of Impressionism* (New York, 1973), p. 494.

14. J. K. Huysmans, "L'exposition des indépendants en 1880," reprinted in Huysmans, *L'Art Moderne* (Paris, 1883), pp. 249–282.

15. Ibid., pp. 249–282.

16. Ibid., pp. 249–282.

17. Merlhès, no. 36.

18. John Rewald, *Cézanne: A Biography* (New York, 1990), p. 159.

19. Gauguin to Schuffenecker, Copenhagen, January 14, 1885, in Linda Nochlin, ed., *Impressionism and Post-Impressionism, 1874–1904: Sources and Documents* (Englewood Cliffs, N.J., 1966), p. 159.

20. Gauguin's remark in Merlhès, no. 141: "I like Brittany, it is savage and primitive. The flat sound of my wooden clogs on the cobblestones, deep, hollow and powerful, is the note I seek in my paintings."

21. Gauguin to Schuffenecker in Nochlin, p. 158.

22. Merlhès, 1984, no. 129.

23. Letter to Charles Morice at the end of 1890 in Richard Brettell et al., *The Art of Paul Gauguin* (Washington, D.C., 1988), p. 60.

24. B5.

25. Eugène Manet to Berthe Morisot (beginning 1882), in Rewald, 1973, p. 467.

26. The phrase "deeply commercial" comes from Pissarro to his son Lucien, October 31, 1883, in Rewald, 1973, p. 490; "cunning," from Camille Pissarro, *Camille Pissarro: Letters à son fils Lucien,* ed. John Rewald (Paris, 1950), p. 234; "naive," from Pissarro to his son in Sweetman, p. 147.

27. Jack Lindsay, *Cézanne: His Life and Art* (New York, 1969), p. 252.

28. Sweetman, p. 187.

29. John Russell, *Seurat* (New York, 1965), p. 176.

Chapter Three

1. W4.

2. W1.

3. Victor Hugo, *Les Misérables*, vol. II (Paris, 1967), p. 108; quoted and translated in T. J. Clark, *The Painting of Modern Life: Paris in the Art of Manet and His Followers* (New York, 1985), p. 26.

4. Meyer Schapiro, *Vincent Van Gogh* (New York, 1950), p. 46.

5. L429.

6. W4.

7. W1.

8. *Complete Letters,* vol. I, p. xli.

9. Ibid., pp. xli–xlii.

10. L619.

11. L460.

12. L462.

13. See Merlhès, 1989, p. 56.

14. Malingue, no. 60.

15. Merlhès, 1989, p. 67.

16. B16, L495, L536.

17. Merlhès, 1989, p. 54.

18. B5.

19. John Rewald, *Post-Impressionism: From van Gogh to Gauguin* (New York, 1978), p. 21.

20. B11.

21. Quoted and translated in Robert Rosenblum and H. W. Janson, *19th-Century Art* (New York, 1984), p. 452. Maurice Denis's remark originally appeared in an article published in *Art et critique* in August 1890.

22. Malingue, no. 60.

23. L544a.

24. L463.

25. L459a.

26. L605.

27. *Complete Letters*, vol. I, p. xliii.

Chapter Four

1. Merlhès, 1984, no. 142.

2. L469.

3. L480.

4. L493.

5. L493, 494a.

6. L535a.

7. L498.

8. L498.

9. L514, 535.

10. For the text of this letter, see Merlhès, 1989, p. 70.

11. L498.

12. L498.

13. L496.

14. L506, 501, 547.

15. L522.

16. L544.

17. L544.

18. L544.

19. L544, 544a.

20. L544a.

21. L346.

22. L544.

23. L583.

24. L544.

25. L556.

26. L556.

27. L519, 522, 538.

28. L552, 544.

29. L545.

30. L547.

31. L522.

32. L538, 535.
33. L538.
34. L523.
35. L532.
36. L535.
37. L538.
38. Thomson, 1993, p. 84.
39. Ibid., p. 88.
40. Malingue, no. 71.
41. Ibid., no. 73.
42. Merlhès, 1984, no. 165.
43. L544.
44. L534, W7.
45. W7, L534. For an extensive discussion of van Gogh's decorative program for the Yellow House, see Roland Dorn, *Décoration: Vincent van Goghs Werkreihe für das Gelbe Haus in Arles* (Hildesheim, 1990).
46. B15, L526.
47. B15.
48. L544a.
49. Henri Cochin, "Boccace, d'après ses oeuvres et les témoignages de ses contemporains," *Revue des Deux Mondes,* July 15, 1888, pp. 373–413. For discussions of van Gogh's *Poet's Garden* series, see Jan Hulsker, "The Poet's Garden," *Vincent: Bulletin of the Rijksmuseum Vincent van Gogh* 3, no. 1 (1974), pp. 22–32; Ron Johnson, "Vincent van Gogh and the Vernacular: The Poet's Garden," *Arts* 53, no. 6 (February, 1979), pp. 98–104; John House, "In Detail: Van Gogh's *The Poet's Garden, Arles,*" *Portfolio* 2, no. 4 (Sept./Oct. 1980), pp. 28–33; and Merlhès, pp. 113–114.
50. L541.
51. L534.
52. L480.
53. L493.
54. L531.
55. L501.
56. L549.
57. Thomson, 1993, p. 92.
58. L544a. For some reason *The Complete Letters* translates "Veronese green" as "malachite green." I have restored "Veronese" as it is not only the original but the more accurate term. For discussions of van Gogh's *Self-Portrait as a Buddhist Monk,* see Vojtech Jirat-Wasiutynski, H. Travers Newton, Eugene Farrell, and Richard Newman, *Vincent van Gogh's Self-Portrait Dedicated to Paul Gauguin: An Historical and Technical Study* (Cambridge, Mass., 1984), and for a critique of Jirat-Wasiutynski et al., see Merlhès, 1989, pp. 117–118.
59. L545.

60. Tsukasa Kodera, *Vincent van Gogh: Christianity versus Nature* (Amsterdam & Philadelphia, 1990).

61. L542.

62. W7.

63. Emile Burnouf, "Le Bouddhisme en Occident," *Revue des Deux Mondes*, July 15, 1888, pp. 340–372. For a discussion of the impact of this article on Vincent van Gogh, see Merlhès, 1989, pp. 114–120.

64. B8.

65. For an extensive discussion of van Gogh's "naturalized religion," see Kodera.

66. For a discussion of nineteenth-century French Japonist writers and van Gogh's assimilation of their texts, see Debora Silverman, *Art Nouveau in Fin-de-Siècle France: Politics, Psychology, and Style* (Berkeley, 1989), chap. 6; and *Van Gogh and Gauguin: The Search for Sacred Art* (New York, 2000), pp. 41–43.

67. L545.

68. L544a.

69. L534.

70. B3.

71. L512.

72. L544a, 492, 541.

73. L522, 513, 541.

74. L543.

75. L504.

76. B15.

77. W8.

78. L514.

79. W8.

80. W8.

81. For a scholarly account of Hugo van der Goes's mental illness, see Rudolf Wittkower and Margot Wittkower, *Born under Saturn* (New York, 1969), pp. 108–113.

82. L514.

83. L556.

84. L556.

85. L539.

86. Vojtech Jirat-Wasiutynski and H. Travers Newton, in their *Technique and Meaning in the Paintings of Paul Gauguin* (Cambridge, 2000), agree with Mark Roskill, in his *Van Gogh, Gauguin, and the Impressionist Circle* (New York, 1970), that Gauguin painted his self-portrait on Bernard's canvas and Bernard did the same on Gauguin's. Each artist, however, must have determined, or acceded to, the placement of the other's smaller image within his own self-portrait.

87. Thomson, 1993, p. 92.

88. Malingue, no. 71.

89. Thomson, 1993, p. 83.

90. L545.

91. L546.

92. L545.

93. L544a.

94. Merlhès, 1984, no. 167.

95. Thomson, 1993, p. 92.

96. Malingue, no. 71.

97. L527.

98. L520.

99. L520.

100. L547.

101. Thomson, 1993, p. 93.

102. Merlhès, 1984, no. 165, translated in William Darr and Mary Mathews Gedo, "Wrestling Anew with Gauguin's *Vision after the Sermon*" in Mary Mathews Gedo, *Looking at Art from the Inside Out: The Psychoiconographic Approach to Modern Art* (Cambridge, 1994), p. 69. Darr and Gedo provide a sensitive and precise account of the complex formation of *The Vision after the Sermon*.

103. B21.

104. Merlhès, 1984, no. 162, translated in Gedo, p. 66.

105. B8.

106. B12.

107. L520.

108. Merlhès, no. 158, translated in Gedo, p. 33.

109. Merlhès, 1984, no. 159, translated in Gedo, pp. 64–65. Debora Silverman's *Van Gogh and Gauguin: The Search for Sacred Art,* which appeared as this manuscript was going to press, has significantly changed the terms of debate regarding Gauguin's religiosity. She has made the strongest case yet for the enduring influence of the Catholic education that Gauguin received as an adolescent. According to Silverman, Gauguin's seminary school would have inculcated him with the desire to transcend a corrupt material world through meditative introspection. This devaluing of nature and exalting of interior experience profoundly shaped his later conception of an art based on "abstraction" rather than the slavish copying of reality. He would, therefore, have had more of an identification with than an ironic distance from the "superstitious" Breton women in *The Vision after the Sermon*. And, in Silverman's view, Vincent, who had a very different religious background, would have played no role in the resurfacing of Gauguin's spiritual concerns.

110. Victor Hugo, *Les Misérables,* trans. Norman Denny (New York, 1998), pp. 1141–1142. For a thorough discussion of the influence of Hugo's novel on both Gauguin's self-portrait and his *The Vision after the Sermon,* see Merlhès, 1989, pp. 92–107.

111. L533.

112. L534.

113. L533.

114. L539.

115. B19.
116. Thomson, 1993, p. 90.
117. L544.
118. Ronald Pickvance, *Van Gogh in Arles* (New York, 1984), p. 189.
119. L495.
120. L571.

Chapter Five

1. William McKinley Runyan, *Life Histories and Psychobiography: Explorations in Theory and Method* (New York, 1982). Elizabeth C. Childs has recently provided yet another explanation for van Gogh's ear cutting in "Seeking the Studio of the South: Van Gogh, Gauguin, and Avant-Garde Identity" in Cornelia Homburg et al., *Vincent van Gogh and the Painters of the Petit Boulevard* (St. Louis, 2001). Childs argues that Vincent's decision to cut his ear may have been influenced by his knowledge of Japanese brothel culture. Japanese courtesans occasionally offered severed fingers as proof of their devotion to their clients. They also indulged in other luridly masochistic gestures such as stabbing their arms, legs, and genitals. A particularly interesting aspect of Child's admittedly speculative theory is that it offers additional evidence of the links between van Gogh's Japonism and his feminine identification. By cutting his ear he would have identified with the female courtesans who mutilated their bodies to prevent the loss of male admirers.
2. L558b.
3. L576.
4. L558.
5. L558.
6. L558b.
7. B19a.
8. L498.
9. Merlhès, 1984, no. 193.
10. Ibid., no. 183.
11. L559.
12. L534.
13. L533.
14. L583.
15. B19.
16. Merlhès, 1984, no. 179.
17. Ibid.
18. L559.
19. Merlhès, 1984, no. 179.
20. Ibid., no. 193.
21. Ibid., no. 179.

22. For affinities between Gauguin's *Grape Gathering: Human Misery* and van Gogh's *Sorrow,* see Henri Dorra, "Gauguin's Dramatic Arles Themes," *Art Journal* 38 (Fall 1978), pp. 12–17.

23. "Vincent's Sermon" in *Complete Letters,* vol. I, pp. 87–91.

24. L564.

25. Merlhès, 1984, no. 193.

26. Malingue, no. 75.

27. L534.

28. L559, 561, 563.

29. B19.

30. L562, 561.

31. L561, 562.

32. B19.

33. B19.

34. L403; Vincent's italics.

35. W9.

36. L560.

37. L560.

38. L558a.

39. L560.

40. L545. See Ronald Pickvance, *Van Gogh in Arles* (New York, 1984), pp. 224–225.

41. For Gauguin's encounter with Sérusier, see John Rewald, *Post-Impressionism: From van Gogh to Gauguin* (New York, 1986), pp. 183–184.

42. For the relationship between Gauguin's *Madame Roulin* and *Blue Trees,* see Vojtech Jirat-Wasiutyenski and H. Travers Newton, *Technique and Meaning in the Paintings of Paul Gauguin* (Cambridge, Mass., 2000), pp. 132–135.

43. Merlhès, 1984, no. 192. For valuable discussions of Gauguin's *Portrait of Vincent van Gogh Painting Sunflowers,* see Jirat-Wasiutyenski and Newton; and Jirat-Wasiutyenski, "Paintings from Nature versus Paintings from Memory" in *A Closer Look: Technical and Art-Historical Studies on Works by van Gogh and Gauguin, Cahier Vincent 3* (1991), pp. 90–102.

44. Meyer Schapiro, *Vincent van Gogh* (New York, 1950), p. 60.

45. L560.

46. L605.

47. Paul Gauguin, *Avant et après,* in *Gauguin's Intimate Journals,* trans. Van Wyck Brooks (Mineola, N.Y., 1997), p. 11.

48. Merlhès, 1984, no. 192.

49. Ibid., no. 191.

50. L565.

51. Merlhès, 1984, no. 192.

52. L558, 562.

53. L563.

54. L558b.

55. L560.

56. B19a.

57. Gauguin, 1997, pp. 8–9.

58. L561.

59. L339.

60. L339.

61. L560, 563.

62. Merlhès, 1984, no. 182.

63. Gauguin, 1997, p. 10.

64. L564.

65. For a discussion of Maupassant's "Le Horla" in the context of hypnotism, somnambulism, and van Gogh's awareness of his mental difficulties, see Victor Merlhès, 1989, pp. 218–222.

66. Guy de Maupassant, "The Horla" in *Selected Short Stories,* trans. Roger Colet (London, 1971), p. 339.

67. Ibid., pp. 332, 336.

68. Ibid., p. 320.

69. Ibid., p. 336.

70. Douglas Cooper, ed., *Paul Gauguin: 45 lettres à Vincent, Theo et Jo van Gogh* (Lausanne, 1983), VG/PG, pp. 265–271.

71. Van Gogh's reference to "le horla" does not appear in *Complete Letters.* See L574 in Vincent van Gogh, *Verzamelde Brieven van Vincent van Gogh,* vol. 3 (Amsterdam and Antwerp, 1952-1954).

72. Malingue, no. 75.

73. Ibid., no. 78.

74. Paul Gauguin, *Avant et après,* in *The Writings of a Savage,* ed. Daniel Guérin, trans. Eleanor Levieux (New York, 1990), 252.

75. L539.

76. B12.

77. B14.

78. L497.

79. Gauguin, 1990, p. 68.

80. L564.

81. L604.

82. For Gauguin's conversation with Dr. Rey, see Merlhès, 1989, pp. 245–246.

83. Thomson, 1993, pp. 94–95.

84. L558a.

85. For rainfall in Arles, see Pickvance, 1984, and Merlhès, 1989.

86. Gauguin, 1997, p. 7.

87. Ibid., p. 11.

88. Merlhès, 1984, no. 175.

89. Ibid., no. 181.

90. Ibid., no. 193.

91. For Bernard's letter to Aurier, see Rewald, 1986, pp. 245–246.

92. L 564. But the interpolation does not appear in *Complete Letters*. For a facsimile of the original and a transcription, see Merlhès, 1989, pp. 229–232.

93. L564. But the interpolation does not appear in *Complete Letters*. For a facsimile of the original and a transcription, see Merlhès, 1989, pp. 229–232. The nearly untranslatable interpolation appears as follows in the original: "...et Delacroix un homme de Dieu de tonnerre de Dieu et de foutre las paix au nom de dieu."

94. For Gauguin's conversation with Marie Henry, see Merlhès, 1989, p. 246, n. 4.

95. Gauguin, 1997, p. 12.

96. L571.

97. *Complete Letters*, vol. I, p. xlvi.

98. For psychoanalytic and psychoanalytically oriented discussions of *Van Gogh's Chair* and *Gauguin's Chair*, see Humberto Nagera, *Vincent van Gogh* (Madison, Conn., 1990); Harold Blum, "Van Gogh's Chairs," *American Imago* 13 (1956), pp. 307–318; Wayne Andersen, *Gauguin's Paradise Lost* (New York, 1971); Albert J. Lubin, *Stranger on the Earth: A Psychological Biography of Vincent van Gogh* (New York, 1972); Charles Mauron, *Van Gogh—Etudes psychocritiques* (Paris, 1976); and John Gedo, *Portraits of the Artist* (Hillsdale, N.J., 1989).

99. L563.

100. L571a.

101. L626a.

102. L118.

103. L252.

104. *Verzamelde Brieven*, L626a.

105. Merlhès, 1984, no. CI.

106. B14.

107. For the idiomatic and literary uses of the candle as a metaphor for the phallus, see Mauron, p. 89.

108. L533.

109. B21.

110. B21.

111. L574.

112. Paul Gauguin, *Noa Noa: Gauguin's Tahiti*, ed. Nicholas Wadley, trans. Jonathan Griffin (Oxford, 1985), 25.

113. T. J. Clark, "Freud's Cézanne," in *In Visible Touch: Modernism and Masculinity*, ed. Terry Smith (Sydney, 1997). Clark remarks that he "never understood why writers about Cézanne shy away from the strict coincidence of the ten years spent on the three large *Bathers* with those of the founding of psychoanalysis—the years of Freud's self-analysis and the publication of *The Interpretation of Dreams* (1900), the letters to Fliess, the treatment of Dora, the writing of *Three Essays on the Theory of Sexuality*. I like to think of the Barnes picture as roughly the equivalent of *The Interpreta-*

tion of Dreams, and the cooler atmosphere of the painting in the Philadelphia Museum as corresponding to that of the *Three Essays.*"

114. Gauguin, 1990, p. 139.

115. Ibid., p. 180.

116. L574.

117. T19.

118. L613.

119. Gauguin, 1997, pp. 9–10.

120. Ibid., p. 10.

121. B21. *Complete Letters* dates this letter to beginning December 1888. I have used the Pickvance, 1984, redating of the letter to November 22, 1888.

Chapter Six

1. L568, 569.

2. L566.

3. L571, 568.

4. L573.

5. L566.

6. L572.

7. L571; all quotes in this and the next two paragraphs are from L571.

8. Alphonse Daudet, *Tartarin of Tarascon—Tartarin on the Alps,* trans. Henry Frith (London and New York, 1969), p. 123.

9. Ibid., p. 132.

10. Ibid., p. 136.

11. Ibid., p. 224.

12. Ibid., p. 228.

13. L571.

14. Georges Braque in Doris Vallier, "Braque: La Peinture et Nous," *Cahiers d'Art,* vol. 1 (Paris, 1954), p. 14, quoted and translated in Mary M. Gedo, *Picasso: Art as Autobiography* (Chicago, 1980), p. 85. See *Picasso: Art as Autobiography* for a valuable discussion of Picasso's relationship with Braque.

15. L571; all quotes in this and the next four paragraphs are from L571.

16. L573.

17. Paul Gauguin, *Avant et après,* in *The Intimate Journals of Paul Gauguin,* trans. Van Wyck Brooks (Mineola, N.Y., 1997), p. 86.

18. Gauguin, *Avant et après,* in *The Writings of a Savage,* ed. Daniel Guérin, trans. Eleanor Levieux (New York, 1990), p. 23.

19. John Rewald, *Post-Impressionism: From van Gogh to Gauguin* (New York, 1986), p. 341.

20. Malingue, no. 95.

21. Ibid., no. 92.

22. Thomson, 1993, p. 114.

23. T10.

24. L595.

25. B21.

26. L576.

27. L605.

28. L607.

29. Debora Silverman, *Van Gogh and Gauguin: The Search for Sacred Art* (New York, 2000).

30. See John Gedo, *Portraits of the Artist: Psychoanalysis of Creativity and Its Vicissitudes* (Hillsdale, N.J., 1989), pp. 139–160, for a discussion of van Gogh's difficulties with "self-esteem regulation." Gedo regards this as the "core of the artist's psychopathology." See also W. W. Meissner, *Vincent's Religion: The Search for Meaning* (New York, 1997), for a psychoanalytic discussion of Vincent's identification with Christ and his religiosity in general. Meissner is both a psychoanalyst and a Jesuit priest.

31. T19.

32. L613.

33. L613.

34. T4.

35. L615.

36. L615.

37. L615.

38. L615.

39. L615, B21.

40. Thomson, 1993, p. 107.

41. Ibid. I have used the dating of this letter to c. October 20, 1889, found in Thomson, 1993, and in Douglas Cooper, ed., *Paul Gauguin: 45 lettres à Vincent, Theo, et Jo van Gogh* (Lausanne, 1983). However, Francoise Chachin, in Richard Brettell, et al., *The Art of Paul Gauguin* (Washington, D.C., 1988), and Ronald Pickvance, in *Van Gogh in Saint-Rémy and Auvers* (New York, 1986), date this letter to December 1889.

42. T19.

43. Rewald, p. 369.

44. L643. For a valuable discussion of van Gogh's *L'Arlésienne* see Judy Sund, "Famine to Feast: Portrait Making at St.-Rémy and Auvers," in Roland Dorn et al., *Van Gogh Face to Face: The Portraits* (Detroit, 2000), pp. 182–227. Sund rightly sees *L'Arlésienne* and its variants as in many ways self-portraits. However, she identifies the portrait in the Galleria Nazionale d'Arte Moderna in Rome as the version given to Gauguin. I have accepted the conclusion in Cooper and in Pickvance, 1986, that van Gogh gave Gauguin the painting (F543) now in Dr. Ruth Bakwin's collection in New York.

45. L643.

46. Gauguin to van Gogh quoted in Pickvance, 1986, p. 211.

47. L646.

48. Malingue, no. 111.

49. Ibid., no. 113.

50. Gauguin, 1997, p. 10.

51. Ibid.

52. Ibid.

53. Ibid.

54. Gauguin, 1990, 246.

55. Ibid., p. 247.

56. Ibid., p. 248.

57. Ibid., 247–248.

58. Ibid., p. 246. *Diverses choses* consists of Gauguin's musings from 1896 to 1898 in the blank pages of the illustrated manuscript of *Noa Noa*.

59. Ibid., 250.

60. Ibid., p. 246.

61. Gauguin to van Gogh quoted in Rewald, p. 350.

62. My discussion of Gauguin's feminine identification and of Meyer De Haan as a substitute for van Gogh is indebted to John Gedo's stimulating *Portraits of the Artist: Psychoanalysis of Creativity and Its Vicissitudes* (Hillsdale, N.J., 1989), pp. 139–160.

63. Malingue, no. 87.

64. Freud used the phrase "unruly homosexual feeling" in a letter to Ernest Jones regarding his relationship with Wilhelm Fliess and Carl Jung. See Peter Gay, *Freud: A Life for Our Time* (New York, 1988), p. 276. Although Mark Roskill, in his *Van Gogh, Gauguin and the Impressionist Circle* (New York, 1970), convincingly ascribed this emotion to van Gogh, it can be applied to both partners in the collaboration.

65. Maurice Denis, "De Gauguin et de van Gogh au classicisme," *L'Occident* 90 (May 1909), pp. 187–202, quoted in Carol M. Zemel, *The Formation of Legend: Van Gogh Criticism, 1890–1920* (Ann Arbor, Mich., 1980), p. 96.

66. Ibid.

67. Merlhès, 1984, no. 181.

68. Malingue, no. 78.

69. Ibid.

70. L623a, 626a.

Selected Bibliography

Gauguin's Letters

Cooper, Doglas, ed. *Paul Gauguin: 45 Lettres à Vincent, Theo, et Jo van Gogh.* Gravenhage and Lausanne, 1983.

Malingue, Maurice, ed. *Lettres de Gauguin à sa femme et à ses amis.* Paris, 1946. Published in English as *Paul Gauguin: Letters to his Wife and Friends.* Translated by Henry J. Stenning. London, 1946.

Merlhès, Victor, ed. *Correspondance de Paul Gauguin: Documents, témoignages, 1873–1888.* Paris, 1984.

Thomson, Belinda, ed. *Gauguin by Himself.* Boston, 1993.

Gauguin's Writings

Avant et après, facs. ed. Copenhagen, 1951. Published in English as *The Intimate Journals of Paul Gauguin.* Translated by Van Wyck Brooks. Mineola, N.Y., 1997.

Guérin, Daniel, ed. *The Writings of a Savage: Paul Gauguin.* Translated by Eleanor Leviaux, with an introduction by Wayne V. Andersen. New York, 1990.

Wadley, Nicholas, ed. *Noa Noa, Gauguin's Tahiti.* Translated by Jonathan Griffen. London, 1985.

Van Gogh's Letters

Van Gogh-Bonger, J., ed. *The Complete Letters of Vincent van Gogh,* 3 vols. Boston, 1978.

Van Crimpen, Han, and Monique Berands-Albert, eds. *De Brieven van Vincent van Gogh,* 4 vols. The Hague, 1990.

Verzamelde Brieven van Vincent van Gogh, 4 vols. Amsterdam and Antwerp, 1974.

Van Gogh and Gauguin

Childs, Elizabeth C. "Seeking the Studio of the South: Van Gogh, Gauguin, and Avant-Garde Identity" in Cornelia Homburg, et al. *Vincent van Gogh and the Painters of the Petit Boulevard.* Exh. cat., St. Louis Art Museum, 2001.

Denis, Maurice. "De Gauguin et de van Gogh au classicisme," *L'Occident* 90 (May 1909), pp. 187–202; reprinted in Maurice Denis, *Le Ciel et l'Arcadie,* Jean-Paul Bouillon, ed. Paris, 1993.

Druick, Douglas, et al. *Van Gogh and Gauguin: The "Studio of the South"* Exh. cat. The Art Institute of Chicago, 2001.

Jirat-Wasiutynski, Vojtech. "Paintings from Nature versus Painting from Memory" in *A Closer Look: Technical and Art-Historical Studies on Works by van Gogh and Gauguin, Cahier Vincent 3* (1991), pp. 90–102.

Loevgren, Sven. *The Genesis of Modernism: Seurat, Gauguin, van Gogh, and French Symbolism of the 1880s.* Bloomington, 1971.

Maurer, Naomi. *The Pursuit of Spiritual Wisdom: The Thought and Art of Vincent van Gogh and Paul Gauguin.* Madison, N.J. and London, 1998.

Merlhès, Victor. *Paul Gauguin et Vincent van Gogh, 1887–1888: Lettres retrouvées, sources ignorées.* Taravao, Tahiti, 1989.

Rewald, John. *Post-Impressionism from van Gogh to Gauguin.* New York, 1986.

Roskill, Mark. *Van Gogh, Gauguin and French Painting: A Catalogue Raisonné of Key Works.* Ann Arbor, Mich., 1970.

_____. *Van Gogh, Gauguin, and the Impressionist Circle.* Greenwich, 1970.

Silverman, Debora. *Van Gogh and Gauguin: The Search for Sacred Art.* New York, 2000.

Svenaeus, Gösta. "Gauguin and van Gogh," *Vincent: Bulletin of the Rijksmuseum Vincent van Gogh* 4 (1976) pp. 20–32.

Uitert, Evert van. "Vincent van Gogh in Anticipation of Paul Gauguin," *Simiolus* 10, no. 3/4 (1978–1979), pp. 182–199.

_____. "Van Gogh and Gauguin in Competition: Vincent's Original Contribution," *Simiolus* 11, no. 2 (1980), pp. 81–106.

_____. *Vincent van Gogh in creative competition: Four Essays from Simiolus.* Zutpher, 1983.

Van Gogh, V. W. "Van Gogh and Gauguin," *Vincent: Bulletin of the Rijksmuseum Vincent van Gogh* 1, no.1 (1975), pp. 2–7.

Psychoanalytic Studies

Blum, Harold. "Van Gogh's Chairs," *American Imago* 13 (1956), pp. 307–318.

Bonicatti, Maurizio. *Il caso Vincent Willem van Gogh.* Turin, 1977.

Gedo, John. *Portraits of the Artist.* Hillsdale, N.J., 1989.

Kuspit, Donald. "The Pathology and Health of Art: Gauguin's Self-Experience" in Mary Gedo, ed., *Psychoanalytic Perspectives on Art*, vol. 2. Hillsdale, N.J., 1987.

Lubin, Albert J. *Strangers on the Earth: A Psychological Biography of Vincent van Gogh*. New York, 1987.

Mauron, Charles. *Van Gogh: Etudes psychocritiques*. Paris, 1976.

Meissner, W. W. *Vincent's Religion: The Search for Meaning*. New York, 1997.

Nagera, Humberto. *Vincent van Gogh: A Psychological Study*. New York, 1967.

Rose, Gilbert. "Paul Gauguin: Art, Androgyny, and the Fantasy of Rebirth" in Charles Socarides and V. Volkan, eds. *The Homosexualities: Reality, Fantasy, and the Arts*. Madison, Conn., 1990.

Schneider, Daniel E. *The Psychoanalyst and the Artist in Three Modern Painters*. New York, 1949.

Schnier, J. "The Blazing Sun," *American Imago* 7 (1950), pp. 143–162.

Westermann-Holstijn, A. "The Psychological Development of Vincent van Gogh," *American Imago* 8 (1951), pp. 239–273.

General: Gauguin

Amishai-Maisels, Ziva. *Gauguin's Religious Themes*. New York and London, 1985.

Andersen, Wayne V. *Gauguin's Paradise Lost*. New York, 1971.

Bodelsen, Merete. *Gauguin's Ceramics: A Study in the Development of His Art*. London, 1964.

Brettell, Richard, et al. *The Art of Paul Gauguin*. Exh. cat. Washington, D.C., National Gallery of Art, 1988.

Darr, William, and Mary Mathews Gedo. "Wrestling Anew with Gauguin's Vision of the Sermon" in Mary Mathews Gedo, ed. *Looking at Art from the Inside Out: The Psychoiconographic Approach to Modern Art*. Cambridge, 1994.

Eisenmen, Stephen F. *Gauguin's Skirt*. London, 1997.

Goldwater, Robert. *Gauguin*. New York, 1983.

Jirat-Wasiutynski, Vojtech. *Paul Gauguin in the Context of Symbolism*. New York and London, 1978.

Jirat-Wasiutynski, Vojtech, et al. *Vincent van Gogh's Self-Portrait Dedicated to Paul Gauguin: An Historical and Technical Study*. Cambridge, Mass., 1984.

Jirat-Wasiutynski, Vojtech, and H. Travers Newton. *Technique and Meaning in the Paintings of Paul Gauguin*. Cambridge, 2000.

Orton, Fred, and Griselda Pollock. "Des Données Bretonnantes: La Prairie de Représentation" in F. Franscina and C. Harrison, eds. *Art and Modernism: A Critical Anthology*. London, 1982.

Sweetman, David. *Paul Gauguin: A Life*. New York, 1995.

Thomson, Belinda. *Gauguin*. London, 1987.

Widenstein, George. *Gauguin*. Raymond Cogniat and Daniel Wildenstein, eds., vol. 1. Paris, 1964.

General: Van Gogh

Faille, J.-B. de la. *The Works of Vincent van Gogh, His Paintings and Drawings.* Amsterdam, 1970.

Graetz, H. R. *The Symbolic Language of Vincent van Gogh.* New York, 1963.

Hammacher, A. M., and R. Hammacher. *Van Gogh: A Documentary Biography.* London, 1982.

House, John. "In Detail: van Gogh's *The Poet's Garden, Arles,*" *Portfolio* 2, no. 4 (Sept./Oct. 1980), pp. 28–33.

Hulsker, Jan. "The Poet's Garden," *Vincent: Bulletin of the Rijksmuseum Vincent van Gogh* 3, no. 1 (1974), pp. 22–32.

_____. *The New Complete Van Gogh: Paintings, Drawings, Sketches, Revised and Enlarged Edition of the Catalogue Raisonné of the Works of Vincent van Gogh.* Amsterdam and Philadelphia, 1996.

Johnson, Ron. "Vincent van Gogh and the Vernacular: The Poet's Garden," *Arts* 53, no. 6 (Feb. 1979), pp. 98–104.

Kodera, Tsukasa. *Vincent van Gogh: Christianity versus Nature.* Amsterdam and Philadelphia, 1990.

Nordenfalk, Carl. "Van Gogh and Literature," *Journal of the Warburg and Courtauld Institutes* 10 (1947), pp. 132–147.

Pickvance, Ronald. *Van Gogh in Arles.* Exh. cat. New York, The Metropolitan Museum of Art, 1984.

_____. *Van Gogh in Saint-Rémy and Auvers.* Exh. cat. New York, The Metropolitan Museum of Art, 1986.

Pollock, Griselda. "Artists, Media, Mythologies: Genius, Madness, and Art History," *Screen* 21 (1980), pp. 57–96.

Pollock, Griselda, and Fred Orton. *Vincent van Gogh: Artist of His Time.* New York, 1987.

Schapiro, Meyer. *Vincent van Gogh.* New York, 1950.

Sund, Judy. *True to Temperament: Van Gogh and French Naturalist Literature.* New York, 1992.

_____. "Famine to Feast: Portrait Making at St.-Rémy and Auvers" in Roland Dorn et al. *Van Gogh Face to Face: The Portraits.* Exh. cat. Detroit Institute of Arts, 2000.

Sweetman, David. *Vincent van Gogh: His Life and His Art.* New York, 1990.

Welsh-Ovcharov, Bogomila. *Vincent van Gogh and the Birth of Cloisonism.* Exh. cat. Toronto, Art Gallery of Ontario, 1981.

Zemel, Carol. *The Formation of a Legend: Van Gogh Criticism, 1890–1920.* Ann Arbor, Mich., 1980.

_____. *Van Gogh's Progress: Utopia, Modernity, and Late-Nineteenth-Century Art.* Berkeley, 1997.

Index